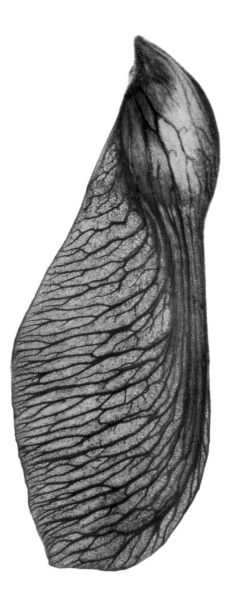

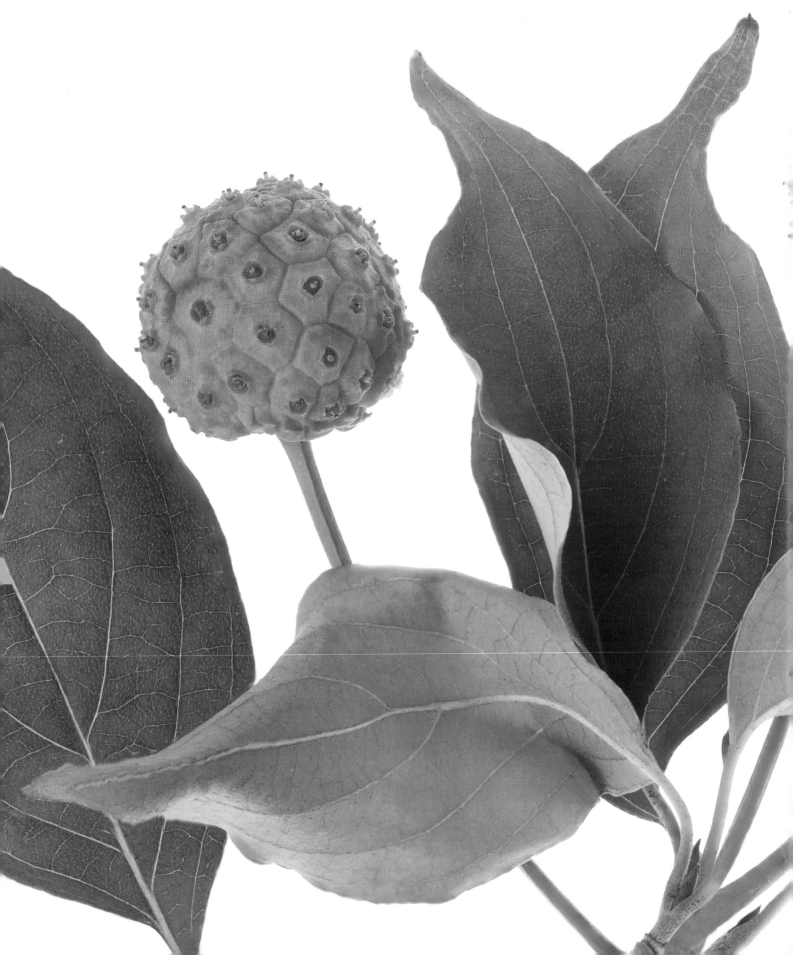

Seeing Seeds

A journey into the world of
seedheads, pods, and fruit

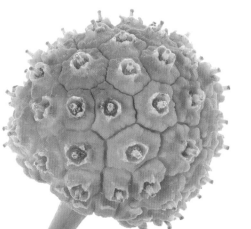

Photography by
ROBERT LLEWELLYN
Written by
TERI DUNN CHACE

TIMBER PRESS
Portland, Oregon

Dedicated to **SAVION GLOVER**,
who dances at the intersection of discipline and joy.
It occurs to me that seeds do the same thing,
in their own way.

Page 1: A side view of a red maple "key" or samara. At this intimate level, it almost looks like part of a human or animal. Seeds in fact are alive—"alive but asleep."

Pages 2–3: The oddball fruit of the Kousa dogwood, which mature coral red and have pulpy, edible interiors.

Opposite: Salsify, a relative of the common dandelion, disperses its seeds on the wind.

Text copyright © 2015 by Teri Dunn Chace.
Photographs copyright © 2015 by Robert Llewellyn.
All rights reserved.
Published in 2015 by Timber Press, Inc.

An excerpt from the essay "The Forest in the Seeds," in *High Tide in Tucson*, by Barbara Kingsolver (Harper Perennial, 1995), is reprinted by permission of the publisher.

An excerpt from the story "The Author of the Acacia Seeds," in *The Compass Rose*, by Ursula K. LeGuin (HarperCollins, 1982), is reprinted by permission of Curtis Brown, Ltd.

An excerpt from the essay "How Flowers Changed the World," in *The Immense Journey*, by Loren Eiseley (Vintage Books/Random House, 1959), is reprinted by permission of the publisher.

An excerpt from the chapter "The Lives of a Cell," in *The Lives of a Cell: Notes of a Biology Watcher*, by Lewis Thomas (Bantam Books, 1979), is reprinted by permission of the publisher.

An excerpt from the chapter "May," in *The Rural Life*, by Verlyn Klinkenborg (Little, Brown, and Company, 2003), is reprinted by permission of the publisher.

Timber Press
The Haseltine Building
133 S.W. Second Avenue, Suite 450
Portland, Oregon 97204-3527
timberpress.com

Printed in China
Text and cover design by Susan Applegate

Library of Congress Cataloging-in-Publication Data

Dunn Chace, Teri, author.
 Seeing seeds: a journey into the world of seedheads, pods, and fruit/photography by Robert Llewellyn; written by Teri Dunn Chace.—First edition.
 pages cm
 Includes bibliographical references and index.
 ISBN 978-1-60469-492-5
 1. Seeds. 2. Seeds—Pictorial works. I. Llewellyn, Robert J., illustrator. II. Title.
 QK661.D866 2015
 581.4'67—dc23

 2015006910

A catalog record for this book is also available from the British Library.

"Though I do not believe that a plant will spring up where no seed has been, I have great faith in a seed. Convince me that you have a seed there, and I am prepared to expect wonders."
—HENRY DAVID THOREAU
from the unfinished manuscript "Faith in a Seed," 1862

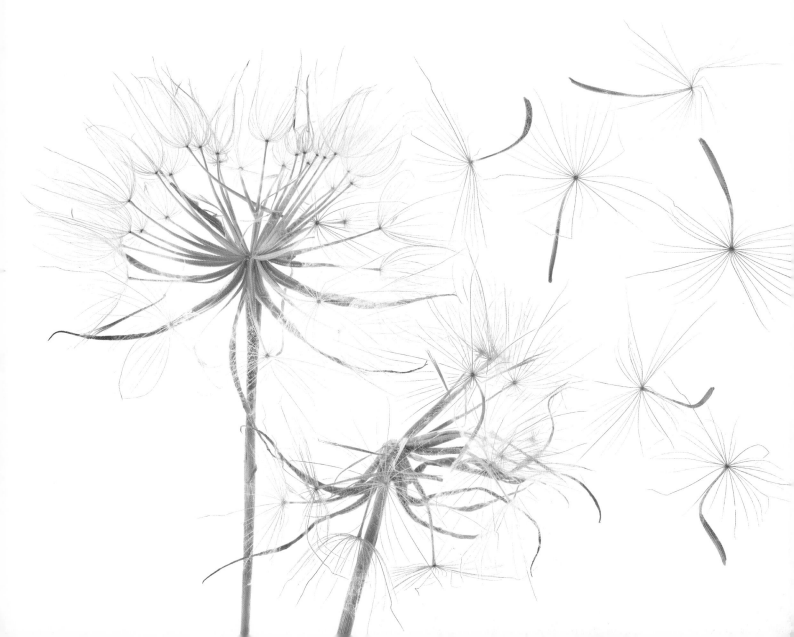

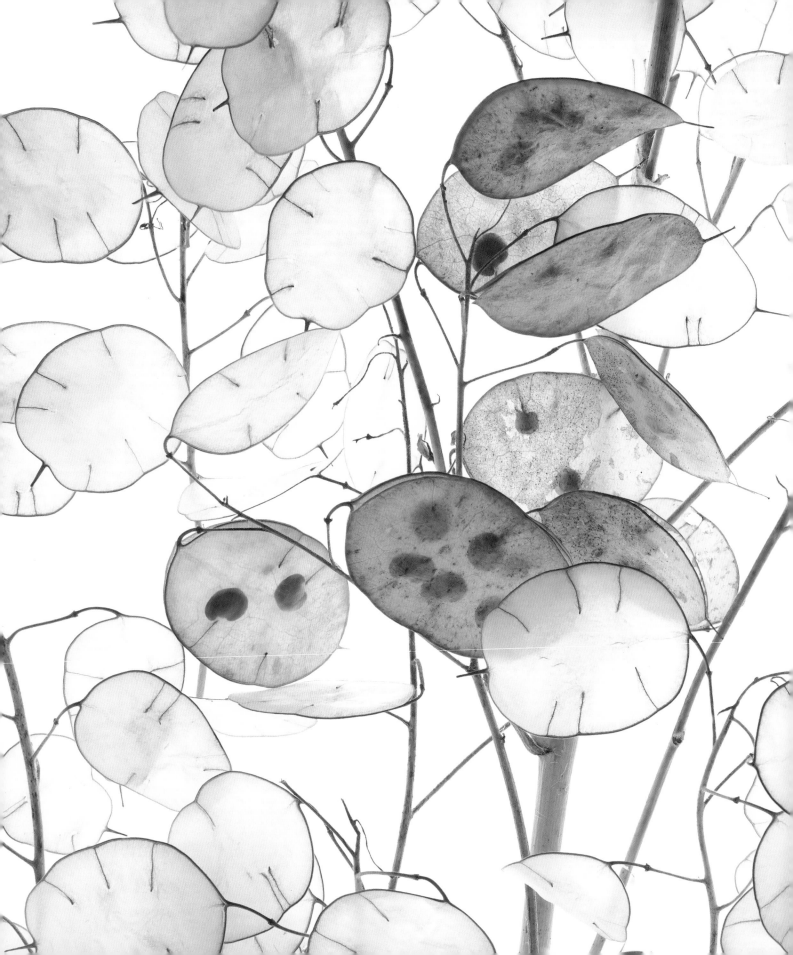

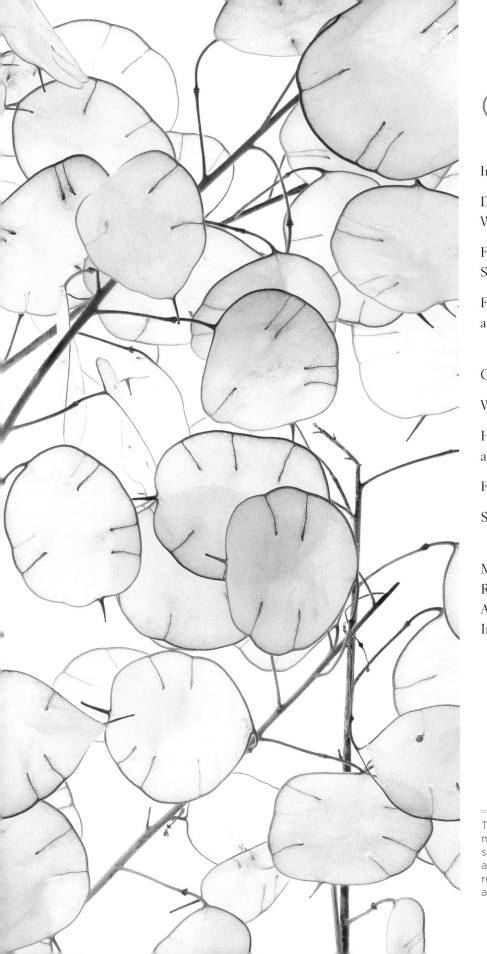

CONTENTS

Introduction 9

Definition: What are Seeds? 13
Why Do They Exist?

Form: Why Are Seeds 27
So Diverse?

Function: What Do Seeds Do, 43
and How Do They Do it?

Garden Flowers 59

Weeds and Wildflowers 117

Herbs, Spices, Fibers, 157
and Medicine

Fruits and Vegetables 183

Shrubs and Trees 217

Metric Conversions 273
Recommended Reading 274
Acknowledgments 277
Index 278

The strangely appealing pods of the money plant, *Lunaria*, are flat and thin—somewhat like coins. They can house a few flattened seeds, which are not released until the papery covering dries and disintegrates.

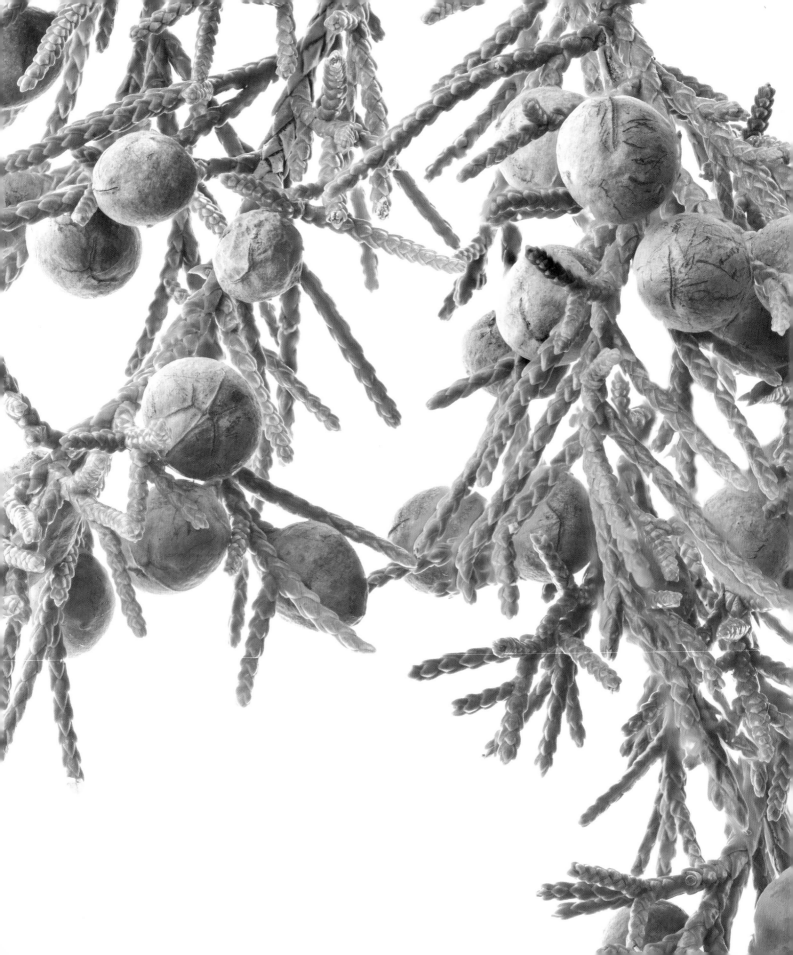

INTRODUCTION

The edge of a mystery

If you have ever been on a journey and returned a changed person, I invite you to sit down with this book. I've been on a seeds odyssey. Not with seeds in my pockets or sewn into my hemline like an immigrant, a preservationist, or a long-ago plant explorer, but with Bob Llewellyn's exquisite and insightful photographs as my pathway. I had thought I was well equipped with horticultural and botanical knowledge, seeing as I am a lifelong gardener, an amateur botanist, and the author of various books about plants and nature. While I am not a scientist, I have delved into their thick books and scholarly papers. Although I am not a farmer, I have heeded reflections of everyone from Scott Chaskey to Vandana Shiva to Michael Abelman. I have also talked with local and distant farmers and gardening friends about this project.

Like a child in a fairy tale who follows a beckoning songbird far from home into unrecognizable territory, my seed journey began with curiosity and took me to strange places. Sometimes the load seemed heavy and the road looked long—seeds are complicated and puzzling. Other times a seed revealed its inner secrets before drifting away on a breeze. The ingenuity of the seeds of this world, not to mention their sheer volume of production, is astounding and real. Many seeds are small, but we should underestimate none of them. What they contain and do is huge, mysterious, and important.

Eastern red cedar "berries" appear only on the female trees. Botanically they are small, seed-bearing cones.

This book highlights 100 representative seeds, fruits, and pods. Even after settling on five logical categories, I questioned some of the designated slots. Seed versatility is a given, and variations in form and function are legion. But we can discern patterns and principles. These pages are but a glimpse into the complexities and quirks of plant life and its drive to reproduce and ensure its own continuation.

Some seeds appear to follow a straightforward path. A flower is pollinated, petals fall off, and the ovary swells with ripening seeds. But even this sequence is a remarkable achievement when we examine the discernible steps. Other plants do things their own way. Horsetail spores literally dance into new growing locations. Cedar cones hoard winged seeds inside—until they don't. Wisteria pods, touch-me-nots, and okra catapult ripe seeds. Most figs are parthenocarpic, and thus bypass sexual reproduction. Datura seeds poison you or take you out of your mind. Even teeny-tiny rose seeds are not simple structures; extracting them from rose hips and sowing them will not produce a plant like the parent. I hope that after you spend some time with Bob's images and my short expositions, you will begin to notice and respect any seeds you encounter, anywhere.

In the end, like the adventurers who took Jules Verne's imaginary journey to the center of the earth, travelers in the realm of seeds witness things both familiar and bizarre, test various assumptions, and emerge in a new place. That different location is still on this planet, but the future is fragile and understanding is provisional. It is within our power to learn more about and participate in the diverse circle of life. Everything plants do or can do, every fruit or pod or loose seed, is connected to us and to all living things. There is no autonomy; nothing is entirely solitary. To say we are co-evolutionary with seeds is to graze the edge of a mystery. A life force is embedded in everything, not just in seeds.

The journey begins

On a mild autumn afternoon where I live in upstate New York, foliage was red, yellow, and orange; squirrels were collecting acorns; birds were alighting in the bushes and trees; and fluffy white clouds were scudding across the blue sky. I stood in a friend's backyard, taking it all in. I had been invited to pick grapes for jelly.

"Are they ready?" we wondered as we tromped across the overgrown lawn, armed with clippers and bags. We sniffed the fragrant air as we approached the thickly growing vines on their groaning supports. We picked a couple of dusky purple grapes and popped them in our mouths. They were sweet, but the skins were tough. And, unlike store-bought ones, inside were small, slender tan seeds. We spit these into the grass.

"Seeds. What are they, really?" my friend mused.

Autumn is the season of seeds, from acorns to grape seeds to windblown fluff from milkweed, goldenrod, and fireweed. If no one eats a seed, does it automatically grow into a new plant next spring? What is inside a seed? How does it all work? Does it all work, or is there a lot of wastefulness?

These are good questions. That afternoon came back to me when I first browsed through Bob's gorgeous photographs of a wide array of seeds, many of which were taken in autumn. His images amaze me, but they also remind me that this corner of the plant world is arguably its most important. No seeds means no flowers or plants. No seeds equals no fruit or nuts. Without seeds to nourish them, animals and birds would struggle or perish. Without seeds to nourish us, farms and foraging would come to an end. Human beings would be endangered.

For plants, making seeds is serious business. It takes time, resources, and energy. Sometimes the plant is so worn out after going through the process that it dies or goes dormant. Sometimes it takes off the next year to regroup or releases a greatly reduced production.

Sometimes seeds are all that remains—the hope for and the beginning of a new generation.

A note about the photographs

If you think the photographs in this book are unusual, you are correct. Bob uses a unique technique known as image stacking, which allows every part of the picture to be in sharp focus. He places his quarry on a light table, then takes many shots from slightly different vantages. Afterward, he stitches them together using a software program originally developed in Russia for use with microscopes. The result has, as a reviewer of this book's predecessor, *Seeing Flowers*, remarks, "the same heartbreaking clarity you'd find in a nineteenth-century botanical illustration."

Photographing seeds, pods, and fruits requires a fair amount of inventiveness and flexibility. Sometimes Bob had to carefully slice open a fruit to reveal its hidden contents. Sometimes he had to search a room for seeds that had flung out in his absence. Sometimes he had to soak, dry, coax, pry, or pin plant bits to expose seeds. He went down the rabbit hole into a wonderland.

Bob's intimate images, made with remarkable skill and care, invite awe and inspire curiosity. Come travel with us into that wonderland.

DEFINITION
What are seeds? Why do they exist?

"Nature does not move in mysterious ways, really. She just moves so slowly we're inclined to lose patience and stop watching before she gets around to the revelations."

—Barbara Kingsolver
"The Forest in the Seeds" from *High Tide in Tucson*, 1995

"All we can guess is that the putative Art of the Plant is *entirely different* from the Art of the Animal. What it is, we cannot say; we have not yet discovered it. Yet I predict with some certainty that it exists, and that when it is found it will prove to be, not an action, but a reaction: not a communication, but a reception. It will be exactly the opposite of the art we know and recognize. It will be the first *passive* art known to us. Can we in fact know it? Can we ever understand it?"

—Ursula K. LeGuin
"The Author of the Acacia Seeds" from *The Compass Rose*, 1982

PREVIOUS Flowers always capture our attention at the height of their full bloom. For example, it wasn't long ago that this acanthus flower spike was clothed in glorious hues of mauve and white. As flowers fade and brown, it's amazing to realize that a potential repeat performance is lodged within each and every seed.

RIGHT If the seeds inside a fruit such as an apple can produce a whole new plant, why does the plant bother producing flesh and peel? Most times, these outer coverings are more than just protection. Fruit flesh lures dispersal agents who will eat that bountiful outer part and, hopefully, discard the seed.

A SEED IS BOTH the beginning and the end of a plant's life. In between there is a dramatic rise and fall in size and complexity, like a bell graph or a swelling symphony. Additional players contribute to the drama. At the end, self-replication has occurred. We return to where we started, but it's a new generation.

A seed is the beginning because it contains an embryonic plant. A seed also houses a supply of stored food meant to nourish the embryo until it can develop roots and top growth. For now, is encased in a protective shell, sometimes quite hard and moisture resistant.

A ripe seed is a starter kit. This is not only a practical arrangement, but it also might strike us as excessive.

Think of the tiny black apple seeds concealed deep inside the abundant sweet flesh, or the tiny, slick grape seeds I spit into the grass in my friend's yard.

We have to admire the roles that other creatures, from birds to humans, play in the life of plants. Maybe the sweet, crisp apple flesh is meant for us; perhaps the juicy, succulent grapes are intended for the birds. Or, to express this in reverse terms, maybe seed dispersal is the reason for the fruit. (Or it could just be nature's abundant excess.)

Seeds are not always digested when they are ingested. A bird eats a grape, gains nourishment from it, flies someplace else, and excretes the seeds, dispersing them and providing a ready dose of fertilizer.

There is a range of seed forms. Tiny, even dustlike, seeds are lone rangers. Carrots and related plants, such as fennel, dill, and Queen Anne's lace, generate one-seeded fruits. Pods, like green beans, peas, tamarind, and catalpa, are simply vessels for the seeds inside. A fruit such as an apple, a melon, or a lemon is technically a mature fertilized ovary with multiple seeds lodged within. All this variation doesn't change the basic fact that the seeds—with different degrees and types of protective and nurturing parts and materials—harbor embryonic plants.

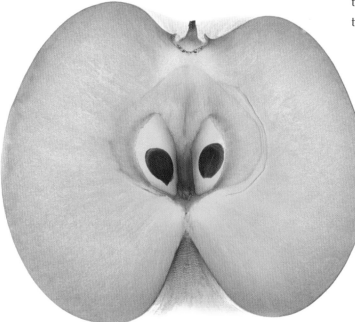

A seed also marks an ending, as it represents the consummation of a plant's life. The plant grew, flowered, got pollinated, and produced seed. Its work is done. It can rest or die now. It has successfully left behind the next generation, or at least potential for the next generation.

Seeds exist to ferry and carry on their own kind into the future, the same principle as eggs in the animal world. They can't reproduce or spread without help from their environment (including, occasionally, humans), which provides a vivid reminder of the interrelatedness of all life.

Of paternity and pollination

Seeds are part of a cycle of sex, child rearing, and death, similar to that of humans. As expert gardener Carol Deppe notes, "Plants, like most people, have fathers. With plants, as with people, it may not be entirely obvious who the father is." What is most apparent to our eyes, and often all that remains as evidence of a union, is the mother of a seed. The father pollen has been delivered one way or another (more on that in the next section).

If all goes well and according to plan, the seed or seed-containing fruit or pod develops on the mother, the plant before us. Using Deppe's reasoning, we can say that the fathers are in the neighborhood, but the children grow to maturity with their mother. This is hardly unprecedented in the animal world, but it's an interesting angle from which to view plants. The development of the seed, and thus of the next generation, happens at home.

As with animals, including humans, the process at its inception involves fertilization. Unfertilized seeds are actually not seeds; they are only ovules. With few exceptions, they cannot develop into a new plant unless they are fertilized. Is there waste, are there duds, do some fail to make it to the next round? Yes, of course, just as female animals cast away unfertilized eggs during menstruation. Females may also discard or miscarry flawed

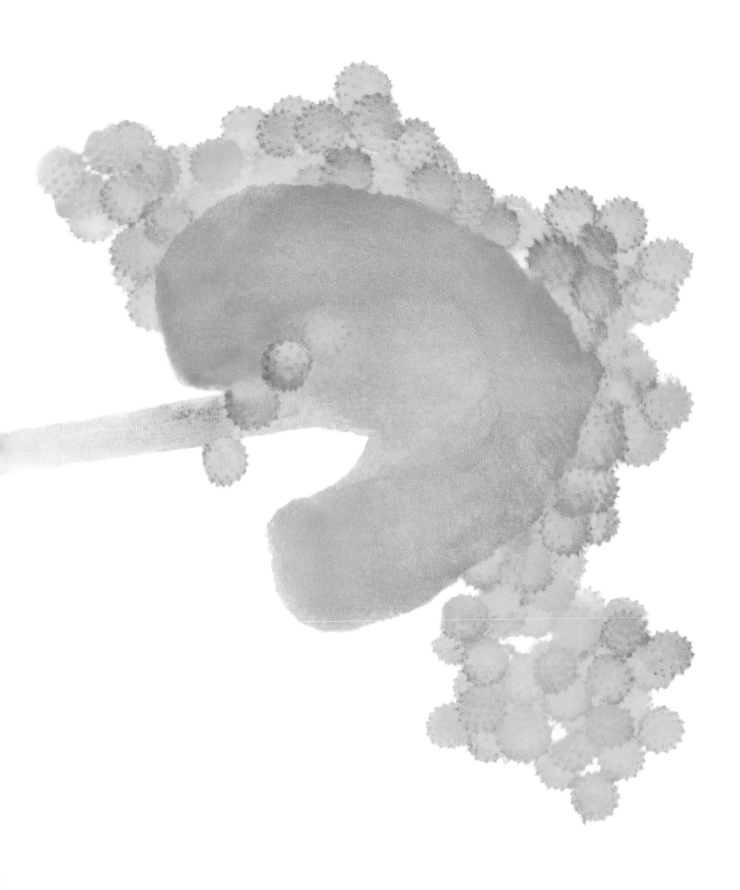

seeds that were incompletely fertilized or that introduced mutated, damaged, or undesirable genes.

The male parts can and often do generate more than is needed. Some pollen will never meet the female parts, but instead drift or fall away. Also, pollen must be from the same or a related plant. To cite an example from my own garden, beet pollen could meet purple coneflower stigma, but nothing will come of the match.

From the smallest lone-ranger seed to the biggest, juiciest fruit, the pollen must be viable and of a matched plant. Then it must get to where it is going, be received by a good ovule, and be put to use.

The meeting is not always a slam dunk. Sometimes pollen has to take a tortuous journey down a long and winding hallway, past physical or chemical obstacles, to reach its destination.

This process can be envisioned as a miniature version of what happens when a seed is planted. Picture pollen grains as little seeds, and imagine that the stigmatic surface is fertile ground, like a well-composted garden or good, healthy farmland. When the pollen at last arrives safely on a compatible surface and when the conditions are right—not too hot, not too cold, not too dry, not too moist—it begins to grow. This little shoot expands down the style, or pollen tube, until it gets to the waiting ovule, where it delivers its half of the genetic package.

The self-contained final product is the triumphant result. Seeds are the end result of a long, intricate, fraught fertilization dance.

Of monocots and dicots, corn and beans

Seeds fall into two major groups: monocots and dicots. Corn is an example of a monocot, as are cereal crops like wheat and rye. Dicots are beans. Who can forget the elementary-school windowsill arrayed with little cups of sprouting bean seeds?

Entirely different kinds of plant come out of monocots and dicots. Monocots are the more primitive seed. They generate a grasslike seedling from the top and a rudimentary root from the base. If you happen to plant a monocot seed upside down, don't fret. It will execute a U-turn underground and carry on.

Monocot is short for monocotyledon, which means one cotyledon or embryonic leaf. Scientists have identified additional common characteristics of monocot plants. The first leaf and those that follow have parallel venation. This is true of corn, certain grasses, members of the lily family, and onions and garlic.

There are more telltale characteristics. A monocot's vascular system, when magnified, is random and scattered, lacking any particular pattern. Monocot pollen shows but a single furrow or pore, but when flowers develop, they are in parts of three. (No one knows why.)

As for the rest of a typical monocot, the original baby root that initially supports the plant is soon joined by many lateral, fibrous roots. The plant parts never become thick or substantial, which is why practically all monocots are herbaceous plants. Again, picture a typical corn plant and its components.

But how do those tassels at the top become corn kernels? How does a monocot achieve the creation of seed for its next generation? More plant sex. The tassels (something quite similar tops grass plants) are the male parts. They produce, then shed, pollen. The female flowers are lower on the plants, and the slender silks there receive the pollen from their own and nearby tassels. Fertilization

OPPOSITE An extreme close-up of pollen from a hibiscus flower. Pollen grains are always quite small and produced in abundance. Each one encloses, protects, and nurtures male plant sperm. Gymnosperms, such as pine trees, need to produce huge amounts to ensure pollination, but the more advanced angiosperms (flowering plants like this one) don't have to be as prolific because they can rely on insects for help.

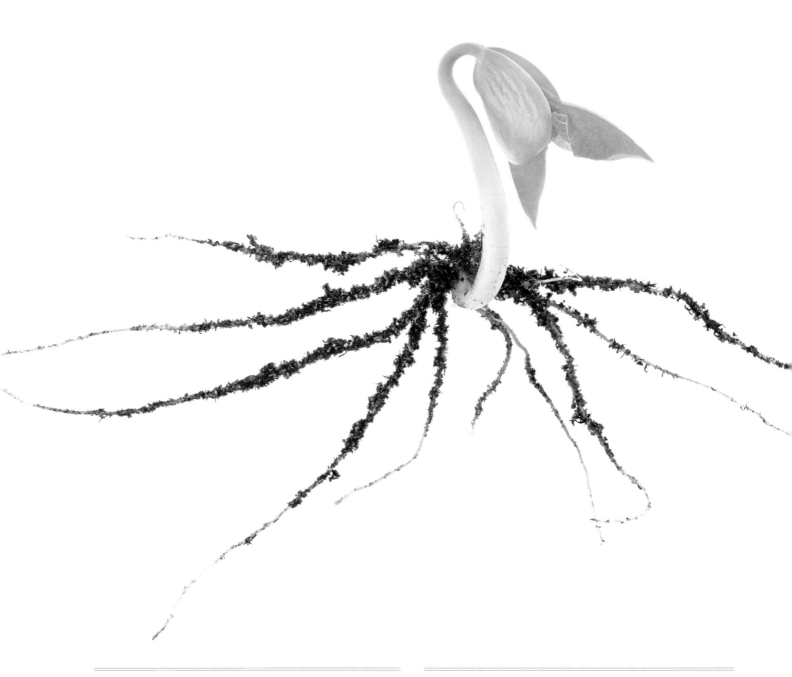

ABOVE Beans are the classic example of dicot seed. Di refers to two parts; thus, a germinating seed splits and a pair of identical initial leaves emerges. Meanwhile, roots develop from a radicle. Many dicot plants exhibit thickening of roots as well as top growth, which leads to more substantial plants than monocots, including trees and shrubs.

OPPOSITE If you peer into the architecture of a monocot seed, you will find only one embryonic leaf. This is true whether it is a corn kernel or, as shown here, a lily seed. When it emerges, the first leaf as well as those that follow will have parallel venation. This is true for all monocots.

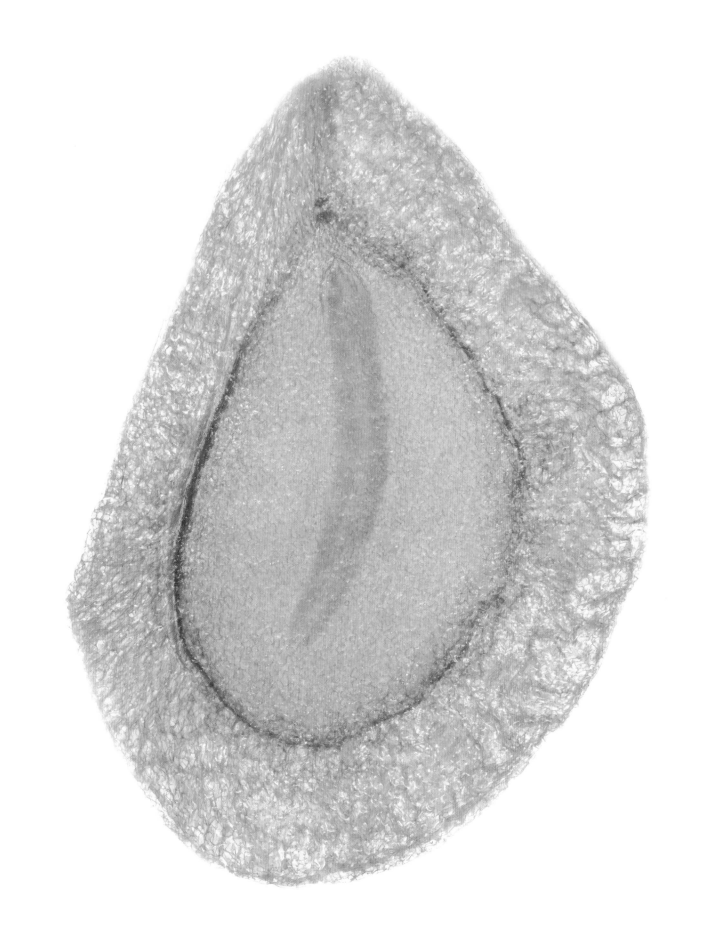

follows, and one slender silk per kernel develops. Incomplete ears indicate that pollen didn't succeed in reaching every silk—or that, once reached, it didn't grow down the pollen tube to the ovary. (Conditions could have been too dry, too wet, too hot, or too cold.)

Beans are dicots, short for dicotyledon, which means there are two embryonic leaves inside every seed. When one of these raises its germinated self above soil level, the two little wings you observe are the first two leaves. During the launching process, the bean splits into two identical halves and those initial leaves unfurl. Typically they're attached to a single slender stem. At the same time, a single proto-root begins to emerge from the bottom as the baby plant gets growing.

Studying a bean seed is also a dramatic way to view classic dicot characteristics. Cut or split one open with your thumbnail. Observe the two mirrored halves, the two identical baby leaves curving protectively over a minute, leafy bud. Everything is here, just in miniature: leaves, stem, bud, embryonic root.

As with monocots, additional common characteristics have been identified for dicots. The dicot system for transporting water and nutrients is decidedly more complex than that of its monocot cousins. Vascular tissue tends to be arrayed in concentric circles, or rings, with identifiable inner and outer layers.

The leaves of dicots have more elaborate netted or branched venation (think of maple or oak leaves, for example). Floral parts, namely petals, as well as sexual parts, stamens and pistils, are more numerous. They are usually in fours or fives, or multiples of these. Pollen has three furrows or pores, although this can only be observed under a microscope. (Again, no one has decisively explained these numbers.) The embryonic root emerges, launching what can become a substantial root system. Many dicot species exhibit thickening and produce trees, shrubs, and substantial perennial plants. Dicots are more sophisticated plants than their cousins.

Researchers have divided dicots into subgroups based mainly on pollen characteristics. This level of detail is the province of laboratory (molecular and DNA-based) research. It's out of range of what we can see and enjoy in the plants shown in these pages and residing in our yards, parks, and gardens. The closer one looks and the more carefully one studies, the more plants yield still more details of their incredible complexity and diversity.

When dicots grow up and develop seed, they form flowers, which get fertilized. The petals shrivel or drop off, eventually leaving behind the goal of a fertilized ovary. When all goes routinely, what happens within the seed is a repeat of the past. Complex chemical and physical processes must deploy to replicate all those tiny plant parts and all that genetic information. It is truly amazing.

On the inside

The insides of monocots and dicots are also very different. The seeds of flowering plants contain all the necessities in one complete package. As ecologist Jonathan Silvertown notes, "A seed is really an embryo in a picnic basket."

The interior of a monocot seed is not overly complicated. The corn kernel is largely a starch reserve, as is obvious to anyone who has eaten corn, fed it to animals or pets, or ground cornmeal. The inside of a dicot seed also harbors food to nourish a baby plant, but the nutrition resides mostly in the cotyledons. The curious among us might wonder what the rest is composed of, and what it is for.

And yet there are similarities. All seeds are composed of three main, identifiable parts: the outer coat, the interior endosperm, and the embryonic plant.

OPPOSITE A sprouting bean seed clearly shows all the key parts that will lead to a brand-new plant: the protective outer coat, the interior endosperm, and the embryonic, two-parted plant. When it swings into action, the stem sends up the first pair of leaves and the roots begin to expand downward. The seed coat remnants may linger for a while, but they are soon dwarfed and forgotten. Their work is done.

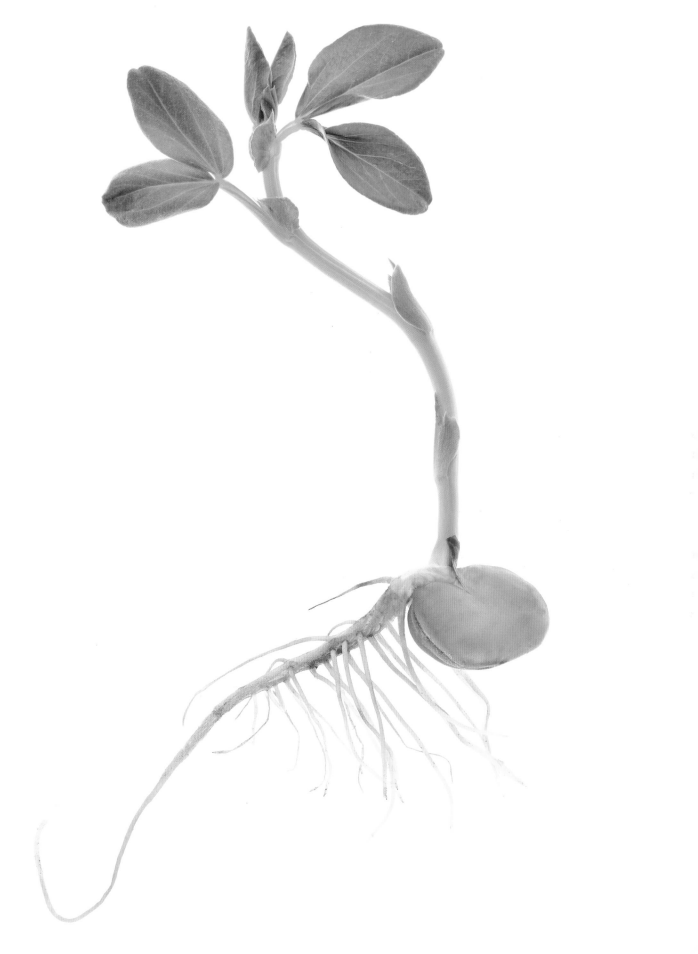

The embryo

The embryo is the product of successful fertilization. Although it is undeveloped and very small (in the case of some seeds, very very small), a plant embryo has within it in all the genes, information, and chemical mechanisms needed to generate a new plant. Its pollen parent, or father, provides genetic material. Its egg parent, or mother, also makes a genetic contribution, and supplies material to protect, nurture, and grow the embryo.

For seed to occur, there must be both a male and a female contribution (again, with few exceptions) from two plants in the same vicinity, in the same garden, or sometimes even on the same flower. This is the case with a great many commonly cultivated plants, from beans and peas to lilies, roses, and apples. Botanists refer to these flowers as perfect. In these cases, fertilized embryos and seed should be straightforward matters.

For some plants, the male and female parts are on the same plant. These plants are monoecious, or one household. With corn, the silky flowers below await pollen from the tassels above. The male flowers develop first, followed by the female ones. You can also view this on your squash vines.

For other plants, the male and female parts are on separate plants. These are dioecious, or two household. Familiar examples include hops, marijuana, ginkgo trees, holly, and asparagus.

Sometimes it is desirable to have only the male plant in a home landscape. For example, male asparagus doesn't expend energy making seed, and thus develops bigger spears to harvest. Gingko fruits falling off female trees make a terrible mess. In other scenarios, it is advantageous to have both. Female hollies have decorative berries. Female kiwi vines bear the delicious fruit. For these plants, if you want fruit, often you'll need to accommodate at least one male plant. A reputable nursery with savvy staff can honor your request for male plants, female ones, or some of both.

There are always exceptions, as the plant world is complicated. For example, some spinach plants are monoecious and some are dioecious. One way or another, the flowers get pollinated and spinach seed develops. But if you want tasty leaves, seek out slow-to-bolt varieties, which take more time to form seed. Going to seed tends to change the taste of spinach foliage and make it bitter.

There is a third, fairly rare, process: apoximis, from the Greek for "without intercourse." In this case, seed forms without fertilization. Some familiar plants, such as dandelions (see page 134), are able to do this.

RIGHT A bean seedling is born. The seed coat splits and the stem emerges, bearing a first pair of leaves. "Dicot" implies "two."

OPPOSITE Some plants, such as kiwi, are dioecious, carrying male and female parts on separate plants. Fruit, and therefore seeds, are produced only on the female plant. This is why gardeners, farmers, and orchardists have to plant both male and female plants if pollination is to succeed and a harvest to follow. Other examples of dioecious plants include holly, gingko trees, and hops.

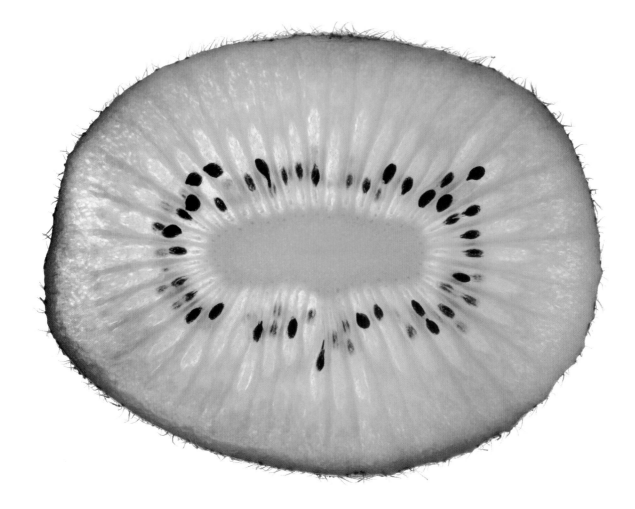

Generally speaking, when male pollen and female ovules get together, an embryo is the result. Sophisticated research on plant embryos shows a great deal of variation in terms of size and shape as well as position within the seed. Some embryos fill much of the available space, while others are so petite as to be barely detectable. Some lodge in the lower half of the seed, some take up the middle, and some are curled around just under the seed coat like a kitten snuggling in a small box. All are the germ of a new plant.

The endosperm

The endosperm can make up a significant portion of a seed's interior. This is a supply of stored food intended to nourish the embryo. The endosperm is not present on some seeds, like orchid seeds, which are often as small as dust.

The origin of the endosperm part of a seed has been traced backward. A (male) pollen grain, upon mating with the (female) stigma, splits in two. One part fertilizes the ovule and leads to the embryo. The other part grows into endosperm, generally with a little help or contribution from the ovule's embryo sac. However, because it forms separately from the embryo, the endosperm develops on its own. Although adjacent and sharing DNA, they are separate entities, like fraternal twins.

Endosperm tissue is composed of nourishment in the form of starch and sometimes other treats like proteins or fats and oils. The developing embryo may absorb or consume the endosperm now or later, partially or completely. Monocots such as corn and wheat rely on the endosperm to get going and growing, and it is not uncommon for some endosperm to remain on the plant at maturity.

Dicots tend to slurp it all up quickly, which results in bigger, burlier seed leaves (cotyledons). At maturity, bean and pea seeds have consumed all their endosperm. When there is any left, in monocots or dicots, it can provide energy to support germination or the first steps into photosynthesis.

In dicots, endosperm is not as dominant. The two cotyledons provide the food, and they are bigger than those on monocots. Evolution researchers see a trend away from endosperm. Most advanced seeds, such as those on orchids, have little or none.

A good, hearty endosperm is attractive to more than just its intended embryo partner. Humans like to eat seeds, as do birds and animals. Nutritional content varies, as does flavor. Some endosperms take the form of nourishing liquid, such as coconut milk. Some endosperms are especially popular with humans. Wheat is a favorite example; ground endosperm is flour and ground endosperm along with the ground seed coat or bran becomes whole wheat flour. (Wheat germ is the embryo.)

When we harvest bean seeds for eating, we're doing so early in their maturation process, so some endosperm is still present and we can enjoy its nutrition and flavor. Once a seed starts consuming or using the nutrition in its endosperm, less is available for other creatures. The seed then loses some appeal, but it is on its way to a new form. On the other hand, endosperm can have staying power. Anasazi beans can store for ten years and still be good for eating.

OPPOSITE A seed coat protects the precious contents. Sometimes there is an inner and outer layer, as with this lotus seed. But physical protection is not the full story. In its role as gatekeeper, the seed coat determines when it will finally allow moisture and air to breach it and permit germination to proceed. A complex system of chemical, hormonal, and environmental cues work together. Scientists continue to study how a seed knows when it is time.

Many seeds that we like to eat benefit from roasting or cooking. Heat ruptures cells, which releases fragrant oils. Something that smells good tends to taste good, too.

The seed coat

The seed coat is the outermost protective layer of a seed. The seed coat physically and chemically shields the seed from harm until the seed germinates. The coat helps to ensure that the contents are kept intact rather than nibbled on or digested by an animal or insect.

But the seed coat is not just defensive. It also serves to control germination. It is in charge of maintaining dormancy; think of it as the gatekeeper or firewall. Several elements are at work. Water is kept out; the contents inside can be preserved with just enough moisture to remain alive but not enough to germinate until the time is right. Air, too, is temporarily excluded, as germination requires sufficient oxygen. A tough seed coat is hardy all the way down to the microscopic level. Nothing and no one gets in without permission.

If you look closely, you can often discern outer and inner seed coats. The inner one will be quite thin—perhaps papery, membranous, or even transparent—while the outer one will be thicker, dry, and hard. A classic example is the peanut. Humans and animals will eat the papery inner seed coat but discard the harder outer seed coat.

Often, but not always, the outer coat is dry and resilient, brown or black in color. It can be as tough as a husk or a shell, which in fact grows harder as it matures. It may be only partially digestible or completely indigestible. While stirring a pot of chili recently, I noticed that some of the red coats of the kidney beans had relinquished their hold, but seemingly reluctantly. Curious, I picked one out and set it on a plate to examine it more closely. I was impressed to discover that, despite long hours of simmering in hot liquid, the seed coat was not shredded, pockmarked, torn,

or in pieces. It had just split open under the pressure and neatly slipped off the bean, like a sock sliding off a foot.

A few seeds, such as cycads and pomegranates, have a sarcotesta, or fleshy outer coat. An aril is not a sarcotesta. It is an outgrowth from one of the ends of a seed (or the funiculus, which attaches the seed coat to the ovary wall like an umbilical cord). Mace, the red coating on nutmeg, is an aril (see page 178 for more details). Often colorful and tasty, both the sarcotesta and aril are ingenious ways for a plant to coax a vertebrate into eating, and thus dispersing, its seeds.

Inside the insides

On a deeper level, seeds contain chemicals and hormones that regulate metabolism, as well as instigate and guide dormancy and germination. They also provide necessary information to the next generation. Wild plants are packed with complex, diverse information, including aspects that have yet to be revealed or tested, such as resistance to certain pests and diseases or the ability to weather or germinate in adverse conditions. We must be grateful that seed banks and seed libraries, not to mention gardeners and seed companies that nurture heirloom and open-pollinated seeds, preserve and protect this abundant genetic treasure.

In contrast, in cultivated, hybrid plants, humans have managed to channel significant data. Mysteries and surprises have been bred out or blocked. If you sow a hybrid seed, you get a uniform, predictable plant. This has been a boon to agriculture, of course, and often to gardeners, too. But uniformity carries limitations and risks. Chances are there will come a day when we need or want to return to the wild, the variable, the adaptable seeds to tap into their great and complicated bounty.

The questions of why seeds are the ways they are and how seed cells do what they do continue to provide fascinating areas for study. We have been able to pry open this tiny world, only to find profound complexity when we peer inside. It is humbling. Imagine the patience and the attentiveness of botanists and seed savers who travel to these strange places, questioning, discovering, and marveling.

FORM
Why are seeds
so diverse?

"The uniformity of the earth's life, more astonishing than its diversity, is accountable by the high probability that we derived, originally, from some single cell, fertilized in a bolt of lightning as the earth cooled. It is from the progeny of this parent cell that we take our looks; we still share genes around, and the resemblance of the enzymes of grasses to those of whales is a family resemblance."

— Lewis Thomas
 from *The Lives of a Cell: Notes of a Biology Watcher,* 1979

"But there is an essence inside variability
always quivering with the joy of returning
to the origin."

— Rumi
 "The Well of Sacred Text"

PREVIOUS Gardeners and cooks know that seeds come in a range of sizes, shapes, and colors. But a closer look not only delights or intrigues the eye. All this variation also begs a larger question: Why? Surely not just so we can tell them apart or be attracted to pretty food to eat. For answers, we must also look at how seeds are formed and how this diversity serves a plant's interests.

OPPOSITE The seedheads of dill and related umbelliferous plants are the result of a great many closely packed individual flowers forming individual seeds. To succeed in this process, such flowerheads must do all they can to entice pollinators. Thus they provide a fairly flat landing platform as well as sight guides and scent enticements. They also tend to have a prolonged blooming period and to welcome a range of insects.

THERE IS A LOT of diversity among seeds, but there are also identifiable patterns or types. Even some truly weird-looking novelty seeds conform to categorization, even if it doesn't seem so at first glance. The photographs in this book take you on a tour of myriad examples, including special intricacies, unique quirks, and the occasional anomaly.

We can witness or infer the typical cause and effect at work when seeds form. When the work of pistils and stamens is done, they shrivel from view. Petals and sepals behave similarly. Fertilized pistils result in seeds below, down in the ovule. The ovary now dominates, swelling and growing around the developing embryonic seeds within. To return to Carol Deppe's terminology, the mother now nourishes and protects her babies. This is essential for successful reproduction.

Seedheads

Seedheads are one of the most common forms in which we notice seeds. On many familiar herbaceous plants, seedheads follow flowerheads. For example, imagine the connection between the summertime inflorescence of Queen Anne's lace, purple coneflower, or a grass plant as it transitions to its late-season dried form. They are, to use a term both technical and visual, persistent.

As summer turns to autumn and winter, stalks topped with seedheads seem to stand out more. This is especially true when the plants have colonized a roadside ditch, congregated in a vacant lot, or filled the corner of a garden. Sometimes flower arrangers and crafters swoop in and snip these dried blooms to use in wreaths, centerpieces, and arrangements. Teasel and Jerusalem sage, for example, are prized in their seedhead form.

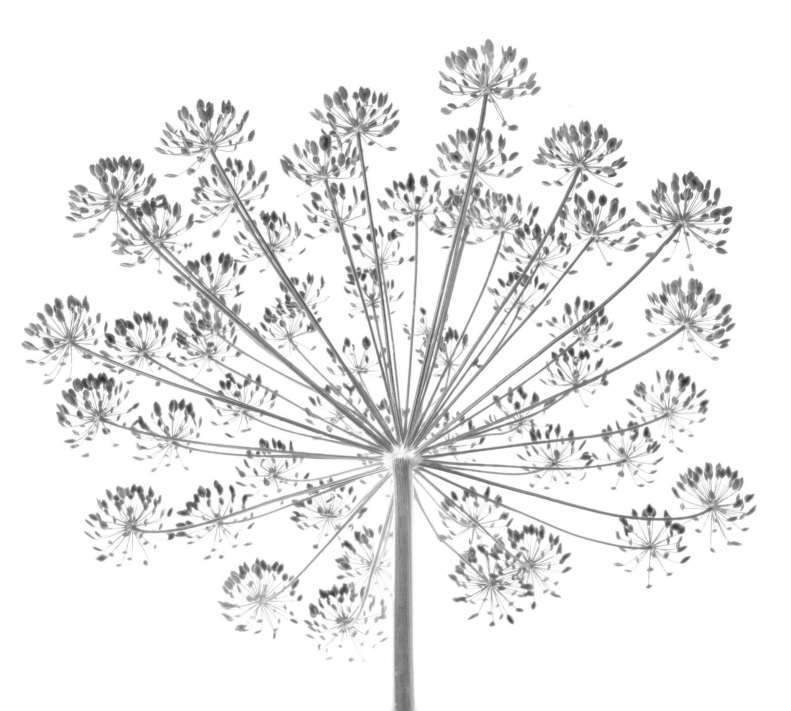

If left on the plant, seedheads often attract hungry birds, both those that are migrating and those that stay around and forage for food. The broader form is easier for the birds to cling to or sit on while they dine. In northern winters, seedheads can bear jaunty caps of snow, adding a dimension of interest and even spare or elegant beauty to the landscape in the quiet season.

A seedhead is, as the name suggests, a place for many single-fruited seeds. The flower that precedes it is actually a gathering or composite of many small flowers or florets. Whether a dandelion, a flat-topped umbellifer, the plume of a grass, or some other dried form, a seedhead is where seeds develop and reside for a time. The house in which they grew up, so to speak, remains after the bounty has been shed or eaten. Gardeners and cooks who want those seeds find that timing is everything. One common technique is to harvest the seedhead as it begins to dry out, cinch it in a paper bag, and put it in a warm, dry spot. When the seeds are discharged, they will be captured.

Not much is left on the plant after the little seeds have blown or shaken away, been eaten, or been harvested. The tough, spindly remains consist of a stout, sometimes hollow, ribbed stem; a main flower stalk; the remnants of once-clasping bracts or sepals; and, in some species, halves of split-open fruits. The seedhead parts shelter and protect their bounty until they dry out, which literally loosens their grip. This, then, is nature's plan: Seeds are guarded until they are mature, at which time they are free to go forth and multiply.

OPPOSITE Pods are the province of the bean family (Fabaceae). If you split or break apart dry pods, such as these from a honey locust tree, you can observe that the seeds are lined up at regular intervals. This is no accident. They were preceded by neatly organized ovules. The carpel then evolved to fold or wrap over them, which produced the seams.

Pods

Pods are the province of one group of plants, albeit a very large one: the bean family (Fabaceae). Pods split into equal halves along seams—sometimes easily, sometimes with the aid of a sharp fingernail or a knife. Open up a pod and you will see seeds, such as peas. Look closer: They aren't randomly lodged in there, but rather attached to the pod at equal intervals. In some cases, they are nestled in individual, approximately equal-size compartments, which may be easier to appreciate or count after the seeds are out.

A pod is preceded by a flower, which obviously must get pollinated before it can move into this phase. Flowers in this family have both male and female parts in the same blossom and are therefore self-pollinating (cross-pollination can and does occur, but it is not the rule).

Not surprisingly, the form of the flower corresponds to the pod parts and accounts for its design or layout. A pod originates from one folded leaflike carpel, and the seeds within develop from one or more ovules inside it. In a bean family flower, the carpel is the sum of all the female parts arrayed around the ovules. Once the ovules are fertilized and on their way to becoming seeds, the carpel evolves to enclose and protect the contents. Neatly lined up ovules become neatly lined up seeds. The carpel becomes, essentially, a wrapper.

Similar but more complex are follicles and capsules. These dry, inedible structures develop from flowers with more than one carpel, so they contain two or more seeds. Like a pod, they can break open or be broken along a seam. Milkweed is a follicle; look for the telltale detail that it opens along only one seam. Various sorts of capsules abound, but they all share the ability to split apart and release their seeds. Examples of plants that produce true capsules include everything from lilies to orchids to willow trees.

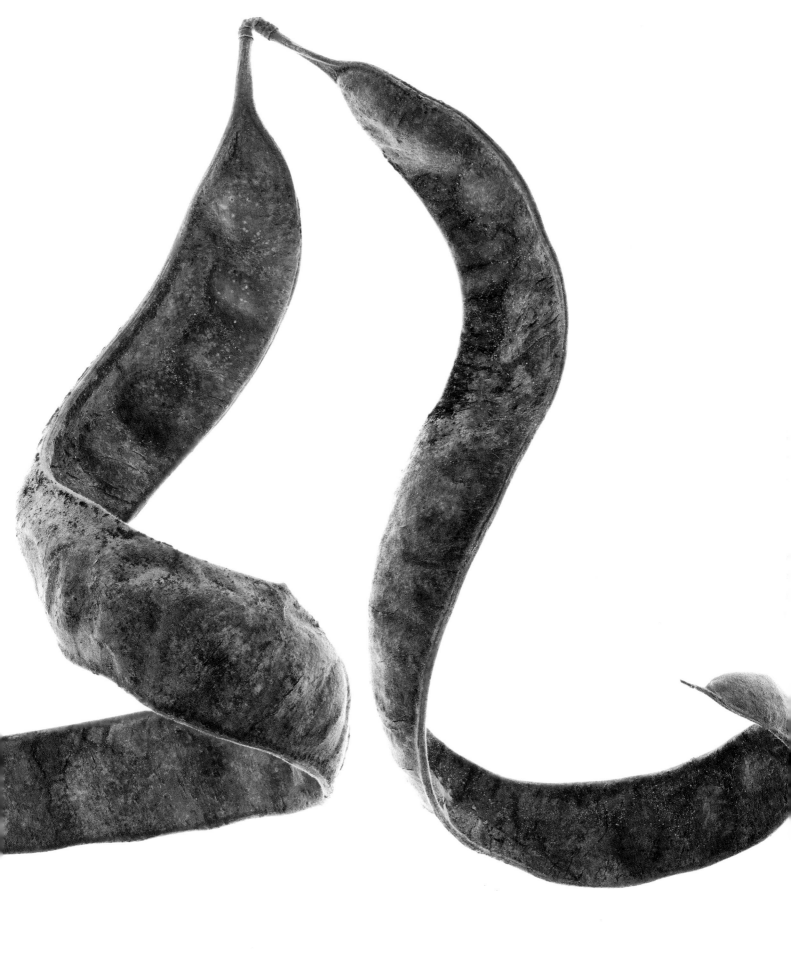

Fruit

It makes sense that a complex flower will yield an intricate structure for its seeds. Botanically speaking, a fruit is a seed-containing ovary. A flower that has more than one or many ovules can be expected to receive pollen for most or all of them. Once these are fertilized and on their way to becoming seeds, the ovary swells and a protective fleshy fruit forms around them.

Botanists classify fruits rather precisely, and their divisions are not necessarily intuitive to civilians. There are three major groups: simple, multiple, and compound.

Most fruits we know and eat are simple. These come from one flower with one pistil (a single carpel or several carpels fused into one). After pollination, seeds and pulp develop. Single-seeded fruits are quite common. A familiar example is an achene, the dry seeds found on anything in the daisy family (Asteraceae), including bachelor's buttons, chicory, and sunflowers. This category also includes drupes, which are fruits with pits, including so-called stone fruits like cherries, plums, and peaches.

All the citrus fruits are also considered simple fruits. So are true berries, defined as fleshy fruit derived from a single ovary. Blueberries are true berries, as are currants. So are grapes and, believe it or not, bananas. The category even encompasses plants we usually think of as vegetables, such as tomatoes and cucumbers. All of these will have more than one seed inside because their flowers had more than one carpel.

Seeds classified as multiples come from flowers that had several separate pistils. Probably the most familiar examples are raspberries and blackberries. These are not true berries, but aggregates: Their many globules arose from multiple carpels, and each one has a seed inside. Small wonder that blackberries can be so very seedy to eat.

Compound fruits are formed from flower clusters. A model example is a mulberry; every fruitlet was once an individual flower. Figs, jackfruit, and pineapples also fall into this category.

A fruit in any of these forms seems like an extravagant extra layer of protection for the seeds within. Fruit flesh, such as the juicy grape, crisp apple, or tart currant, is not endosperm. Nor is the not-very-edible pithlike stuff found in, say, a pomegranate. Yet this material, along with the outer peel, encloses and protects the seed or seeds within. Of course it also aids dispersal of the seeds, which is covered in the next section. Likewise, apple skin or

RIGHT Different fruits have developed different strategies for dispersing their seeds. Usually the goal is to get the pith or pulp eaten and the seeds ejected intact. Pomegranates are a variation. Technically, this fruit is a many-seeded berry. Each seed has a sarcotesta, a sweet-tasting, fleshy ruby-red coating that we and other creatures relish. The white seed is hard enough that we usually spit it out or, at least, don't digest it.

OPPOSITE Nuts are yet another type of seed receptacle. The outer nut covering and nutmeat within are not the seed. The seed is generally quite small and lodged inside; thus a nut is actually a single-seeded fruit. Some nuts will split open readily at maturity, like the four-winged husk of this bitternut hickory fruit. Others are tough to crack. Squirrels eat and distribute bitternuts, despite their harsh flavor.

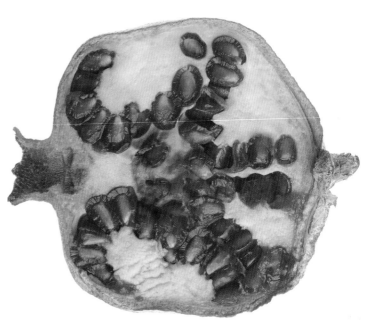

avocado peel is not a seed coat, although it is a protective coating, often quite sturdy, for what lies within. The seeds are embedded deeper, in the heart of a fruit.

Nuts

A nut is not a seed. It is a single-seeded fruit. The covering, or shell—the ovary wall—is hard and dry. The seed (or, rarely, pair of seeds) is attached or fused to the ovary wall. A nut is a rather simple structure, botanically speaking.

A nut does not split open at maturity, even though you can often see the line or seam where it could. This quality is indehiscence. In nature, a nut will crack open only after its covering breaks down or decays, or if it is eaten by an animal, bird, or insect. Humans have our own methods, from nutcrackers to whacking with a hammer to putting stubborn black walnuts in a bag and driving over them with a pickup truck (I watched someone do this once, and it worked).

It is possible to grow a new nut tree from seed. Seedlings pop up on their own in the vicinity of various kinds of nut trees. But the hard coat has to break down, followed by the nutmeat, and you must protect the burgeoning growth from foraging rodents and other creatures. Many also require a cold period, which you can provide outside in a garden setting or indoors via a stratification project in a fridge, cool greenhouse, or cold frame. Note that if the source was a hybrid tree, the seeds will not come true; that is, the new plant will not be the same. An easier way to raise young nut trees is to buy seedlings

from a reputable nursery for autumn (in a mild climate) or spring planting.

A few additional items are considered nuts. Sunflower seeds are nuts, one seed per; a sunflower is actually composed of numerous tiny flowers. After pollination, many nuts follow, and each ovary wall clasps a single seed inside. Acorns, too, are technically nuts, as there is really only one seed in there. Samaras, the seeds of maple trees, are actually winged nuts. All nuts lack a proper seed coat around their seeds, so the shell takes on that role. There is no double wrapping here, as there is with so many fruits.

The naked seeds

Nonflowering plants, or gymnosperms, include conifers as well as cycads, cypresses, ginkgo trees, and a few others, including a number that are now extinct. The most well known is the pine nut, or the seed of the pine tree (the tasty ones we use to make Italian cookies or pesto come from a handful of species, usually *Pinus edulis* or *P. pinea*).

Gymnosperm translates from Greek as "naked seed." These are more primitive than flowering plants; they have been around much longer. But they are not as diverse or as geographically widespread, and over time they have become greatly outnumbered. But gymnosperms are better at surviving in dry, colder habitats, which accounts for the forested mountainsides of the Northern Hemisphere.

Without insects or any other assistance, pollination is simply not as efficient. Pollen production is prodigious because it has to be. The usual path to seed production

OPPOSITE The most familiar gymnosperms, or naked seed plants, are conifers, but if you live in or travel to Florida and other mild-climate areas, you've also seen cycads. These are smaller modern-day descendants of ancient plants that once populated the earth in the time of dinosaurs. While most gymnosperms depend on wind pollination, cycads long ago evolved a relationship with beetles. But their seeds are no more protected or guarded in their cones than the seeds in any pinecone. The red seeds of the cardboard plant, *Zamia furfuracea*, fall right off the female cone.

occurs when the pollen from softer, shorter-lived male cones, or similar specialized organs bearing pollen in tiny sacs, reaches the more substantial, longer-lasting female cones or similar specialized organs.

The agent is almost always wind. If you have ever parked a car under a conifer in spring on a breezy day, you may have found a light but impressive dusting of yellow or greenish pollen grains. While wind pollination (discussed at more length in the next section) seems chancy compared to the way flowering plants work with insects, birds, and animals, it was an advancement over water-aided pollination, which is how the very earliest plants reproduced. The exception is cycads, whose pollination is aided by beetles.

Plenty of variation exists in this group. The majority of gymnosperms are monoecious, with both sexual organs or cones on the same plant. Pines are the classic example, but firs, larches, and spruces also conform to this arrangement. Others are dioecious, with separate male and female plants. Both cycads and ginkgo trees, which are still around but are of ancient origin, are dioecious. Still others are either or both: yews, junipers, cedars, cypresses, giant sequoia, coast redwood, and dawn redwood can go either way.

For pollination to lead to seeds, a pollen grain must land directly on an ovule. Female cones are laden with ovules (two per scale on a typical pinecone) to increase their odds of successful reproduction. Fertilization is rarely instant and often slow; in some cases, it can take up to a year. More than one egg may get fertilized, but one zygote ultimately tends to win out and become a seed.

Gymnosperm seeds are referred to as naked because they are not enclosed in an ovary. In the sago palm, a type of cycad, the seeds are arrayed out in the open on the surface of a leaf. In conifers they are tucked within the cones, which offer some measure of protection. They are not as posh, as complicated, or, arguably, as attractive as the fruit of a flowering plant, but they still provide something of a

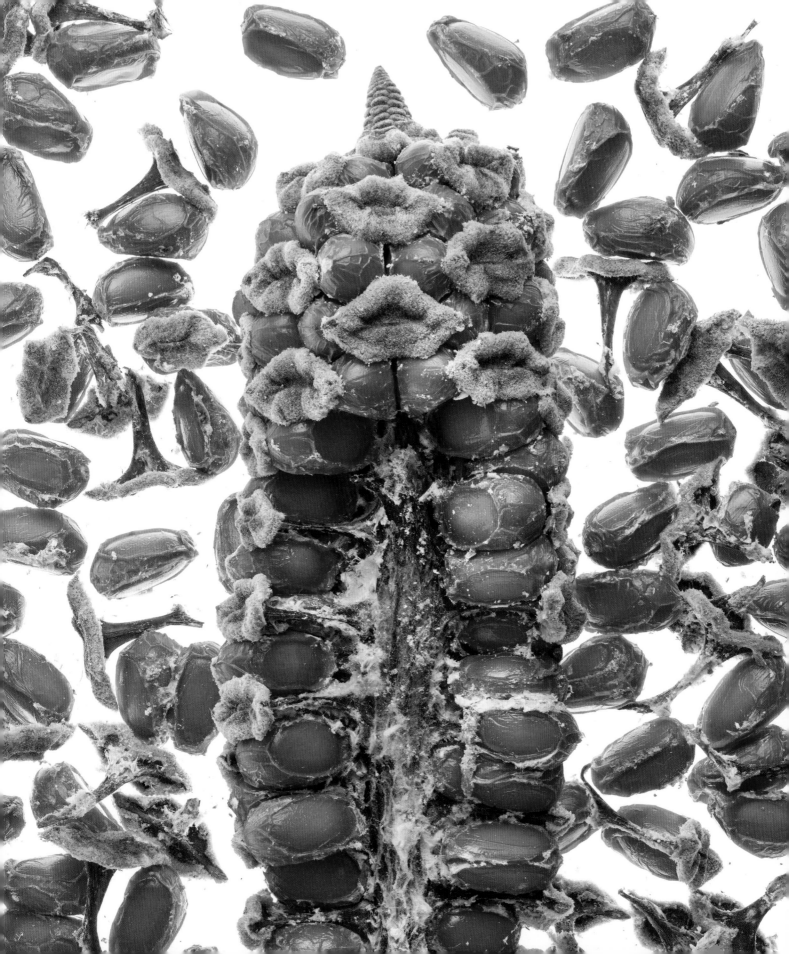

shield. Often cones are covered in resin, or pitch, which helps hold them together. This sticky material inhibits the release of seeds until high temperatures—hot, dry summer or autumn days or even a forest fire—melt it and release the bounty. Although individual seeds may have a thin seed coat and nutritive tissue around their wee embryo, it is by no means a fortress. Once exposed or released, the seeds are vulnerable to challenging environmental conditions and to creatures or insects that might eat them.

Given their comparatively plain appearance and simple form, it can be hard to know if a gymnosperm seed is ripe, whether you want to eat it or plant it. Enterprising gardeners should keep an eye on the squirrels and go collecting when they do. Alternatively, you can gather cones when they are fat but still somewhat green and sticky. Place them in (labeled) bags and let them dry out in a warm, airy spot. Eventually the cones will pop open and release their naked little seeds.

In nature, cones will dry out right on the tree and the seeds will fall to the ground below, leaving behind open, empty cones that some people use as decoration. Many cones naturally hang downward, which enables seed release. An exception is fir cones, which remain upright. But these cones eventually disintegrate, and papery bits and seeds flutter down together.

Alternatives to seeds

Not every plant reproduces, or can reproduce, via seeds. Some reproduce vegetatively, or asexually. Some use seeds sometimes, and other methods concurrently or at other times. A few are even parthenocarpic—literally, virgin fruit. These oddballs, including some figs and watermelons, produce fruit without fertilization and yield sterile (seedless) fruit. Here's a quick overview of common alternatives seen in nature—and often exploited by gardeners and the nursery industry.

SPORES Certain plants, considered even more primitive than gymnosperms, reproduce via spores. A spore, like a seed, is a reproductive unit capable of producing a new plant. It is a comparatively simple item made up of one or more cells. While wind may start off the process by sending the spores forth into the world, water is needed to help fertilization along. Ferns, mosses, horsetails, and mushrooms use variations of this two-stage dance.

BULBS, CORMS, AND RHIZOMES Some plants are able to generate offsets, bulblets, bulbils, or scales; all are smaller than the parent bulb but, under the right growing conditions, will lead to a new plant. Tulips and many lilies use this avenue.

DIVISION A rhizome is really just a thickened rootstock. In nature, it will elongate and send up new pup plants, sometimes at a distance from the parent plant. Gardeners may intervene, breaking or slicing off and replanting pieces with growing eyes to get additional plants when and where they want them. This process is called division. Candidates include potatoes, peonies, dahlias, irises, hops, and the woodland wildflower Solomon's seal.

CREEPING STEMS Sometimes plants will make copies of themselves and spread when stems or branches root. Many familiar vines and groundcovers, such as English ivy, wintercreeper, poison oak, and poison ivy, do this. If you've ever yanked them up, you've seen the roots that formed at the nodes along the lanky horizontal stems or runners (stolons) as they traveled along the ground.

LAYERING Branches or canes of certain berry plants, like trailing blackberries and boysenberries, may bow to the ground and root where they touch the earth. The tip can form a new top and, eventually, an entirely new

OPPOSITE Flip over a fertile fern frond and you will see reproductive structures, but they are not seeds. Rather, they contain minute spores. Successful reproduction requires moisture or water, not to mention a dash of good fortune in terms of timing and spore placement. It's a decidedly less efficient, more primitive system than that of flowering plants.

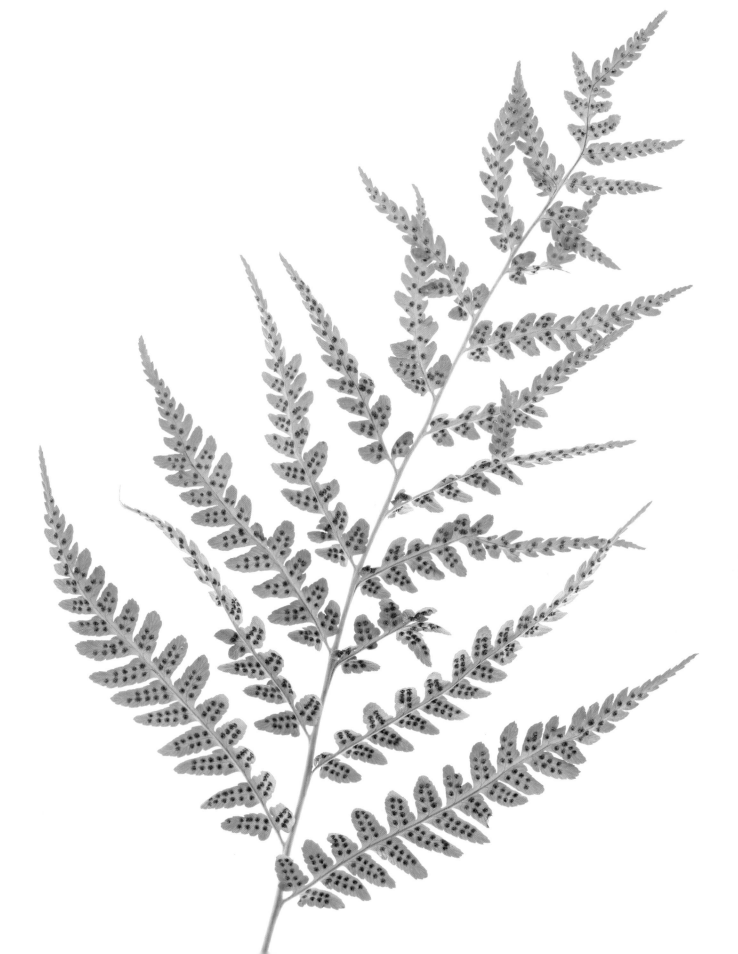

berry plant. (Suckers are an exception. While technically offshoots of the parent plant, they often have scant root systems that cannot support a new plant.)

CUTTINGS Many plants can be propagated from a young stem or branch, which will root and can be planted. Cuttings are also a great way to get more houseplants.

TISSUE CULTURE This is an efficient, cost-effective technique for generating large quantities of uniform new plants. Clones begin life in a test tube and eventually get moved into flats and pots.

For the most part, these methods make new plants faster than seeds do. Plants made by division, layering, and tissue culture are also uniform; they are copies or clones of the parent plant. Thus the nursery industry, tree farms, greenhouse-plant production operations, and avid gardeners tend to prefer these methods as good, reliable ways to get new plants. But as with purebred dogs, problems as well as virtues are propagated. In the end, while slower and certainly less predictable, new plants that arise from seeds are arguably more genetically diverse and resilient. Their variability is a virtue.

Flower to seed: When *this* becomes *that*

Certain flower parts morph into certain seed parts. Every plant has its own unique appearance at any given stage in its development, but there is a general chain of events in a mature flower.

It happens gradually, on a small scale, while we are not watching, so the seed-bearing structure that comes after a flower fades sometimes looks mighty strange. The correlation can seem baffling. These whirligig seedheads, for example, followed from a beautiful clematis blossom. At the base of each twisty tail is an achene, or tiny fruit. The plume attached to it originated from the long styles of the blossom. In this new phase, it can help the achene drift or fly to a new location.

For most plants, the transformation occurs on such a small scale and so gradually that few of us will ever witness it. More likely we will notice a flower and then, sometime later, observe that the plant has gone to seed. We may even pause and wonder how that particular flower became this seed or fruit. Painstaking observation and scientific research provide some—but not all—insights into the process.

In imperfect flowers, there is a male flower and a female, separate from one another. These can be on the same plant, or monoecious, as with corn. They can also be on separate plants, or dioecious, such as hollies. In the more common, more widespread perfect flowers—most familiar and popular flowers and fruits fall into this group—both the male and female parts are on the same plant. They may or may not work together. They may or may not be self-pollinating. But there is always a life cycle.

Male parts

The male part of a plant, or stamen, is a two-part construction consisting of the supporting filament with an anther on top. Pollen develops and ripens on the anther. Think of pollen as plant sperm. If pollination doesn't occur, pollen shrivels and fades away. If pollination is accomplished, all that may be left after fruit or seed develops are some dried pollen remnants at the top, or blossom, end.

Female parts

Collectively, the female portions of a flower—the style, stigma, and ovary—are the carpel. The pistil is composed of two parts. This is easy to see in the center of, for example, a lily flower. It consists of a stigma atop a supporting style, which turns out to be hollow and becomes a pollen tube. Often the stigma is sticky, so pollen grains are captured and commence their journey down the pollen tube toward the goal of fertilizing an ovule or ovules below. Once the pistil's work is done, it dries up and is jettisoned (like the stamens, it shrivels and falls away if

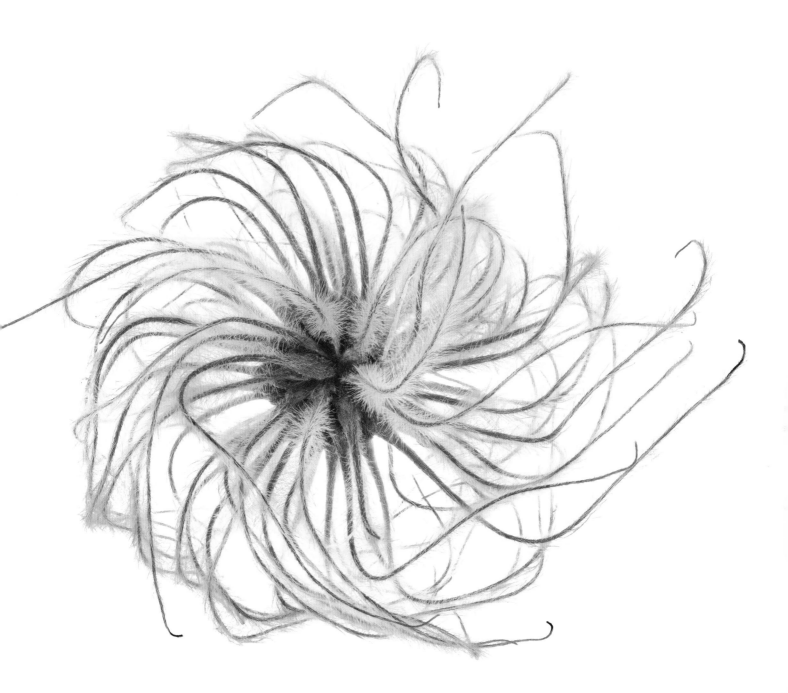

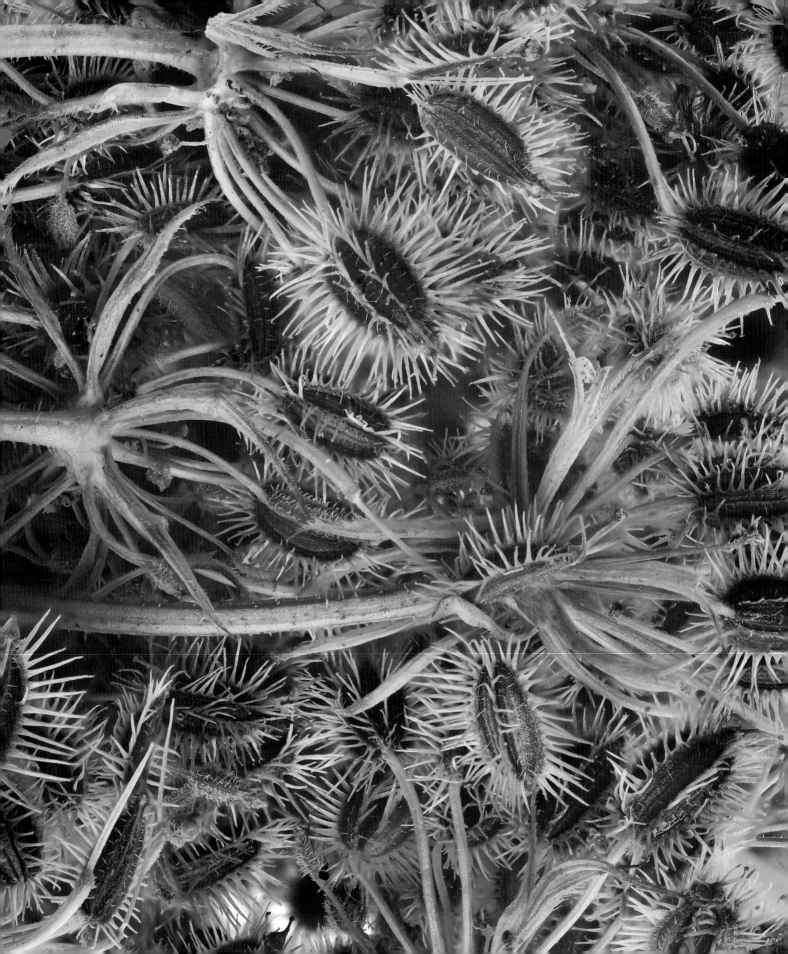

never used). Fertilized ovules, which are essentially eggs, become seeds.

At the base of the flower, the enclosing ovary, when present, grows and swells to become an enclosing fruit, pod, or capsule. The top parts play their role and fade away, yielding to the bottom parts. These in turn expand in size and hold the seeds of the next generation. What you see at the seed stage are larger and matured structures that were present all along but considerably smaller and less developed below or at the base of the flower.

Other parts

Flowers often include other parts that play their part in the cycle and can remain on the plant after seed develops. The calyx is the outer whorl of floral leaves, or sepals, and is very obvious on a rosebud. The calyx will peel back and curl downward, yet remain on the plant. True petals, whether distinct or fused into a corolla (or considered tepals—petals and sepals that are not clearly differentiated, as is the case with tulips), tend not to linger. They coaxed pollinators with their colors, markings, and scents. They sheltered the other structures within, but they are not very durable. Ultimately they fade and dry. They may fall off or hang on limply, but they certainly diminish in size and importance after pollination is under way.

Many seeds and seed capsules, fruits, pods, and even nuts are adorned or enhanced with structures such as hairs, hooks, tufts, feathers, spikes, spines, prickers, pappi,

stickers, wings, and more. These features are meant to help the seeds. They can protect them from being eaten—a well-armed spiky ball is certainly a deterrent to predators. They can provide a layer of insulation and enwrap seeds in a safe setting, physically protecting them from harm as well as stabilizing internal temperature and moisture levels. These structures can also aid dispersal, as when they grab onto animal fur or human socks, or float like wee parachutes on the wind or as odd-looking sailing vessels on water.

These appendages originate from various sources. Sometimes they are part of the seed coat. Sometimes they are a modified calyx, enlarged sepals, or bracts that have evolved. Sometimes they are literally the ovary walls, or are embedded in or nestled in the carpel, and are unfurled or released after a capsule splits open and they are exposed. These often weird-looking and unique features further demonstrate that a flower's passing is not an ending, but rather a transition to another form.

Generally speaking, the beauty, intricacy, and extravagance of flowers are passing phenomena. Flowers exist to facilitate pollination. It is their goal in life. Seeds may not be as dramatic or showy, at least not at first glance. But they are equally diverse, and they are a plant's true and final purpose. A flower does not really die, although we often say that it does. Instead, in going to seed it enters a new, specialized phase of life—a journey toward the goal of reproduction to self-replication.

OPPOSITE Examine any seed in the crowd atop a faded Queen Anne's lace plant, and you'll discover that each one is adorned with myriad small, spiky hairs. Evidently these serve two functions. They make the seed less palatable, and they help a seed grab onto any passing creature— whether a bird's feathers, a human's trousers, or a dog's coat—and thus get a ride to a new home.

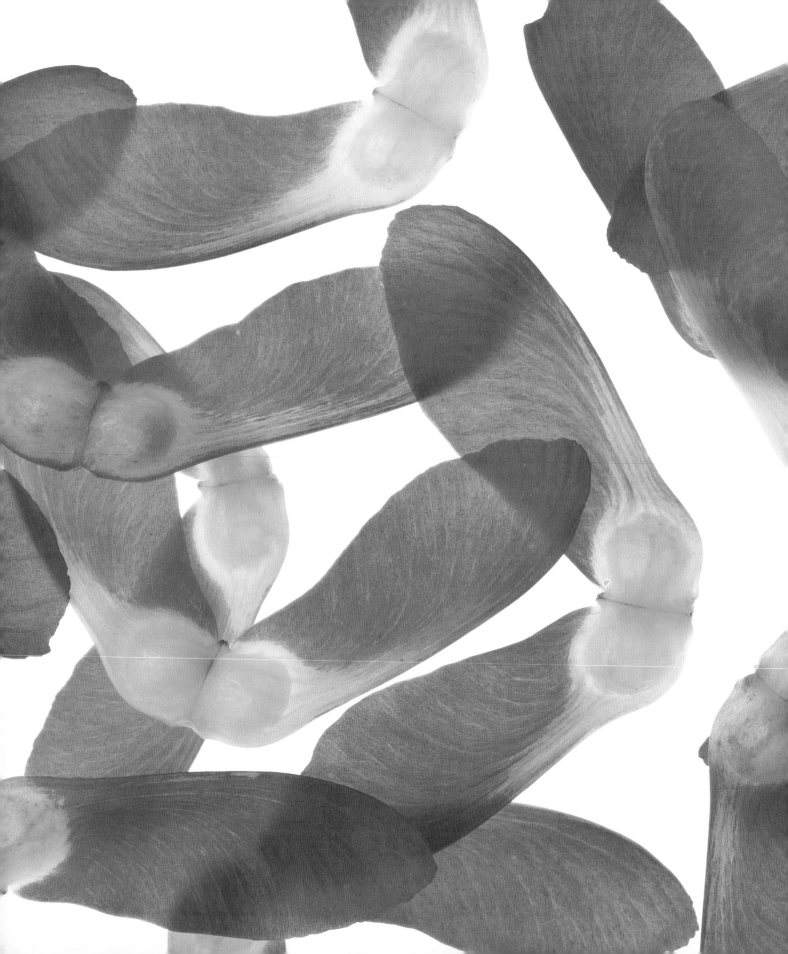

FUNCTION
What do seeds do,
and how do
they do it?

"The twisted strips were wisteria pods that I had brought in a day or two previously and placed in a dish. They had chosen midnight to explode and distribute their multiplying fund of life down the length of the room.

A plant, a fixed, rooted thing, immobilized in a single spot, had devised a way of propelling its offspring across open space. Immediately there passed before my eyes the million airy troopers of the milkweed pod and the clutching hooks of the sandburs. Seeds on the coyote's tail, seeds on the hunter's coat, thistledown mounting on the winds—all were somehow triumphing over life's limitations. Yet the ability to do this had not been with them at the beginning. It was the product of endless effort and experiment."

—LOREN EISELEY
"How Flowers Changed the World," from *The Immense Journey*, 1959

"Everything in the universe has a rhythm, everything dances."

—MAYA ANGELOU, 2011

PREVIOUS Every fall, most maple (*Acer*) trees send forth twirling, sailing samaras by the hundreds or even thousands. These have an ingenious design. The heavier fruit is encased to keep it safe and dry, but also flanked by aerodynamic wings. With the aid of wind, these wings can take the maple seed far afield; gravity ultimately brings the samara down to earth. Their work done, the wings disintegrate. The seed will break forth and germinate when conditions are right. Ash trees (*Fraxinus*), elms (*Ulmus*), and hoptrees (*Ptelea*) also produce samaras.

OPPOSITE Dandelions are among nature's wiliest seed-sown plants, much to the chagrin of gardeners and groundskeepers who fuss over green lawns. Huge numbers of tiny, lightweight seeds are carried far and wide on the wind, thanks to help from the attached plume. This design also allows the heavier seed to dangle below without obstruction or interference as it floats along. The plume breaks down and disappears quickly once the seed lands.

WHAT HAPPENS ONCE a seed has formed? Assuming it is not separated from the plant before it has a chance to fully develop and ripen, and assuming there have been no physical or genetic mishaps along the way, it should be viable. It should be ready, willing, and able to generate a new plant. But where and how and when? And how will it get there? How perishable is it?

Dispersal, dormancy, and germination are all part of the next phase. So many things have to go right, it's a wonder seeds ever form new plants successfully. And yet by sheer numbers, wily survival mechanisms, and the resources to sprout, they do. Every seed has a story, and many are pictured and described in this book. The journey seeds take may be odder and yet more practical than you have ever imagined.

Dispersal

Seeds that are left to their own devices—that is, not harvested for eating, gardening, or farming—make their way into the world by many different means. Mobility varies. Sometimes the seeds fall around the base of the mother plant, and nothing more complicated than gravity is the agent of dispersal. Sometimes they land close by. Other times they end up far, far away. The plant from which the seeds came cannot move unless a strong wind tosses it or a human, animal, or implement dislodges it. Plants can perish when they are moved, as gardeners and landscapers sometimes learn the hard way. But seeds can travel.

Seeds move about for many reasons. If they establish themselves too close to home, crowding ensues. Seedlings compete for real estate, soil moisture, nutrients, and sunlight. Those that are jammed up around the base of their plant of origin often don't make it to adulthood.

A mature plant—or, more likely, a population—already occupies the home base of a seed. This can attract the attention of predators, and creates unsafe conditions for a young, vulnerable seed. And staying close won't meet the parent plant's overall goal of sending forth progeny that succeeds.

Seeds are better off setting out into the wide world to find a hospitable place of their own. Getting out of the immediate neighborhood will also provide opportunities to diversify the gene pool.

Wind travelers

In order for a seed to travel on a breeze, it must be tiny and lightweight. The lighter it is, the further afield it may

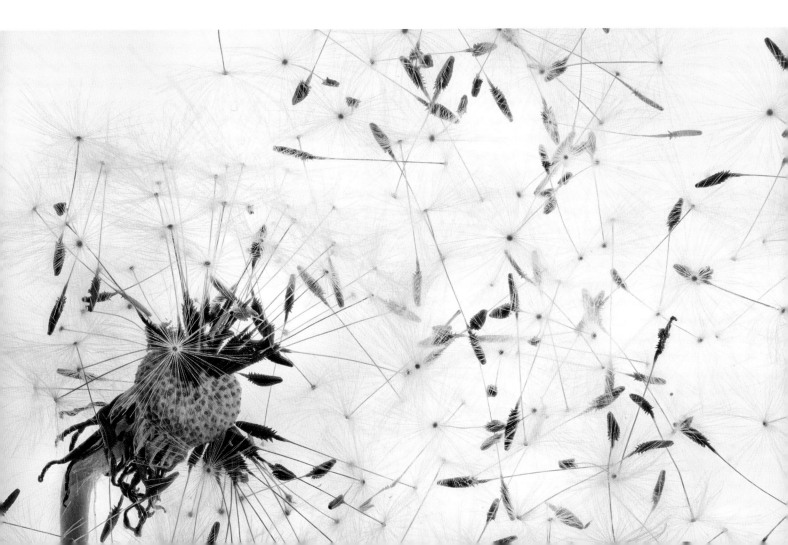

float. Some seeds, like those from orchids, are so small as to be dustlike. To lighten their load, they have sacrificed any endosperm. Even the seed coat isn't anything to write home about.

Many small seeds have a navigation assist in the form of an attached plume, tuft, or silky hairs. The dandelion has a stalked plume that acts like a parachute, twirling and whirling while mostly keeping the fluff up and the seed dangling below. Thistle seeds, on the other hand, have slim plumes coming directly off them at all angles, and consequently they tumble about more randomly.

The technical term for this sort of seed is achene, which includes the seed itself, a seed case, and optional lightweight, flexible appendages that assist a soft landing and can lodge or trap a seed, as in a rocky crevice or down among grasses. The fluffy stuff may ultimately detach and drift around before disintegrating.

Wind travelers often have different or additional features to get and keep them airborne. A portion of their interior may be inflated or empty, basically nothing but an air pocket. Such a seed or capsule can be larger, have more surface area, and still be able to fly. A typical example is the pod of the goldenrain tree; in the human world, think of a hot-air balloon.

Still other seeds get wings. Maple keys, or samaras, are seemingly everywhere in autumn. They whirl as they fall from trees or get tossed about by the wind. Elm trees have their version, as do ashes. These seeds are bigger and heavier than those of most herbaceous plants, and the wings, while papery in texture, do not break or snap

OPPOSITE Wisteria pods are drama queens. While garden beans, locust tree pods, and mesquite fruits just settle down and let their outer covering degrade before releasing their seeds into the environment, wisterias don't wait. The pod constricts as it dries and soon springs apart, catapulting its seeds. Thus the plant sends new babies out into the world at a distance from the mother plant, which might crowd or shade them and compete for resources.

off easily. More often they wither away once they have delivered the seeds to a new home.

There is a correlation between seed size and mass of its transport. Evolution had to favor the successful proportions (short or insubstantial fluff wouldn't get a dandelion seed anywhere). A seed's point of attachment to the parent plant is also designed to hang on until it has an opportune moment to let go. A light puff of wind may not impress the dandelion seedhead or the maple samara. It will wait for a breeze with promise.

Sailors

For a seed to be able to travel on water—whether an estuary, the open sea, a pond, or a rolling river—it needs at least two key qualities. It needs to be waterproof, at least for a while, or it could sprout too soon or rot because it is waterlogged. It also needs to be buoyant so it can float rather than sink, although eventually it will settle on land and (one hopes) germinate. Coconuts, for example, can travel on ocean tides for great distances and wash up on far-off beaches.

A tough, impervious seed case or coat is an essential for waterborne seeds. It will keep moisture out and perhaps even discourage birds and other creatures from snacking. There is a lot of variation in the interiors of some of these seeds, including air pockets, corklike material, and spongy tissue. In time the inner and outer material will break down or disintegrate, exposing or releasing seeds.

Like their airborne cousins, waterborne seed structures may also sport handy extras like barbs or hooks. Sometimes these assist navigation. The thorny shape of a water chestnut can serve as a keel. Later, these protuberances may snag roots, lodge in soil, or cling to the ankles of shoreline plants, ending or slowing the seed's journey. They may also allow the seed to grab a water bird's feathers or the fur of an animal, sending its journey on a new path.

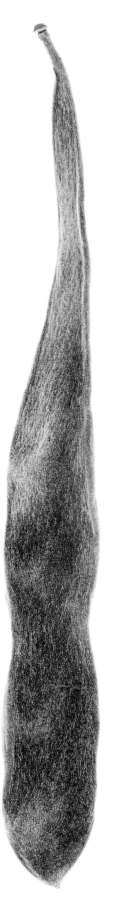

Pop stars

Seeds develop on a plant and eventually mature or ripen, reaching a point where they are ready to disperse. Typically, green and growing gives way to brownish and drying.

Drying out is imperative for seeds that take dispersal into their own hands. This process involves contraction, shrinking a bit, tightening up. In the construction and design, tension develops. When the tension reaches a critical point, the case unrolls, unfurls, or flings open. The capsule bursts. Seeds catapult. The story of dry wisteria pod, recounted in the chapter-opening quote by naturalist Loren Eiseley, is a classic example. Had Eiseley not brought it indoors, the same thing would have happened outside. Kids always get a kick out of pinching fat jewelweed capsules, which pitch their many seeds in all directions.

With some seeds, the tension is created and released not in dryness, but in response to water or humidity. A seed case swells and stretches until it can hold no more moisture, then built-up pressure bursts it apart. Some tropical plants operate this way.

Expulsion is not always self-contained or triggered internally. Some seeds don't break open until an external force acts on them. An animal, bird, or human brushes against the seed, or wind, rain, or tide tosses it about. Seeds can even be nudged by their neighbors. One burst pod may create enough movement in a plant or plant colony to get the party started.

Ejected seeds may end up a good distance from where they began. The world record appears to belong to an African tree in the bean family (Fabaceae), *Tetraberlinia moreliana*, whose seeds landed almost 200 feet (60 meters) away. However, the object is just to get out from under the parent plant. Most of the time, this happens.

A mess is often left behind. Curled or mangled remnants of the seed capsule or pod betray the force of the release. If you look closely, you may discover that the

explosion was not random. Fragments often correspond to whole or half carpels. You may be able to identify and count peeled-back sepals. The seeds are gone, distributed at last.

Keep your ears open. If you listen closely, sometimes there are even sound effects—an audible pop as something bursts open, an airborne ping of a flung seed, and perhaps even the plunk of a landing.

Hitchhikers

In *The Dharma Bums*, Jack Kerouac comments that a hitchhiker must depend "solely on himself and thereby learn his true and hidden strength." This turns out to be equally true for seeds that grab rides on animal fur, human clothing, and farm machinery, car tires, train wheels, bales of hay, organic packing materials or ballast, and more. A seed is lighting out on a solo journey for the territory, with high hopes.

In order to attach to someone or something that moves it along, a seed needs the ability to stick (and, later, to unstick). Anyone who has ever spent time tugging burdocks out of a dog's fur can appreciate the tenacity of those prickers. (Burdocks were actually the inspiration for Velcro.) Close inspection of this particular hitchhiker shows bracts enclosing the burr end with little curved hooks that are attached to sheaths. The seeds are within. When the hooks are yanked in an attempt to dislodge them, the sheaths open and release many seeds. Removal itself can be a built-in seed-dispersal mechanism.

Some such seeds are merely sticky, with numerous tiny hairlike prickers, while others sport mini hooks or barbs. Some seeds develop formidable spines, claws, or horns that are visible to the naked eye. In all cases, the aim is to attach and travel. Detaching need not depend on human tugging. An animal, even a persistent dog and some birds, can scratch or bite off a hitchhiking seed. If the host creature moves through vegetation or water, the seed's grip can gradually loosen as the prickers soften or slowly decay. Or the seed can get rubbed or abraded off.

ABOVE For a seed or capsule to be a successful hitchhiker—whether the inadvertent ride is via animal fur, human clothing, tractor tire, or bird plumage—it must have two key qualities. It must be able to attach, whether with a grasping pricker or thorn or similar appendage, or via tenacity supplied by a textured surface. In due course, it also needs to have the ability to detach. Sometimes the dispersal agent helps, as when a dog chews or tears off the annoying burdock or teasel (shown here) seedhead or a cow or sheep rubs it loose on a fence or bush. Sometimes it simply falls off during a bumpy ride or when its own structure disintegrates over time.

OPPOSITE Many familiar fruits, whether cultivated like this bitter melon or wild like a bramble berry, use the dispersal method of enticing a creature to consume their flesh but jettison their seeds. Not coincidentally, fruits tend to be at their most appealing and delicious stage when the seeds are ripe or nearly so. In this way, fruits avoid the possibility of unripe seeds being dispersed too soon.

The ultimate goal is to get the seed to a suitable spot, disembark, and germinate. Research suggests that a period of travel is often built in to the overall plan. Seeds assisted in this fashion would not germinate at the moment they leave their parent plant. A little more time is needed, either for the seeds within to fully ripen or to ride out a cold winter or a dry season.

In the belly of the beast— food voyagers

Traveling inside an animal is yet another successful, widespread seed-dispersal method. By some estimates, at least half of seed-producing plants rely on animals to ingest their seeds and move them a distance from their mother plant.

The majority of fruits are in this category. They attract birds, fish, animals, and humans with their color, beauty, fragrance, and tasty flesh. The flesh lures and nurtures with fat, sugar, starch, and protein. Many plants produce their fruit at the top or outer edges to make it more accessible. A fruit, berry, or drupe is at peak and enticing flavor and value to the eater only when the seeds within are ripe. We don't eat unripe fruits because they're not as appealing; the unripe fruit doesn't want you and your dispersal services too soon.

From the plant's point of view, the valuable part is the seeds embedded inside the fruit. These tend not to be as complicated, ornate, or textured as the seeds discussed previously. Instead, they're usually hard and smooth. The coating, whether true seed coat or endocarp, only has to be tough enough to withstand gastric juices and

enzymes in the digestive tract. (Although there are times when gastric juices and enzymes are necessary to trigger germination, as is believed to be the case with chiltepins, the wild ancestor of peppers.) The eater's job is to deposit undigested, intact seeds somewhere distant in a pile of feces, which functions both as temporary protection from the elements and a starter dose of fertilizer.

Timing is important. Consider a fruit—say, a viburnum or pyracantha—that ripens in autumn. Birds love to consume them, and birds eat heavily at that time of year because they need energy to migrate or to weather the upcoming winter. This type of fruit is a boon to the hungry birds, but also good for the embedded seeds, which get consumed, moved, and deposited in great numbers.

In many cases, birds are the ideal consumer. They don't chew their food, so seeds remain intact, whereas a raccoon, fox, deer, or bear could mash certain seeds while eating. Perhaps this is why so many seeds that are wrapped up in a substantial, juicy package are small and slick, such as those in apples, pears, blueberries, and grapes. Also, certain plants have long-established relationships with particular creatures (for example, only the aptly named nutcracker bird can extract seeds from the cones of the European arolla pine). Any damage to either population upsets the balance and impacts the survival and reproductive prospects of both parties.

Ripeness and harvest

Plants provide cues for humans and other creatures that want to gather seeds. Watch a fertilized flower as it withers. Ideally, time your intervention for the moment when seeds are as mature as possible, just short of falling off, getting carried away by a bird or animal, or rotting in place.

A change in color is a common sign. The seeds or seedhead will darken—say, from tan to brown or black. Many flowerheads will lead to seedheads that shatter and shower the seeds all over the ground. Pick them a touch early and bag them, or array them on a cloth or in a cool, dry, windless spot. For seeds hidden within a capsule, pod, or similar container, the color of the covering can be a useful signal.

In other cases, you can listen. Observe when the wind rustles, or poke or shake the structure: ripe seeds will rattle within. Moisture, such as recent rainfall, watering, or morning dew, can be the enemy of your quarry. Seeds harvested wet or damp are vulnerable to rot. Wait until midday, or swoop in on a dry day.

So-called wet seeds embedded in a fruit are another

ABOVE Pods and capsules have a clever way of signaling that their contents are ripening: they darken. Tan, brown, dark brown, and black are practically universal signs that the show is over and seed production is well under way or complete. Drying out may also alter the shape, as is the case with honey locusts. These pods go from green to red-brown to dark brown, but the seeds inside are not fully ripe until the pods begin to twist irregularly.

OPPOSITE Once a capsule is dark and dry, only the ripe seeds within contain life and warrant attention. This is when humans, animals, and birds intervene to harvest the seeds, even if they won't be consumed or planted right away. It's convenient and often necessary to get rid of all the superfluous dead, dry material. There are various ways to do this, depending on the plant. You can collect ripe crocosmia seeds, shown here, by simply shaking or sifting them free of the cracked, dried pods.

matter. Hungry creatures are often presented with a choice. If we eat at the moment of peak flesh ripeness, the seeds might not be totally mature. Seeds will grow larger and fatter inside an overripe fruit, such as a tomato or melon.

For gardeners and farmers who wish to save seeds for next year or beyond, the answer is to reserve some of the crop for eating and some for saving seeds. (Seeds from hybrid plants will not resemble their parent; save from stable heirloom or open-pollinated varieties.) Those designated for seed need time to reach maturity. Vegetables cultivated for eating, like broccoli, are typically picked before they complete their reproductive cycle. We want them young and tender, not old and seedy. But to harvest seed from a vegetable plant, you have to leave it in your garden longer (and potentially subject it to more disease and pest pressure). Some popular vegetables are biennials, which don't set seed until their second year, further extending the timeline.

The same principle applies to perennial plants, including many favorite flowers, common herbs and weeds, and trees. Spare a few. Plants expend a lot of energy developing and maturing seeds, and they are often depleted afterward, which shortens their life span. Flag a handful from which you intend to collect seed, and let them proceed in their natural cycle. Deadhead the rest of the patch before they can go to seed. The ones you spared the extra work will likely be more robust when they renew their growth the following spring.

Dry seeds

Even those of us who have never farmed tend to use expressions like "separating the wheat from the chaff," also known as threshing. This refers to getting rid of all

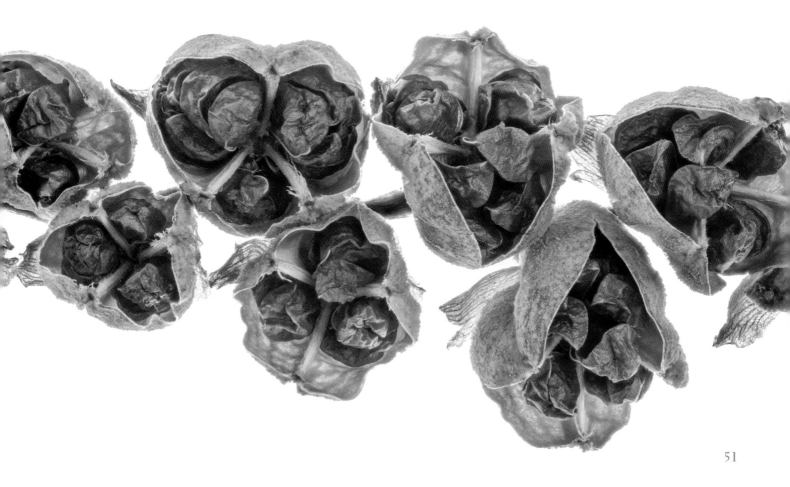

the other plant parts so only seeds remain. Seeds tend to be heavier than bits of twigs, leaves, capsules, and pods, so the old-fashioned method involves swishing dried plant material in a large pan or bowl and letting the wind or your breath disperse the unwanted debris. I know a gardener who struggled with isolating caraway seeds she had so carefully nurtured. She put everything in a shallow pie tin and stood in front of a fan. Her family thought it was an eccentric sight, but the method worked. In the case of beans, it's easiest to pick over the whole mess and pluck out the seeds. In some cultures and places, this is still a late-fall or winter family activity.

Wet seeds

Extracting seeds from fleshy fruit requires a little work. You can eat a fruit and reserve the seeds, or cut one open and scoop or cut out the seeds. Rinse them off and dry them on paper towels or cookie sheets.

More challenging are fruits whose seeds are coated with a thin gelatinous layer, such as cucumbers and tomatoes. The coating is a germination inhibitor that will break down in time of its own accord. You can hasten the process by soaking the seeds in water. The coating will eventually slip off or disintegrate, and viable seeds will sink to the bottom. You'll probably get a somewhat smelly layer of fermented goo on the water's surface. Strain away the water and moldy gunk, dry the seeds, and eat or store them as you wish.

Anyone who has ever sliced a tomato or a cucumber has undoubtedly noticed that the seeds have a wet, slick coating. This gelatinous layer is designed to keep small seeds moist, as they are vulnerable to drying out before they are ripe. It also contains germination inhibitors that prevent premature sprouting. This is why you never cut open a tomato to find sprouted seeds crowding the interior.

Dormancy: Asleep and alive

If you think seed dormancy—when, why, and how a seed finally sprouts—is confounding to gardeners, imagine being a scientist who is trying to unlock such secrets. A dormant seed is a living thing. Even if it looks dead, it is in a state of suspended animation.

Dormancy's purpose is not a mystery. The seed is protecting the embryonic plant within. Perhaps it is still immature and needs a little more time to develop. Maybe conditions outside the seed are not right. Perhaps both.

A seed invariably breaks dormancy when it judges that conditions are ready and right.

But for the gardener who just wanted to sow one more row of salad greens in midsummer in time to join ripe tomatoes, the failure of seeds to germinate can be frustrating. In nature, sprouting may take years because of hard seed coats. Everything else is happily growing in the summer: There is heated and fertile soil, warm air, light, faithful watering, perhaps even a little dose of fertilizer. Why are the seeds so slow and uncooperative?

The general answer is that seeds are somehow wired to be responsible for the continuity of their species. After coming this far, a seed will avoid risking failure by sprouting at an inopportune time. It wants the baby plant to have its best chance of survival and growth. Something inside the lettuce seeds knows that sprouting in midsummer heat is going to be challenging for the growth and maturity of the resulting plant. Lettuce prefers to sprout quickly in cool, damp spring or fall weather. The seed knows this is not the right year, or this is not the place for it to get the necessary resources to support the growth of what promises to be a large plant.

The more specific answer seems to lie somewhere in the province of growth-promoting hormones duking it out with growth-inhibiting hormones. Gardeners, nurseries, horticulturists, and botanists have experimented at this crossroads with tipping the scales toward growth. They have learned that three things tend to end dormancy and inspire sprouting, depending on the plant: a chilling period, exposure to light, and the introduction of moisture.

By careful science or by trial-and-error, in the distant past and in recent times, humans have figured out to how nudge some seeds awake. The actual internal mechanisms are clearly complex. They vary from plant to plant and from one year to the next, and they are affected by variables seen and unseen. Stubborn secrets remain in this complex realm.

Germination: Fair and fickle

Left to its own devices, a seed has its own ways. It lets down its guard when it is ready. The seed coat opens the gate when the time is right, although how it determines this has been the subject of a great deal of intensive research and still is not fully understood for many plants. A brew of internal triggers of chemicals and hormones appears to balance the process. Conducive environmental conditions—the right soil temperature, the correct air temperature, sufficient day length and light—play major roles.

The right soil is key, too. Most plants prefer soil that is not heavy, compacted, or soggy. Many seeds do not like to germinate in super-rich ground. An abundance of organic matter can generate too much carbon dioxide, which can actually retard germination.

Some seeds germinate only after a period of chilling followed by a warming trend. This is because in temperate and colder climates, if seed tried to germinate upon ripening in the fall, it would be killed by winter. So these seeds evolved to ripen, go dormant for their normal winter, and break dormancy when spring is due. Some gardeners re-create a period of artificial chilling, also known as stratification. This can be as simple as tucking certain seeds in the fridge.

Remember, seeds don't have calendars or windows to the outside world. They can't check to see whether it is fall or spring, or what day it is, or what the weather is like. Occasionally they are fooled by an unseasonable thaw in early spring or an Indian summer. But those plants probably won't live to pass on their genes. Only those that have learned to wait out long, cold periods before sprouting in consistently warm weather survive to reproduce. This why many species, especially from colder climates, display dormancy. It is simply a learned survival tactic.

Some seeds germinate only when they are on or quite

near the soil surface, exposed to light and air. Many familiar weeds can lie dormant for months and years until this happens. And we've all heard the story about the grain of wheat in the pharaoh's tomb that didn't germinate until it was brought to the surface many centuries later.

While seeds cannot see conditions on the surface, evidently they can sense the situation. If temperatures are stable above them, it must still be winter (or, in hotter climates, the height of summer). Or there may be a layer of vegetation or other obstruction that would be difficult to break through. Instability, increasing or seed-friendly warmth and moisture—hints of change or disturbance—cue seeds that their opportunity is coming. Microorganisms in the soil can also play a role in breaking down a seed coat. Once a seed is awakened, oxygen and nutrients in soil or water quickly join the fray, and germination proceeds.

Gardener-tended germination does not always advance as well or as quickly as we might wish. A seed coat can be a daunting barrier to breach. To spur a seed to germinate, you have to provide or approximate ideal conditions. You might be nudging or compelling the seed to accelerate or forgo its own stubborn, mysterious, or established agenda, or the habits that help it succeed in its faraway origins. You might need to soak it in water or in water mixed with certain chemicals. You may have to sand or abrade part of the seed coat away, nick it with something sharp, or force it open with a blade or blunt object.

Or perhaps the seed responds to warmth, high heat,

or fire. There are seeds that only germinate after a forest fire. I knew a gardener who persevered with Matilija poppy seeds by placing them in a clay pot, covering it with hay, and tossing in a match. I was skeptical, but she breached the hard seed coat and triggered germination. A year later, she was very proud to show off two small but healthy plants that resulted.

You might consult books, other gardeners, and the Internet and still fail to succeed. Perhaps your rare alpine primrose is guarding its secrets, or you might have to be more patient. Maybe the seed wasn't completely ripe when collected. Or perhaps the seed coat was harmed in handling or storage and the contents dried out or were invaded by insects, some toxin, or rot or disease. Don't be too quick to pronounce a dud, however. Despite their small size and unremarkable appearance, seeds are wily and resilient.

On the other hand, there are times when you don't want a seed to germinate. Proper drying is mandatory or the moisture within will freeze, expand, and kill a seed. Seed-saving gardeners and those who order early or carry over surplus from the previous year know that a cool, dark, dry place offers the best storage conditions. Humidity is the enemy. Keep the bounty in a spot with no or limited enticements to germinate, a location where a seed coat and its precious contents will remain intact and stable. Cooks seek the same environment in their pantries and spice cupboards.

Larger seeds, with a greater surface area protected by more substantial, thicker seed coats, tend to last longer in appropriate storage. Generally speaking, the coats of squash, muskmelon, and bean seeds will protect their contents for several seasons, while tiny lettuce or poppy seeds probably shouldn't be stored for long if you hope to grow more plants from them.

It is often said that the smallest seeds—such as lettuce, parsnips, parsley, and onions—store poorly. Their tiny surface area makes them vulnerable to drying out and losing

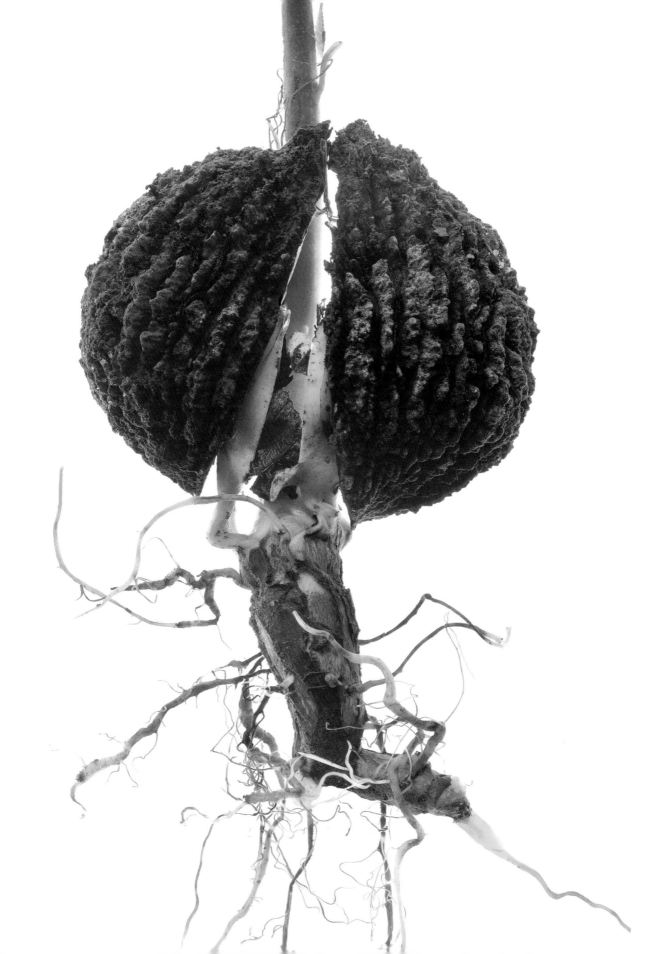

viability. This is not a problem when you never want your coriander or caraway to sprout.

Similarly, seeds that are thin or flaky purportedly store less successfully, while round ones are considered more durable. While this may seem intuitively true, it might not be. The mechanisms for long-term storage are not well understood. Plenty of research has been done, but it is not conclusive.

Home gardeners who save seeds for future use, either casually or with great care (using the advice of those with more experience or the detailed information in the books on the subject; see page 274) find that results vary. Sometimes they surprise us. Seeds are remarkably plucky.

Extravagant wastefulness? A meditation

When reviewing all this information about how seeds function, a nagging question arises: Isn't there a lot of waste? So many seeds are produced, but proportionally so few mature plants result. All that energy and ingenuity, only to end up in the wrong spot, ruined, waterlogged or desiccated, forgotten, spent, spoiled, mashed, or crushed—or half grown and then shaded out, outcompeted, mowed, blown down, burnt, poisoned, buried, yanked up, drowned, or blasted by unseasonable frost or heat. What a huge outpouring for such a meager return.

Humans and many other mammals do not experience reproduction's apparent wastefulness on the same scale. No dandelion weeps for its hundreds of lost or aborted offspring. But a modern-day human couple losing an embryo or an infant experiences heartbreaking grief. Gardeners and farmers, too, by virtue of the planning, investment, and nurturing they put into raising plants, also lament those that don't succeed and reach maturity. We value the individual more than nature does, it seems.

If we remove our human perspective, producing a surplus of seeds may actually be an operable strategy. Nature doesn't really intend for all thousands of dandelion seeds to germinate, or for every single acorn to make a great oak.

To the extent that plants and their seeds are components of a given ecosystem, losing a certain number—or even a majority—in order to nourish creatures or the soil is not a complete loss. It may not be their flagship purpose, but it is still a contribution to a greater whole. Indirect but important benefits come back to the plants that sacrifice some of their output. The soil gets nourished so more plants can grow. The creatures that eat the seeds also disperse some. Nothing exists in a vacuum.

If producing entirely too many seeds is a gamble, is it a bad bet? Probably not. After all, plants are successfully self-replicating away, year after year, decade after decade, century after century, without assistance from us. (Interference from us, as with GMO seeds, is another, sobering matter.) Aren't seed-producing plants an advancement over primitive plants? If you accept Darwin's basic tenet of survival of the fittest, they are managing just fine—at least in theory. What we judge as wanton fecundity may instead be a perfectly functional system.

And thank heavens for all the wild and weird diversity, which ensures something, somewhere, will always be making and propagating itself via seed. As celebrated scientist Lewis Thomas once remarked, the world may be "too big, too complex, with too many working parts lacking visible connections." But they are working parts. Seeds work.

OPPOSITE Why do so many plants produce so many seeds? Surely we don't want every red maple key, for instance, to lead to a new tree—we'd be overrun. The expression "if you want to dance, you have to pay the fiddler" comes to mind. Some of these keys will nourish the soil their brethren germinate in.

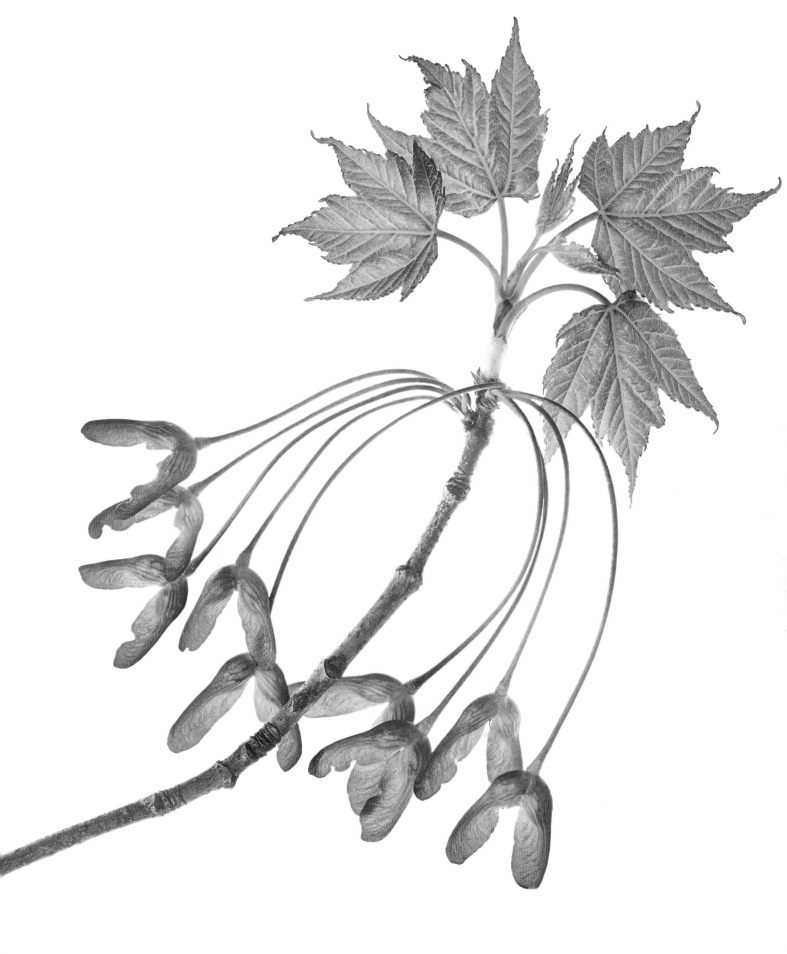

GARDEN FLOWERS

THE SEEDS OF garden flowers are either a blessing or a nuisance. They are considered a blessing when the gardener wants a plant to self-sow. You get free landscaping as the plant creates a colony and fills in an area—or, at least, you get free plants. Conversely, plants a gardener did not intentionally sow can become an annoyance. The best-laid landscaping plans are altered, or the unwanted, competitive offspring crowd out the desirable plants.

There is also the matter of hybrids. If a flower gets pollinated and seed is produced, those seeds may lead to more new plants. However, some hybrid seeds are sterile and thus are not a threat. Others germinate, but the offspring do not look just like the parent. They may be a different color or have a less refined growth habit. If you don't wish to be saddled with yanking out unwanted seedlings next season, remove flowers before they have a chance to go to seed. Pick bouquets!

On the other hand, if you want to try your hand at collecting and sowing favorite flower-garden seeds, it can be rewarding and fun. Track down the information you need online or from books.

Study the tangled heart of a clematis seedhead, and you'll discover surprising symmetries.

blackberry lily

Iris domestica

When you see this plant's small orange flowers (no more than 2 inches across), you might mistake it for a lily. The flowers are six-parted and the bright petals are speckled like those of some lilies. Also, like day-lilies, individual blooms last only a single day. But the blackberry lily is actually an iris—not too long ago it was shifted into Iridaceae. Its fan of lance-shaped leaves arising from a creeping rhizome helps confirm its member-ship. Its flower stems are leafless, which is another irislike quality. Gardeners have long enjoyed this native of China and India, and in some areas it has escaped into fields and roadsides.

The *blackberry* part of the name is revealed when this easygoing plant goes to seed. As the fat green pods ripen, they split open to expose clusters of glossy black seeds that look like plump little blackberries. They are fun novelty in autumn as the growing season winds down. However, they are neither sweet nor succulent like real blackberries.

Unless you go to the trouble of providing support like individual stakes, this plant's stems often bend and collapse under the weight of its so-called berries. In due course, the seeds ripen, come loose, and bounce and roll all over a flowerbed. They are quick to germinate the following spring, to the extent that you might find yourself pulling out little surplus plants.

Little speckled orange lilylike flowers yield to these blue-black berry clusters in the fall. The berries fall off and roll away, and seeds sprout readily the following year. And because this is a species and not a hybrid, the new plants will look just like the parent plant.

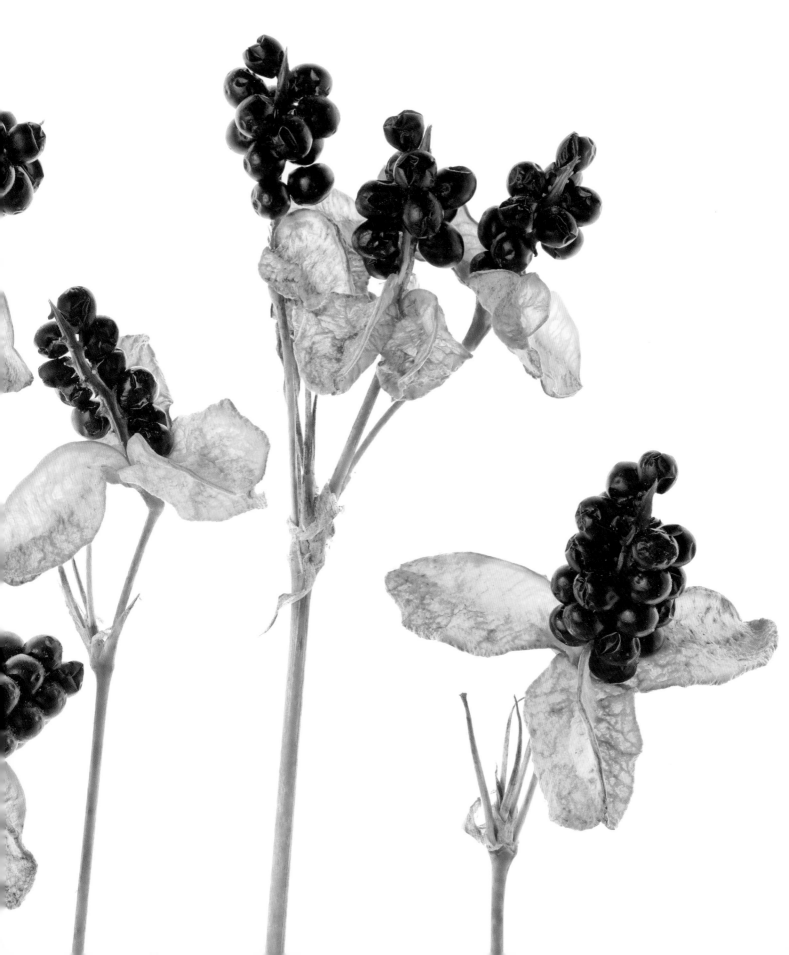

butterfly vine

Mascagnia macroptera

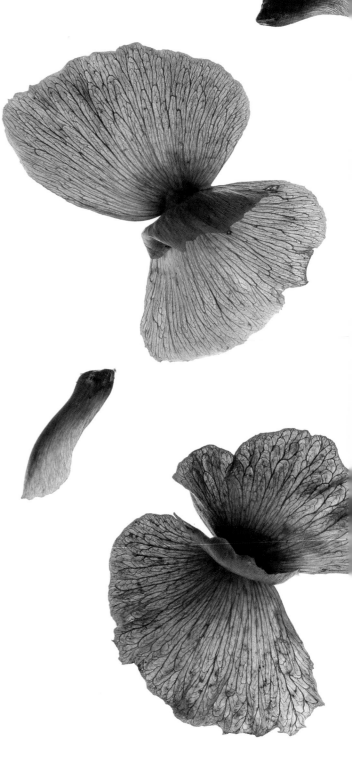

The pods of this plant do look like butterflies. At first they are chartreuse, and later they dry to tan; at this point crafters swoop in and clip them off. As is or spray-painted, they can then be added to dry arrangements or potpourri, or even attached to the top of a wrapped gift.

The seeds are in the body of the butterfly, which can be pulled apart to expose them. Viable ones are firm. Those that have been spoiled by age, the elements, or munching insects crumble when handled. The wings serve the same purpose as those on a maple or elm samara—they make the seeds flight-worthy.

Although commonly known as butterfly vine, this is actually a rangy bush with twining, vinelike stems. A mature plant can become quite a tangle. You can train it on a support, such as a lamppost or mailbox, or drape it over a fence or arbor to tame it and show off the flowers and cute pods. It has been known to reach 20 feet high in cultivation, especially if it gets supplemental water.

In its native Mexico, this plant has escaped from gardens and swarms over roadsides and abandoned areas. Gardeners in similarly warm climates, such as Texas and along the Gulf Coast, find it to be a low-maintenance, heat-tolerant, vigorous grower. You can rein in its rampant ways somewhat by raising it in a large container. Diseases and pests do not seem to bother it. The clusters of 1-inch pinwheel-shaped flowers appear in spring and may repeat in the fall; they're usually bright yellow and have five petals. Real butterflies just may stop by.

This vine's large papery-winged pods are so unique and appealing that gardeners will put up with riotous growth just to admire them or harvest them for craft uses. Seeds are lodged in the butterfly's body.

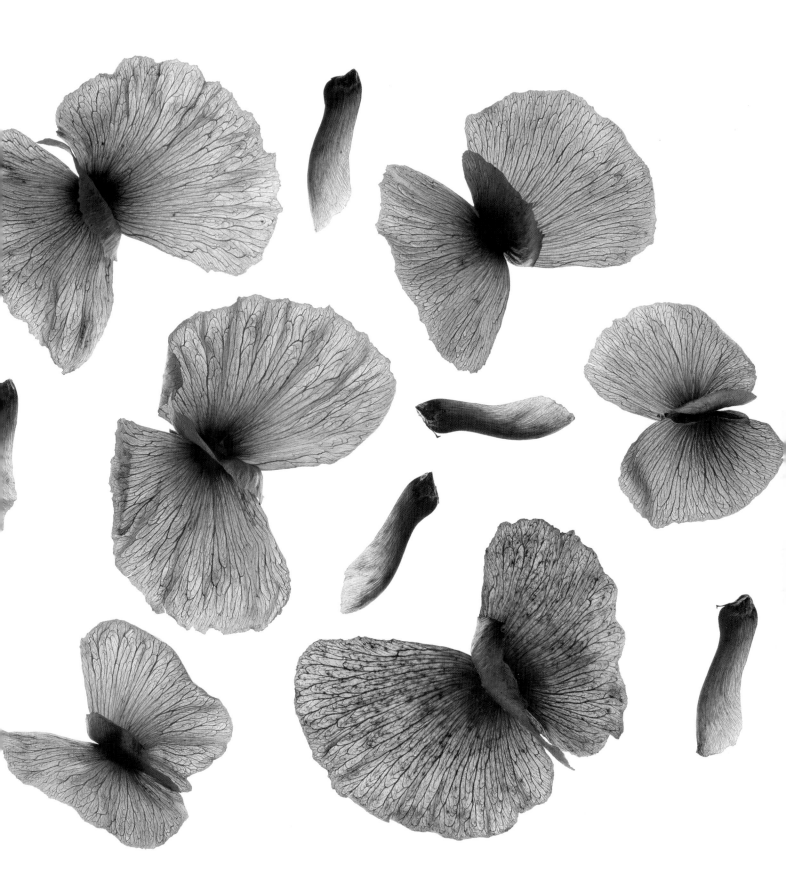

Chinese lantern

Physalis alkekengi

I first saw this plant when I was a child. It was growing in large, vivid patch in a nearby yard, and I was enchanted by the papery inflated fruits as well as their descriptive name. Later in life, neighbors complained loudly about the Chinese lantern, calling it invasive and yanking it out. It does get out of hand, especially in sunny spots with decent-quality soil. In the renowned reference *Perennials for American Gardens*, authors Ruth Rogers Clausen and Nicolas H. Ekstrom can hardly contain their scorn: "This unaccountably popular plant has all the subtlety of a neon sign," they sneer. "A good plant for a child's garden, but an adult's sense of aesthetics should be mature enough to avoid it."

The neon-sign comparison is fairly apt. The bright orange husks, which are technically calyces, attract attention to the ripening seeds even as they shelter them. The round marble-size seeds—also orange or red—are housed within. They are not safe to eat.

The white flowers often escape notice earlier in the summer, as they are less than 1 inch across and easily overwhelmed by the abundant 2- to 3-inch ovate leaves. Peer closely and you'll see that these little bell-shaped flowers have five lobes, which eventually segue into the five sections of the lanterns. The flowers and therefore the lanterns are lodged in the leaf axils; this likely gives them a little extra support, although productive plants end up bowing or slumping under the bounty.

If you decide to grow Chinese lantern, you may figure you can just pick lots of bouquets and thereby prevent the plant from self-sowing. But, like many invasive plants, it has other tricks up its sleeve. It also expands via questing, vigorous underground roots.

Even if you have a patch of this plant in your yard, you may have to search your memory to recall that the flowers look like little white bells. Chinese lantern's colorful husks are technically calyces, with round orange-to-red seeds lodged inside. Unlike their near relatives Cape gooseberry (*Physalis peruviana*) and tomatillo (*P. philadelphica*), the fruits and seeds are not edible.

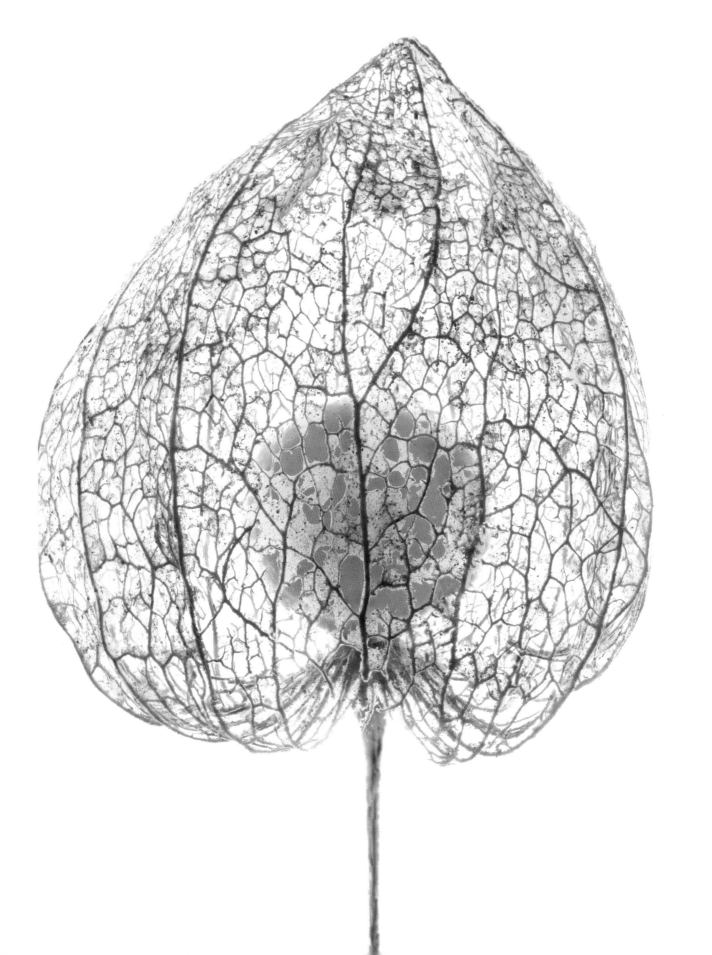

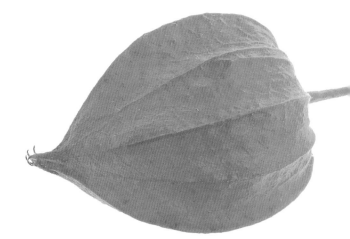

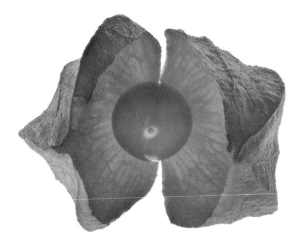

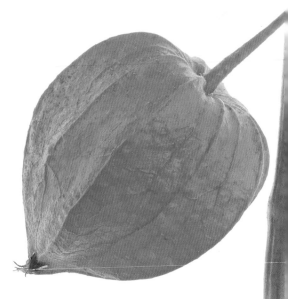

ABOVE Is the fruit safe to eat? Well, only when it's fully ripe. Unripe fruits—like their relatives potatoes—contain solanine, which, at best, causes gastric distress. You're better off eating relatives such as the tomatillo.

RIGHT The inflated papery "lanterns" develop from five-parted flowers. Thus they have five segments and ten ribs.

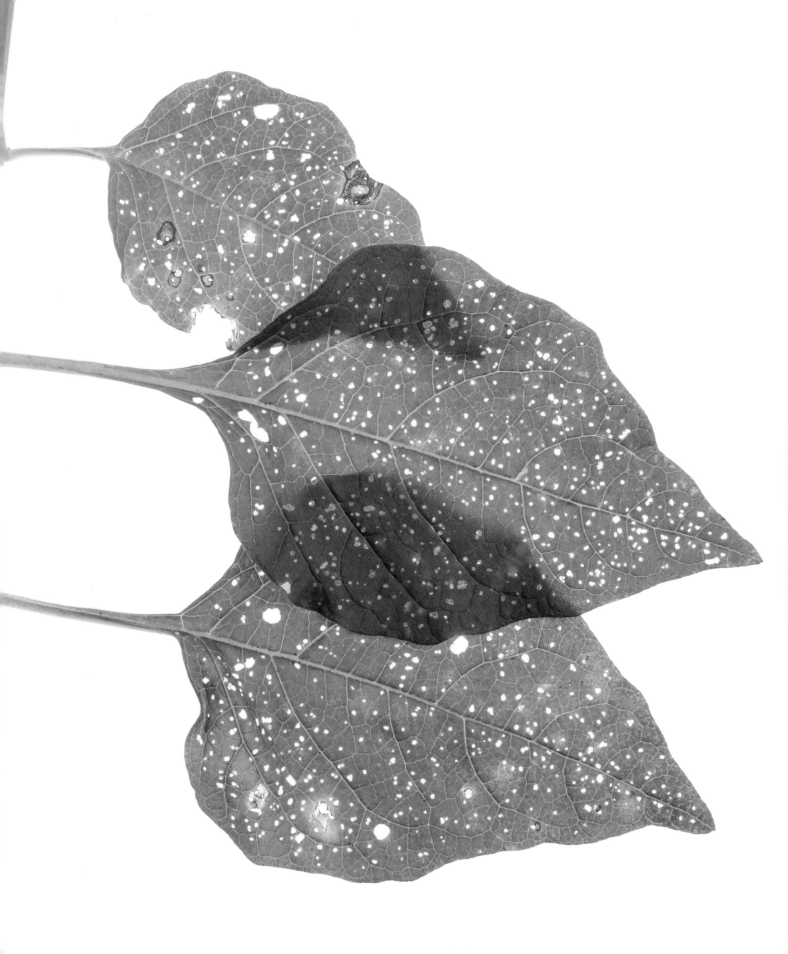

clematis
Clematis species

If you grow this vine, either the familiar big-flowered hybrids or perhaps one of the more offbeat species, you get a treat every autumn: whirlwinds of fuzzy seedheads. Clematis flowers come in all sorts of colors, from bright purple to rich red to classic white, but the seedheads are inevitably white, perhaps with a touch of green. They look like something out of a Dr. Seuss book, roughly symmetrical but with a touch of eccentric exuberance.

In fact, these whirligigs are made up of numerous seeds, each one attached to its own silky or furry tail, assuming successful and full pollination. And before your curiosity leads you to pluck and sow a few, remember that seeds from hybrids don't come true. You might get little plants in time, but they may never produce flowers. Species clematis, such as *Clematis tangutica*, *C. lasiandra*, or *C. texensis*, may reward your skill and patience, whether you collect ripe seed or buy it. Seek advice and encouragement from a clematis nursery or society.

Clematis seed is an achene. Lodged at the base of the feathery tails, these start out green and eventually turn brown. The tail is meant to help an achene travel on the wind.

Tails that bear fertilized seeds at their base tend to elongate and become more silky and sleek—no doubt in preparation for an upcoming flight to a new home. In comparison, those that have not been pollinated have noticeably shorter, stubbier tails. These break off and drift away very easily, lacking the anchor of a seed and the motivation of meaningful work to hang on to. That said, the seedheads in any state are still attractive, and they are a welcome, whimsical sight as the gardening year winds down.

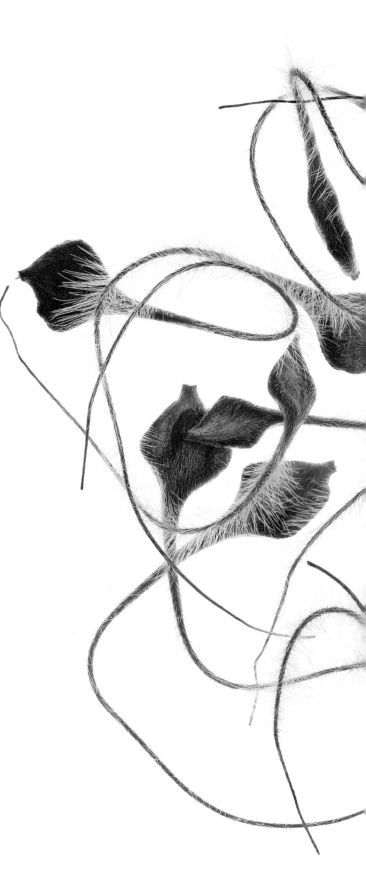

Tease apart a typical clematis seedhead and you'll discover that each fuzzy tail is attached to a single seed. Left to their own devices, these will disperse on the wind or get transported by a bird, animal, or water to a hopefully hospitable new home. Of course, seeds from hybrid clematis will not produce plants that look just like their parent.

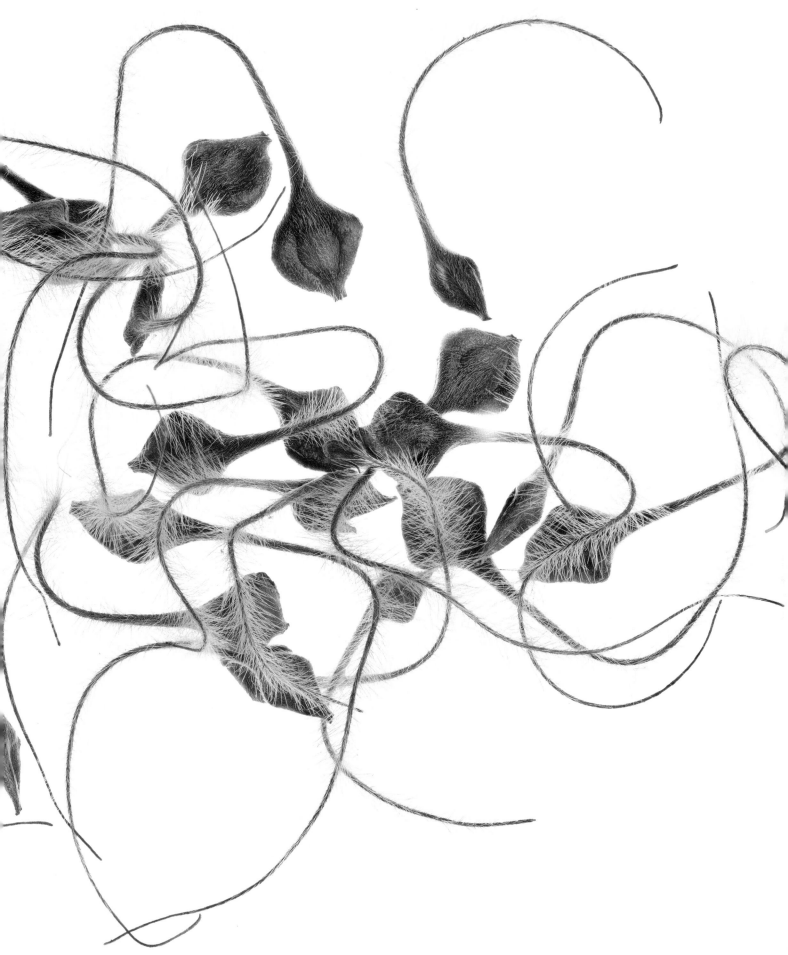

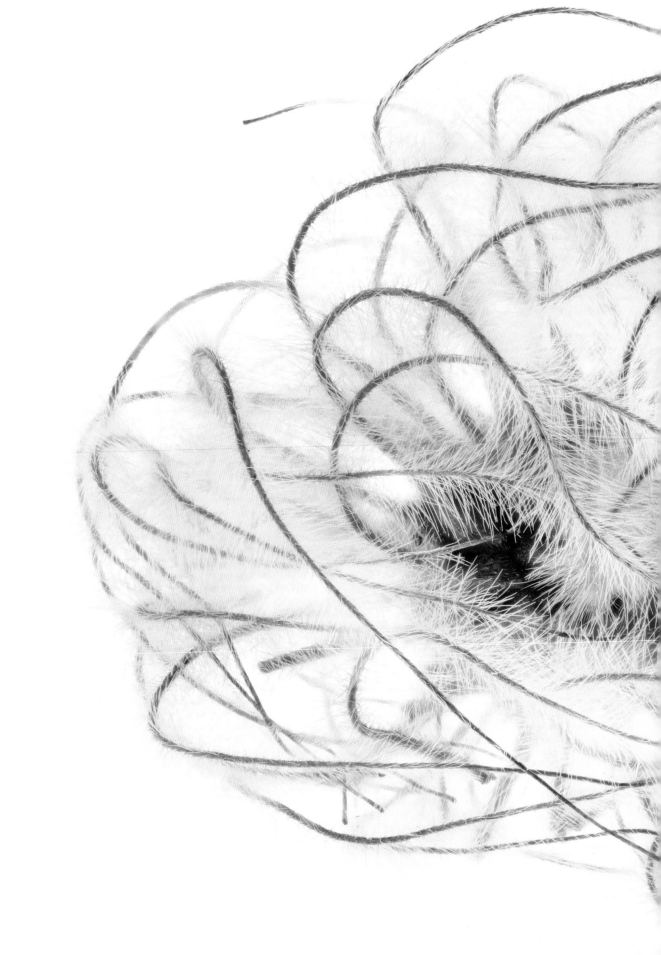

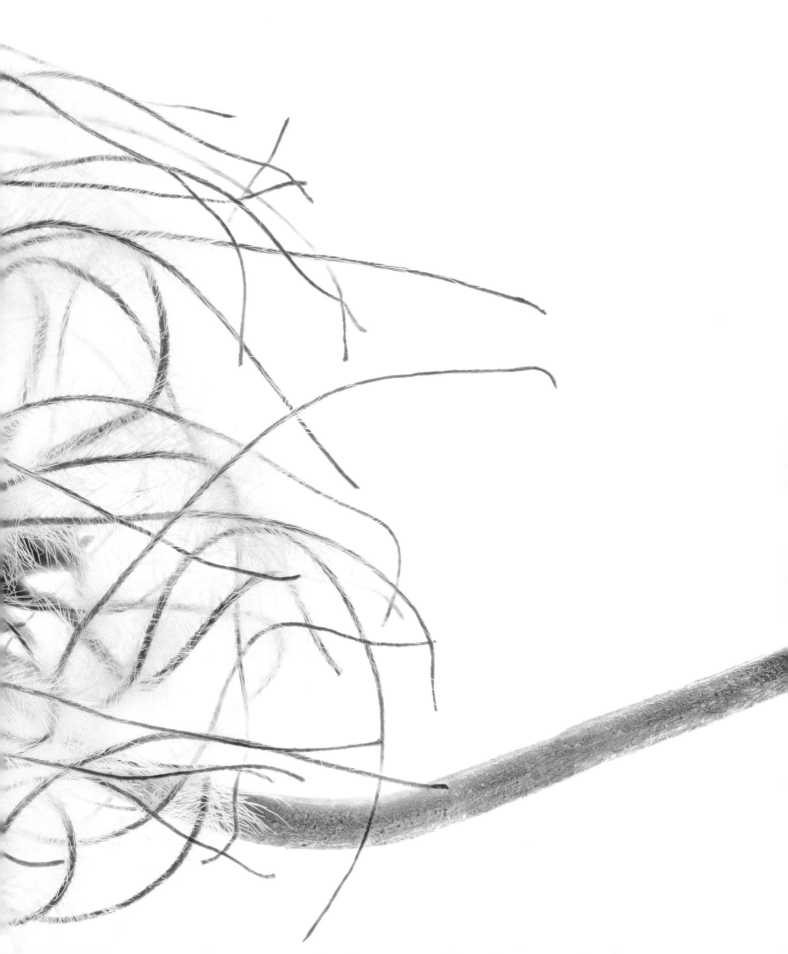

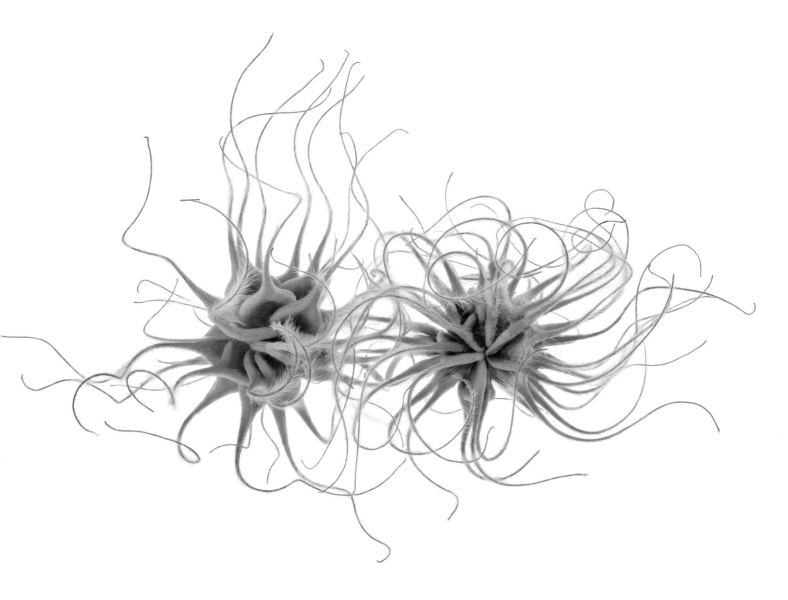

PREVIOUS The tails in a mature clematis seedhead are like the fluff in a dandelion puffball, in the sense that they take up most of the volume. Each one is attached to a single seed and will help it get and stay airborne while it travels to a new home.

ABOVE No matter the flower color or bloom size, all clematis eventually form some version of these fuzzy-looking green-and-white seedheads.

OPPOSITE While roughly symmetrical, fully developed clematis seedheads have an eccentric exuberance, as though Dr. Seuss drew them.

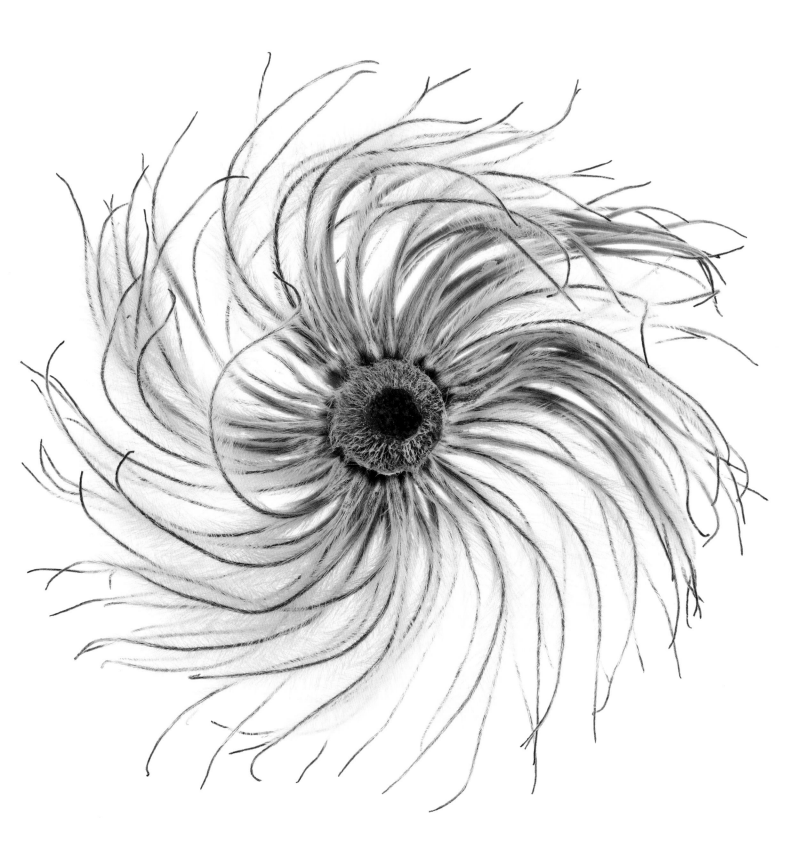

hellebore

Helleborus species

Those who garden where the winters are cold and snowy cherish hellebores, for their early appearance is a sign of spring. The two most popular species are Lenten rose, *Helleborus ×hybridus*, and Christmas rose, *H. niger*. The nodding or cup-shaped blooms come in a charming range of hues, from white and green to pink, yellow, and dark purple, sometimes speckled and freckled with contrasting colors. The petals are actually sepals; the true petals are reduced to nectaries, all centered by a boss of jaunty stamens. Hellebores are notoriously variable. Named hybrids and fine strains are available if you have a color preference.

But all good things must come to an end, and when their blooms finally fade, a follicle, or podlike fruit, forms. Watch for it and the seeds it contains. It is easy to become distracted by all the other spring flowers surging into bloom at this time.

Hellebore follicles are beautiful in their own right. Initially green, they swell in the flower's center while the sepals persist around them. The little oval seeds within are dark brown; sometimes they are flattened on two sides, which allows them to stack tidily in their vessels. The follicle eventually splits along one inward-facing seam, and the now-black seeds tumble out.

Horticulturists have learned the hard way that seeds collected in early summer are not ready. The embryo within requires more time to mature. Indeed, plant hormones protectively block germination, only relinquishing their control when cold weather comes. This is no big deal if you let your hellebores self-sow, but if you collect or buy seed, you must allow for or mimic this process by providing a warm period followed by a chilling one. One last piece of important advice: Handle these seeds with care. They contain glycosides, which are poisonous.

Gorgeous and durable blossoms of the hellebore eventually produce plump follicles clustered in the centers. The petals (technically sepals) hang on for a time, cupping the follicles while the seeds swell within.

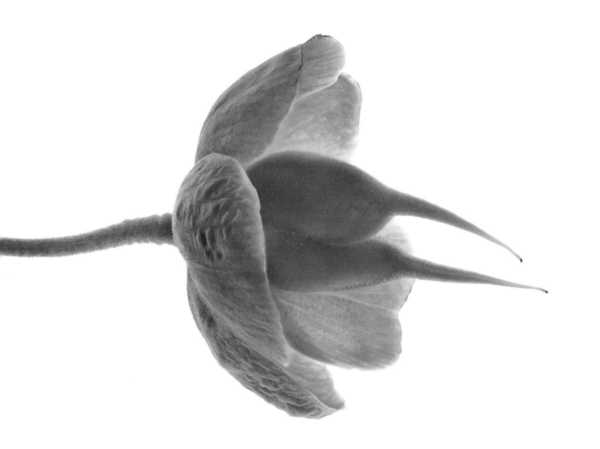

Hellebore seeds develop inside plump follicles. Resulting plants are variable, which is why prized named hellebores are raised by division or cloned.

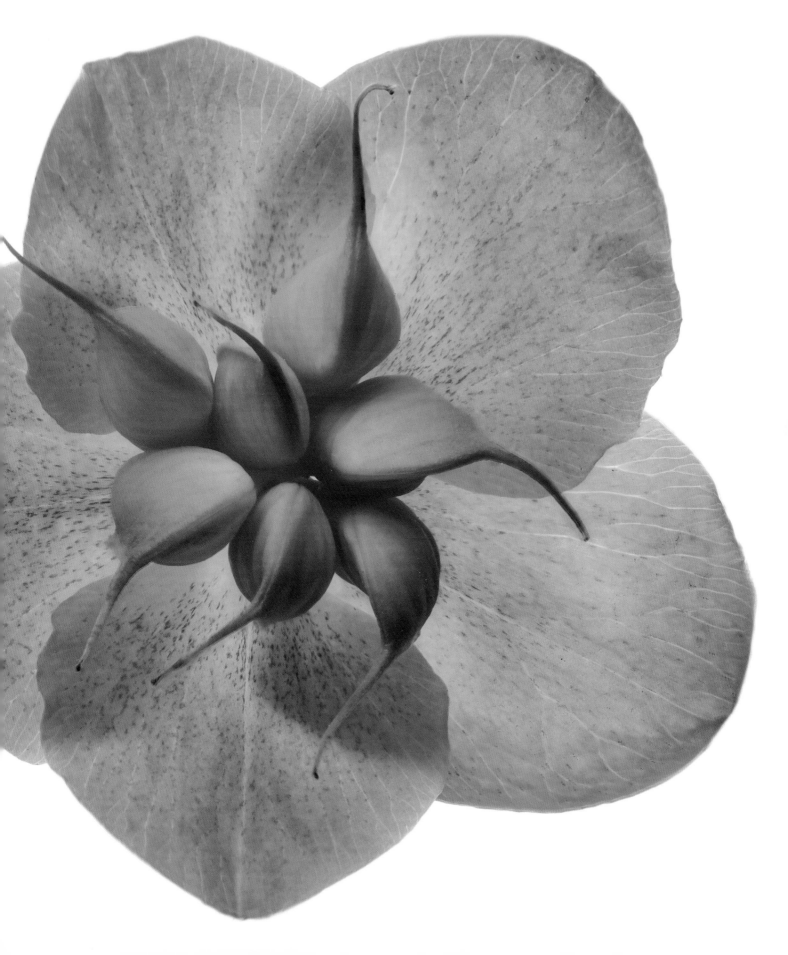

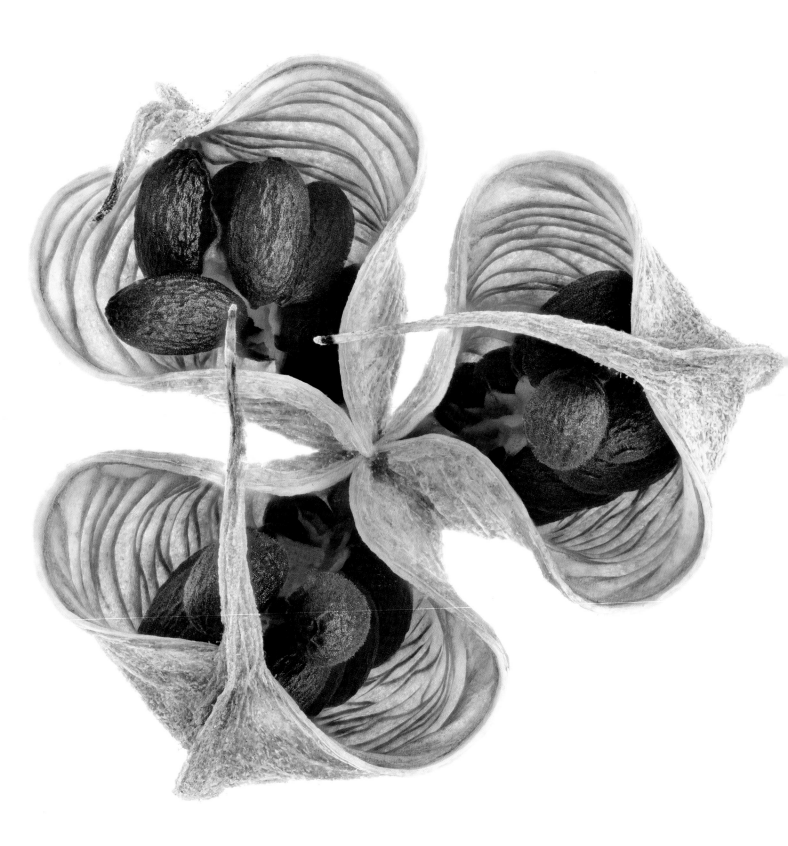

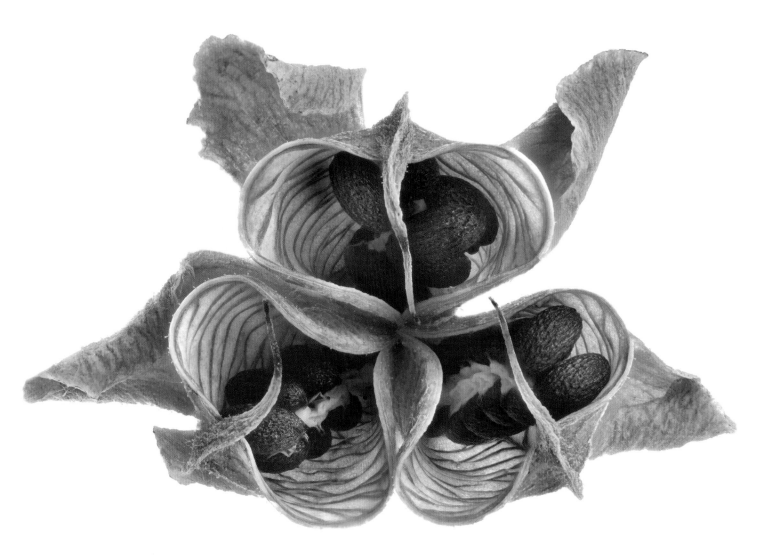

When ripe, hellebore follicles split open to reveal handsome blue-black seeds inside. If you have a good spring flower garden full of tulips, daffodils, and more, you might miss this stage—but you shouldn't, as it is beautiful in its own right. As the follicles dry out, the seeds darken and fall out. They may eventually germinate. To sprout them yourself, seek instructions and advice from books, the Internet, or other hobbyists, as they have tricky requirements.

hollyhock

Alcea rosea

A friend once gave me an envelope of hollyhock seeds. Scrawled on the outside was "pink, from Nantucket originally, single. Full sun!!" The contents were a bit disconcerting. Instead of the hard little brown seeds I anticipated, I found a mess of lightweight, faded bits of plant debris and dried flowers that reminded me of mouse fur. Nestled in the bottom were some actual wafer-thin seeds, about the size of tomato seeds and distinctly fuzzy. They clung to my fingers when I prodded them. From this, I was supposed to conjure stalks as tall as me, studded with pretty pink flowers?

But these seeds were not as odd or disconnected from their origins as they seemed. There is a certain continuity. Hollyhocks open blossoms lower on the stalk first. Once open, you can observe five overlapping petals. Meanwhile, upper unopened blossoms resemble fat buttons that hint at what the seed capsules will end up looking like: disk-shaped and five-parted. Insects pollinate hollyhocks. The many little seeds packed within are not flight-worthy; their textured, fuzzy surface, more apparent when magnified, helps them adhere to fur, feathers, fingertips, and even clothing.

Ardent seed savers have noted that hollyhock seedlings are quite variable. Cross-pollinating insects can introduce different colors. Semi-double or double flowers can pop up. Purity of a line is assured only if a patch of one strain is well isolated from other hollyhocks. Powdery mildew and rust are chronic problems with these plants, so saving seeds from the healthiest individuals should be a priority. Now that I know all this, I wonder whether my gift seeds will actually produce pink hollyhocks. Only one way to find out.

Individual hollyhock seeds are small and often hard to separate from the chaff of their capsules, dried flower petals, and other plant debris. They are both textured and fuzzy, so they adhere readily to almost anything, from bird feathers to human fingertips.

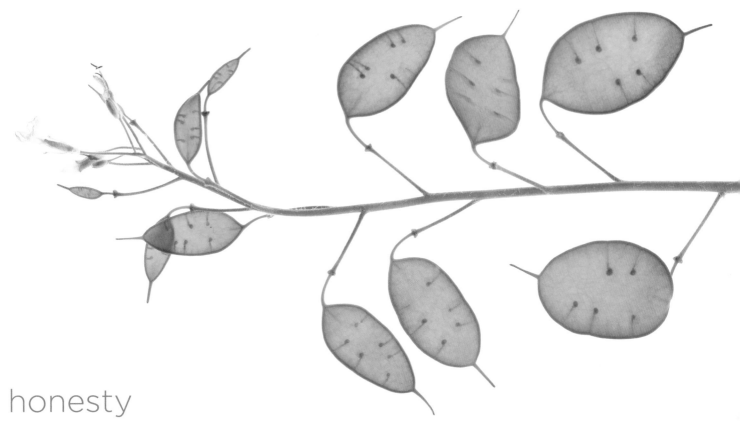

honesty

Lunaria annua

The round, flat seedpods of this plant are so distinctive that they have inspired a host of common names. Money plant is the most intuitive, as they do resemble coins, but you might also hear silver dollar plant, moonwort, and honesty. *Lunaria*, the genus name, means moon-shaped. It is hard to say where *honesty* comes from, as not everyone equates money with virtue. Possibly it refers to the fact that the seedpods are so enduring, both on the plant and indoors in bouquets. Or maybe it calls attention to their practically see-through appearance, as transparency is an element of honesty or integrity.

Money plant is a biennial member of the cabbage family (Brassicaceae) and related to stock (*Matthiola incana*) and rocket (*Hesperis matronalis*). As is characteristic of flowers in this family, they are four-petaled and either white or in pastel shades, generally pink, light purple, or mauve. They waft a soft, sweet scent.

The seedpods for all these related plants are siliques, which means they are like a slender sandwich holding and protecting the seeds, with two walls or valves that split along a seam when the time comes to release them. Initially green, they dry as summer turns to fall. Those of the money plant are so thin they are papery, and they dry white to silver. Eventually, if left in the garden, they turn brown. The actual seeds within are, as you'd expect, flat and disk-shaped. There are at least three to a coin. You can get them out by pulling gently on the protuberance at the top, like a ring-pull tab on a can, then peeling it away. The embedded seeds will come off easily. In nature, release occurs when the frail cover disintegrates.

ABOVE To manually extract the seeds from an honesty silique, tug gently on the protuberance at the top, as you would with the tab on a ring-pull can. It will peel back, and you can then pluck out the individual flat, disk-shaped seeds. In nature, the seeds release when their ultimately frail and papery covering breaks down.

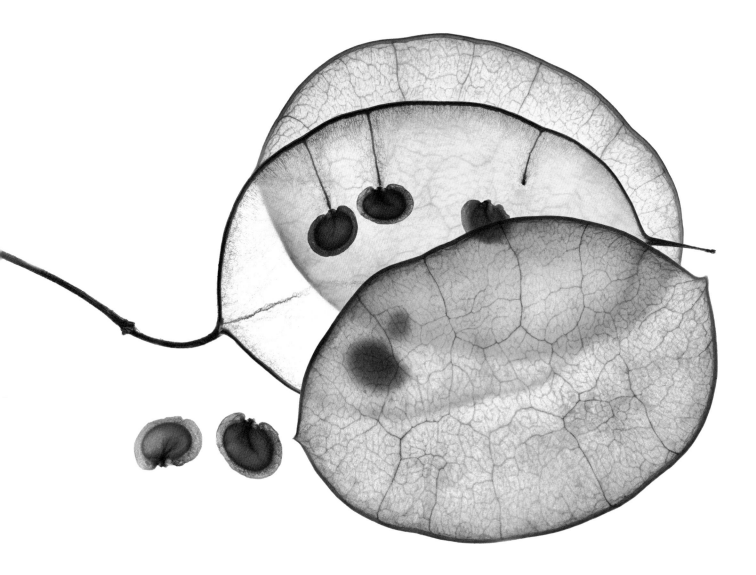

The pods—technically siliques—of the honesty plant are transparent. Transparency is a desirable feature of honesty or integrity, so perhaps this is the origin of the name. The small seeds are held inside and ripen gradually as the siliques go from green to silver or nearly white to, if left on the plant, tan.

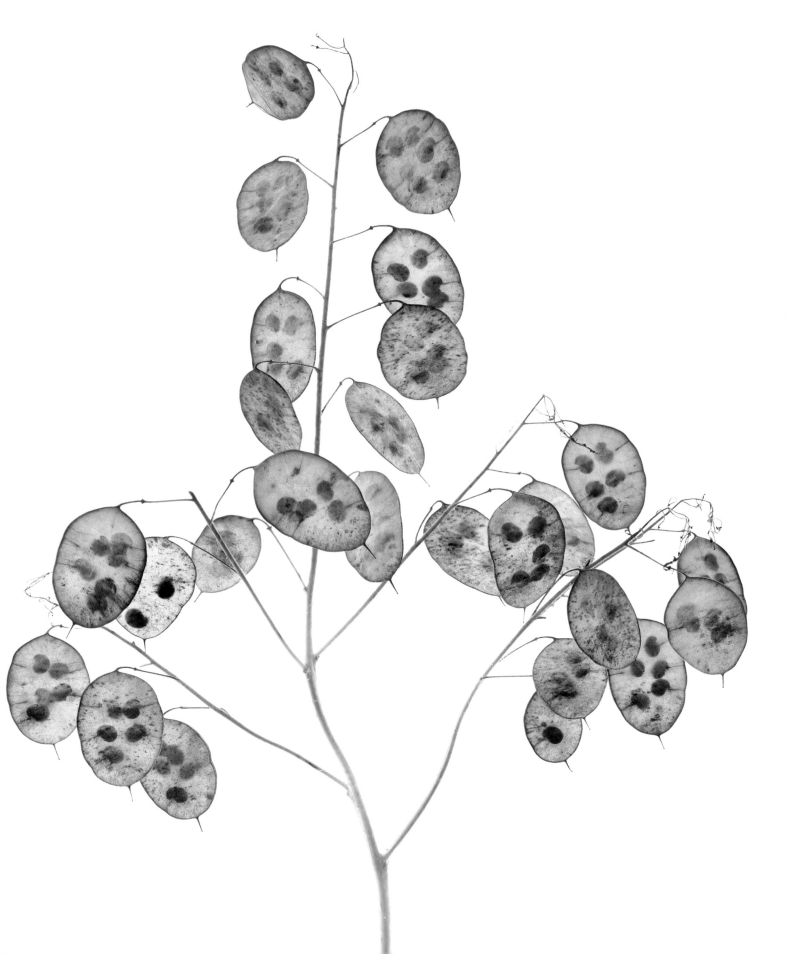

jewels of Opar

Talinum paniculatum

Some people love this interesting sub-shrub plant, while others hate it. It is native to the American South, parts of Latin America, and the Caribbean. Foliage is light green to chartreuse and succulent; it is often admired for its drought tolerance in areas where summers are long and hot. The little flowers are hot pink with yellow stamens. They might remind you of *Hypericum* blossoms, but they are more closely related to *Portulaca*. They are followed by clouds of jewel-like fruits in shades of bright to dark red.

Like many invasive plants, this one spreads readily by more than one means. The fruits ripen scads of small black seeds, and in hospitable conditions there are more seedlings with each passing year. Established plants form carrotlike taproots. The longer you wait, the harder it is to extract these. Some gardeners applaud all this growth and enjoy patches or ribbons of this low-care, colorful plant. Some try confining it to a container so it won't get out of hand. In areas with cold winters, it dies or dies down, which keeps it more manageable. Others decry it as a beast and a pest, warning that it will take over and become nearly impossible to eradicate.

The common name has a quirky origin. Opar is an imaginary and opulent lost city deep in the African jungle, featured in several of Edgar Rice Burroughs' Tarzan stories. In the series' fifth book, *Tarzan and the Jewels of Opar*, the tree-swinging hero returns (Jane is already in the picture). To get the treasure he's after, he has to navigate past a beautiful queen who has a crush on him, among other obstacles. On consideration, it's an inspired name for plant with mixed reviews and seductively beautiful fruit.

Someone, somewhere, with a good imagination or sense of humor, bestowed upon this plant its unique common name. The jewels of Opar are treasures Tarzan sought in one of Edgar Rice Burroughs' epic adventure stories. Opar was a beautiful city hidden in a jungle, and Tarzan faced many obstacles. These fruits are enchantingly beautiful, with their various hues from ruby red to dark red-purple.

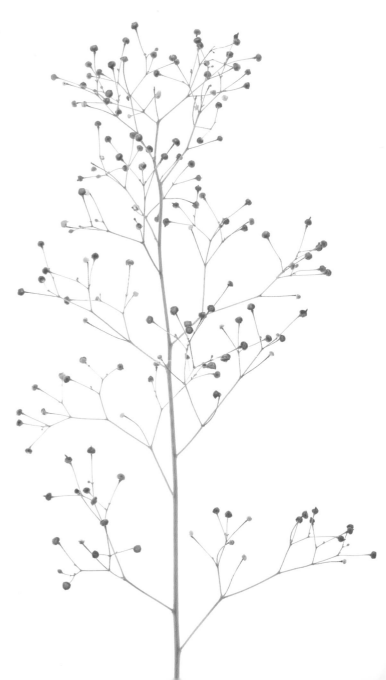

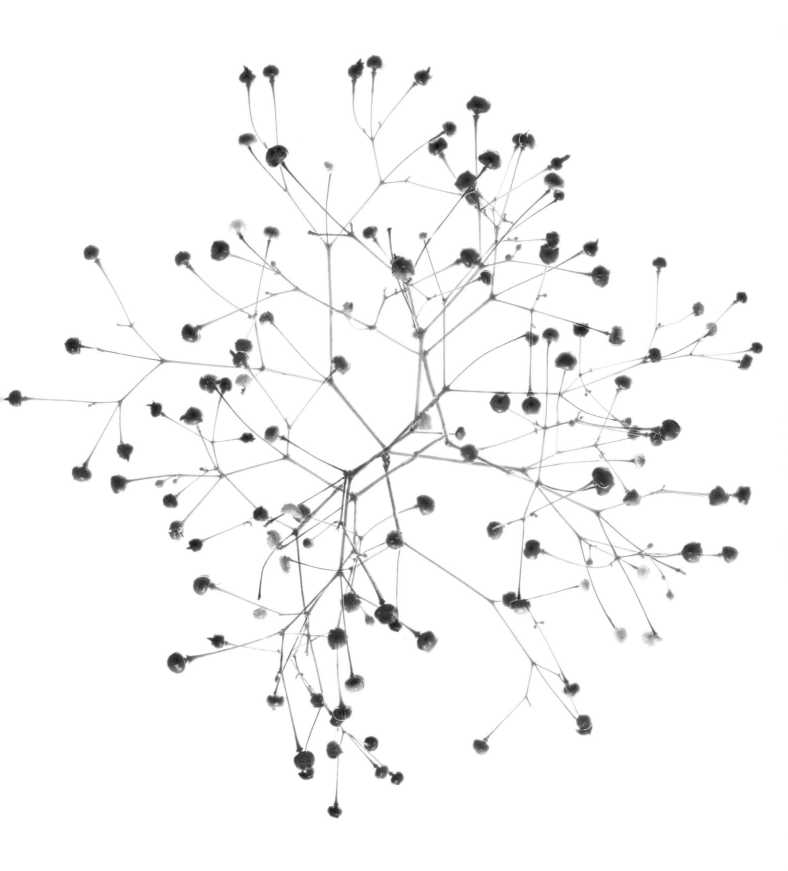

larkspur

Consolida species

It is easy for a gardener—or anyone, for that matter—to be more attracted to flowers than the seeds that follow, especially when the blossoms are colorful and the seeds are little dark-colored bits. In the case of the popular annual larkspur, the blooms are irresistibly pretty, jaunty spikes in shades of blue, purple, pink, and white. Seed packets usually feature a mix. Individual flowers are spurred, requiring the pollinator to dip in. Larkspurs are especially popular with hummingbirds, but bees and butterflies come around, too.

If you pour those dusky seeds out of a larkspur packet, you may be pleasantly surprised. Roughly pyramidal, they are textured on all sides and covered with broken ridges; they almost look corrugated. Like the delphiniums to which they are closely related, these seeds require some darkness to germinate, so cover them with a sprinkling of soil mix after sowing. Also like delphinium seeds, they seem to have a short shelf life. They dry out and fail to sprout if stored over more than a season or two.

However, out in the garden and left to their own devices, larkspurs self-sow readily. Somewhat furry, tapered follicles,

no more than 1 inch long, crack open and spill their bounty of seeds. Assuming their parents were growing happily in that site, a new generation emerges the following year. It's fun to see what colors pop up.

There's no visual way to tell which seed will generate a pink spike and which will generate a lavender one, and so on. That information is encoded deep in the embryo inside the seed.

RIGHT Close examination of an individual larkspur seed reveals its ornately ridged or corrugated surface. Presumably this helps it adhere better to soil or even an animal or bird that might move it along. Its dark color helps disguise it on or in the ground to prevent it from being plucked up or eaten. But when held and admired, it's a dusky beauty.

OPPOSITE Lovely larkspur blossoms come in a range of hues, from purple to pink to white. The plants are annuals, best suited to cooler climates. If you want a repeat performance, allow yours to form their furry little pods and drop the seeds, or buy fresh seed each year.

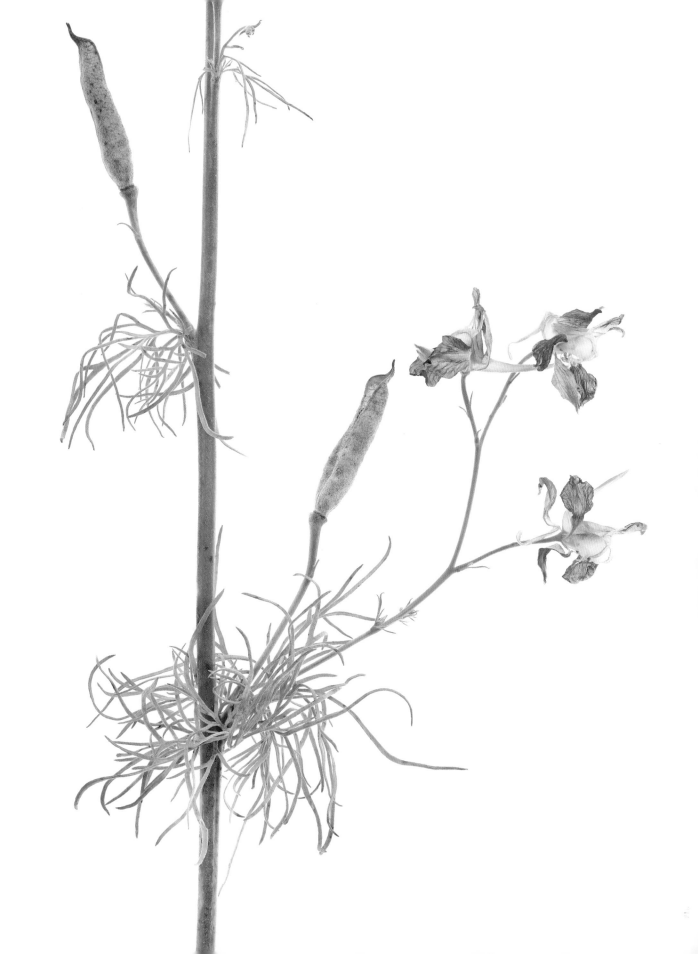

lotus

Nelumbo nucifera

Even nongardeners and those who are not religious can identify the iconic multipetaled lotus flower. The edible starchy rhizome is a common ingredient in many Asian dishes. The foliage is also admired for its size and beauty, as well as the attractive way water beads up and runs off like quicksilver, thanks to a coating of microscopic bumps. Even the pods are familiar to many; when dry, a pod resembles a brown showerhead and is popular in dried arrangements. The seeds are perhaps the only parts that are not immediately recognized outside of their native areas. They are lodged, one per hole, in that unique seedpod. They range from as small as a pea to as large as a marble. They are edible.

You can raise new plants from these seeds. Working with root pieces is faster, of course; those new plants will be copies or clones of the parent plant. Seed-raised plants vary, which is fine if you are an unfussy or curious gardener, or a hybridizer.

The seeds are so tough that they are sometimes incorrectly called nuts. They will germinate better if you lightly sand their coats. Seeds as old as 2000 years have been successfully sprouted. Their ability to remain viable so long is the subject of extensive research. Scientists hope to learn something that can be applied to human aging.

Lotus seeds (among others) have also gone into space on Chinese satellites and returned. Researchers were interested in exposing them to ultraviolet light and an environment of high vacuum and low gravity, conditions hard to maintain on Earth. So far, space lotus seeds not only sprout faster, but also exhibit interesting characteristics. Experiments are ongoing. You can now buy "Space Lotus" hybrid plants.

The large-blossomed lotus, up to 10 inches across, is beautiful even as its petals and stamens fade and fall. The central pod is left atop a tall stalk. If pollination occurred (usually aided by bees or beetles), substantial seeds form. When ripe, these will drop into the water below and sink. Come winter, dried and empty pods are the only sign that lotus is still in the pond.

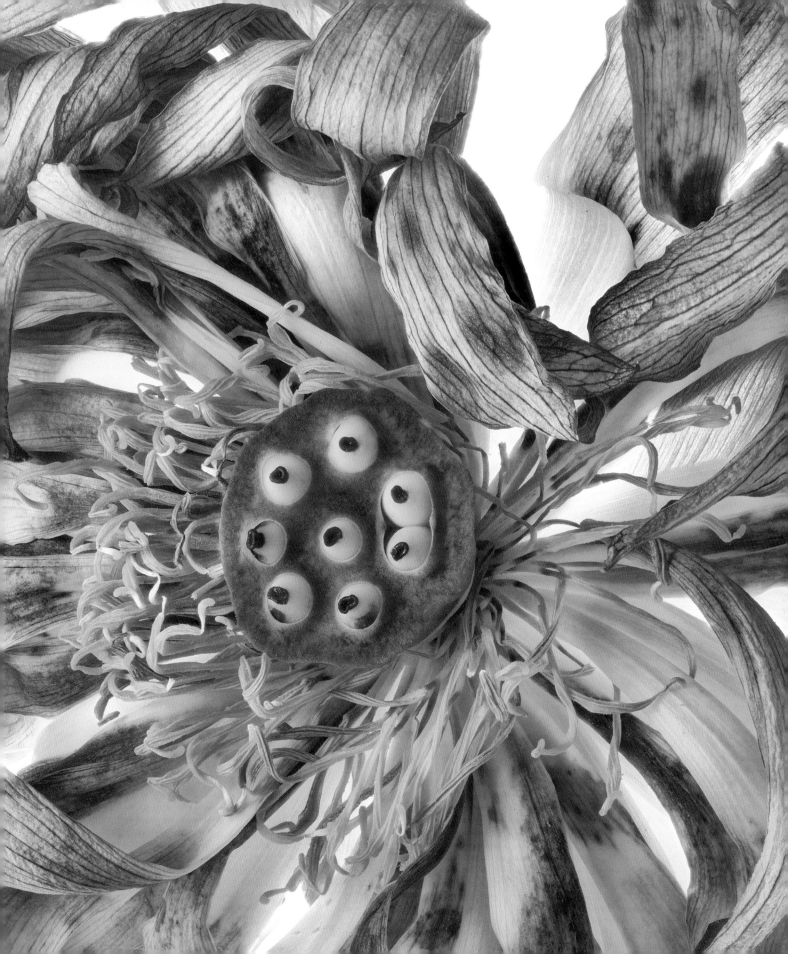

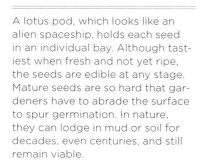

A lotus pod, which looks like an alien spaceship, holds each seed in an individual bay. Although tastiest when fresh and not yet ripe, the seeds are edible at any stage. Mature seeds are so hard that gardeners have to abrade the surface to spur germination. In nature, they can lodge in mud or soil for decades, even centuries, and still remain viable.

love-lies-bleeding

Amaranthus caudatus

Love-lies-bleeding is an astonishing plant to behold. It is the size of a small shrub (about 3 feet high and wide), and cloaked in light green textured oval leaves and contrasting bright red plumes. These can be easily 12 inches or longer, and are composed of densely packed petalless flowers. These may become so heavy that they pull a plant down, unless the stems are leaning on adjacent plants or a fastidious gardener stakes them. They can break off in a heavy summer storm. Other common names are tassel flower and dreadlocks plant. An especially handsome lime green version, 'Green Cascade', is available.

Native to India and Africa as well as Peru, love-lies-bleeding likes heat and sun and is best suited to a longer growing season. It can take up to three months to produce its spectacular flower chains. These remain good-looking well into autumn and may be harvested for dry arrangements. In temperate gardens of North America and Europe, it is often enjoyed as an annual or bedding plant.

Ornamental gardeners may relish the drama. However, in South America, where this plant is called *kichiwa*, it is raised as a crop for its plentiful, tiny seeds, or amaranth. These are high in protein, contain various vitamins and minerals, and are gluten free. Unlike their popular cousin quinoa, amaranth also lacks saponins and doesn't require rinsing before eating. Cultivated seeds, which may be white, light brown, or even pink, are tastier than the more peppery black wild ones. They are suitable for many recipes, including baked goods and cereal. Meanwhile, in Asia, amaranth greens are eaten like spinach and valued for their high iron and calcium content.

If harvesting food from this plant interests you, shop around. Some seed catalogs offer choices of leaf and grain varieties.

The abundance of tiny seeds that follow love-lies-bleeding's colorful plumes are edible—you may have even seen them for sale in your local health-food market as amaranth. These seeds are high in protein and lack gluten. Unlike quinoa, which is a relative, amaranth lacks saponins, so you do not have to rinse it before cooking. If you'd like to grow your own crop, trawl seed company offerings for varieties recommended for kitchen use.

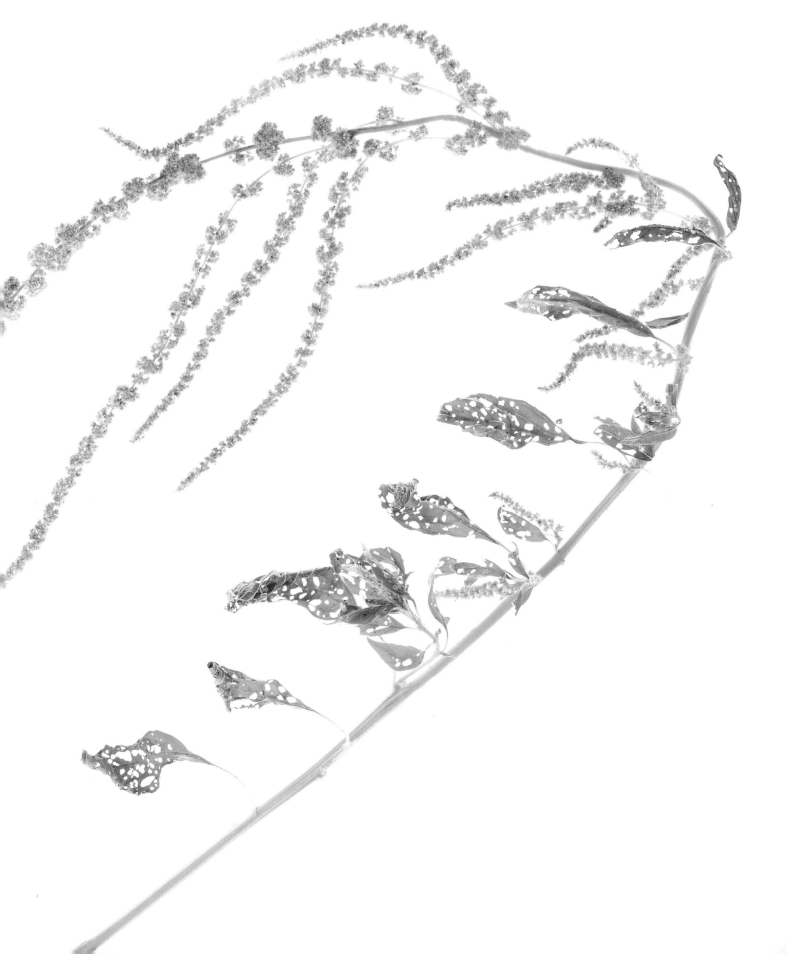

morning glory

Ipomoea species

Like many popular garden annuals, morning glory is easy to grow. Start the seeds indoors early, or poke them into the ground in a sunny spot after danger of frost has passed. Erect guide wires or string early on. Left to its own devices, the plant becomes a tangle.

The seeds look like small, wrinkled brown peas. The coat is especially hard. This is practical; the plants are cold-sensitive, and the seed coat toughness delays germination until conditions have warmed up. Before sowing, soak the seeds, or nick or file their coats.

Ipomoea 'Heavenly Blue' is probably the most widely grown and admired morning glory. Crimson 'Scarlet O'Hara' is another favorite. Purple 'Grandpa Ott' and various mixes are also available. If the plants are happy, they'll bloom into autumn. To the chagrin of some gardeners, many morning glories self-sow prolifically, and getting rid of unwanted seedlings the following year can be tedious.

These seeds contain LSA (d-lysergic acid amide), a less-potent cousin of LSD. A sufficient dose involves hundreds of mashed or ground seeds, eaten or mixed with juice. Users inevitably report nausea, as well as hallucinations and so-called "contemplative feelings." However, seeds can be coated with toxic methyl mercury, which acts as a fungicide. Only dubious cleaning methods are available. In addition, some species produce no interesting effects. Thrill-seekers may want to look elsewhere.

RIGHT Morning glory is a carefree and vigorous plant and, following pollination, the pods are usually plentiful. Between one and eight dark seeds will develop inside.

OPPOSITE As pods ripen, they turn brown and harden. They will crack open if pinched or rubbed. The seeds within are very hard, so if you intend to sow them, soak them overnight or sand or nick their surface beforehand.

FOLLOWING A fertilized morning glory flower transitioning to its pod stage has a certain animal, or rather insect-like aspect, as if it were a tiny, menacing pale green spider plotting its next move.

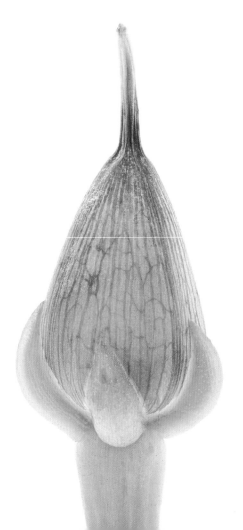

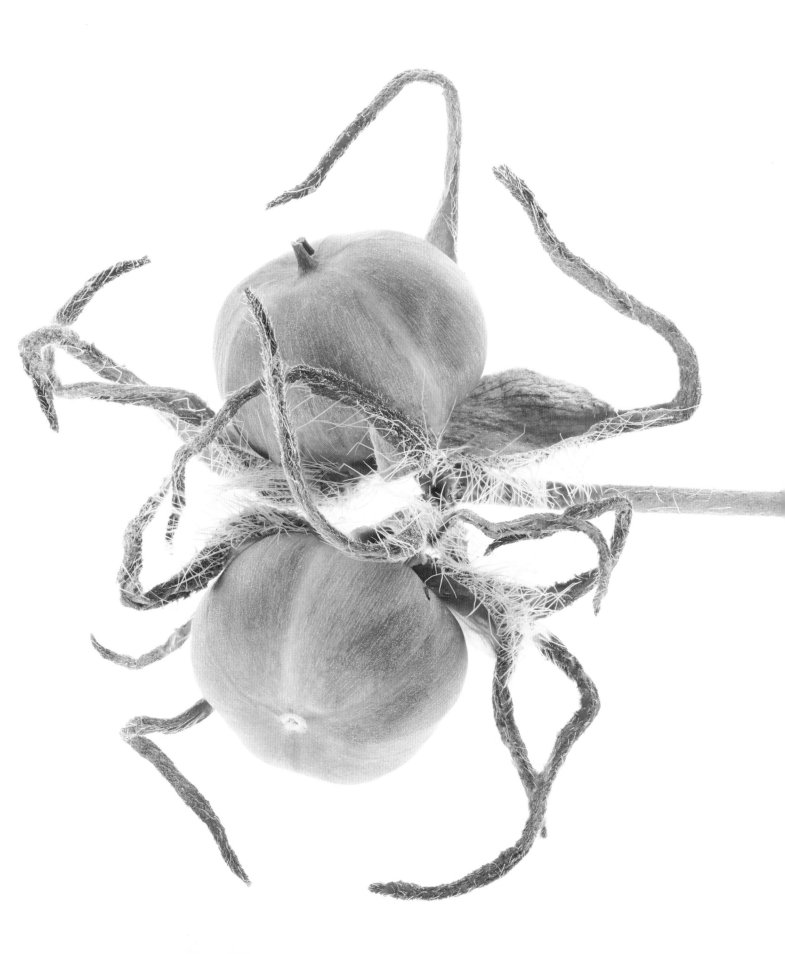

ornamental onion

Allium species

There was a time when an onion's place was in the vegetable patch. Then, thanks in large part to 'Globemaster', a blockbuster hybrid (between *Allium christophii* and *A. macleanii*) with a large purple-hued flowerhead, gardeners began to welcome so-called ornamental onions into their springtime flowerbeds. Bulbs were sold by the same places that marketed Dutch tulips and daffodils.

Other ornamental onions with pretty umbels followed. Standouts include pink *Allium unifolium*, blue *A. caeruleum*, purple *A. christophii*, and colorful mixes. Obviously the species types can and do self-sow and come true. 'Globemaster', its successor 'Purple Sensation', and more crosses may be attained only by buying named bulbs.

Vegetable garden onions, mostly variations (subspecies and groups) of *Allium cepa*, can be raised from seed, bulbs, or bulblets sold as sets. All are daylength sensitive, so you need to match your choice to your latitude in order to avoid harvesting pickling-size onions when you want nice large bulbs.

Onion seeds of all species and types are abundant and small. The tiny pods shatter easily. Harvesting them when they are dry and mature can be tricky, so some gardeners simply bend over flower stalks and use string or a rubber band to close a paper bag around them. If you are determined to be thorough, deploy some of the age-old techniques such as threshing and winnowing, gently rubbing the dry heads between your hands, or stomping on them. Always store onion seeds in a cool, dry, dark place; they are vulnerable to heat and moisture and tend to lose viability after a season or two.

The ball or pom-pom is typical of members of the onion or allium family. This is actually a flowerhead containing a great many small flowers. Not surprisingly, lots of seeds follow. The heads shatter easily when ripe, so if your goal is to collect the seeds, proceed with care. Either clip off a nearly dry one and bag it, or fold over a flowering stalk and bag it right in the garden, cinching a rubber band or string around the stem to prevent spillage.

peony

Paeonia species

The first time I saw a split-open, segmented peony seedpod, I recoiled. It doesn't take much imagination to liken one of these to a tiny multiheaded dragon fiercely clutching its magic prized seeds.

Plump and five-parted, a peony pod ripens gradually over the summer and is generally substantial enough to protect the contents from weather and nibbling insects. Once it turns dark brown and the segments start to split along their seams, you can extract its seeds. These are tan to pale white; dark coloration signals that the seed coat has become thicker and harder. Black ones may be slower to germinate.

Like other garden favorites with stout, fleshy roots, it is faster and easier to raise new peony plants via division. Undertake this project in autumn, when the plants are dormant or nearly so. Replant each new piece with several growing eyes shallowly, no deeper than 1 or 2 inches down. If they are planted too deep, they won't form flowers.

Peonies raised from seeds—planted slightly deeper, 2 to 3 inches down—take a few years to form a decent plant. If you want to control where they go, snip off the pods in autumn and tuck them in a plastic bag of slightly moist soil. Store it in the fridge over the winter. Plant these in the garden the following spring. Often they sprout a few little roots and baby leaves while still in storage.

While any herbaceous peony produces pods, the seeds are not always fertile. Those of Itoh hybrids, the classic *Paeonia* 'Coral Charm', and many tree peonies are sterile. Seeds of most others will grow, but the flowers will not be quite like their parents.

Peony blossoms are spectacular, but so are peony pods. After the petals fade and fall off, this outlandish-looking structure forms and swells. It is five-parted, as was the flower that preceded it. Many of the big, plush double-flowered ones are infertile; look for these weird pods on the older types with the lower petal counts.

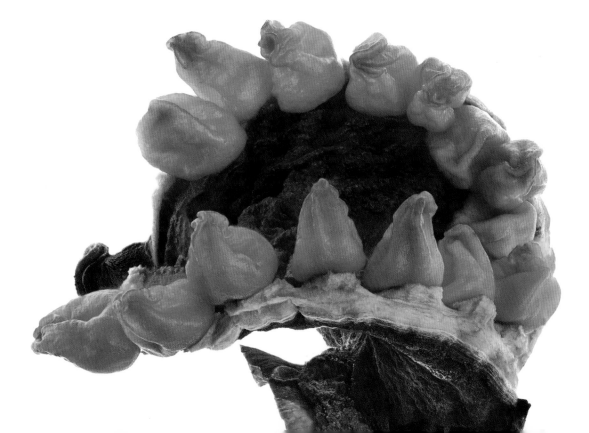

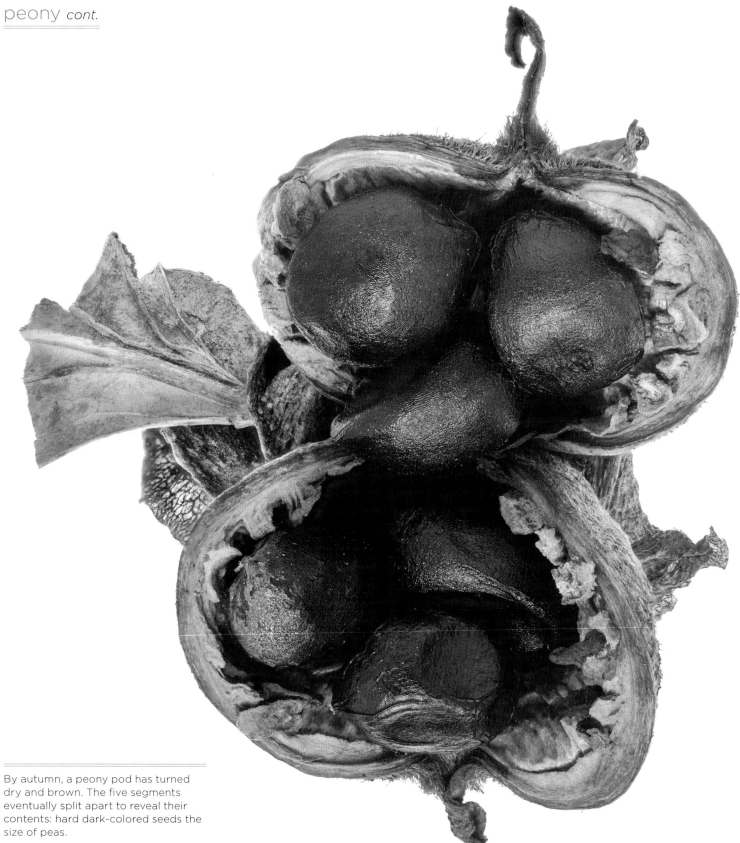

By autumn, a peony pod has turned dry and brown. The five segments eventually split apart to reveal their contents: hard dark-colored seeds the size of peas.

poppy

Papaver species

Cooks and bakers value poppy seeds for crunchy texture, a little color contrast, and subtle nutty flavor. Look very closely: They are not actually round, but shaped like kidneys. Also, they are not always black; some are dark blue, while others are brown or tan. The dark ones are widely used to adorn bagels and rolls, to enhance coleslaw and salad dressings, and to sprinkle over fish, meat, and noodle entrées.

These tiny seeds are generally healthful—low in calories and sodium and high in various beneficial nutrients (calcium and magnesium, among others). If you ingest ones from the popular opium poppy, *Papaver somniferum*, they also contain opium alkaloids. The opiates are present in trace amounts, but it is possible to fail a drug test within forty-eight hours of eating a poppy-seed bagel.

However, you're not going to get high or even experience relief from pain. Various drugs, including morphine and heroin, are derived not from poppy seeds but from the sticky sap. This latex can be gathered only from scored, immature seedpods. Those who grow poppies as a crop must choose between raising them for the latex or letting the capsules, and the seeds within, proceed to maturity.

Gardeners, on the other hand, prize *Papaver somniferum* for its gorgeous flowers. These are so big and plush they are sometimes marketed as peony-flowered poppies. Other poppies, including the famous little red Flanders, or corn poppy (*P. rhoeas*), and Shirley poppies (a cultivar), are pretty, too, although not as large or dramatic. The blooms of Oriental poppies, *P. orientale*, are certainly splashy. However, nobody harvests the seeds of any of these species for food or medicine; they lack the flavor and chemistry of their showy relative.

An unripe poppy pod is still green, with its distinctive stigmatic disk perched on top. At this stage opium poppy pods are scored and the sap or latex that dribbles out is harvested. Lest you set aside questions of legality and consider trying this at home, be aware that it takes huge quantities of poppy pods to produce an appreciable harvest. Gardeners are far better off enjoying *Papaver somniferum* for the beauty of its plush blossoms.

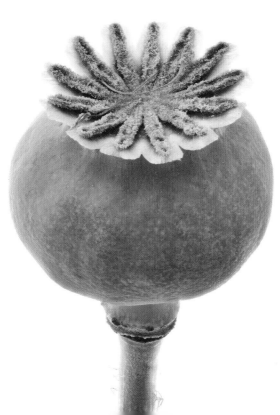

A ripe poppy pod bears close examination, for it is complex and interesting. The lid part, or operculum, shelters but does not clamp down on the dry capsule. Ripe seeds are finally able to escape via the small pores or slits; in fact, you can turn one over and shake it like a peppermill. Depending on the species, there may be upwards of 200 tiny seeds inside.

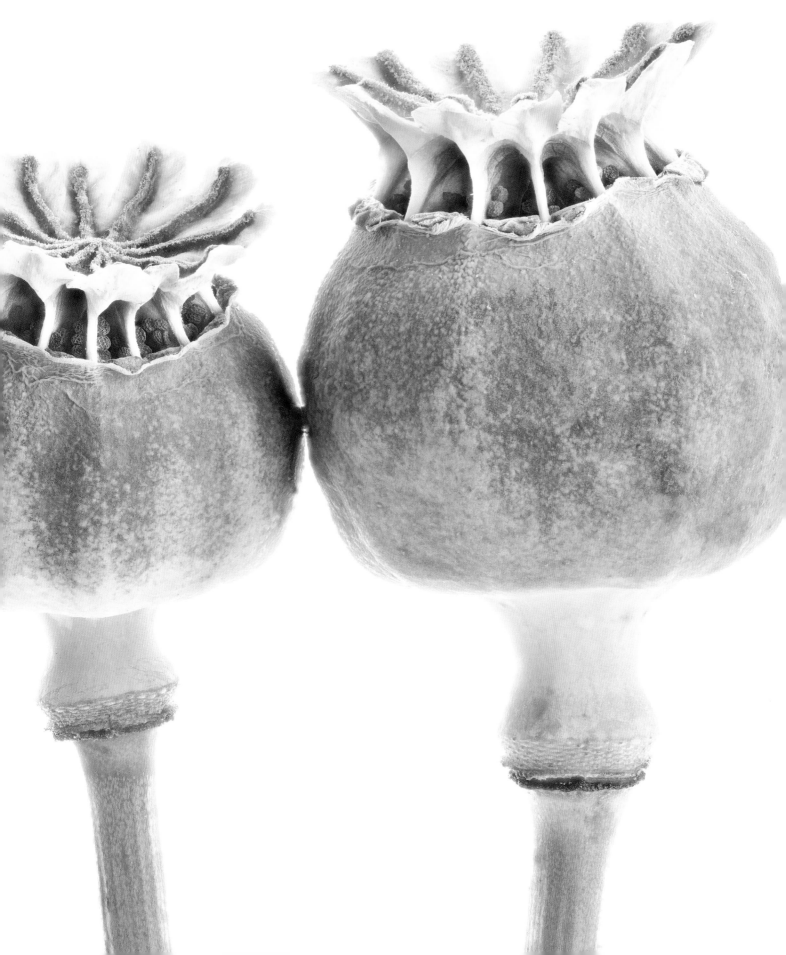

The little yellow blossom of the woodland wildflower called celandine poppy, *Stylophorum diphyllum*, gives way to a small, bristly, oblong seedpod. The genus name literally means "style-bearing," and the prominent style is a key identifying feature. Note the style's remnant at the top of the pod.

OPPOSITE Yet another variation on the poppy capsule is found on the annual corn, or Flanders, poppy, *Papaver rhoeas*. The plants self-sow in gardens and fields. The tiny seeds have been known to lay dormant for decades.

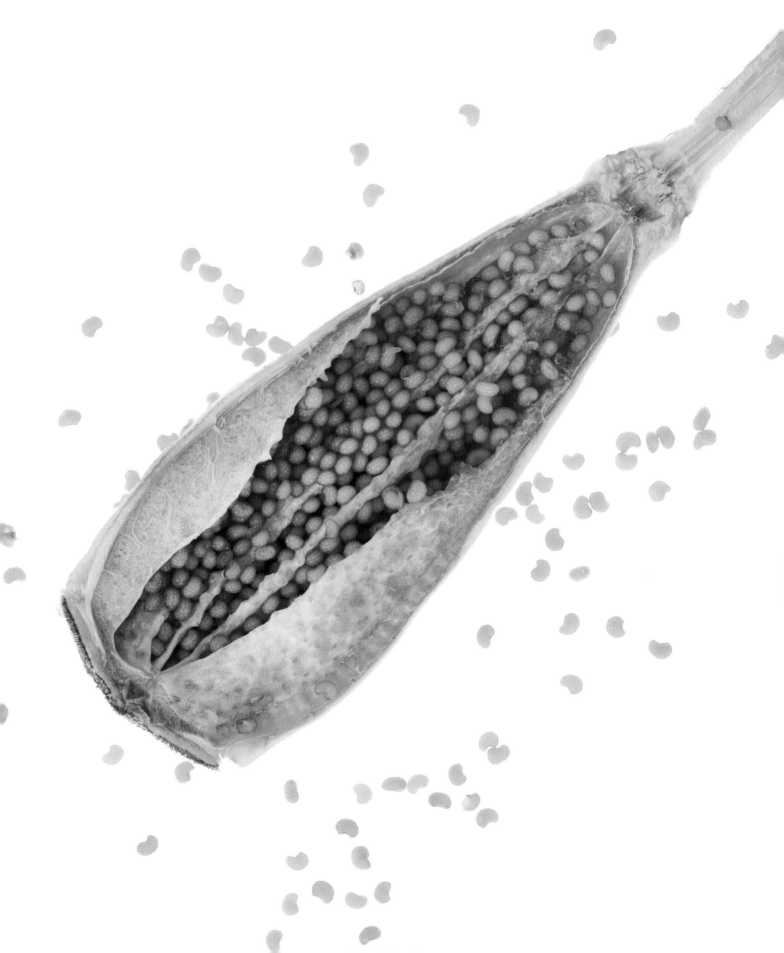

sea oats

Chasmanthium latifolium

Ornamental grasses have enjoyed a recent wave of popularity. These plants, which are largely low maintenance and attractive in all seasons, have made their way into public gardens and commercial plantings as well as curb strips, perennial borders, and even containers. Textures range from fine as feathers to coarse as corn. Planted en masse or mixed with perennials or shrubs, they are now familiar.

These are not lawn grasses. They are tufted or fountaining clump-formers that will flower and go to seed. Wild oats—aka inland sea oats, river oats, or spangle grass—is a smaller-statured grass that came into cultivation and continues to enjoy popularity. It is one of the few that does well in part or dappled shade.

Its foliage is handsome enough, emerging lustrous green with a blue-purple cast and shifting to plain green by summer, when it might remind you in size and form of a small bamboo plant. But the main appeal of this species is its loosely pendulous spikelets. These develop in midsummer, starting off green but darkening over time. A rustling breeze calls attention to their oatlike form. When backlit with a slant of late afternoon or evening light, they're just gorgeous. In autumn, after they have turned red-purple or copper, they look like licks of flame.

Unlike lawn grasses, this grass's main mode of expansion is not its roots, but the seeds. The spikelets shed like crazy and the seeds are abundant (the parts we can see are actually bracts sheltering the tiny seeds). Seedlings in ensuing years are inevitable, unless you go to the trouble to trim off the seedheads. Why not harvest them for bouquets?

The spikelets of this beautiful grass have captured the hearts of many gardeners. When they appear in the middle of summer, they are green and shimmery, earning the common name spangle grass. The tiny seeds lodged inside are not an issue until autumn, when they ripen as the spikelets turn reddish or bronze. If loads of self-sown sea oats are not what you want, either pick armloads for bouquets—they mix well with garden flowers—or mow down your patch before they mature.

spider flower

Cleome houtteana

So tall are the plants (up to 6 feet) and so big and bountiful are the whiskery flower clusters (racemes may get to be 8 inches across), that nongardeners are often astonished to learn that this plant is an annual. Even those of us who grow it every year are amazed that spider flower pulls off such a robust show from such a humble little seed.

The showy, scented flowerheads come in shades of pink, purple, and white, plus bicolors, all of which bloom continuously from June until autumn's first frosts. They have a spiderlike form with protruding stamens that attract bees, butterflies, hummingbirds, hummingbird moths, and other pollinators. The palmate leaves have a sticky texture. Where a stalk meets a stem, there is a small, sharp spine, which might also account for the common name.

Flowers are followed by long, very skinny pods that eventually split open and distribute their bounty all over your garden. Remember that offspring of hybrids will not necessarily resemble their parents from the previous year. The fruit capsules, which are siliques, originally caused botanists to group this species with the cabbage family (Brassicaceae). Later, based on DNA analysis, it was moved to the caper family (Capparidaceae). Nowadays it seems to have its very own family, Cleomaceae. In any event, they open via two valves (which arose from flower carpels) and release dozens of seeds. Seeds rot easily in storage, so make sure they dry out thoroughly first. When planting, press them gently into the soil surface, as they need light to germinate. Notice how they are shaped like tiny textured snails, which may be an adaptation to increase their surface area.

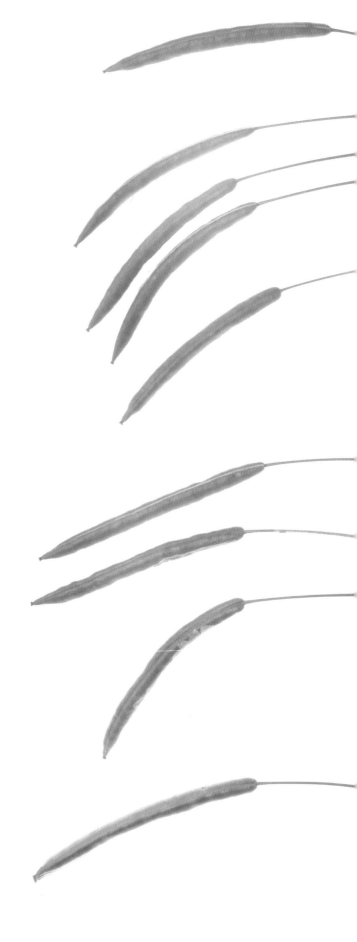

On the plant, spider flower pods, actually siliques, are picturesque and distinctive. Derived from the flower carpels, they are especially long and slender, with seams along their skinny lengths.

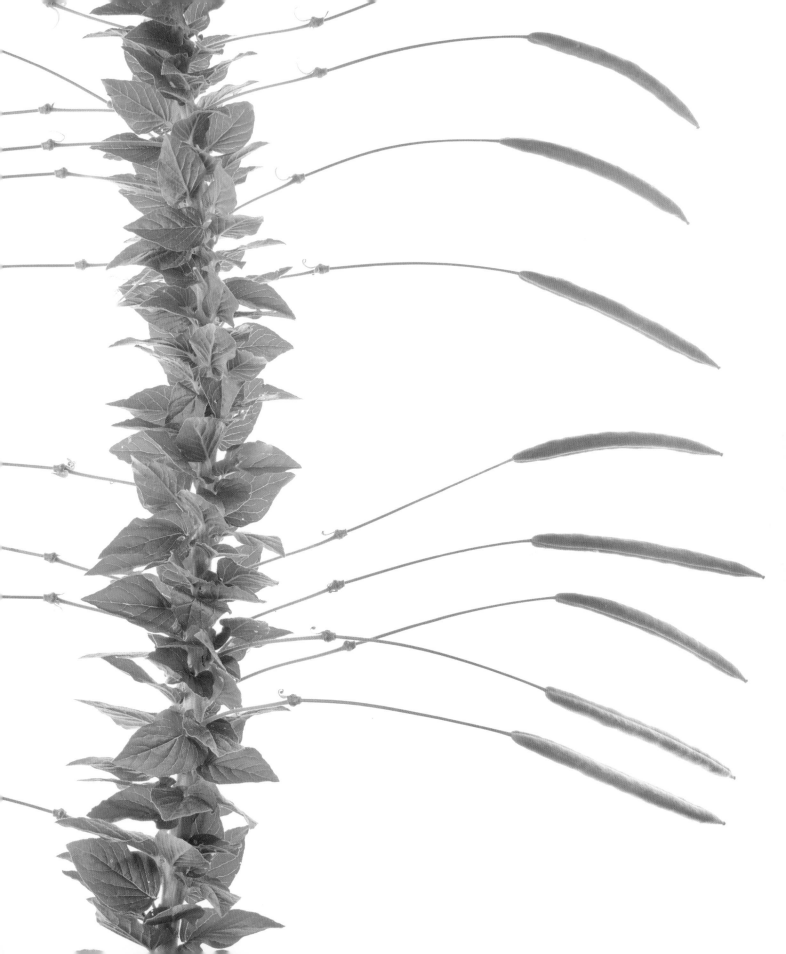

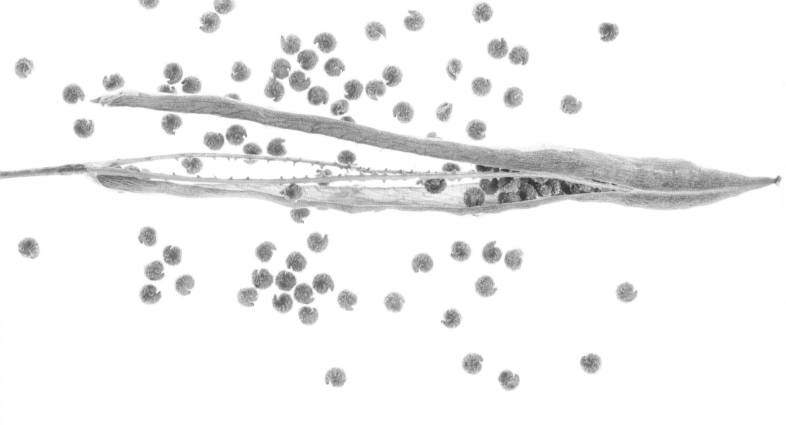

If you peer into the siliques once they are brown and dry, you'll observe a bounty of tiny textured seeds. Their rough surface is thought to help them adhere to the soil once they are shed. The interesting snail-like shape may also play a role in helping the seed gain purchase in hospitable soil. Just remember that many favorite varieties are hybrids, so seedlings won't look just like their parent plants.

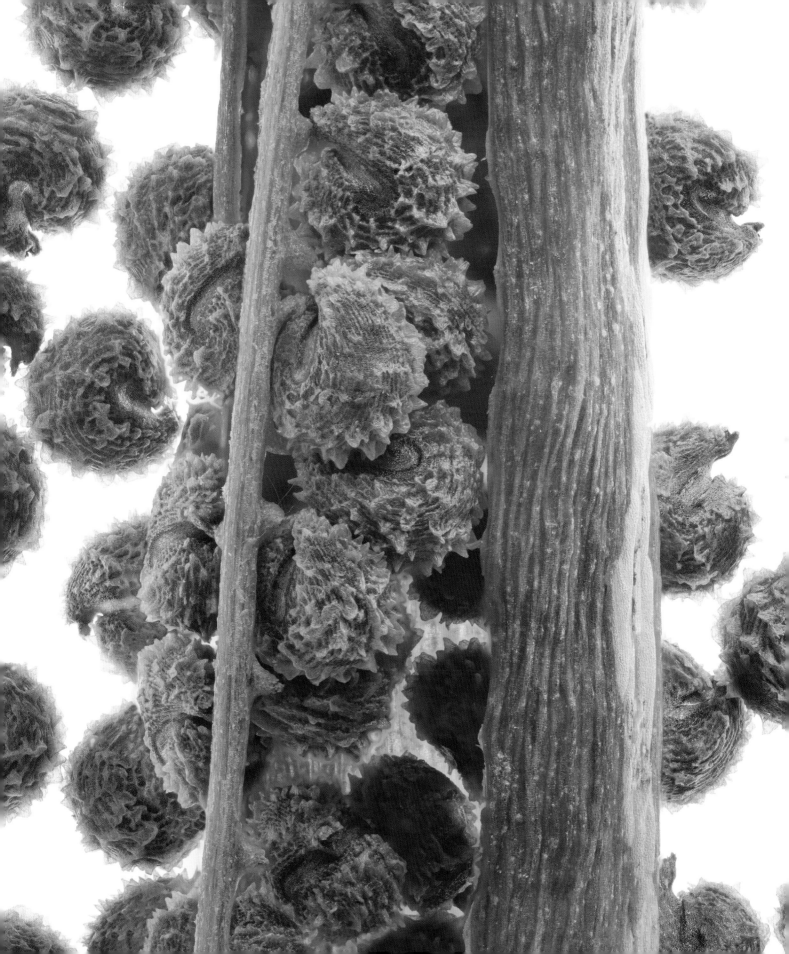

sunflower

Helianthus annuus

Sunflower seeds remind me of baseball games. Pouring a few out of a small bag, breaking each one apart in my teeth, spitting out the hull, and eating the tasty small kernel within— it's a summertime treat. Some stadiums are littered with soggy hulls after a game. I remember, during a slow inning at Fenway Park, commentators and camera following an epic hull-spitting contest going on in the Red Sox bullpen. Tim Wakefield was masterful.

Humans prefer the tough-shelled striped or gray ones, which snack companies douse in salt. Birds prefer the easier-to-crack, thin-shelled black oil ones, which are meatier and provide more nutrition and calories. These are a sure method for luring birds, especially finches and cardinals. Squirrels tend to follow. You'll see lots of activity, and husks will pile up on the ground below a bird feeder.

Do not overfill your feeders, or seeds may spoil. Clean up the hulls regularly. They may attract animals and birds, and they contain a chemical that retards the growth of other plants. If you grow your own, be aware that the roots also exude allelopathic chemicals. Bear this in mind when planting or allowing self-sown volunteers.

Gardeners and farmers grow two basic kinds of sunflowers: the types that produce edible seeds and the seedless hybrids developed for flower arrangements. If you grow a seed type and want a harvest, net or bag the flowerheads early to thwart birds. Seed savers also isolate nonhybrid types from other stands by at least 1000 feet to prevent cross-pollination as bees and other insects browse the pollen.

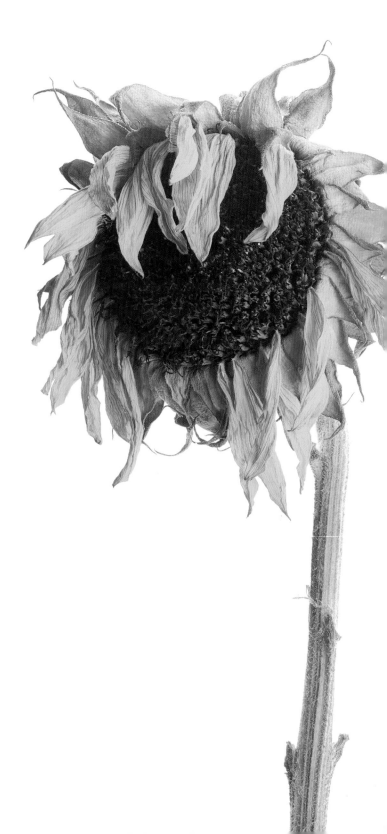

A ripening sunflower seedhead, it has long been noted, is compact, neat, and uniformly packed—no bald spots, no stacked-up areas. Someone clever went a step further and confirmed that the spirals correspond to Fibonacci numbers. This works for a sunflower because new seeds are added from the center, pushing those at the edges outward. Following the Fibonacci sequence allows growth in this fashion indefinitely.

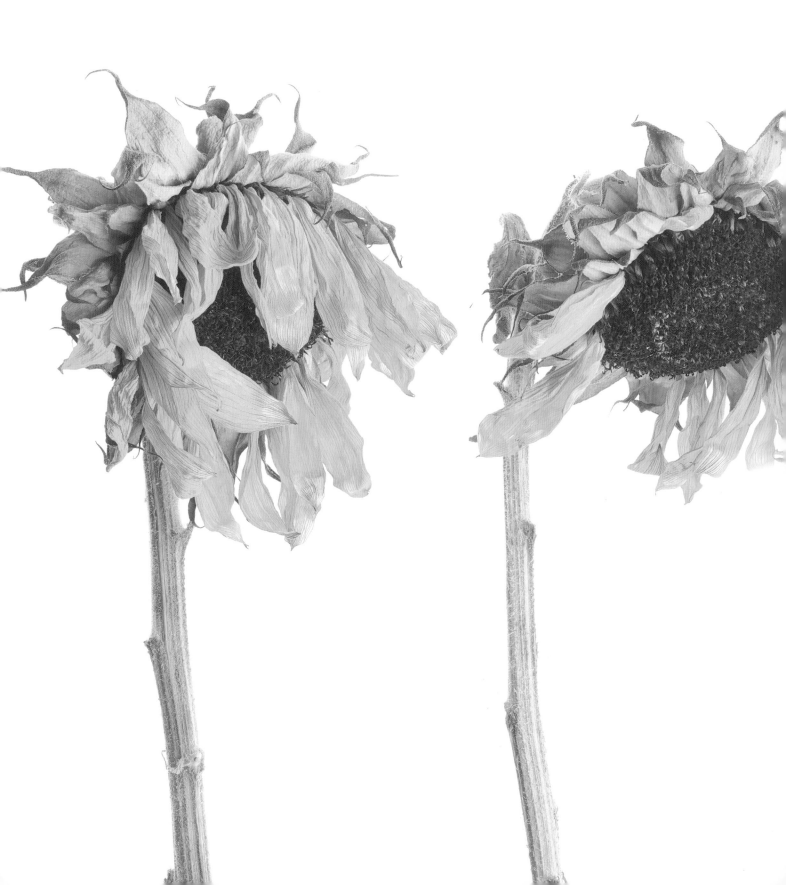

yucca

Yucca filamentosa

This plant earns its common name from the sharp-edged, spear-shaped foliage that has occasional curly threads along its margins. It is handsome for its foliage alone. Some cultivated varieties have striped or colorful blades.

Yuccas also develop flower stalks, which arise from the center and have nodding creamy white bells. These may be followed by large green seedpods. By the time those form, however, nobody may notice. The plant commands attention best when in full bloom.

Butterflies and other insects visit, but evidently the only successful pollinator is the co-evolved yucca moth. It lays eggs in the flower ovary, packing them into place with pollen. Seeds develop, but so do larvae, which eat some seeds. In other words, yucca is simultaneously pollinated and parasitized by these specialized moths. It has made, shall we say, an uneasy bargain. Researchers have discovered that if the larvae are too numerous or are greedy eaters, the plant jettisons those fruits. Intact seeds must survive.

A yucca pod is a stout, elliptical capsule, 2 to 3 inches long. It matures from green to brown and splits open to reveal light to medium brown seeds. Husks or bits persist on the plant well after the flower stalk has dried. The seeds fall to the ground and either germinate in the neighborhood or, with luck, get moved along to a new, suitable spot. More often, however, yuccas generate new plants via suckers or offsets (aka pups).

Yucca plants are also monocarpic, which means they are depleted after producing viable seed. The flowering stalk, with its attached seedpod remnants, withers away, as does basal foliage on the main rosette. If your garden yucca has not done this and has been around for many years, you can conclude that it has never been successfully pollinated.

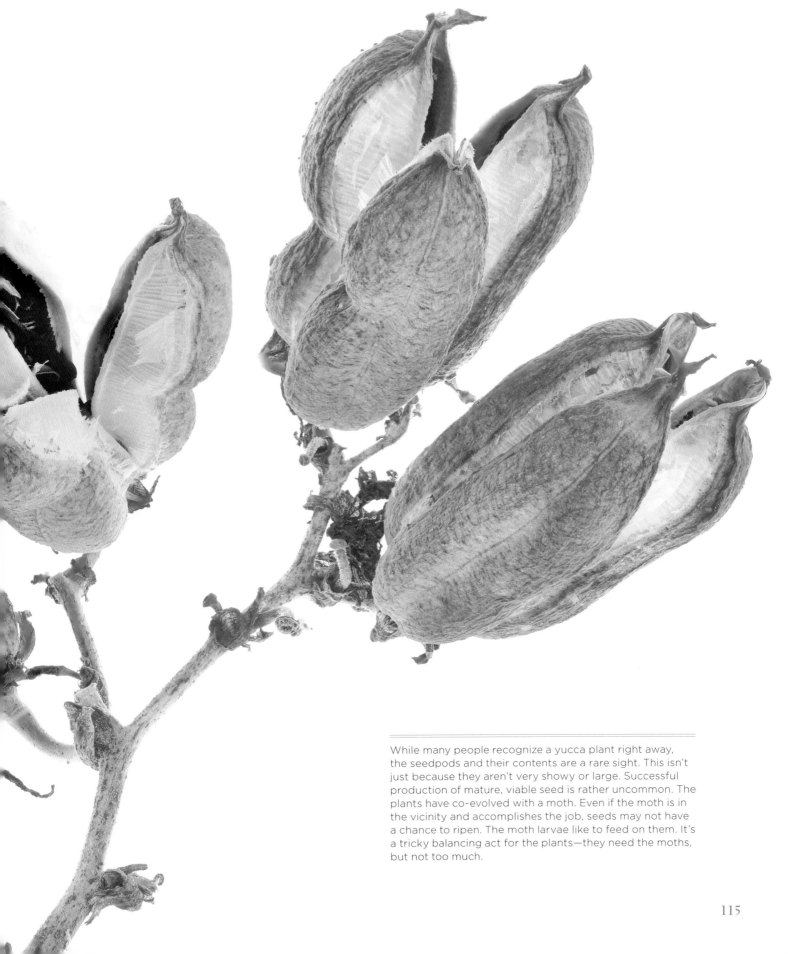

While many people recognize a yucca plant right away, the seedpods and their contents are a rare sight. This isn't just because they aren't very showy or large. Successful production of mature, viable seed is rather uncommon. The plants have co-evolved with a moth. Even if the moth is in the vicinity and accomplishes the job, seeds may not have a chance to ripen. The moth larvae like to feed on them. It's a tricky balancing act for the plants—they need the moths, but not too much.

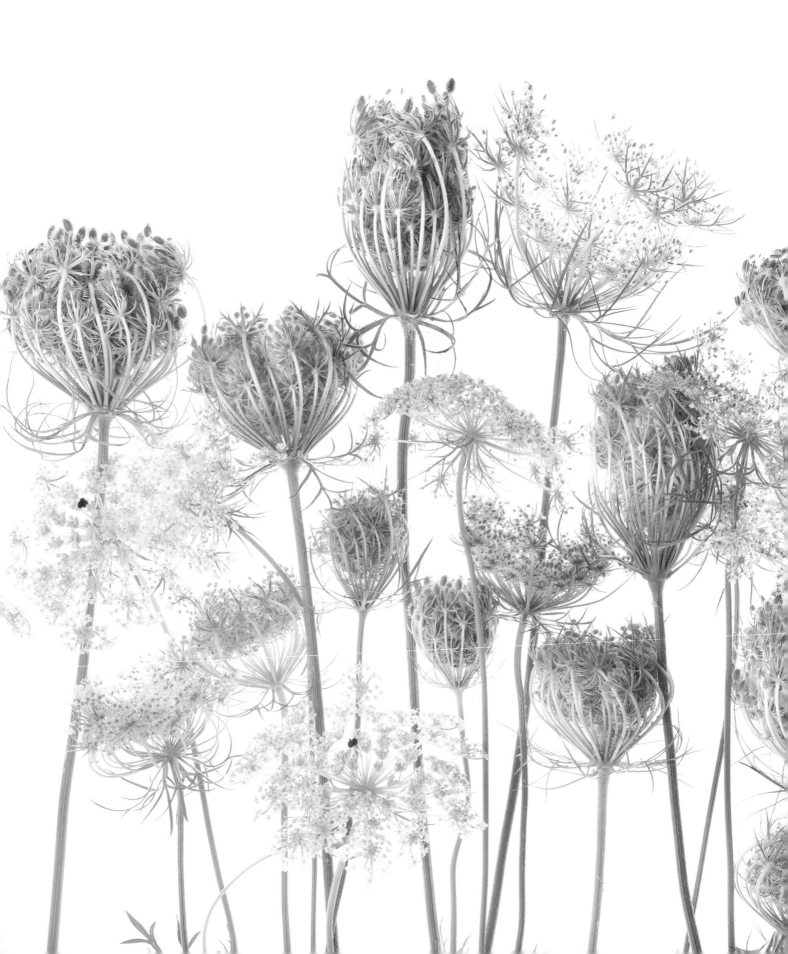

WEEDS AND WILDFLOWERS

WEEDS AND WILDFLOWERS have important roles that are not always obvious in the human-dominated world. Bees and other insects need their nectar or pollen to survive. Birds, insects, and even mammals gain nutrition and energy from eating their seeds, their foliage, or the entire plant. Many provide food for wildlife in more than one season.

When weeds and wildflowers spread, as they so often do, they may enhance or sustain an ecosystem. Some creatures rely on them for shelter as much as food. Stands or larger patches provide places to hide, nest, or protect young ones while they are still small and vulnerable. Also, as such plants stake out their territory, sometimes they prevent erosion or keep other plants out either by their physical presence, allelopathy, or both.

Last but not least, as environmental activist Vandana Shiva reminds us, many uncultivated plants are medicine or food for rural people. This is true not only in her native India, but worldwide.

We don't usually witness or know how wild plants reproduce and contribute. Investigating their seeds with more care and curiosity helps us appreciate some of the unseen forces and interconnections at work.

In any troupe of Queen Anne's lace, you'll find various stages, from just-open to going to seed. The matured seedhead phase is aptly called bird's nest.

arum

Arum and *Arisaema* species

There's something furtive and spooky about the arums, whether the garden novelty lords and ladies, *Arum maculatum*, or the woodland wildflower Jack-in-the-pulpit, *Arisaema triphyllum*. The flowers, with their unique spathe-and-spadix form, are not pretty by any traditional definition. The spathe is like a cloak, a leafy outer covering sheltering or hiding the spadix within. The spadix is a fleshy stem studded with numerous small flowers. Pollinators have to work their way in, coaxed more by scent than color or petal markings. When the pollinator is a fly, count on the enticing fragrance to be unpleasant. Skunk cabbage, *Symplocarpus foetidus*, is a relative.

These plants have both male and female flowers on their spadix, which develop at different rates. Female parts tend to ripen first, with the pollen-producing male parts maturing later. This makes self-pollination unlikely, but pollinators can and do move pollen from one plant to another within a patch.

Once pollination succeeds, the spathe shrivels away. On the spadix, a plump green compound fruit forms. As it ripens, it turns color—orange to red or blue to purple, depending on the species. Each fleshy berry harbors one to six small white seeds. Avid wildflower gardeners report that it is not difficult to remove the outer covering and pulp, but skin irritation can result, as deadly calcium oxalate crystals are lodged in all plant parts. The plant wants to protect itself, including its seeds, from predation.

Up to six months can elapse between flowers and mature fruit. Seeds then need winter or a couple of months in cold storage before they can be sown. While they will germinate within two weeks the following spring, baby plants grow slowly and take several years to reach blooming size.

RIGHT A clutch of darkening berries adorns the spadix of an arisaema. Inside each you will find one to eight small seeds. At least some of these will eventually germinate in the wild or, with patience and a sufficient cold period, in the care of a patient gardener. Nobody ever accused these plants of spreading quickly and rampantly.

OPPOSITE The fruit-studded spadix of an arum plant represents quite an achievement. A pollinator had to get past the protective cupped or cloaklike covering of the spadix (now faded away), then transfer male pollen to female parts. Self-pollination is unusual because female parts are generally receptive before the male pollen is ready. But if the visiting insect gets the job done, these fleshy berries will follow. Small white seeds are inside. Maturity is indicated by a darker berry color—in this case, orange.

FOLLOWING The urge to let go, in arums and many other wildflowers, comes when the seed-studded stalk dries out.

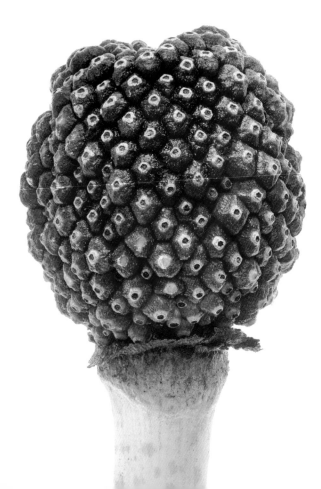

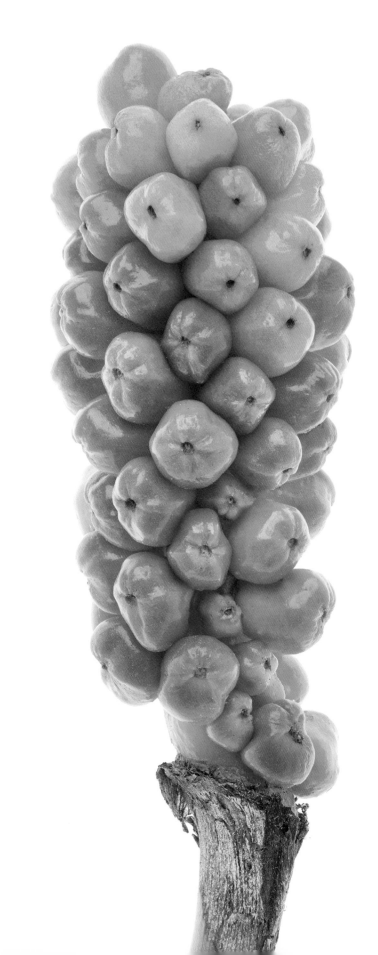

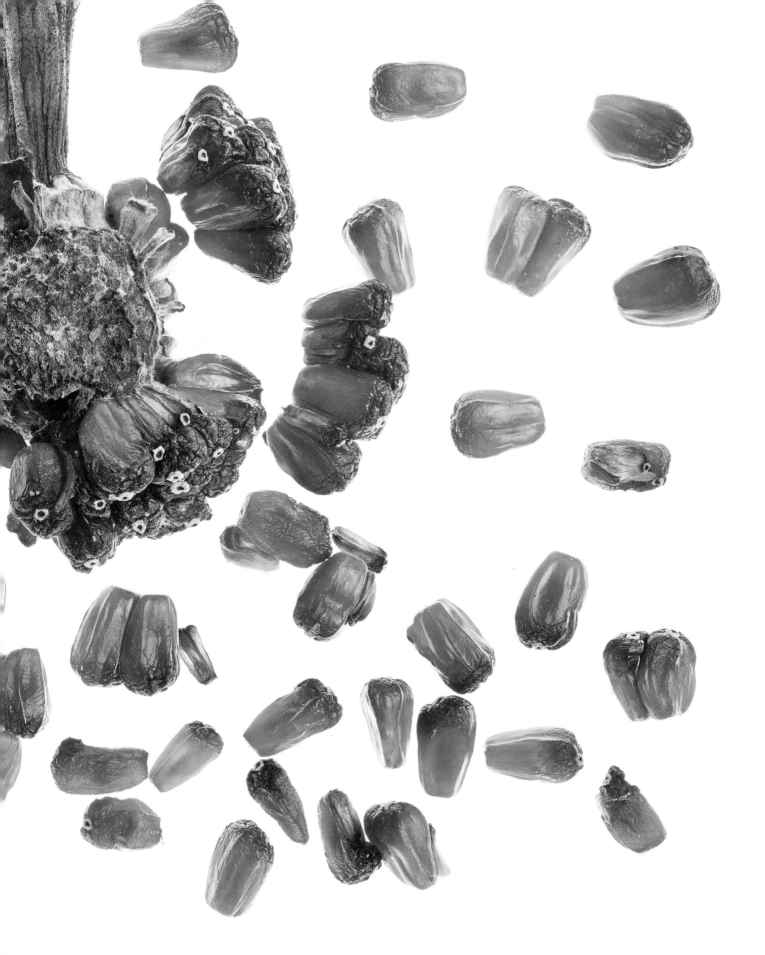

beebalm

Monarda didyma

In midsummer prime, beebalm flowers are a burst of exuberant color. They are often bright red, but there are also some splendid hybrids in pink, salmon, violet, wine purple, and even white. All hold up well. Hummingbirds adore them, as do bees and hummingbird moths. Meanwhile, if mildew doesn't encroach, the foliage is lush, lightly aromatic, and light green (this species is in the mint family, Lamiaceae). But as summer progresses and the soil dries out, the show falters. What was once hearty and vivacious begins to look raggedy and tired.

The flowers are actually clusters backed by whorl of bracts. If you look closely, you'll see that the classic mint-family flower form is present. Individual tubular flowers are two-lipped, with protruding stamens. When a flowerhead goes to seed, the transformation is intriguing. The colorful corollas fade and fall. The round head then swells a bit and darkens.

Tightly packed calyces remain. Seeds are inside, and they are quite small—less than 2 mm across. Each calyx holds one to four seeds, which begin green and eventually turn dark brown. Not all of them mature, even under what appear to be good conditions. A stiff breeze or a gardener's hand can dislodge ripe ones.

Gardeners and horticulturists have noticed, to their chagrin, that beebalms are promiscuous flowers. The many and busy pollinators create lots of crosses, so there is no guarantee that either volunteer seedlings or plants raised from collected seed will look anything like their parent plant. Also, seed-raised plants grow slowly; it will be at least two or three seasons before they get their feet under them. To get exactly the flowerhead color you want, seek out plants raised by division, or divide your own favorite plants once they are established.

Beebalm blooms are actually dense clusters of the classic mint-family two-lipped flowers. When those bits fade and drop, what's left are the calyces, now brown, dry, and darkening. Meanwhile, the rounded shape not only persists but also swells. Teeny-tiny seeds are out of view inside.

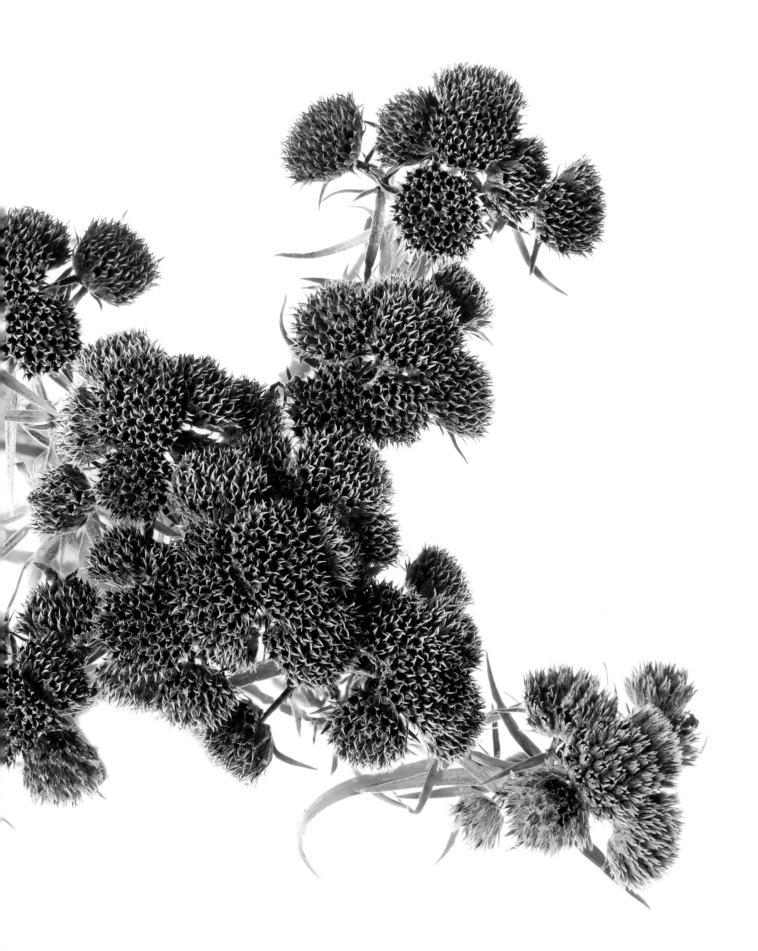

black-eyed Susan
Rudbeckia species

Among daisy-family (Asteraceae) flowers, black-eyed Susan has wide appeal. From a gardener's point of view, it's a low-maintenance plant that generates lots of bright flowers starting in midsummer, and it doesn't require staking. It's also the parent of some superb cultivated varieties, notably the award-winning *Rudbeckia fulgida* var. *sullivantii* 'Goldsturm'.

From a nature-lover's vantage point, the genus offers diversity. There are annual, short-lived perennial, and biennial species, adapted to everything from damp areas to dry ground. And from a wildlife point of view, black-eyed Susan pollen is a boon for native bees and butterflies, and its seeds nourish songbirds, especially goldfinches.

Like all daisies, it has composite blooms. The golden petals are ray flowers, and the brown cone in the middle is composed of numerous disk flowers. Like sunflowers and unlike daisies, however, black-eyed Susan's ray flowers are sterile; that is, neither male nor female. Their function is merely decorative, and passing insects may land on them before visiting the flower's center. The cone, meanwhile, has both. It's easy to see which ones are male because the yellow pollen stands out against the dark cone. A thin ring of yellow appears to advance toward the middle over successive days as concentric rings of the mini flowers mature.

Tiny seeds are contained one to a small dry fruit or nutlet that lacks the bristles or fluff (pappus) that this plant's relatives often develop. These cling tightly on the cone until it ripens, at which time the dark color fades to gray and they loosen their tenacious grip. Then the entire structure shatters when someone or something brushes against it or a stiff wind blows. Individual seeds sport four longitudinal ridges, which helps secure them in hospitable ground.

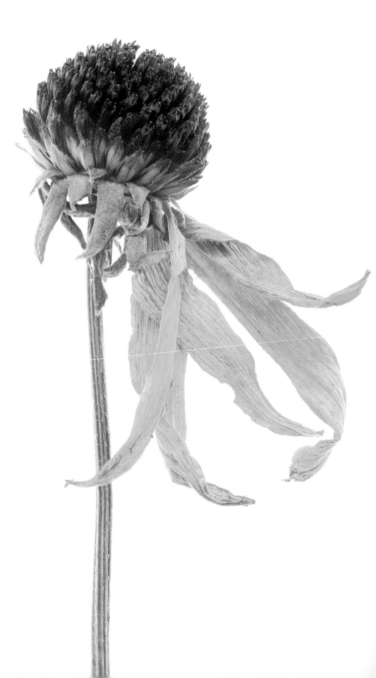

Like all members of the daisy family, black-eyed Susan goes to seed in a flurry of achenes. The center cone of the original flower is made up of many individual flowers, and each one, assuming pollination is completed, develops a single seed. When ripe and ready, they disperse on the wind or at the touch or brush of someone or something passing by.

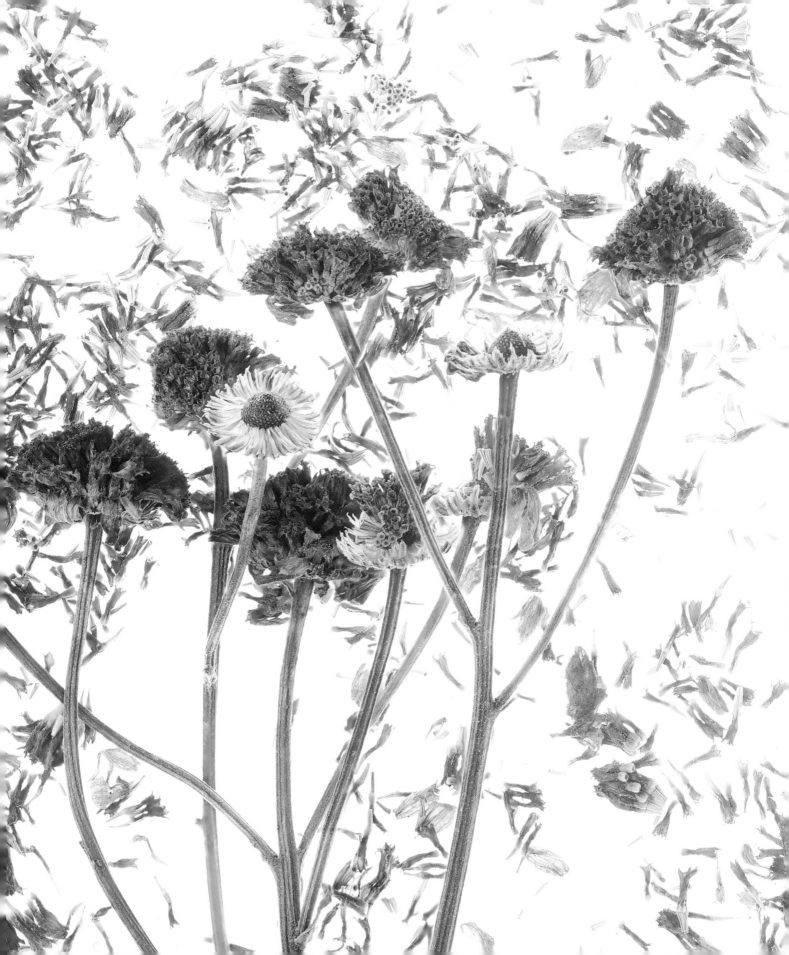

butterfly weed
Asclepias tuberosa

At the height of summer, clusters of brilliant orange flowers in umbels grab the attention of humans and, especially, butterflies. Clumps are common in prairie areas, on roadsides, and around old farmlands. The blooms are so sensational and the plants are so tough that long ago horticulturists took notice. Gardeners can now enjoy the aptly named 'Hello Yellow' and vivacious red-and-yellow 'Gay Butterflies'. There are also numerous related species and locally adapted ones, so do careful research to determine which one you will grow in your location.

This wildflower's plentiful sweet nectar is a magnet not just for butterflies, but also for bees and hummingbirds. This is a host plant for the larvae of monarchs, which makes it a key player in butterfly gardens, especially as habitat destruction, disease, and climate change threaten their survival. The leaves are rather coarse, so caterpillars prefer to dine on the flowers.

Butterfly weed's glorious blossoms are followed by skinny, spindle-shaped green seedpods (follicles) laden with little parachutes—dark brown seeds attached to silky down. At this point, it's easy to see that this species is a close cousin of milkweed.

There are differences between the two aside from the more brightly colored flowers. Butterfly weed's sap is not milky or irritating, the leaves are not opposite, and the long, brittle roots have traditional uses. Native peoples and herbalists have used extracts and powder to treat lung ailments; an alternate common name for this plant is pleurisy root.

Start with small plants and be patient with seeds, which can take several seasons to establish. The taproots break easily and resent disturbance. Choose a spot where they can stay and prosper.

The canoe-shaped tan seedpods of butterfly weed look a lot like those of milkweed because they are close relatives in the same genus. Tucked inside are loads of seeds, each one attached to a piece of fluff that will make it airborne at the first opportunity. If you want to collect the seeds for planting, make your move just as the pod begins to split open.

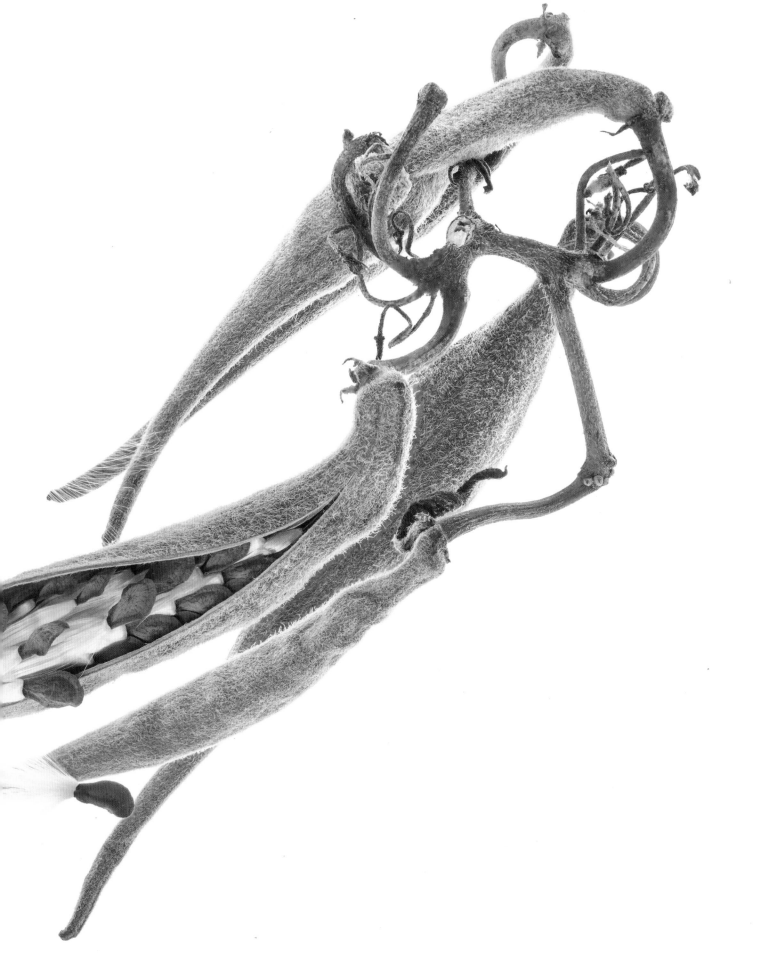

Canada thistle

Cirsium arvense

Urban and suburban dwellers may have a passing acquaintance with this weed from seeing it in abandoned lots or along roadsides. Canada thistle's tenacity is obvious, but its numbers don't overwhelm when opportunities are limited. Where there is plentiful open space, however, it forms sprawling colonies. Most farmers and orchardists hate it.

This thistle is a prickly beast. Its grooved, erect stems are burly. Its foliage is coarse and spiny. Its summerlong red-purple flowerheads are not big or showy enough to be called pretty. Its root systems are tenacious and can extend 3 feet down. It laughs at herbicides, mowers, and tillers, and can generate new plants from root fragments. Plus, it's perennial, whereas most thistles are biennial.

Canada thistle produces prodigious amounts of seeds. A single plant has been known to generate upward of 1500 achenes. These are small, flat brown fruits with one seed inside and a plumed filament (pappus) to send it on its way on the slightest breeze. Not every single plant has this amazing output. Thistle is dioecious—male and female flowers are on separate plants—and seeds form on the females. The bristly female pappus individually is longer than the petals. (Those on male plants are shorter than the petals.)

Goldfinches like this plant. They nest later than many other birds, and thistles fill two needs: the seeds provide nutritious food, and the fluff is good for making nests. Painted lady butterflies also favor it, both as adults feeding on nectar and as shelter and sustenance for their caterpillars.

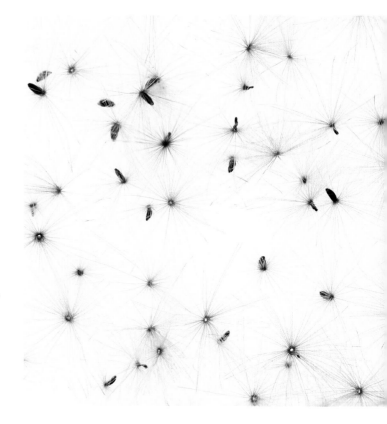

While you may be familiar with Canada thistle, did you know it has separate male and female plants? Both produce flowers, but only the female ones produce seeds. Pollination is rarely a problem because most patches contain plenty of both sexes and they attract all sorts of insects. Seed production is prolific, to say the least. Notice how the plumed filaments are attached to each little seed at all angles, so they tumble and toss easily if randomly.

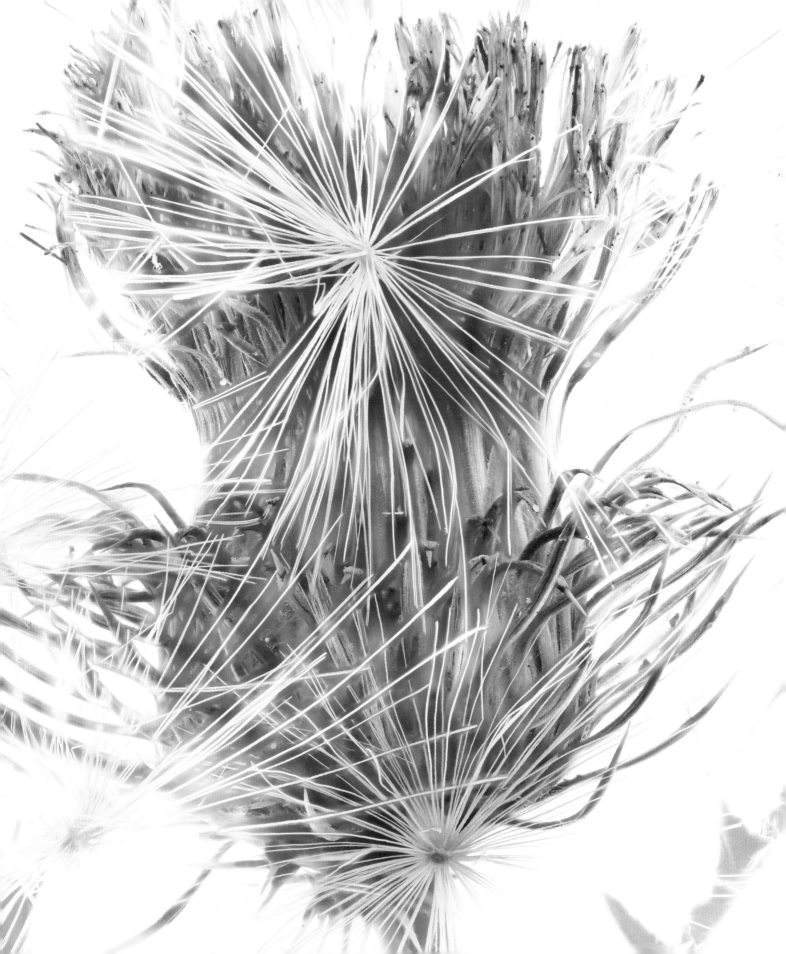

cattail

Typha latifolia

Cattails are perhaps the most iconic pond or wetland plant. Referring to their value to wildlife as well as humans, outdoorsman Euell Gibbons famously called them "the supermarket of the swamp." In North America, Europe, and Asia, indigenous peoples have used all parts of the plant. The starchy roots and shoots, as well as stem portions, can be cooked and eaten. The leaves may be woven into baskets, furniture, and other items. Even the protein-rich yellow pollen can be collected and used like flour. The soft cottony material that fills the heads—or should we say tails?—may be used to stuff mattresses, for insulation, and in rafts.

Cattail spikes are not as simple as they might appear. In most species, male and female flowers reside on the same tail. Smaller male ones are above, and female ones are below as the dominant, or sausage, part. Wind or gravity wafts the pollen downward. But because the female ones develop first, cross-pollination is more common than self-pollination.

When fertilization succeeds, each tiny female flower transitions to a single-seeded nutlike achene with slender silky hairs at the base to aid travel by wind or water. Seeds are a mere .2 to 1.5 mm long. A single cattail spike is capable of producing thousands of seeds. Sometimes they remain on the plant through autumn and winter and disperse the following spring. Seeds can also survive buried in soil or mud for many years, and then germinate when the opportunity arises.

Of course, cattails also expand their numbers via creeping rhizomes. But that makes for homogenous cloned stands or colonies. Cattail seeds keep populations genetically diverse and allow for variations, hybrids, and environmental adaptations.

Pry open a cattail plant's sausage-shaped brown tail, and what do you find? More seeds than you could ever count. Actually, each one is a tiny, nutlike fruit with one seed inside, attached to slim silky white fluff. If all of these released, drifted away, and germinated, there would be a population explosion. The plants themselves, however, regulate dispersal, sometimes hanging on to their bounty over the winter or longer; seeds can also lay dormant for years.

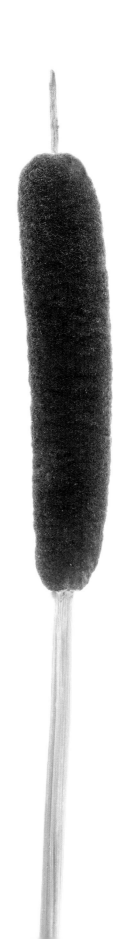

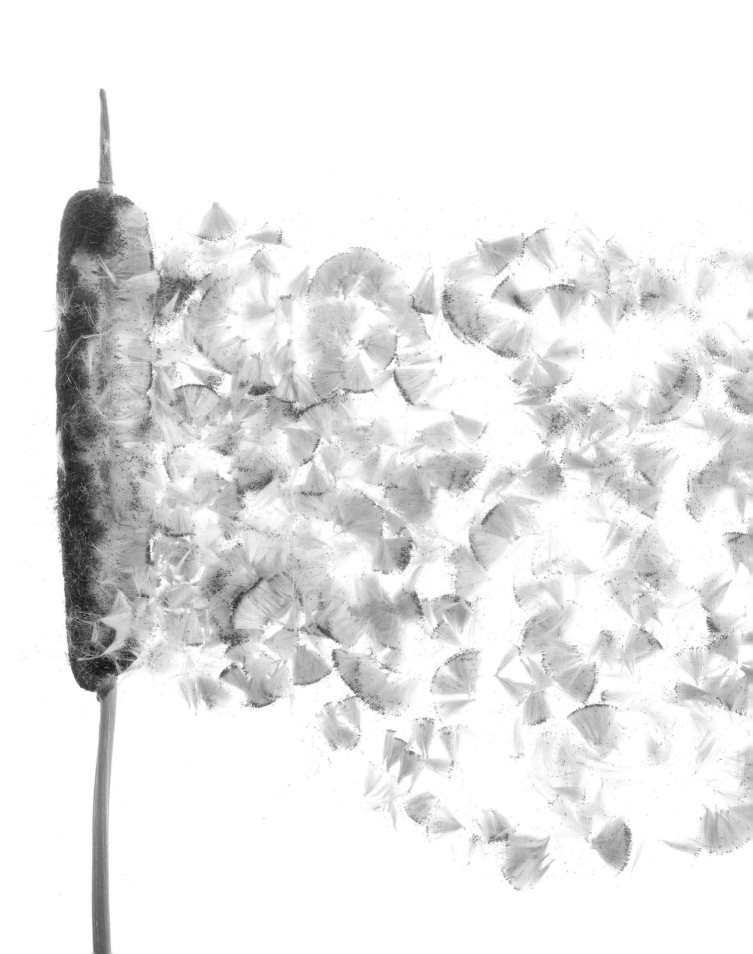

columbine

Aquilegia species

Summer finds cute five-part columbine flowers fading away and foliage taking the stage. With wild species as well as huskier garden hybrids, the leaves frequently become marred by the wandering marks of tiny nibbling leaf miners. If the sight offends you, trim the plants back. The seed capsules persist, and they are attractive in their own right. I leave them.

Columbine flowers nod downward, and nectar resides in those long spurs. Pollinating hummingbirds can reach up and in with their long tongues. Interestingly, columbines may also be visited by bees, which sometimes cheat by poking a hole in a spur's end. After the petals fall, the structure tilts to an upright position. The green fruit is made up of five fused tubes, each tipped with a curled filament. The itsy-bitsy seeds are inside.

If you let your columbines go to seed, like I do, their follicles eventually dry and crack open, scattering seeds. Some may sprout near the parent plant, while others end up all over the garden. Columbine seeds are so small and lightweight that a good breeze will send them on their way. I started with a big-flowered blue-and-white hybrid columbine, so I pluck out young plants that are not that color. (Seeds generated by hybrids, remember, are by definition variable and are unlikely to resemble their parents.)

If you prefer to be more systematic, clip off seed capsules just as they start to dry, bag them, and set them in a warm, dry spot for a few days. Viable black seeds will end up at the bottom. Sow where you want more columbines, or give them a monthlong cold period before sowing in flats. They need light to germinate, so don't cover them over.

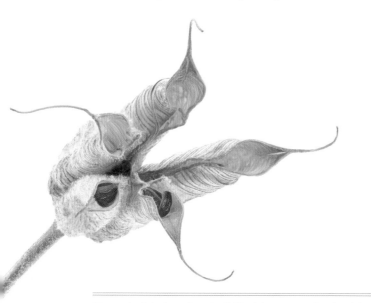

The colorful, dangling, bell-like blossoms of columbines are in five parts, so their seedpods are five-parted. The pods, if you watch, also orient themselves upright. Given the fact that ripening seeds (however small) swell and gain weight, it's believed that this move is meant to prevent the pods from spilling the seeds before they're ready.

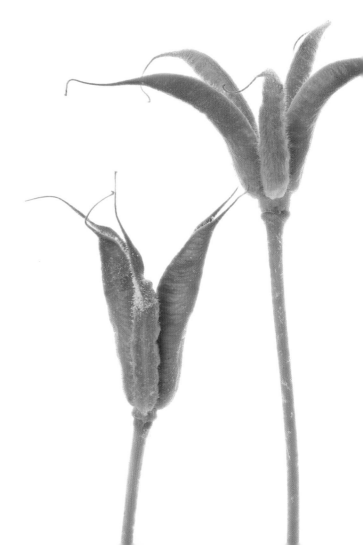

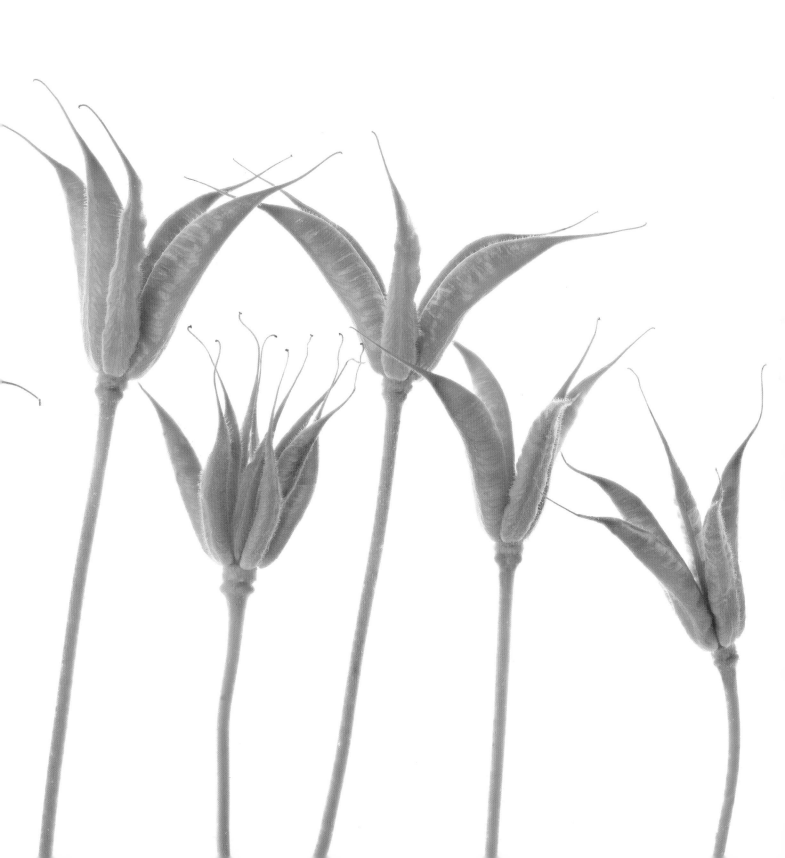

dandelion

Taraxacum officinale

Dandelions are surprisingly quirky. Like other members of the daisy family (Asteraceae), the yellow petals are ray flowers (there are no disk flowers). Each has both male and female parts. An individual flower unfurls, and the male parts in the form of a fused tube elongate; the female part is sheltered inside. (Male) pollen gets shed, then (female) parts start to grow and push it up and out. The female parts poke up above the end of the male tube, resembling a tiny Y. These soon coil back like curlicues. All this leads to seeds, right? Wrong.

Neither this activity nor browsing bees lead to pollination or seeds. Dandelion seeds grow directly from ovules, a process botanists call *apomixis*. Genetically, the resulting seedlings are identical to the parent plant. This does not mean all dandelions everywhere are clones. There are occasional exceptions to ensure some diversity.

Even if a flowerhead never opens or opens only partially, seeds form. Once the seeds are under way, the stem elongates, providing a helpful boost into the prevailing breezes. You have almost certainly witnessed this.

Why does a dandelion waste nectar and pollen on bees with no benefit to itself? No one knows. Some botanists theorize that we are observing a flower in evolutionary transition away from sexual reproduction. Also, dandelions and honeybees are of (mostly) European origin. Honeybees browse at lower temperatures than many native pollinators. Early blooming dandelions help sustain them.

You may also observe that a dandelion seed has a stalk connecting it to the filaments that help it float. This makes it more aerodynamic. The dangling seed has tiny barbs along it that point backward. These help a seed screw down into the soil where it lands.

Every seed of a dandelion has its own stalk and fluffy parachute. The achenes of many related plants lack this long stalk, which gives the seeds an additional boost for covering longer distances. Once released, the weight of the seed will keep this wind traveler pointed downward—just as the weight of the person under a parachute keeps him or her beneath it.

FOLLOWING A close-up of dandelion filaments shows how numerous they are.

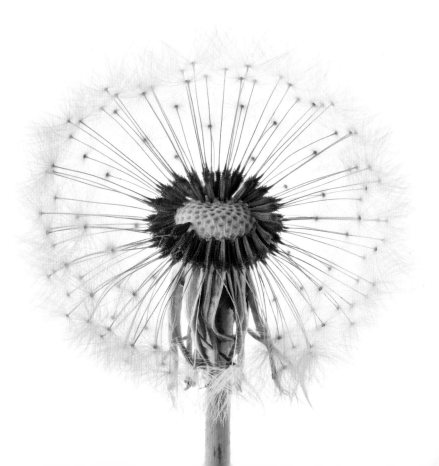

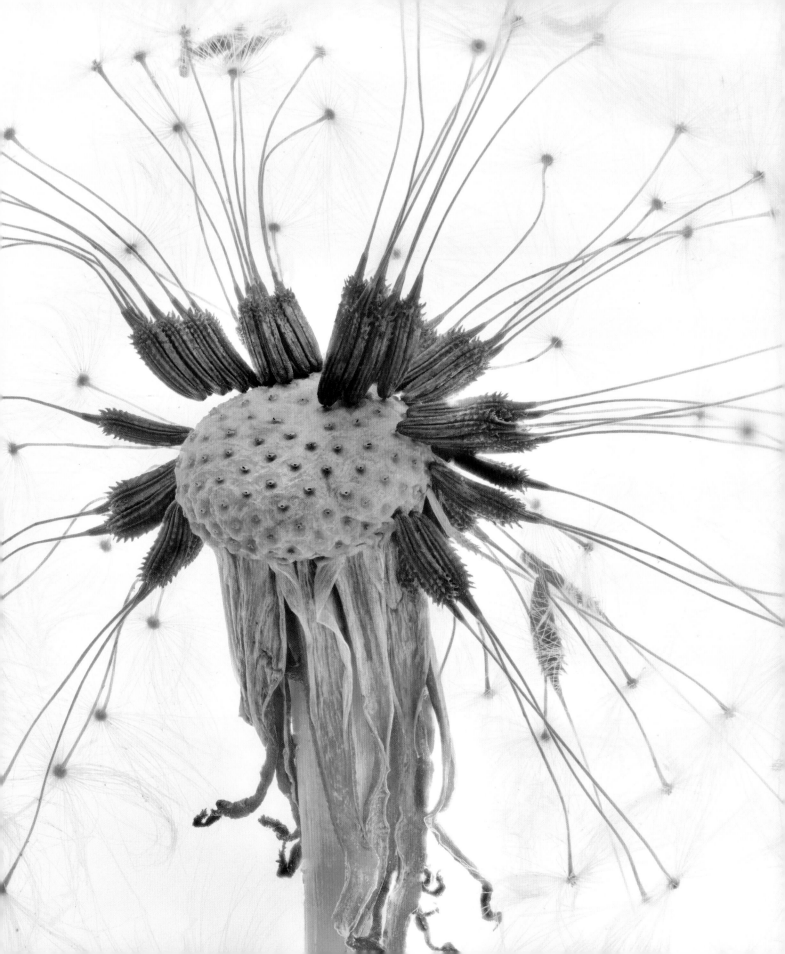

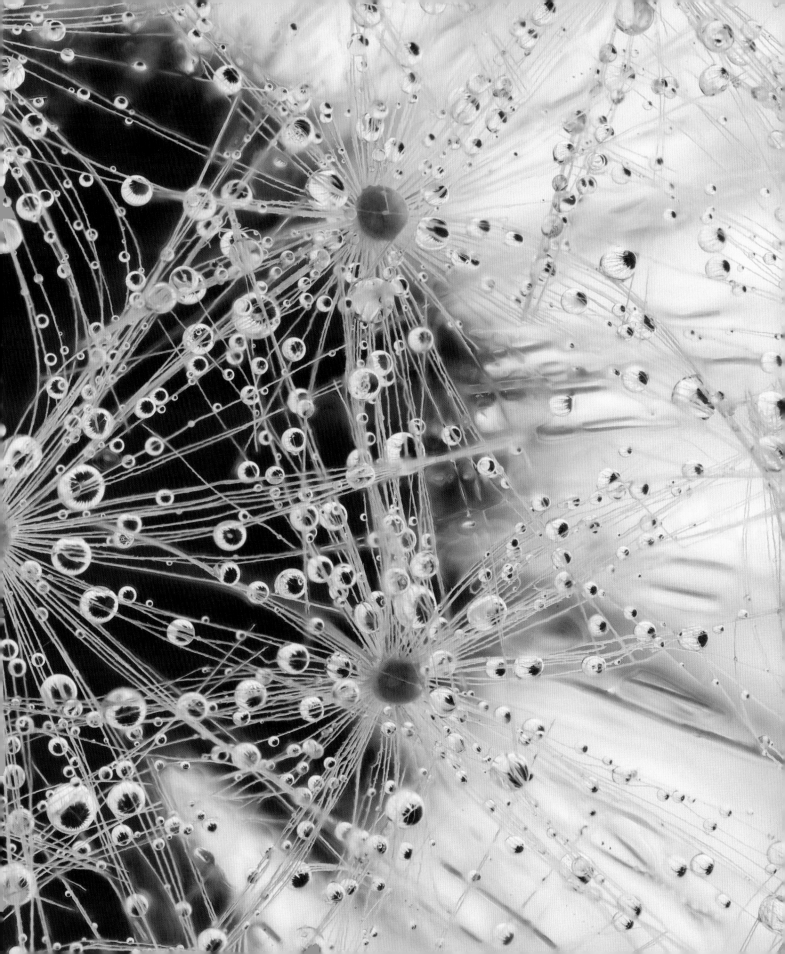

devil's claw

Proboscidea species

This one gets bragging rights among seed collectors. The dried fruit can be tucked into arrangements, but the plant is too astonishing for that. It is akin to hanging a beautiful painting in the midst of a crowd of artwork. Better to display your prize solo, perhaps backlit on a windowsill.

Devil's claw's other common names pay tribute to the various creatures it evokes: ram's horn, unicorn plant, elephant tusks, goat's head. It's also been likened to mastodon tusks or "the giant mandibles of a monstrous ant." The Latin name brings to mind a long nose.

Of about nine known species, some are weeds and others are, at best, garden novelties. Plants are rather sprawling, with thick stems and coarse foliage. The flowers that precede the strange fruits are funnel-shaped and carried in loose racemes. Depending on the species, they may be bright purple, wine purple, pink, or creamy white, sometimes with contrasting flecks or nectar guide markings, vaguely reminiscent of catalpa or foxglove flowers (to which they are not related). Some are unpleasantly scented because of hairlike structures covering every part of the plant, even the pods. These are tipped with glands that exude gummy, aromatic oil.

Bees accomplish pollination. This works well, for a single plant can generate dozens of fruits. A green capsule forms, up to 3 inches long, with a long, slender, 10- to 12-inch-long curved beak. By late summer or autumn, the beak dries to brown and splits into two horns. This aids distribution if it snags the coat of a long-haired dog, a cow, a horse, or a deer. There are up to fifty seeds inside. Some fall out, while others are released after a pod is trod on or rots away.

One of nature's more bizarre seedpods, the fruit of the devil's claw plant is unforgettable. Initially it is green and has a long, slender beak that is about three times longer than the main capsule portion. As the entire thing browns and dries, the beak splits into two curled horns. If you can get past its threatening appearance, the symmetry is admirable.

false indigo

Baptisia australis

Although it might not seem so in these modern times, at least away from Third World countries, seeds are more useful to humans than merely food, either to eat or to plant for a later harvest. Seeds have also been incorporated into decor, jewelry, clothing, and even toys. One versatile plant is false indigo, a member of the bean family (Fabaceae). Its gorgeous deep blue flower spikes are followed by brown pendulous pods that can be harvested to add to floral arrangements or to serve as a child's rattling toy. A near relative with smaller yellow flowers and similar pods, *Baptisia tinctoria*, goes by the common name rattleweed.

Pods are 1 to 3 inches long and hold only a handful of seeds. They begin green and then swell, filling out and darkening until the shell becomes hard and nearly black. Just as the flowers were carried in spikes, so are the pods. You can imagine, perhaps, a Native American or colonist child waving a stem to enjoy the noise.

When you pry open a loose pod, you understand why you can hear seeds rattling around inside. The kidney-shaped golden brown seeds are tenuously attached at first, and they tend to loosen. They may be sown the following spring. Those left on the plant can travel to new homes when withered stems snap off and tumble about in the wind late in the year. In either case, new plants do not reach blooming size quickly. The plant invests its early years in taproot development and foliage growth. To get maximum flowers—and, therefore, more pods—site the plant in a spot with plentiful sunshine.

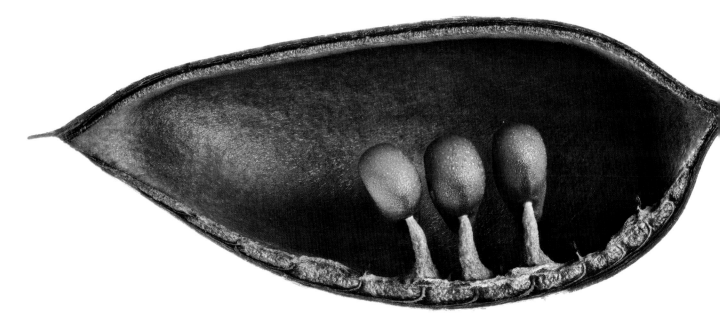

A false indigo's lush green foliage and spikes of vivid blue flowers definitely grab attention. While the pealike pods that follow are not especially long or unusually shaped, they are also worthy of admiration. As they dry, they often become so dark as to be nearly black, which is also a good show against those leaves. Sheltered within are a few seeds; these will come loose and rattle around inside fully ripe pods.

horsetail

Equisetum species

Horsetail looks like it belongs on another planet—because it once did. Plants in this primitive, hollow-stemmed genus are direct descendants of those that prospered in prehistoric times, back when dinosaurs roamed and ferns were as tall as present-day trees. Horsetail prefers damp or poorly drained ground, and it can spread rampantly. It is resistant to most common weed killers, so many farmers, orchardists, and gardeners consider it a nuisance (weed killers are designed to thwart seeds, and horsetails have spores instead). Occasionally water gardeners add a horsetail or two to their displays as a dependably green vertical accent, making sure to confine them to pots to curb their wandering ways.

The plant's main mode of reproduction is via creeping underground rhizomes, which produce new plants from fleshy tubers. Horsetail does not have flowers, nor does it technically produce seeds. But every spring you can observe the formation of strobili, terminal cones or conelike spikes on fertile stems. These generate literally thousands of spores, then wither and dry out. At that point, vegetative stems dominate.

The tiny spores are (mostly) homosporus, which means they are uniform (in fact, sphere-shaped). As with ferns, these spores need moisture to complete their life cycle and generate new plants. Each one has four fascinating slim appendages that remain curled around the main body in humid air and spring outward upon drying. Biologists have filmed them jumping about, something never before observed with other sorts of spores.

Nonetheless, given horsetail's aggressive and productive root systems, the dancing spores seem to be more of a bet-hedging Plan B reproductive tactic. Possibly it was once Plan A, but that was long ago, in a different world.

A fertile stem of a horsetail is often hard to spot in the thickets that these moisture-loving plants tend to form. They generate spores, not seeds. Botanists at a French university managed to capture them on film (look it up on YouTube) and discovered something amazing. Each wee spore is clutched in four tiny arms, which swing wide when conditions are dry enough. The tiny spore leaps and tumbles and dances away to new ground.

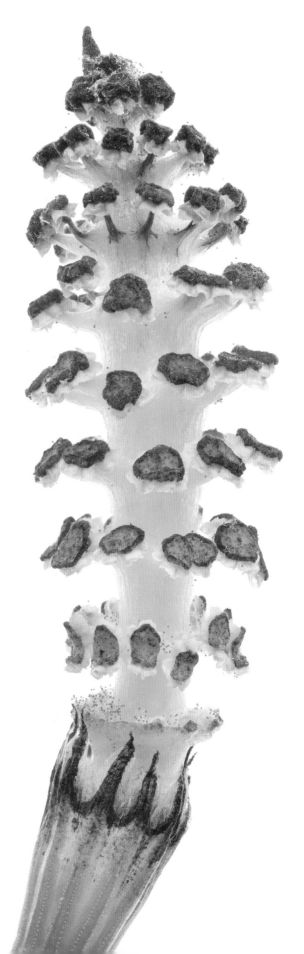

milkweed

Asclepias syriaca

You may have seen these pods in autumn, perhaps even paused to poke silky seed parachutes on their way. Insects pollinate milkweed. Each flower has little slits in the sides, and when an insect lands to drink the nectar, sometimes a foot gets stuck. As it tries to yank away, the claws get caught on wee wirelike filaments that have a tiny saddlebag of pollen on each end. If the insect is able get free, it brings this bundle along to the next flower. Some insects get waylaid; if you examine a patch in midsummer, you'll spot a few fluttering in desperation or already dead and hanging there, dried out.

Given such a system, it is surprising that milkweed pollination succeeds. It is not resoundingly successful when you consider how many flowers are generated. One plant may have up to eight somewhat droopy, sweetly scented flower clusters, with seventy-five blossoms each. And yet only one flower from each umbel goes on to become a pod; the others degenerate and fall. Botanists are not sure why. It may be lack of pollination, or because the big, complicated follicles require so much energy to make.

Milkweed makes up for this shortfall by generating many seeds. Meanwhile, individual plants develop impressive root systems that produce more and more stalks each year. Vegetative reproduction is clearly an additional survival strategy.

The seeds that manage to develop are small (6 to 8 mm) and brown, and they are aerodynamic because they are lightweight and aided by the white silky parachute. Their shape also helps. Wafer-thin and longish, they're distinctly margined with a ridge on one side.

When milkweed seeds release from the pod, they have a lot going for them. Their light, silky filaments allow them to drift and sail like parachutes on a breeze. But their shape also makes them aerodynamic—they're wafer-thin and longer than wide, and a ridge down their length helps stabilize flight.

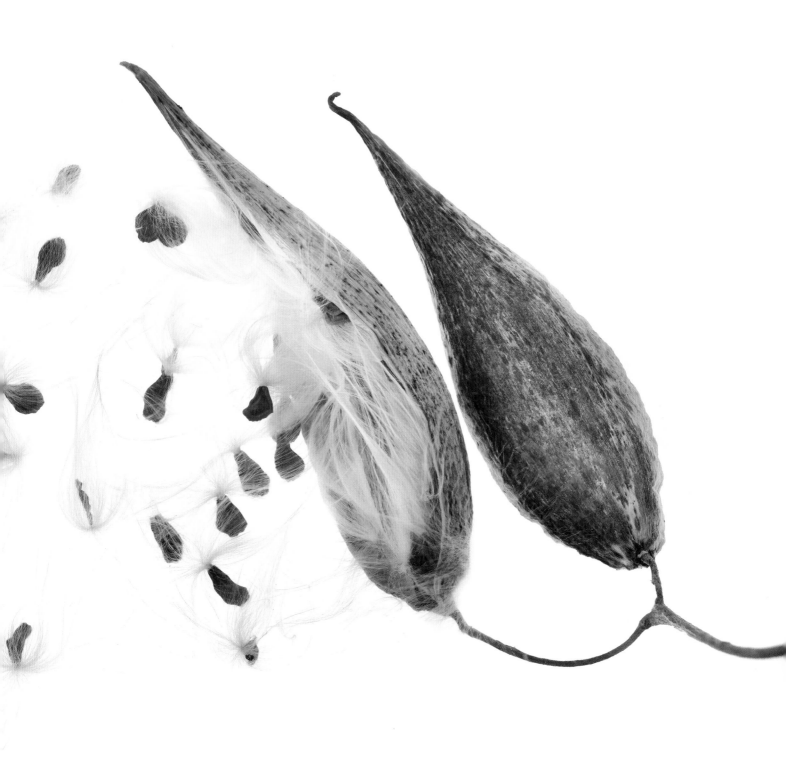

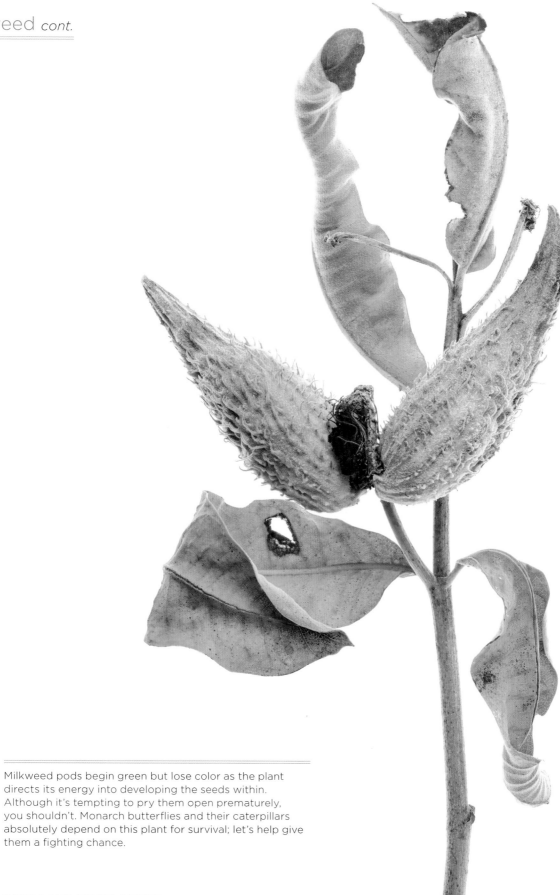

Milkweed pods begin green but lose color as the plant directs its energy into developing the seeds within. Although it's tempting to pry them open prematurely, you shouldn't. Monarch butterflies and their caterpillars absolutely depend on this plant for survival; let's help give them a fighting chance.

mullein

Verbascum species

Common mullein, *Verbascum thapsus*, thrives
in hot sunshine, in dry or gravelly ground. The
rosettes are made up of big, felty gray-green leaves.
Flower stalks emerge in the second or third year. I have
a vivid memory of hundreds of them standing sentinel on
both sides of a dusty road that wound into the pine-dotted
foothills of Idaho's Sawtooth Mountains. They are tough
and stately.

The stiff stalks linger over winter and sometimes for many
seasons after the insignificant yellow flowers have come and
gone. Grab ahold and you'll immediately appreciate their
sturdy structure. The two-parted fruits—now open, gaping
calyces that once held the little flowers—are stiff, brown,
and jammed together on all sides of the stalk. The small
black seeds are less than 1 mm long.

Closely related but less robust moth mullein, *Verbascum
blattaria*, is also biennial and erect. But its flowers and cap-
sules line the stalks at intervals. These are beadlike, two-
celled, and full of seeds. Not all of them open, so it is easy
to observe the capsules in winter and beyond.

Biennials produce a rosette and engage in root growth
their first year. In ensuing years, they flower and produce
seed. When you observe spent mullein stalks and capsules,
the plant is done and dead. It's a remnant.

Hopefully some seeds gain purchase and there
will be another generation. By some estimates,
a single plant can generate up to 170,000
seeds, so odds are good. They do, however,
require light to germinate, which is why
competing or encroaching plants tend to
shade out seedlings. Yet mullein seeds can
remain dormant for a long time. If an area
is cleared or another disturbance creates an
opening, a population will resurge.

Unlike other mulleins, moth mullein (*Verbascum blattaria*)
forms beadlike seed capsules along its stiff stems. But, as
is characteristic of the plant, these are two-celled and jam-
packed with tiny seeds. Not all of them open and spill their
contents at season's end. This might be deliberate, as the
seeds require light to germinate and the odds will not be
good when other vegetation hems in a plant.

Queen Anne's lace
Daucus carota

When this common weed finishes blooming and, presumably, its many mini flowers have been pollinated, it enters a phase known as bird's nest. The formerly lacy flowerhead curls inward and shelters the developing fruit. These fruit are small, oval-shaped, and covered with little spines or barbs. These are intended to adhere to the fur of animals, thereby aiding distribution. The spines are arranged in four neat ridges or rows, covering all sides efficiently.

Each fruit becomes gray-brown to yellow when ripe. It then splits into two halves, and two seeds inside are at last ready to travel. The plant continues to clutch them if the weather is humid, rainy, or snowy. Only on dry days does the bird's nest relax and release the seeds to gravity, the wind, or passing creatures.

One plant can produce up to 4000 seeds. Like related plants, Queen Anne's lace is biennial, meaning it develops a rosette and gets started on its whitish, carrotlike taproot during its first growing season, and it doesn't send up a flower stalk until the following year or beyond. Those who have cut back this plant with a weed whacker or plowed under a patch know that if you don't dig up the rosette, another flowering stalk may arise. This resilience is fairly unique among biennials. Add the prolific seed production and you can see why this resourceful plant is often considered an aggressive weed.

And yet the slim root is as edible and valuable for vitamin A content as the domesticated carrot (which, in fact, was derived from it). And the seeds, which have a pleasant carroty flavor, are as safe to eat as other umbelliferous herbs, like dill, caraway, and fennel.

When in bloom, Queen Anne's lace is broadly flat-topped, but once it goes to seed it curls inward to a concave form that some call bird's nest. This physically shelters the seeds and conserves moisture and humidity while the hooked seeds form and ripen. They are dispersed throughout the winter.

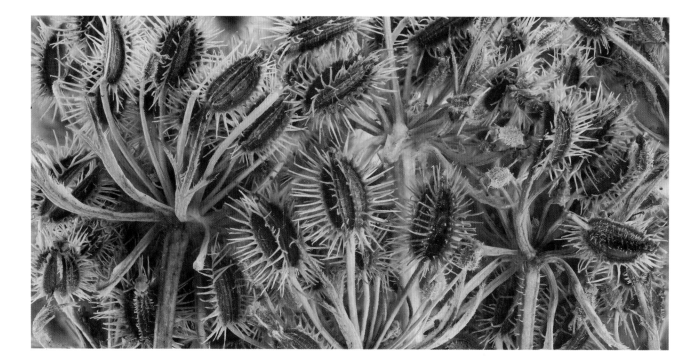

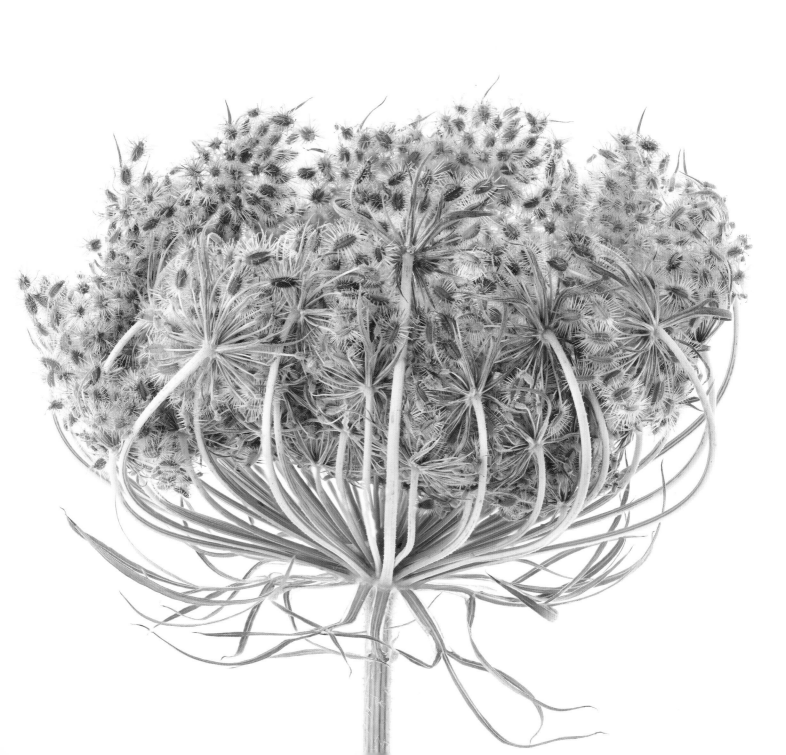

sedge

Carex species

I once went on a guided hike to a wetland with an accomplished botanist. We paused before some grassy plants, and he offered an easy generalization: True grasses have blades; rushes have round, hollow stems like straws; and sedges have three sides and lack nodes. Dutifully, we bent down and ran our fingers along the stems of what turned out to be sedges. "And what is this one's name?" someone asked. "*Carex* something," he laughed, waving his hand. "I can't tell them apart."

I later learned his answer wasn't as cavalier as it sounded. Many *Carex* species exist, and they are vexingly similar. They can cross with one another, so a confirmed identification is tricky. The small flower spikes look an awful lot like some grass inflorescences, so my instinct is to check the stem.

Sedges reproduce quite successfully via their underground root systems. Where grasses and rushes mainly expand via rhizomes, sedges also have tubers. Flowering and going to seed, as is the case with so many other plants, is just an additional way to self-propagate and ensure genetic diversity. Sedges are mainly wind-pollinated, which explains why the flowers are not showy, large, or scented—there is no need to attract pollinators. Of course, given their preferred habitat, it's reasonable to think that water and birds sometimes move ripe seeds about.

Flowers occur at the tops of stems, usually in prickly clusters. They are bisexual or unisexual (having only male or female parts in each flower, not both). The three-angled fruit that follows is commonly called a nutlet, although it is actually an achene—one seed with a hard, dry coat. These nutlets are durable and long-lasting, so much so that archeologists sometimes rely on surviving ones to confirm that an area was once a wetland.

Although sedges expand their numbers quite well vegetatively, they also flower and produce seed. The prickly greenish flower clusters are wind-pollinated, so there is no need for them to be colorful or scented in order to attract insects.

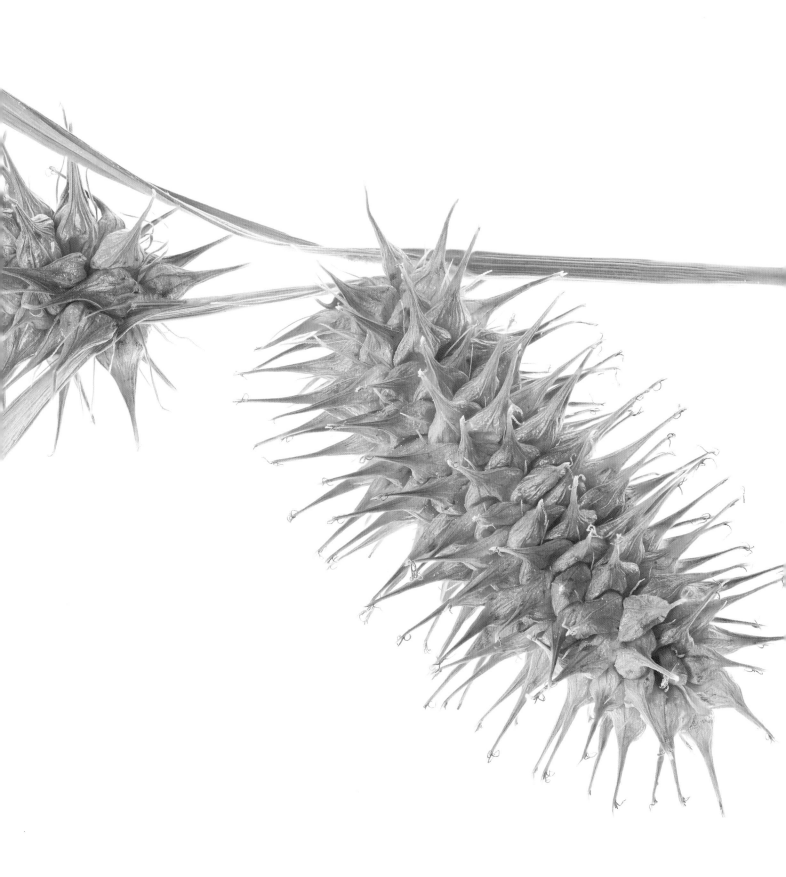

thimbleweed

Anemone virginiana

All up and down the East Coast of North America, from Quebec down to the Carolinas and westward into the plains, various wild anemones decorate woods and thickets early every spring. Palmate leaflets emerge first, and are soon joined by delicate-looking blossoms on slender stalks. These survive for up to several weeks before going to seed. By summer, as the shady canopy increases, the soil gets drier, and the days grow longer and hotter, woodland anemones tend to fade away and go dormant—both their rhizomes or tubers and their seeds. There is no more activity until next spring.

Three in particular come to mind. The wood anemone, *Anemone quinquefolia*, has charming 1-inch blooms that are white backed with pink. The flowers of the rue anemone, *Anemonella thalictroides*, are just as small but often more generously produced; its little mitten-shaped leaves are reminiscent of those of meadow rue, *Thalictrum*. Those of thimbleweed, *Anemone virginiana*, are clearly related; it is only when it goes to seed that the last one earns its common name.

The flowers of all of these little anemones are composed of sepals rather than true petals. All are centered with numerous pistils and stamens, often yellow. Despite the occasionally used common name of windflower, none of these are wind-pollinated. Early bees, flies, and wasps do the job.

Thimbleweed alone forms a distinctive, elongated fruit or cone, maturing a passel of seedlike pistils that resemble a thimble in size and form. The tiny pepper-flake-size dark brown seeds are attached to cottony fluff. After they fly away, the thimble or cottony remnants often linger. In some locales, depleted thimbles can be found in late autumn or winter, when little else is left of the plant.

Other woodland anemones have showier flowers than this one, *Anemone virginiana*. But only the aptly named thimbleweed is followed by a distinctive seedpod. If you happen upon a patch, they poke up here and there like tiny greenish beacons.

tiger lily

Lilium lancifolium

This beauty produces a bounty of nodding, recurved, speck-led orange-red flowers in late summer. A native of Asia, it prospers in cooler climates and moist, acidic soil. Like all lilies, it arises from a stout underground bulb. It's a sturdier, somewhat shorter plant than the similar turk's cap lily, *Lilium superbum*.

Typically in species lilies, a green six-parted seedpod forms. The contents are vulnerable to wet weather (which causes rot) and early frosts (which damage or kill seeds). A pod must be completely dry and brown before you can extract the seeds. There may be as few as twenty and as many as 100. If you hold one up to the light, you can observe the embryo within as a line down the middle.

Enthusiasts and specialists are willing to har-vest seeds for a variety of reasons: to get more plants inexpensively, for hybridizing projects, to maintain genetic diversity, or to free a species of virus infection.

Some lilies also reproduce via stem bulbils, which form in the stem and leaf axils. These are dark pur-ple-brown and up to ½ inch in diameter. They eventu-ally fall off, land below, develop roots, and pull them-selves down into the soil. Alternatively, you can pluck them and plant them yourself. Or you can let the flowers fade, then pull up and bury the entire stem sideways in the ground. You will lose the original plant, of course, but also get some new baby ones. Not surprisingly, all are identical to the parent plant. A healthy tiger lily plant soon begets a colony.

Many lily bulbs produce little bulblets that you can separate off and replant. Sometimes seeds can be collected and germinated (check with experts regarding any special requirements). A few produce bulbils along their stems in the axils or junctions. Pluck these off—they should come off easily if they are ripe—and plant, or even cut off an entire stem and plant it horizontally.

Lily parentage and reproduction has been complicated—and refined—by lily breeders. Seeds may be hard to germinate or sterile. In most cases, the most reliable way to get more *Lilium lancifolum* plants is to collect and plant the stem bulbils when they become ripe.

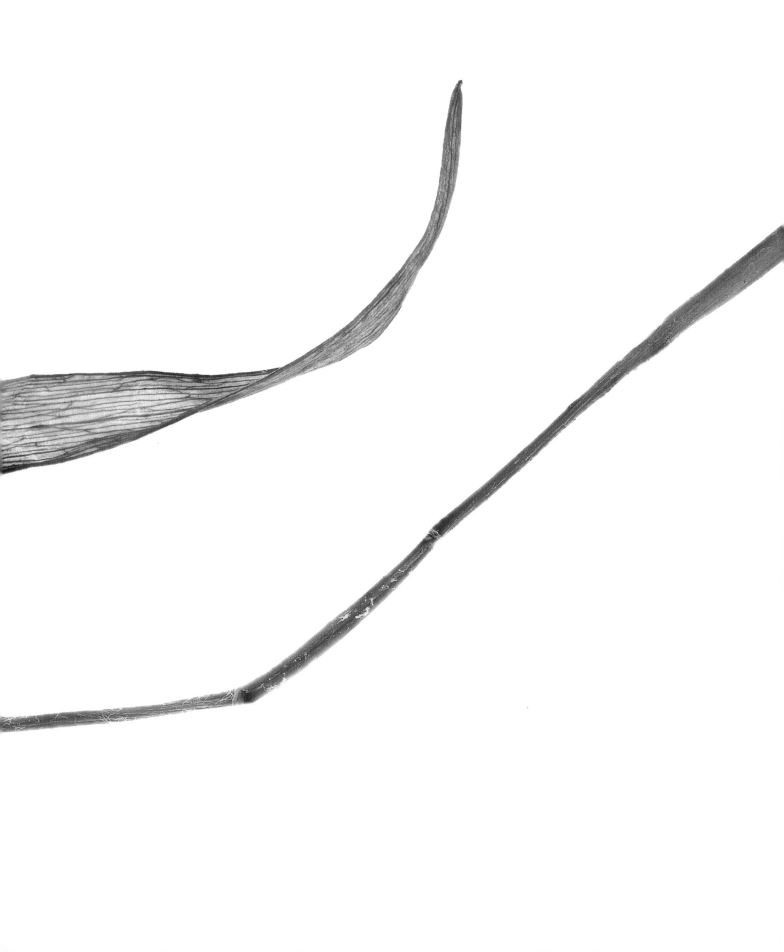

violet

Viola species

In the northeastern United States, where I have gardened for many years, you can count on a violets population explosion every spring. Where once there were a few clumps, now there are dozens. Their dainty little purple or white blossoms are a welcome sight. But as summer arrives and their flowers fade, the romance dies too. Suddenly there are just too many violet plants.

Yanking out a clump provides an opportunity to admire their wiry little rootstocks. But, unlike some productive plants, these don't send out runners with new crowns. The culprit—that is, the reason for the boom—is seeds.

Violets are wily. The little five-petaled, often softly fragrant, flowers draw bees. Pollination is aggressively invited. Whiskery markings and a lighter-colored center direct bees to interior sacs of sweet nectar. There will be no cheating. Green sepals attach not at the base but in the middle, projecting forward around the petals and backward around the stem, which effectively blocks backdoor entry that would miss the pollen. Once pollination succeeds, stalks bend down and seed capsules form safely out of view among or under the leaves.

Capsules are three-parted and hold tiny dark green seeds. As they ripen and the capsule itself starts to turn brown, they do not fall to the ground under the parent plant. Instead, the drying valve compresses on the seeds until it contracts and shoots them out in all directions.

Just to hedge their bets, violets generate another round of flowers in the summer months. You may never have noticed them, though, because they don't unfurl and are hidden under the foliage, where they self-pollinate. More three-part capsules result, and more seeds eject into your garden. Long story short: Although small and sweet in appearance, violets are fierce about seed production and distribution.

Do not underestimate the determination of little violets to increase their numbers. All spring, the flowers aggressively coax pollinators and then quickly form pods. When the seeds within are ripe, the pods shoot them as far as they can—sometimes up to several feet away. Summer actually brings another round of flowers, which are hidden under the leaves and self-pollinate, ensuring more slung seeds.

wild bleeding heart

Dicentra eximia

A seed of this wild dicentra needs help, via ants, to get to a place where it can germinate and thereby create the next generation. An elaiosome, a fleshy, lipid-rich structure, envelops each seed. This physically protects the seed for a time, but germination can proceed only after an ant eats the elaiosome and jettisons the (uneaten) seed. Other wildflowers that have elaiosomes and depend on ant dispersal include trilliums, twinleaf, and wild ginger.

This bleeding heart is found in rocky North American Eastern woodlands of filtered sunlight and humusy soil. Gardeners tend to prefer its larger cousin, *Dicentra spectabilis*, whose bigger locket-shaped flowers come in pink-and-white or white. These are smaller (about ¾ inch long), flatter, and a demure shade of pink. Sometimes they get obscured by the foliage, which further diminishes their impact.

This species blooms continuously from midspring through autumn's first frosts. Thus there will be seed capsules in various stages of development at almost any time during the growing season. Bees are the main pollinators.

Capsules begin green and mature to brown. Many tiny seeds within swell against the walls of the fruit, giving it a lumpy appearance. If you split an immature capsule along a seam, you will observe white or green seeds within. All this development is often hidden from view by the fading blooms, which are reluctant to drop their petals, even after they wither.

Ripe seeds are shiny and black. Attached to each one is an elaiosome, a moist white crest that contains lipids and fats on which ants feed. This is too bulky to aid wind dispersal. Instead, an ant will carry a seed back to its nest and share it.

Later the seed is carted off to and buried at a waste area, often at a distance from the mother plant. This is desirable in case any harm comes to the mother plant, including something as simple or natural as a tree falling on it. It's also hidden from the sight of potential seed eaters, including birds. There it can germinate thanks to the presence of organic matter, including ant frass. This modest wildflower's continuation depends on the niche activities of two such small creatures, bees and ants.

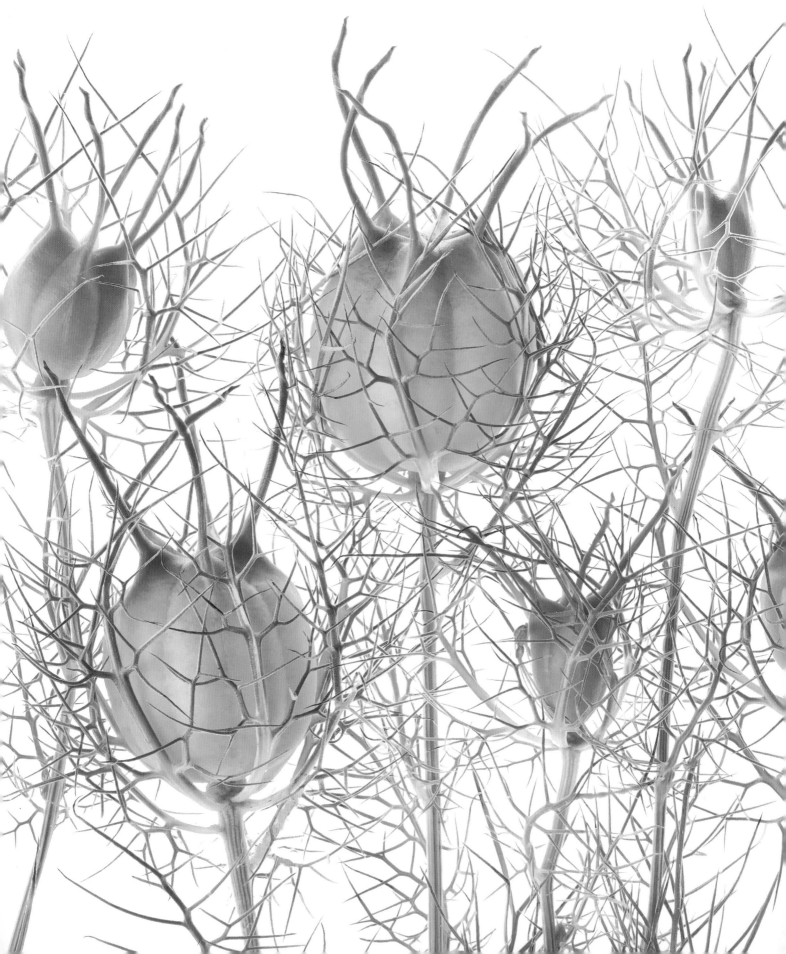

HERBS, SPICES, FIBERS, AND MEDICINE

THE PLANT KINGDOM has long been a primary source of food, of course, but also medicine, decor, cosmetics, clothing, and more. Some traditional uses have been validated, and others debunked. Unlocking the chemical and nutritional secrets of seeds is an ongoing process. Newer uses are unearthed all the time, like pressing omega-acid-rich seeds for their oil.

In our cautious and litigious modern world, certain seeds are termed poisonous, but techniques exist for consuming many as food or remedies. Others have played roles in religious or other rituals as mood-altering substances or hallucinogens. Some so-called poisonous seeds repel one dispersal agent in favor of another.

All seeds, including those in this broad category, are motivated to ensure and protect future generations of the plant on which they originated. For some seeds, the reasons they have certain properties or appearances remain elusive. Such things may be understood in time or qualities may turn out to be—to borrow the detective-story term—red herrings that distract us from what is really going on. We still have a lot to learn.

Nigella plants attract curiosity, if not admiration, when they form seed capsules. In some species, the seeds are a valued spice.

calendula

Calendula officinalis

This cheery annual—usually rich orange, glowing gold, or creamy yellow—is enduringly popular. Some call it pot marigold because it does well in containers. The double-flowered varieties look quite a bit like marigolds, although they lack that unpleasant scent.

Calendula is also well known to herbalists and crafters, who use it internally and externally as an antimicrobial and antibiotic. Tinctures or salves made from the flowers soothe and heal sores, abrasions, and rashes; alleviate digestive tract irritation; and act as a lymphatic for swollen glands. Dried petals make a yellow dye for wool, mordanted with alum. The flowers are even harvested for eating fresh in salads or sandwiches, adding to soups or cooking with vegetables, or drying, grinding, and using as a coloring or saffron substitute.

Calendula blooms are frequently snipped for bouquets or plucked for use in craft projects, so most of us encounter the seeds only at sowing time. The plant is in the same family as daisies and sunflowers (Asteraceae). The fruits, which form in the flower centers (the central disk that is actually composed of numerous tiny flowers), are achenes. Each has only one seed.

And what odd seeds they are. All have a rough texture, but no two are alike. Some are crescent-shaped. Others resemble bugs, wee boats, sultan's slippers, peculiar earrings, or tiny versions of medieval weaponry. There is no obvious reason for this variation, nor are the seeds put to any use beyond producing more plants.

If you don't pick the flowers or deadhead the plants, they will go to seed. Self-sown plants pop up readily next spring and may not look like the originating flower.

If you've always bought these popular annuals in flats, you're missing out on calendula's bizarre-looking, rough-textured, curled seeds, which sprout easily. They resemble bugs, wee boats, sultan's slippers, peculiar earrings, or tiny versions of medieval weaponry.

castor bean

Ricinus communis

Originally from warmer parts of Asia and Africa, this plant was brought to California and the American South as an ornamental. It escaped into the wild and naturalized, so some people incorrectly think it is native. It grows quickly and can be treated like an annual; cold winters do kill it. It has been touted as a tough filler or foundation plant.

The landscaping suggestions come from the fact that it can grow taller than the average person in one season, its entire profile clothed in large palmate leaves. Flowers are odd-looking and green (some male, some female, both on the same plant), followed by prickly reddish seedpods.

All plant parts, including seeds, contain ricin, super-toxic rat poison. Castor bean is in Euphorbiaceae, and as with others in the family, handling plant parts can cause an irritating rash. It would be wise to plant in the back of a border, out of range, but it may be wiser not to grow it at all.

The seeds are oily; by some estimates, more than half their weight is oil. This does not go rancid, so it has found many commercial uses, including in pharmaceuticals and as an engine lubricant. Cold-pressed castor oil is a safe, albeit unpleasant-tasting, laxative.

The smooth and mottled seeds or beans lodged inside the exotic-looking fruit are undeniably handsome. The connection between the three red styles (united at the base) and three-celled ovary is apparent—the more-or-less globular capsule that follows separates into three two-valved carpels.

Consuming just one seed can kill a child; three can fell an adult. They can also be fatal to livestock, poultry, and pets. The red exterior spines are a deterrent to be heeded. Clearly this plant fiercely protects its seeds from predation.

OPPOSITE Weird and rather scary-looking, the fruits of the castor bean plant, *Ricinus communis*, are little red spikeballs. They should be off-putting, for they harbor ricin, aka rat poison. Even handling the plants causes a toxic reaction for some people. Take this plant at its word and give it a wide berth.

FOLLOWING Castor beans—or, rather, seeds—have especially high oil content. It's an unpleasant if durable oil, very slow to go rancid. After proceeding with caution, humans have found uses for it, including motor oil and the now out-of-favor laxative castor oil.

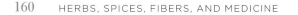

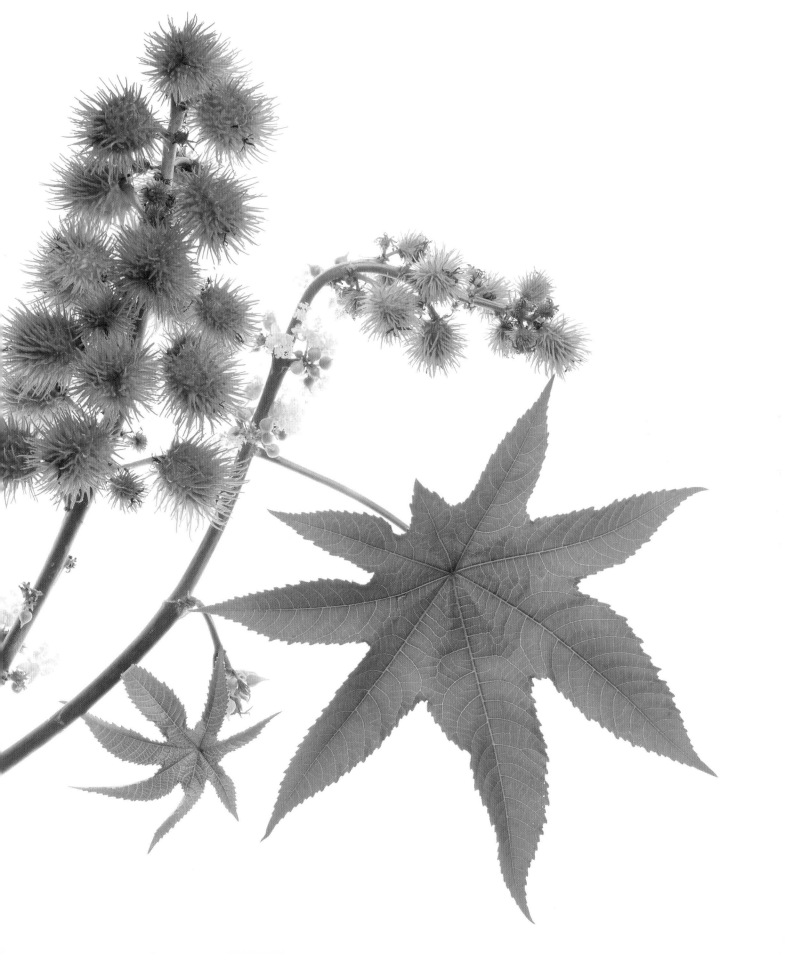

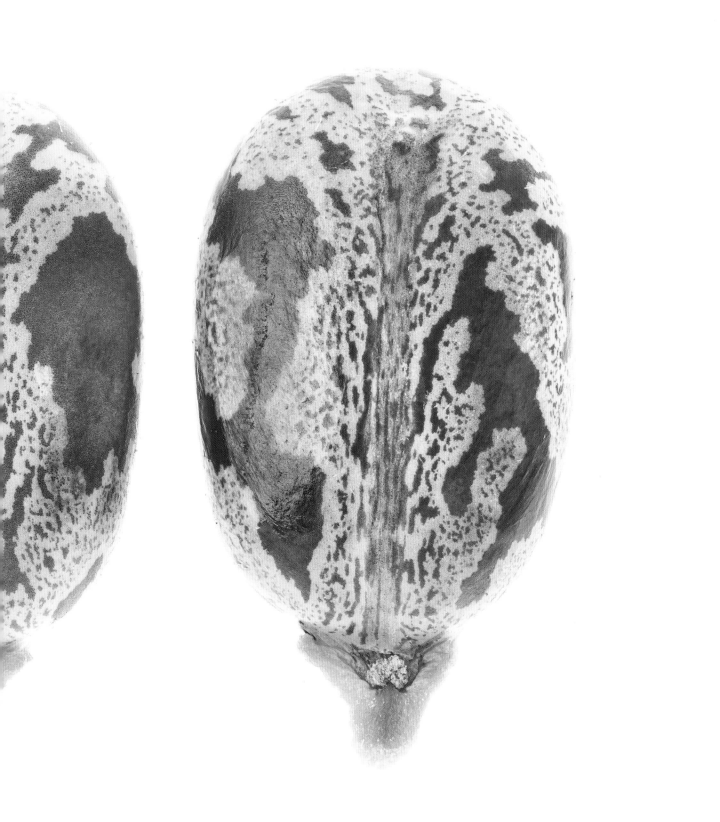

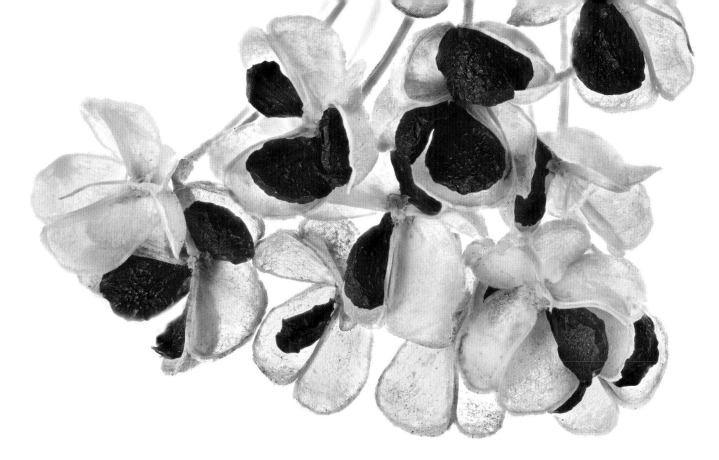

chives

Allium schoenoprasum

Seeds are hardly the first thing we notice about chives plants. Gardeners raise this easygoing perennial herb for its slender, grassy, hollow leaves. Snipped fresh, they add a mild oniony zing to recipes when mixed in or sprinkled on as a garnish. The small purple-to-pink flower clusters are equally edible and tasty in salads, soup, and vinegar, or as garnish.

In addition to the distinctive oniony scent and flavor, chives are produced from a small bulb that is much smaller than those of its onion and garlic cousins. Originally they grow from tiny black seeds that are slow to germinate. Chive seeds also require a period of darkness and constant moisture. This can be a hassle for impatient gardeners, who often prefer to buy seedlings, divide a mature clump, or let their existing plants self-sow and naturally expand their presence over the years.

Like all onion family plants, chives develop their flowers in umbels at the top of stems. Flower petals are a mere ½ inch long with blue-purple anthers. Once pollinated—by bees, not wind—the oblong dark seeds appear. They are quite small, but visible as the flowers mature and even more apparent when petals begin to lose color and fade to tan.

Seeds ripen slowly, however, while mature flowerheads shatter easily. If you want to try collecting them, timing is key. Wait until the flower stem itself turns brown, then pluck. Spare a moment to examine the wee pods. They look like they should hold three seeds, but the number is most often only one or two. To extract them, rub or shake the pods over a bowl or white paper, then discard the frail and dry chaff. While not impressive protection, it is enough.

Unlike many other popular herbs, chives plants are perennials. It may not occur to you to pay attention to the seeds; the pretty purple seedheads tend to shatter, so collection can be tricky. But if you are both inquisitive and lucky, you may get to admire the moment when the papery little pods open to display the tiny black seeds.

coneflower

Echinacea species

This plant is so easy to love when it's in bloom. The robust daisylike blooms, usually with rosy lavender petals (actually ray flowers) hanging shuttlecock-style off a generous central cone (disk flowers), start in midsummer and carry on well into autumn. They are easy to care for and tolerate summer heat and humidity in style. In recent times, plant breeders have had—pardon the pun—a field day with this species, and now it comes in a rainbow of colors, including magenta, green, yellow, and white.

But all good things must come to an end, and when the last frosts of fall finally shut down the coneflower show, we tend to stop paying attention. Dried, bedraggled bits of the ray flowers hang limply, all color drained away. The cone darkens, and unless the gardener cuts back the entire plant while tidying up, it clings on, looking lonely and forlorn atop a brown stem. Goldfinches may stop by for a seed snack. If any human values the plant at this stage, it's probably to harvest the medicinal roots (if this interests you, check out any good herbal reference book).

What happens now is intriguing. Once flowering is finished, the cone fattens. Like all daisy-family members, it is composed of many tightly packed flowers. When pollination has occurred and seeds are developing, expansion is inevitable.

Each little disk flower has the potential to develop one wee nutlet or seed. These are not round or oblong, but four-sided. Everything is so densely packed in a coneflower cone that this shape makes the most efficient use of the tight space. If you're dismembering the cone to collect seed (or just out of curiosity), observe that many are undersize or shriveled and thus not viable.

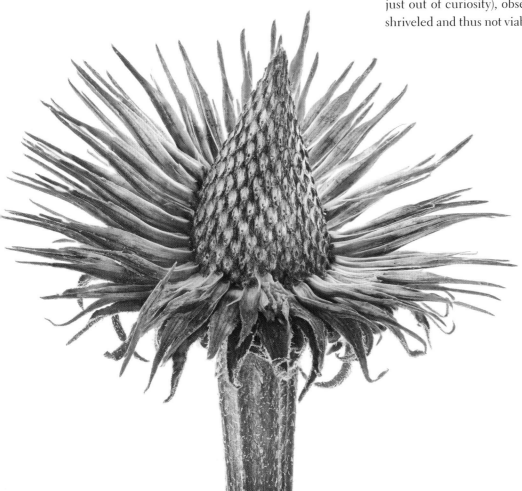

The exuberant coneflower is almost unrecognizable at season's end. The colorful petals (actually ray flowers) are long gone and the central cone, too, is drained of color. Now it is studded with slender, pointy brown achenes or one-seeded fruits. These detach as they ripen.

cotton

Gossypium hirsutum

Although it is still an important crop, nowadays few people can recognize a cotton plant. In fact, I know an avid gardener in Kentucky who could not identify a mystery shrub in his yard. He even queried visitors, who were equally baffled. When it bloomed and went to seed, he finally got his answer.

Harvesting the useful-to-humans part of the plant is labor intensive. The downy white fiber, which is actually almost pure cellulose, forms a protective layer, a boll, around the seeds. This clings tenaciously and must be plucked off. This was the tedious, backbreaking labor of African slaves in the American South and, before them, exploited workers in India and Egypt. Modern cotton farmers use specialized harvesting machines.

Cotton is not the only plant that makes a boll: Flax, which is harvested for its fibers, does, too. One flax boll protects between six and ten seeds. One cotton boll, in contrast, protects up to forty-five seeds.

The development is a familiar process. Plump green buds open to flowers, whose petals transition over several days from creamy white to yellow to pink to dark red. Bees do the pollination work. Once the petals fall, pods form and swell as the fibers within grow. One day they burst forth. You would have to be very patient and careful to discern that each little brown cotton seed has hundreds to thousands of tiny inch-long fibers attached to it. Left to their own devices, the seeds are wind-dispersed (although rodents and birds may grab some fluff for lining their nests).

Farmers do not discard cotton seeds. Some may be reserved for replanting, but most are used for animal feed or pressed to make useful, nutritious oil.

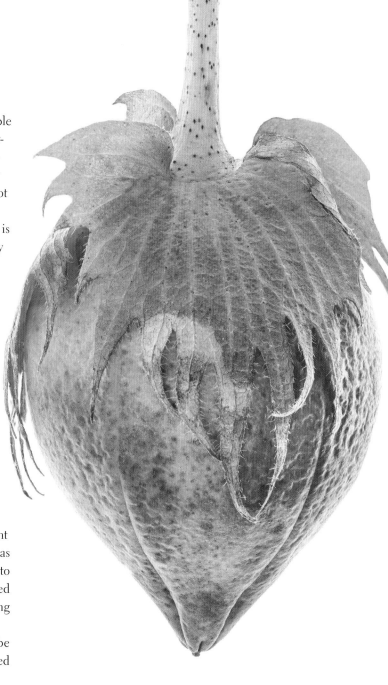

Once arduously picked by hand for its fluffy white fibers, cotton is now machine-harvested. The boll-forming pod holds mainly high-cellulose fibers and several dozen small brown seeds. Left to its own devices, this structure swells until it bursts open, dispersing the seeds and their attendant fluff on the breeze.

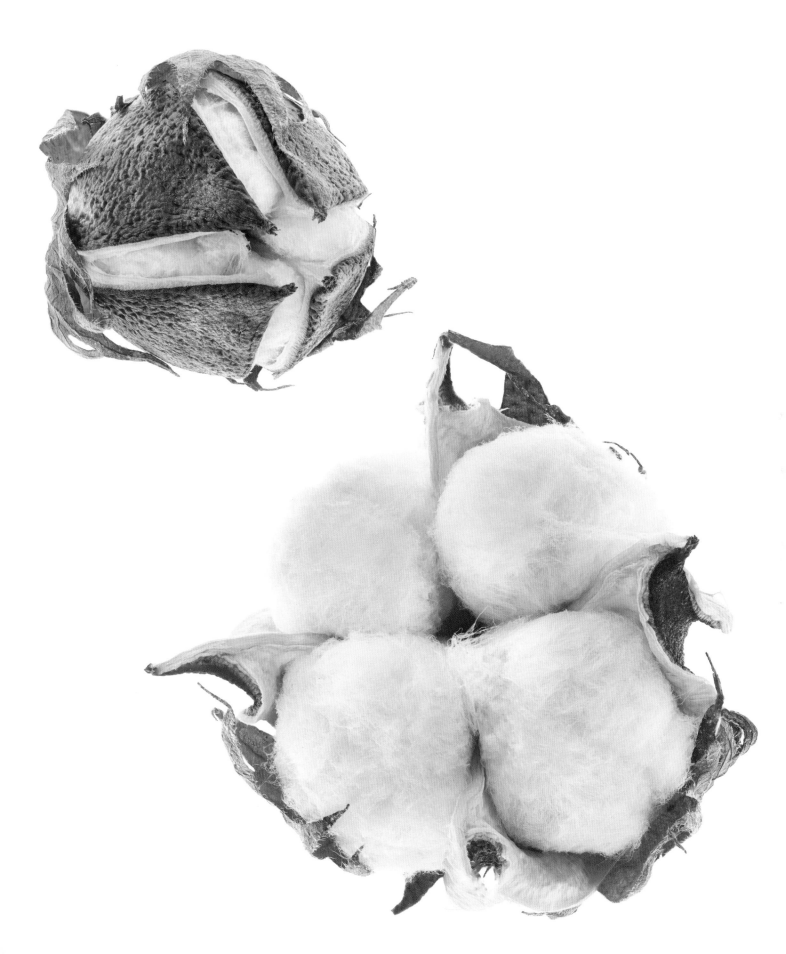

datura

Datura species

For those who came of age in the late 1960s and early '70s, plants in the genus *Datura* acquired a luster of intrigue thanks to the popular "teachings of Don Juan" series by author and anthropologist Carlos Castaneda. He described learning about and experimenting with psychotropic drugs derived from wild plants, including devil's trumpet, *Datura metel* or *D. wrightii*. Those species have a long history of sacred and ritual uses in the American Southwest, Mexico, and South America, where, as Castaneda describes, shamans traditionally supervise preparation and ingestion.

Related species have similar properties and reputation. The hazards of North American East Coast native jimsonweed or angel's trumpet, *Datura stramonium*, were noted early on. Indeed, the common name is derived from the name of the early settlement Jamestown. There are accounts of starving colonists eating the greens in desperation and harming or poisoning themselves; of British soldiers "turning into natural fools" after ingesting it; and of Thomas Jefferson declining to add it to his gardens because he didn't want to risk exposing his household. *Datura innoxia* is closely related. Its moniker, thorn apple, refers to the prickly little egg-shaped fruits that are common to all the species.

Datura plants harbor potentially deadly alkaloid chemicals, including atropine and hyoscyamine. The beautiful trumpet-shaped flowers are the least toxic, and the leaves and seeds are the most potent. Intensity also varies according to plant age, growing conditions, and timing of harvest. In addition to the mental effects, consuming the plant affects heart rate, blood pressure, pulmonary functions, and more. Absent your own Don Juan, you should definitely avoid these plants.

The plants are not overly inviting. Most species smell bad, and they are mainly pollinated by spooky-looking night-flying moths. Handling the plants causes an irritating rash in some people. And the prickly pods certainly broadcast "do not touch," even after they dehisce and release the seeds.

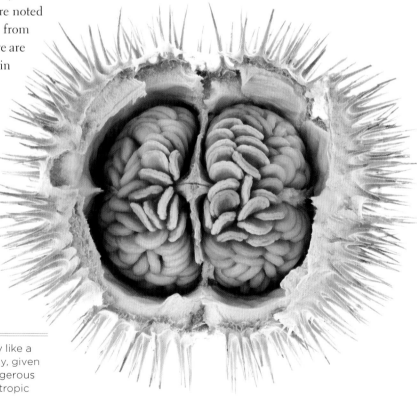

RIGHT The interior of a datura pod looks uncannily like a brain. This is interesting and perhaps a little spooky, given that the plant—particularly its seeds—is full of dangerous alkaloids and has been used as a powerful psychotropic drug.

OPPOSITE AND FOLLOWING While still on the plant, jimsonweed pods are bright green and earn the alternate common name thorn apple.

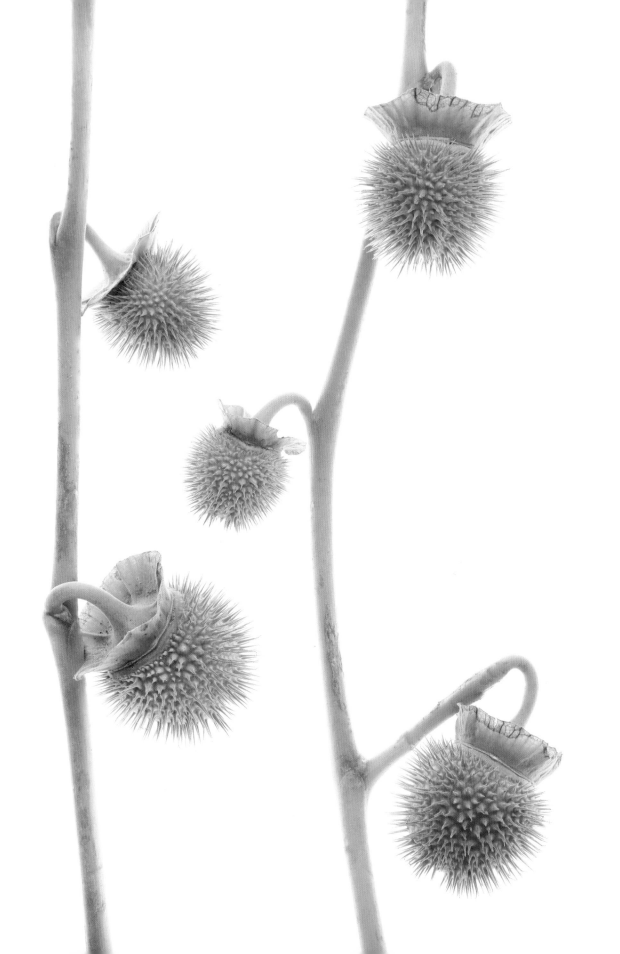

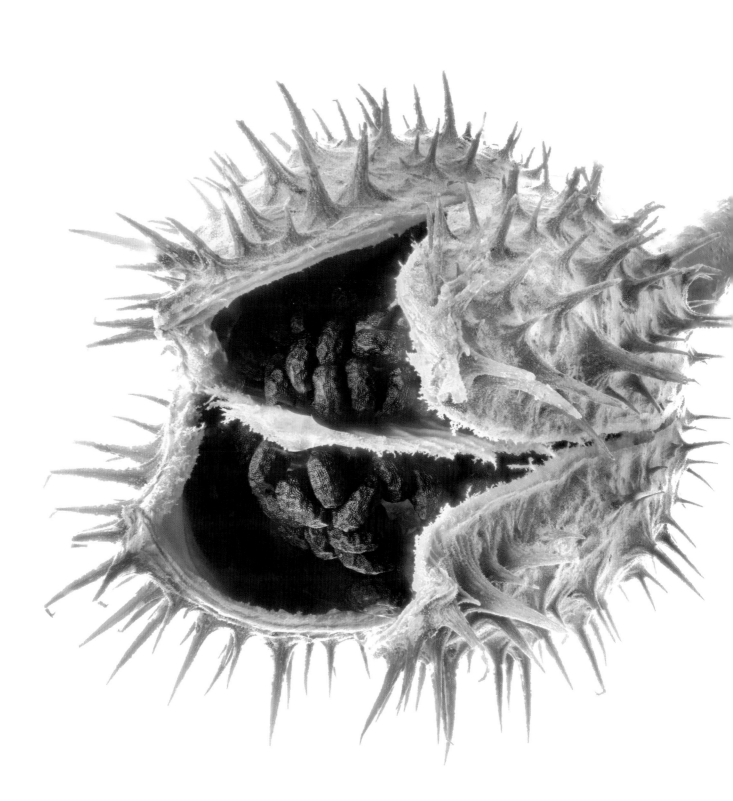

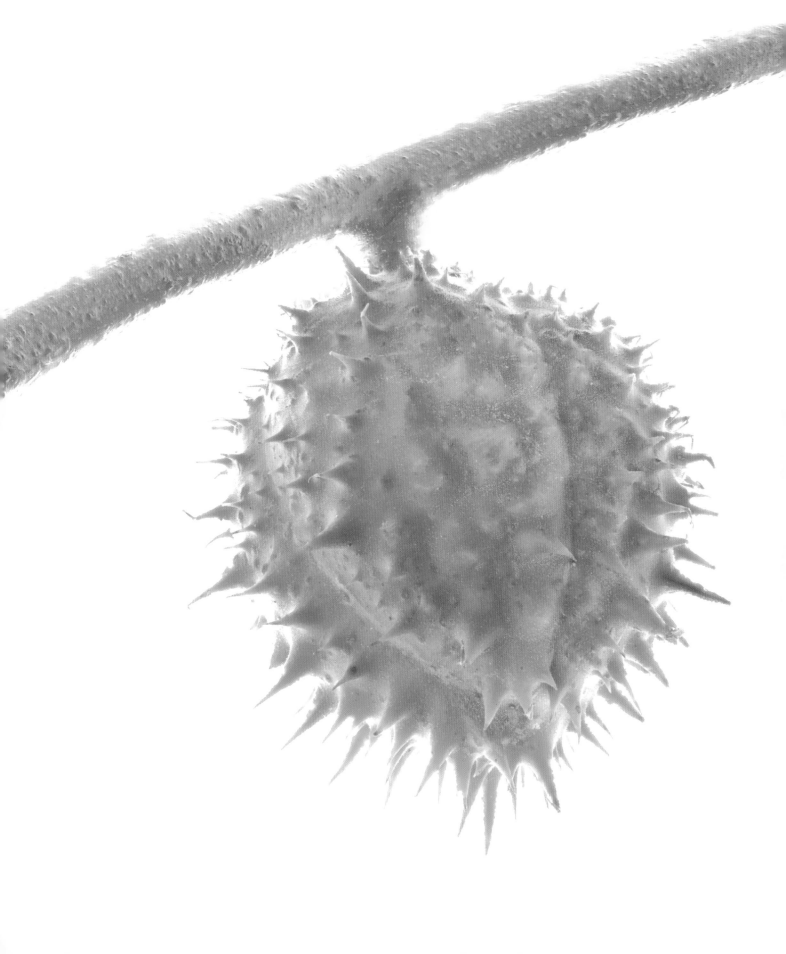

dill
Anethum graveolens

As food, dill seeds are versatile. Uncooked, they impart a faintly grassy, warm, lemony tang when tossed into a salad, slaw, salad dressing, sauce, or jar of pickles. In Indian dishes, they are often sautéed briefly in oil or butter before ingredients like lentils and vegetables are added. Herbalists also value them for soothing stomach distress, including as a carminative.

Aromatic essential oils supply the scent. The entire plant is fragrant, which is purely practical. The odor deters nibbling insects and other common garden pests, such as slugs and rodents. Birds, whose diets often include seeds, also eschew dill. As for pollinators, dill hosts everything from ladybugs to various flies and wasps, many of which are beneficial insects for a garden. But if you have an heirloom variety of dill that you want to preserve, don't grow any other dill varieties. Cross-pollination is the order of the day.

Like other umbellifers, dill seeds are produced in great numbers on broad flowerheads. They are flat and oval, brown with a lighter edge. Be careful when harvesting. If you yank, many seeds will fall off. Instead, carefully cut off a dry flowerhead and place it gently in a paper bag. Store the bag in a warm, dry place until the seeds fall off of their own accord.

Bear in mind that dill seeds need light to germinate, which is why those that fell in the garden sometimes outperform your hand-sown ones. But if you want to use the seeds in recipes, store them in an airtight jar in a cool, dark place. Use them fairly soon; older ones lose flavor as the oils slowly evaporate.

Like all umbelliferous plants, dill produces lots of seeds. These are aromatic and faintly oily. The strong scent appears to deter birds and other creatures that might otherwise eat them and thus reduce reseeded generations.

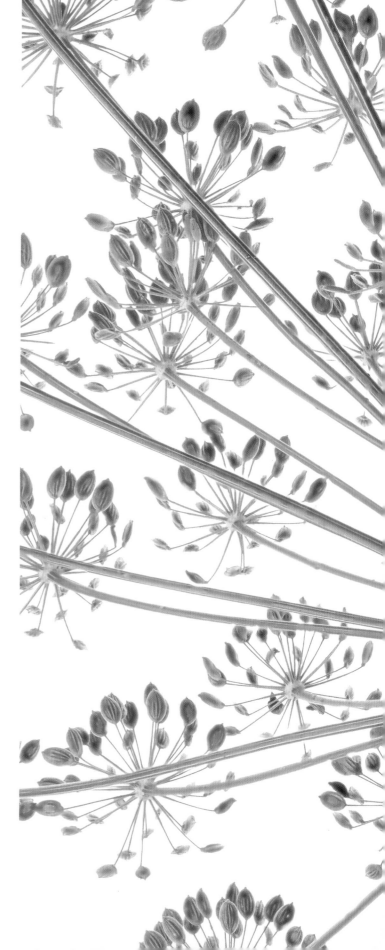

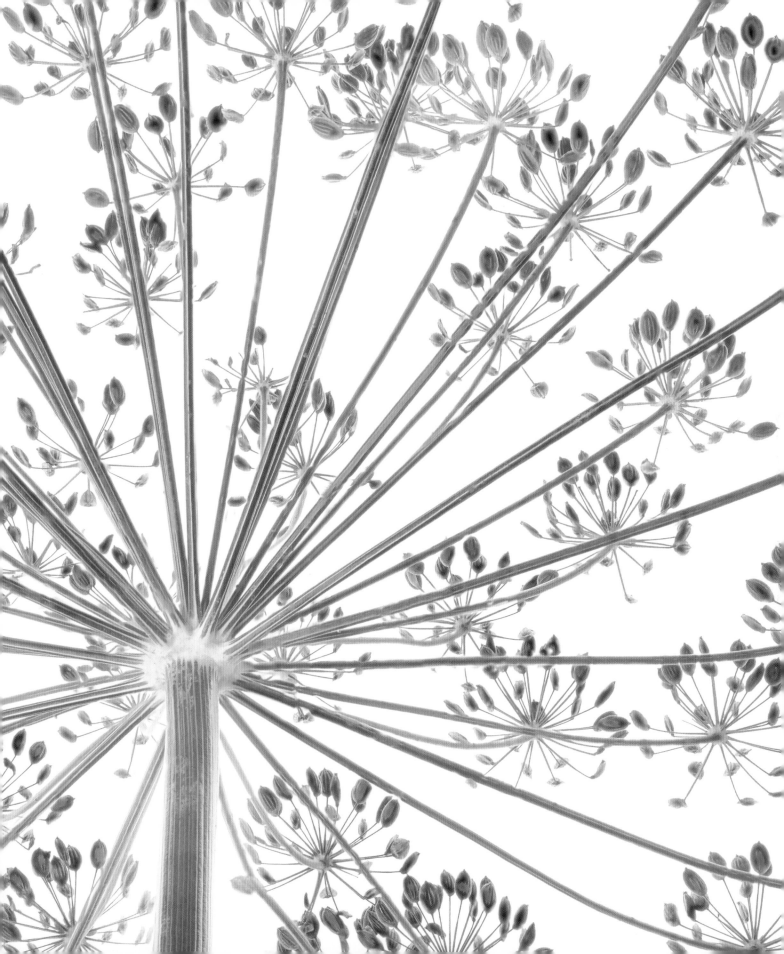

love-in-a-mist

Nigella damascena

Never more than knee-high, pretty love-in-a-mist likes a bright spot in full sun and generates flowers in coveted shades of blue and lavender (other colors are also available). Thready bracts set off the flowers. Foliage is feathery. The plant has long been popular in cottage gardens in the United Kingdom. It performs best in cooler areas and requires supplemental water in hot spells.

The puffy seed capsules that follow the flowers are also attractive. Some people dry them to use in mixed arrangements, to adorn wreaths, or to add interest to homemade potpourri. You have a choice: Snip off the flowers before they go to seed so the plants keep on flowering for a while longer, or let the inflated pods form. If you leave them, love-in-a-mist self-sows.

The seeds are edible and tasty, and as many as fifty are lodged within a pod. They are velvety black and triangular-shaped, and their flavor is smoky or peppery, reminiscent of oregano. A near relative, blackseed or black cumin, *Nigella sativa*, has flowers and pods that look quite similar, but its seeds are more pungent. It is prized in North Africa and parts of Asia and Europe. It's also a key ingredient in the Ethiopian spice mixture berberē, where it consorts with fenugreek, chiles, garlic, ginger, and more. In India, black cumin is added to vegetable dishes and sprinkled over bread.

Like poppies, these plants are in the buttercup family (Ranunculaceae), and flowers, seed capsules, and edible seeds are all valued. *Nigella* seeds and oil have been used to treat Type 2 diabetes, asthma, colon cancer, and opium addiction. Research is ongoing.

RIGHT A typical chambered pod of *Nigella damascena* contains many small, black, oily seeds. Their smoky, oregano-like flavor enhances soups, stews, and breads. African and Indian cooks prize those of close relative *N. sativa*, which are even more pungent.

OPPOSITE The puffy pods of love-in-a-mist dry well; the maroon and green stripes occur naturally and add to their appeal. Crafters like to add them to dried arrangements, wreaths, and potpourri.

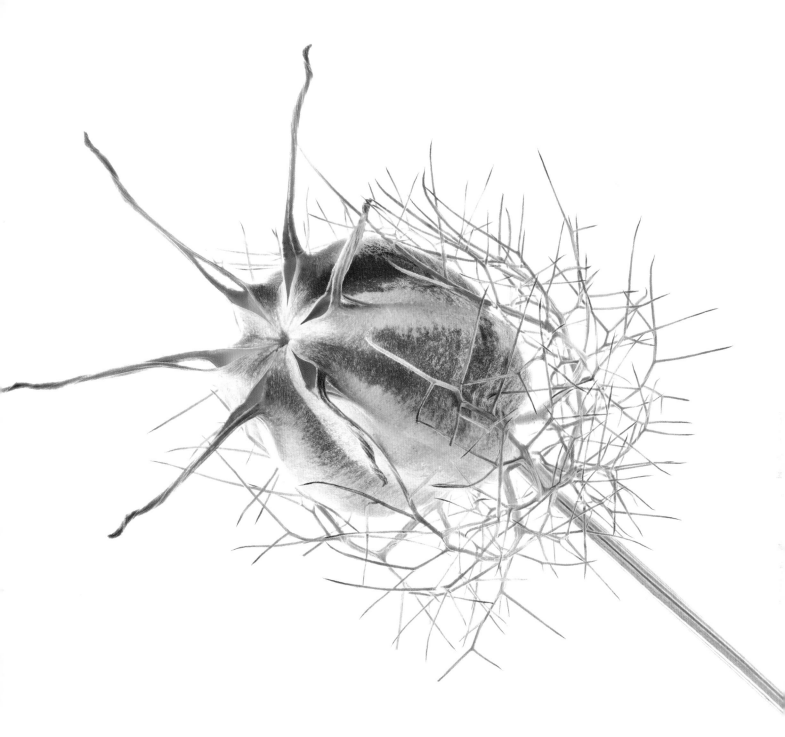

lyre-leaved sage

Salvia lyrata

People appreciate salvias for either the flowers or the foliage. Some gardeners prefer the annual bedding plant ones with dense flower spires, such as bright red *Salvia splendens* and purple-blue S. *farinacea*. Others prize the larger, bushier perennial types with wands of beautiful flowers, such as electric blue S. *coerulea* and lavender-and-white Mexican bush sage, S. *leucantha*. The sages of herb gardens are more modest-size plants, grown for their aromatic leaves. Their flowers, when present, are so inconspicuous that they are hardly worth noting.

As is typical of the mint family, individual salvia flowers are small and not very showy. They are tubular and two-lipped, with nectar and pollen down inside; the lower lip makes a good landing platform. This form attracts bees, hummingbirds, and butterflies.

Pollination in this genus is eccentric. Salvia flowers have only two stamens (not four, like other mints), which are hitched together to form a lever. When a pollinator probes, the lever moves and tips pollen onto it. After it departs, the stamens return to their original position. At the next flower, the stigma waits in the area where the pollen was deposited on the pollinator's body. It's all weirdly reminiscent of a pinball game or a Rube Goldberg contraption.

The small seeds that follow are black, smooth, and oval-shaped. They are sometimes called nutlets, which simply means that they are one-seeded, like an achene, but with a harder, thicker wall.

Shown here is a lesser-known perennial species, lyre-leaved sage (*Salvia lyrata*). It is native to open woodlands and thickets of eastern and midwestern North America, and is rarely seen in nurseries or gardens. Neither the pale lavender-blue flowers nor the leaves, though interesting in shape, can compete with those of their many relatives. But let's appreciate it in seed, which is undeniably exquisite.

Sages are in the mint family, and consequently lack big, splashy flowers. One that demands attention after its flowers pass, however, is the wildflower known as lyre-leaved sage (its foliage resembles the musical instrument). Jaunty veined capsules shelter small, dark, smooth, oval-shaped seeds.

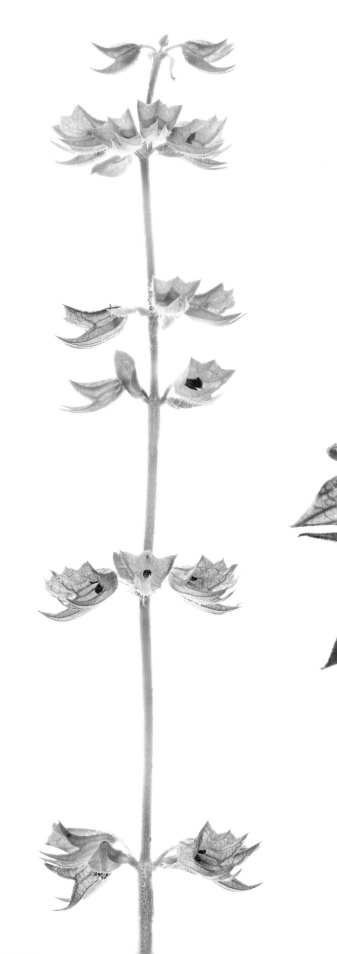

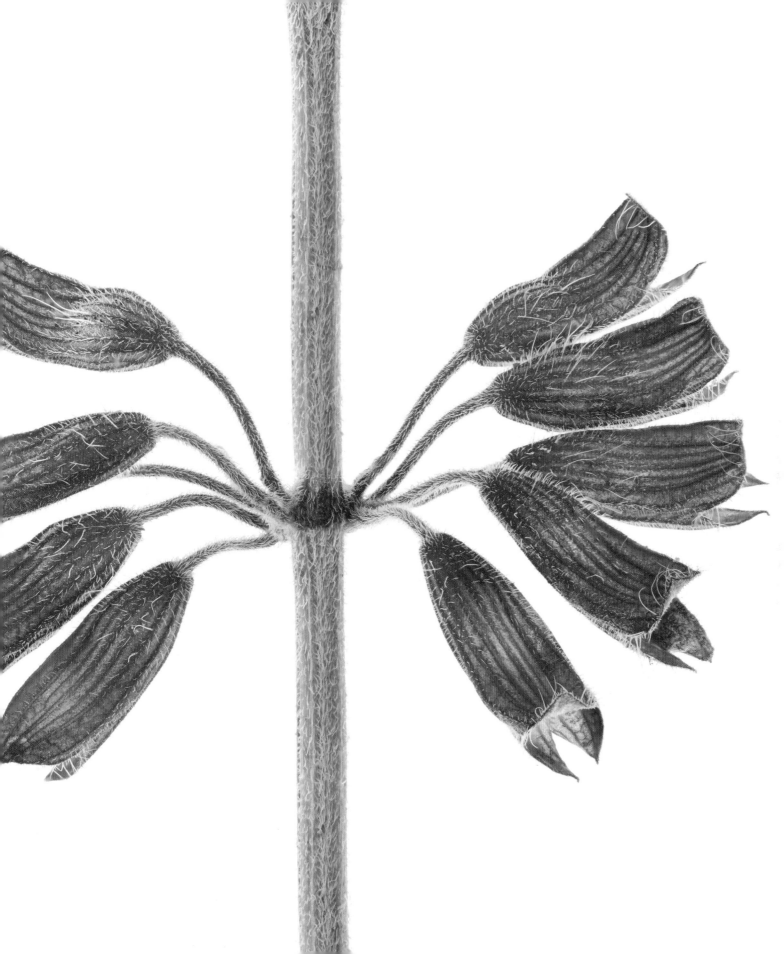

nutmeg

Myristica fragrans

Nutmeg is a seed originating on a large evergreen tree native to the famed Spice Islands of the Moluccas, Indonesia. It is grown commercially in similar habitats, including the island of Grenada, which proudly featured it on its colonial-era flag. The flowers and foliage are also aromatic.

Nutmeg trees are dioecious. Only female ones produce the sour yellowish fruit, which resembles a tough apricot. The pit may be dried for a couple of weeks until the seed rattles around inside, then cracked open to access the tasty nutmeat.

Nutmeg has long been harvested and exported to the rest of the world. It is widely available in powdered (dried, then ground fine) form, and it may also be found whole in natural food and ethnic markets. To use it whole, Indian cookbook author Madhur Jaffrey advises "just hit it lightly with a hammer. It is very soft and breaks quite easily."

Fresh nutmeg seed has interesting fleshy red webbing, mace, that may be peeled off. When dried and powdered, mace is used as a spice in its own right. Its flavor is similar, but both mellower and bit more peppery in comparison. Sometimes you may buy nutmeg seed with mace still on, although dried and brown.

Mace is technically an aril, intended to lure foraging animals into aiding dispersal. It develops from the funiculus, the attachment point of the seed in the fruit.

Connecticut's nickname, the Nutmeg State, can be traced back to its colonial days, when the spice was prized but rare and expensive. Unscrupulous traders whittled convincing-looking facsimiles out of wood. "Wooden nutmeg" became synonymous with fraud.

You may have sprinkled ground nutmeg on your holiday eggnog or into your favorite quiche Lorraine recipe with nary a thought as to its origins. Nutmeg comes from a large Asian tropical tree. After the Western world's initial flurry of excitement over the wonderful flavor of its fruit pits, it became an important crop in areas where it grows well. This brought down its price and widened its availability. The netted coating, initially red, dries brown. Peeled off and ground, it is mace, another valued spice.

pokeweed

Phytolacca americana

If you somehow miss this plant when it pokes up from the ground each spring, there will be no mistaking it by the time the berries form in autumn. Native American pokeweed is a fast-growing, big (sometimes taller than the average person), branching plant. The leaves are large and broad, up to a foot long and tapering at both ends; they have a sharp, unpleasant scent. Small white or purplish flowers form in long tresses by midsummer. Green berries ripen in late summer to wine purple. They look good enough to eat, but don't do it.

This imposing, hearty plant has never become a garden favorite, and for good reason: The roots, fruit, and tiny, snail-shaped black seeds are poisonous to humans. However, Native American tribes, colonists following their lead, and rural people enjoyed collecting and eating the young sprouts and leaves. Leaf and shoot flavor has been likened to asparagus or spinach, but the cook must soak and boil them for a long time, and then perhaps douse the results in a sauce. Dye and ink can be derived from ripe berries. The phytolaccic acid content has also led to plant parts being used for medicinal purposes, but not always with happy results—ingestion can cause vomiting, severe cramps, blurred vision, seizures, and even death.

An alternate common name is pigeonberry, and old references note that passenger pigeons relished these berries. This may account for the plant's wide geographic spread over most of the East Coast of North America, all the way out to the Plains, and down to the U.S. Gulf Coast. Robins and other birds also like them. Perhaps birds are immune—and the preferred dispersers. Or, given that birds do not chew or tend to crush seeds, we might hypothesize that the toxins are concentrated in the seeds. New plants grow readily from seeds as well as the impressive rootstocks.

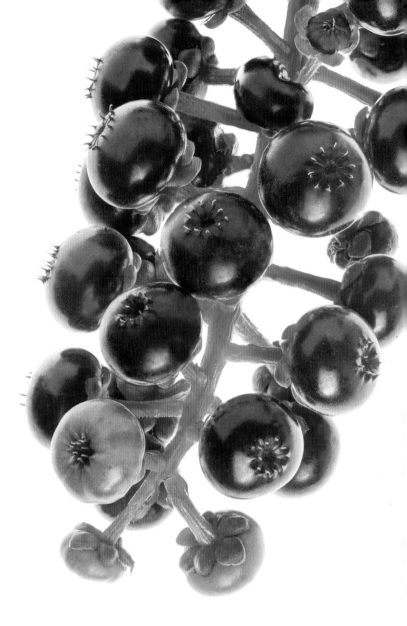

The wine purple berries of pokeweed look luscious, but don't eat them. They are considered poisonous to humans, though they have been employed in inks and dyes. Certain birds, on the other hand, relish them.

yarrow

Achillea species

Yarrow is hardly a splashy or unusual-looking plant, but it is more interesting than it may appear at first glance. It is a member of the daisy family (Asteraceae), and has the characteristic composite flowers. The flat-topped flowerheads are composed of myriad tiny daisylike blooms, each one comprising five petals (ray flowers) surrounding a disk of super-teeny flowers. Like daisies, sunflowers, asters, mums, coneflowers, coreopsis, and more, successful pollination leads to achenes, many individual single-seeded fruits.

Pollination is never a problem. The flat flowerhead makes an easy landing pad, and pollen is plentiful. Lots of flying insects are enticed, including butterflies, bees, moths, and flies. One stalk can produce up to 1500 seeds. Yarrow flowerheads hold their form and sometimes their color well, making them a favorite of gardeners and flower arrangers. Wind disperses the seeds.

Wind sends yarrow seeds short distances, and their rootstocks are able to send up new rosettes each year. Thus yarrow covers its bases, as it has two ways to create future generations. No wonder a plant or two soon becomes a small patch.

Some yarrows are slightly fragrant because of the presence of volatile oils lodged in the leaves, flowers, and seeds. Modern science has identified the compounds, which vary with the species and sometimes even the age of the plant and its health and growing conditions. Derivatives of salicylic acid, which treats acne and other skin conditions, are present; this validates the plant's long use as an anti-inflammatory. Azulene, thujone, and various flavonoids are also detected. These can treat a wide range of conditions, from indigestion to kidney problems. Herbal healers have always been grateful that this is such a tough and prolific plant.

Yarrow is not spectacular in profile or flower, and many gardeners consider it a weed, but the plant has redeeming qualities. When in bloom, the heads nurture a wide range of insect pollinators. Seed crops are bountiful; some are wind-dispersed and songbirds eat others. The entire plant, including the seeds, contains volatile oils that are useful in herbal medicine.

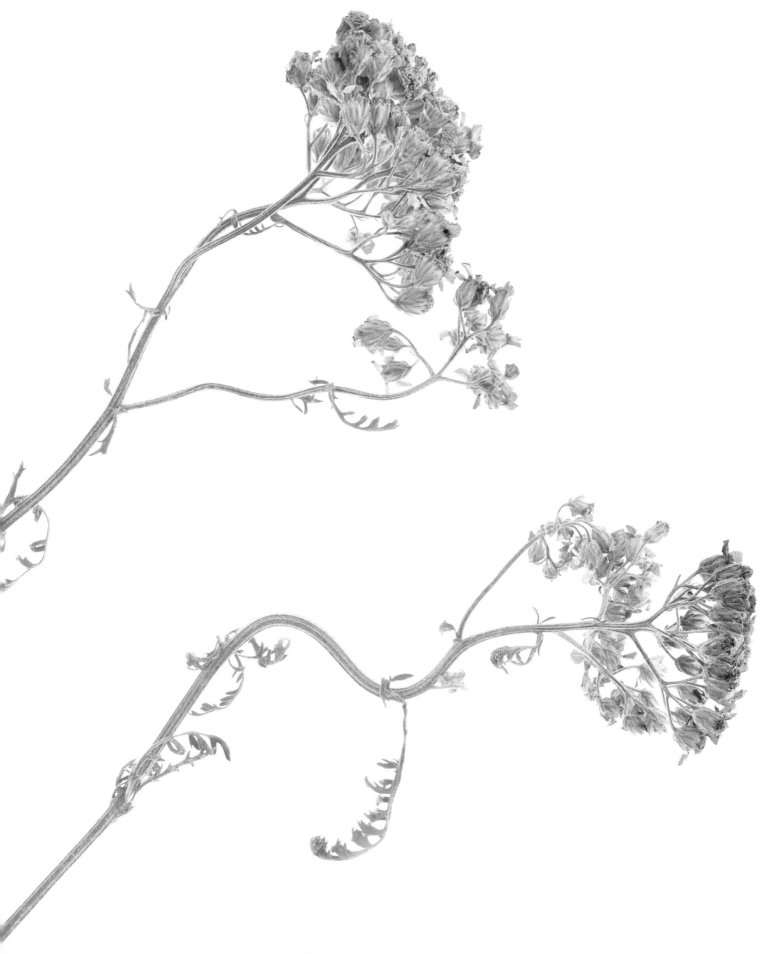

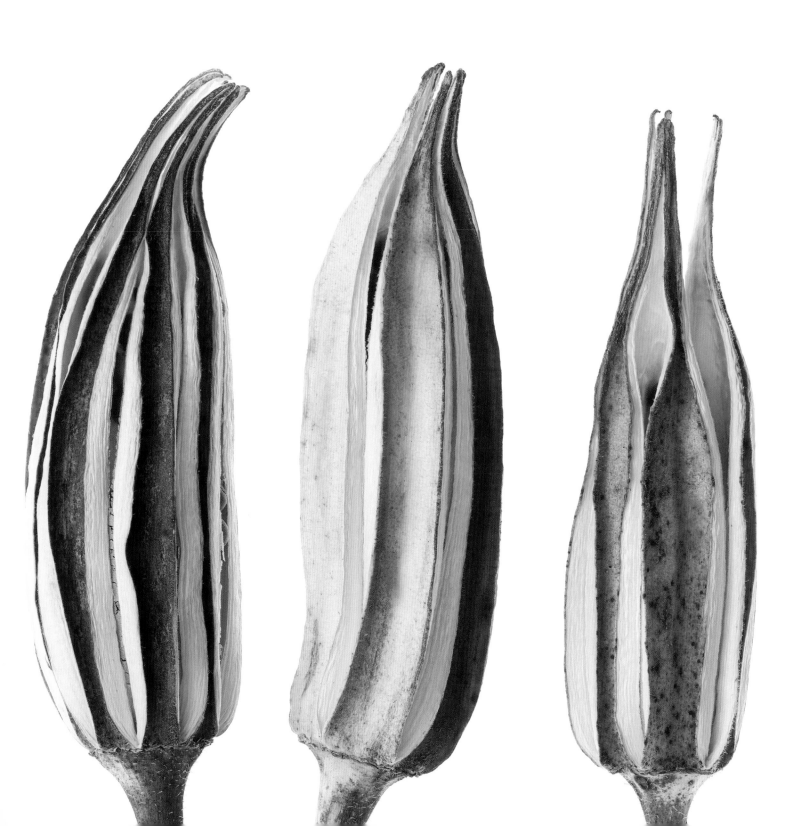

FRUITS AND VEGETABLES

I N THEORY, when we eat fruits, vegetables, and seeds, we are participating in nature's plan for mammals to aid in dispersal. We certainly did so once upon a time. Humans and their activities, including migrations, are inextricably linked to the distribution of many plants. But nowadays we are not really helping. We ingest hybrid fruit and vegetable seeds that may not be viable or will not lead to the same or worthwhile offspring. Most human-consumed seeds don't even get a chance to generate the next generation. They end up at the sewage treatment plant or in a septic field, landfill, or compost pile.

But we can be part of the solution in the realms of agriculture and gardening. We can grow locally adapted and heirloom or open-pollinated varieties. We can urge our friends and neighbors to join us. We can learn to collect and save seed. It is in our species' own best interest to nurture genetic diversity and the resilience it implies. This is urgently needed as our climate changes and population growth continues apace.

Many fruits and vegetables, if left on the plant, form dry seed-filled pods. These beauties are from the okra plant.

apple

Malus domestica

What could be more commonplace than apple seeds? You might even know that these small, dark seeds protect themselves from being eaten by being poisonous (they contain cyanide). Also contained in these little packages is, of course, genetic information.

Your discarded apple core may lead to a seedling, and that seedling might survive and grow large enough to produce fruit, but it won't yield apples like the one from which it originated. This is because apples have been in cultivation for centuries, and the ones we eat are highly bred.

Modern-day orchardists raise named varieties from clones and grafted trees. In grocery stores, we usually find a few popular ones, such as 'Red Delicious', 'McIntosh', and 'Gala'. These tend to have tough skin that withstands jostling and resists bruising. If you live in an area with small orchards and farmers' markets, you will find a wider range of apple shapes, colors, and flavors. But even so-called heirloom apples are not raised from seed.

Historically, apples hail from Kazakhstan, where groves of them still survive on rugged hillsides. The famed repository of apple varieties maintained in Geneva, New York, includes seeds and cuttings from those trees as a bulwark against an ever-shrinking gene pool.

John Chapman, better known as Johnny Appleseed, disseminated apple seeds (not cuttings) over his long and colorful career along the American frontier in the early 1800s. He also spread genetic diversity. Of course, in those days consumers were not demanding predictable, uniform apples; they were mainly making low-alcohol hard cider. But we can thank Johnny for sowing the seeds of regional adaptability, even though that was likely not his intended goal.

RIGHT It's no accident that apple seeds are so small and slick. They don't require the armor that some seeds and capsules have to repel predators. They don't need appendages such as hairs or prickers to grab onto fur or feathers. Their dispersal agents eat the sweet, juicy flesh around them and either discard or fail to digest the intact seeds.

OPPOSITE What you've heard is true: tiny apple seeds, sometimes called "pips," do contain cyanide. This is thought to discourage predators from eating them. A human would have to ingest a massive amount to be affected, no worries! Also their hard shells protect the contents—for the toxins to be released, the seeds need to be mashed or chewed.

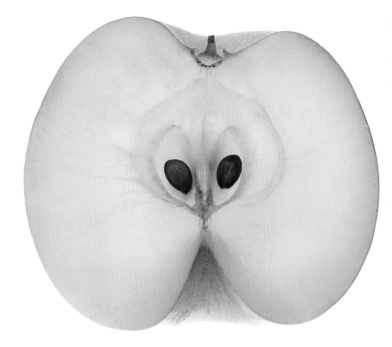

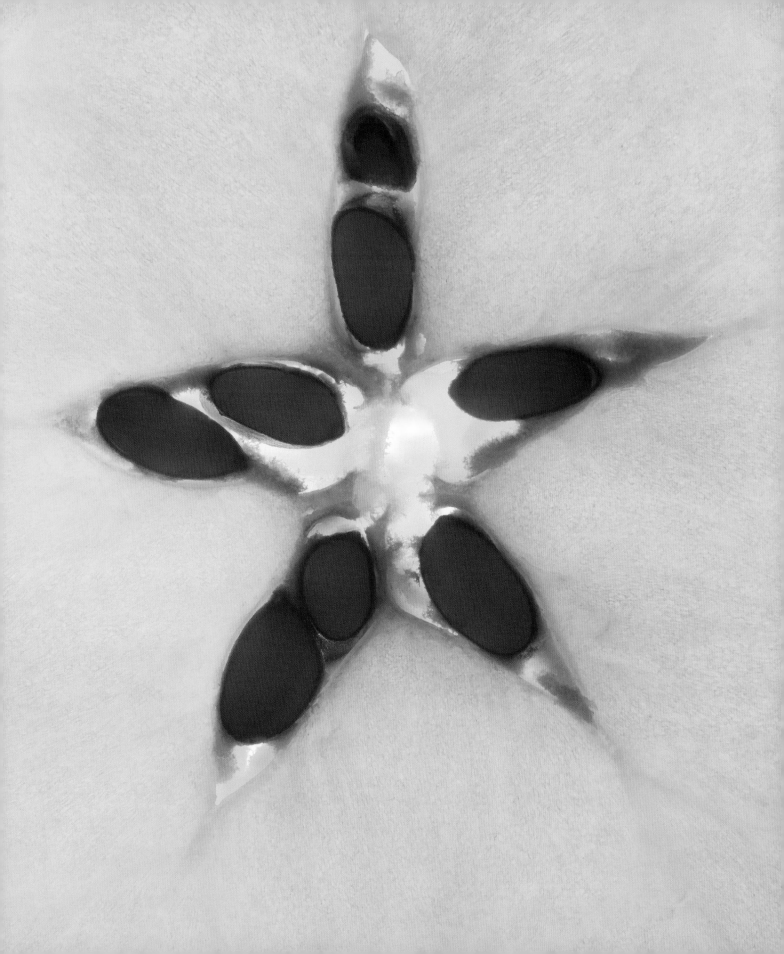

arugula

Eruca vesicaria

These greens have enjoyed a recent surge in popularity as we have become more sophisticated salad eaters. Peppery arugula, also called rocket, is a member of the cabbage family (Brassicaceae). It is rich in vitamin C and potassium. Tender young leaves have a milder flavor; older ones can be downright hot or even bitter.

Arugula is grown the world over. In particular, many Italian and Brazilian recipes feature it. In Egypt, the plant is called *gargeer* and is considered a stimulant or aphrodisiac. So it was once in ancient Europe, where monks were barred from growing it in their gardens. However, there is no particular chemical component of any of the plant parts that supports these beliefs, unless eating something sharp-flavored simply perks you up. Yet an Arabic rhyme, "Lau maratuk errfet serr il gargeer, la zarito tat el sareer," translates loosely as, "If the wife knew the secret of arugula, she would sow it under the bed."

Arugula is simple to grow from seed. Indeed, acquiring a packet might be the first or only time you view the seeds, which are tiny, smooth, and brown. They typically produce edible greens in thirty to forty days.

If plants are allowed to flower and then form seed, their kinship with mustard, collards, and even radishes is apparent. Clusters of small off-white flowers marked with purple (landing-strip indicators for insect pollinators) yield to siliques, which are long, skinny, pointy-ended pods. Within each silique are several seeds. These are perfectly edible and can be eaten raw or toasted; like the leaves, they have a tangy, peppery flavor. Or you can save the seeds and start over again next year. A word to the wise: Different varieties will cross with one another, but arugula does not cross with any other brassica.

The trendy, sharp-flavored salad green gives away its kinship with members of the mustard family when it goes to seed. Its skinny, seed-laden pods, or siliques, are characteristic. The pleasantly peppery seeds are also perfectly edible, raw or toasted.

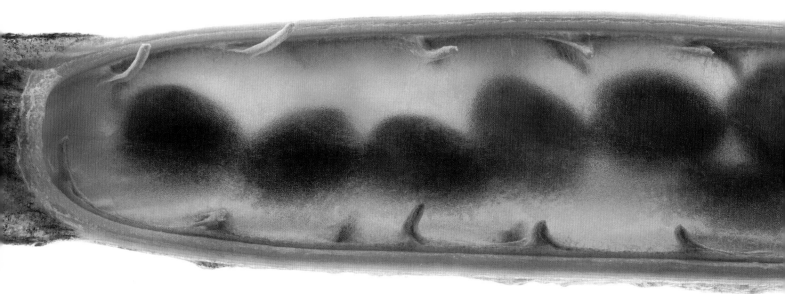

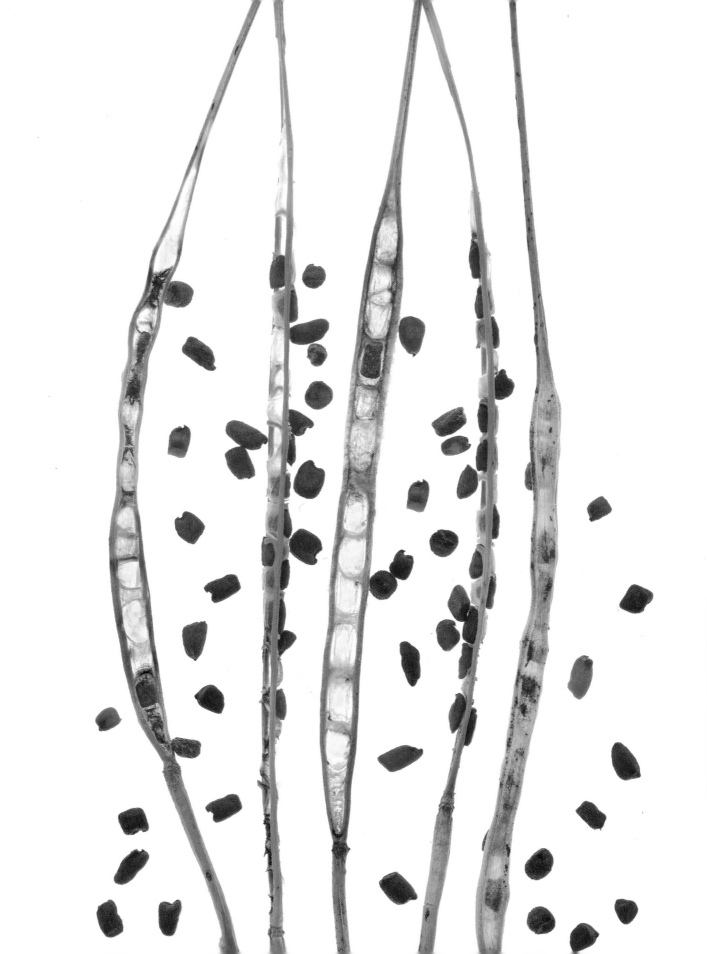

Asian long bean

Vigna unguiculata subsp. *sesquipedalis*

If are unfamiliar with Asian cuisine, a trip to an Asian market can be an exotic adventure. You will see heaping displays of greens and other vegetables that look vaguely familiar but are unknown to you and your palate. Asian long beans may be one such vegetable. They are also known as yard-long beans, a slight exaggeration but nonetheless a nod to the impressive length (24 to 30 inches) they can attain if grown under suitable conditions. They require fertile soil, full sun, and ample space, for they are vining plants, not bushes. In a warm climate, they really do grow an inch or more per day. Pods are usually carried in pairs.

Asian long beans are best eaten while young and flexible (older pods become fibrous and dry). Don't boil these beans in water or submerge them in a soup or stew; they become waterlogged and lose flavor as well as their crisp, juicy texture. Instead, sauté or stir-fry in hot oil (not too much!) to preserve their bright color and intense, delicious flavor. Purple-podded ones lose their color if cooked too long.

Like all bean plants, pollinators are required to generate the seed-filled pods. Many insects are drawn to the white flowers, but bees are not, perhaps because the pollen sheds before the flowers open. Instead, flies, certain yellowjackets, and even ants do the work. This is still a recipe for success, as plants can set lots of beans. If you look closely, you will notice that the stems are loaded with buds that ripen sequentially, with the lower ones maturing pods first. It's possible to harvest for weeks on end well into autumn. If you somehow miss a pod, the dried seeds—beans—within the pod can be used like any dry bean. Some varieties have white seeds, while others are black.

Sometimes called yard-long beans (an exaggeration), Asian long beans are longer and more flexible than green beans. The purplish ones lose their color and revert to green when cooked. If left on a plant too long, they dry out, but you can always harvest and eat the nutritious beans inside.

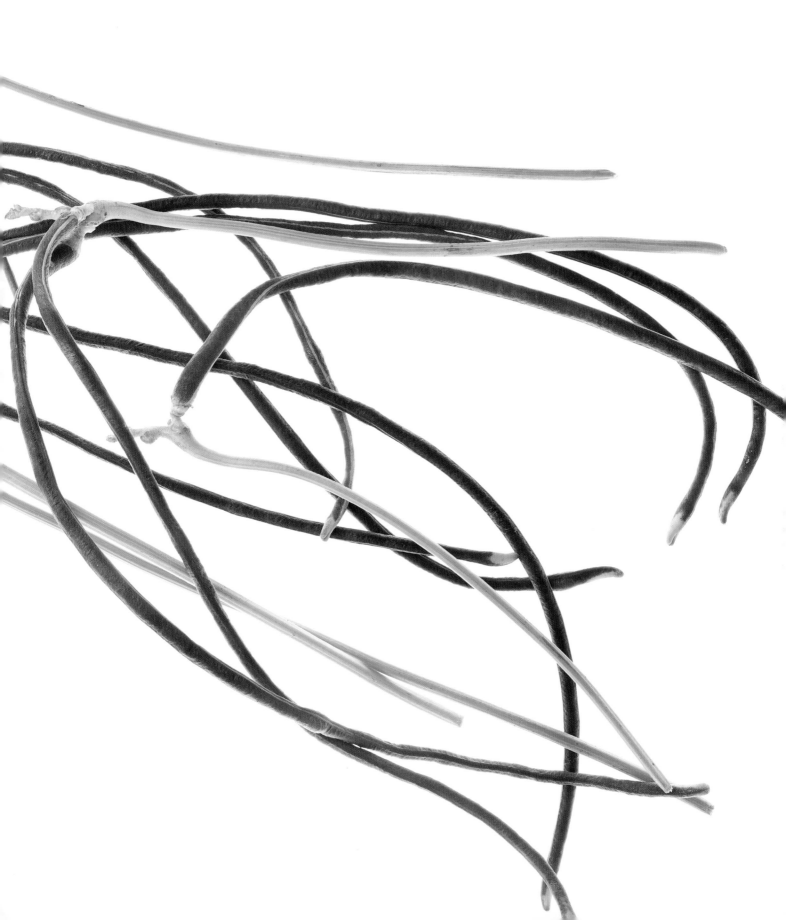

bitter melon

Momordica charantia

This warty, oblong, green-skinned fruit is not really a melon or a gourd. It is a vining cucurbit, classed as an edible gourd. This distinguishes it from decorative gourds like the little pear-shaped ones sold in autumn, or those that crafters dry and use, like the birdhouse gourd. Bitter melon is more closely related to the calabash. It is also kin to the bitter-tasting cacana, *Momordica balsamina*. Asian markets sometimes label this one *karela*.

Bitter melon, or bitter gourd, is actually unripe when green. It ripens to yellow-orange, but by then it is entirely too bitter to eat. A fully ripe fruit becomes orange and mushy, with reddish pith inside. At this point, it separates into three curled-back valves and exposes seeds encased in red pulp or, more correctly, arils.

If the interior of your bitter melon, or *karela*, reaches this colorful but mushy stage, it's too late to eat it. The flesh is even a touch bitter while green, but at least it's still crisp and juicy. The seeds are usually discarded—or, if red-coated and ripe, planted.

If the fruit is picked and sold well before this happens, its flesh will be crunchy and juicy, similar to cucumber or chayote but with a hint of bitterness. It is grown and sold for eating throughout China, Japan, India, Thailand, and the Philippines, as well as parts of South America and the Caribbean. Chefs scrape out the seeds and flesh and stuff the interior with fish or ground pork, chopped vegetables, and spices, or chop up the rind and add it to stir-fries and soups. There is even a bitter melon carbonated drink.

The shape of the seeds is intriguing. They are lobed like a white oak leaf. This form likely has a practical purpose, such as helping the seeds adhere better to the arils and the interior flesh.

Various plant parts have been deployed medicinally, including for antimicrobial and antiviral uses, to treat cancer, for female issues such as abortion and infertility, and to combat diabetes. Western medicine has identified some proteins, steroids, and an insulinlike peptide, but more research is needed.

black salsify

Scorzonera hispanica

The first time salsify appeared on my culinary radar, it was mentioned in an evocative magazine article about the magic of Christmas traditions in Germany. On a frosty day, the author was warmed by a steaming bowl of *schwarzwurzel-suppe*, a black salsify soup drizzled with sour cream and pumpkin seed oil. Just reading about it ignited warmth down to my toes.

There is black salsify and closely related white salsify (*Tragopogon porrifolius*). These are skinny white-fleshed root vegetables. The exterior of each one is the color named (although the black one is closer to dark brown). The flavor is often described as oysterlike (and another common name is oyster plant), but it is earthier and more like artichokes. The thick skin is removed prior to cooking. Black ones will stain your hands as you work with them. Like parsnips, salsify roots will oxidize when exposed to air, so plop them in a pan of cold water (add a little lemon juice or vinegar) to preserve their color while you prepare them. Steam, boil, or sauté in butter, then serve hot with a béchamel or mustard sauce.

This plant grows wild in the Mediterranean region and is used in recipes from Italy to Spain to, as mentioned, Germany. In Greece, the plant has been called billy goat's beard because of the silky filaments on the seeds. They resemble those on dandelions, which is not surprising, as they are in the same plant family (Asteraceae). Salsify's daisylike yellow flowers are pollinated (probably cross-pollinated) by bees. Seeds are, obviously, wind-dispersed.

Salsify is easily raised from seed and requires little fussing. Sow in spring and harvest in autumn. Like some other root vegetables, the flavor is even better after a fall frost. Because plants are biennial, you won't see flowers until the second season.

Salsify is a member of the same plant family as dandelions, and it also has a whitish seedhead full of seed parachutes that are dispersed on the wind. But unlike its cousin, it has an edible root—in fact, it is deliberately cultivated for the root. An alternate name, oyster plant, hints at the flavor, though some people find it more earthy.

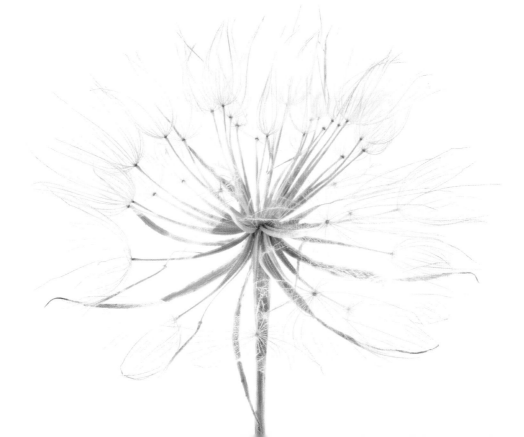

eggplant

Solanum melongena

The closest most of us have come to noticing eggplant seeds is when we slice or dice the spongy-textured fruits for cooking. The seeds are small and unobtrusive, and they don't affect the flavor of the dish. In fact, they add a pleasant little textural crunch.

But the seeds tell a story. Look closely at a disk-shaped slice of eggplant, which reveals seeds arranged in bundles or even concentric circles. If you cut the fruit lengthwise instead, you can observe long, loopy seed trails. The greatest density is toward the bottom of the fruit, away from the plant and the calyx that once clasped the flower.

Botanically, an eggplant is a berry, so once the flowers are pollinated their many carpels lead to many seeds. Pollination can be frustrating for gardeners. Sometimes you get lots of flowers but they drop without forming fruit. While this can be attributed to cool weather (the plants dislike lower temperatures) or too-dry soil (they need evenly moist soil to develop properly), it could also be a pollination issue. Eggplant flowers mostly self-pollinate with the help of wind, although insects can cross-pollinate. Some gardeners have been known to intervene with a wee paintbrush to make sure the flowers distribute their pollen.

Once developed seeds grow larger and turn brown, they are good for scraping, drying out, and saving to plant next year (assuming they are from a nonhybrid type, like the enduringly popular 'Black Beauty'). If you cook and eat an overripe eggplant, the seeds will contribute a bitter taste.

Ever notice how eggplant seeds are tan and soft, blending into the spongy pith and maybe adding only a slight crunchy texture to your stir-fry or casserole? In an overripe eggplant, they are larger, darker, and harder, and their flavor becomes noticeably sharp and unpleasant.

Egyptian onion

Allium ×proliferum

This onion, also known as walking onion, is easy to grow and has a mild flavor. You can prepare and eat it just like any other onion. Typically Egyptian onions are sold as and raised from bulblets; seed production is not common. The plants are perennial and fairly cold-hardy. In fact, they might be the first plant you harvest each spring. The lower white part of the shaft is primarily used as the season progresses.

Each plant slowly but surely becomes a clutch of large green onions. In midsummer, usually starting in its second year, a plant sends up a seed stalk and the bulblets form on top. You can cut off the bulblets and replant them to increase your onion patch, give them away to other gardeners, eat them, or store them for later use or planting. In this way, they are a lot like their cousin garlic.

To raise a good crop, plant deeply. Dig a trench a shovel's depth or more (about 10 inches) and set in the bulblets at intervals. As the green shoots push skyward, backfill the soil. This results in a long white blanched shaft. To harvest, lift a clump with a spading fork and separate out the ones you want. Firm the dirt back around what's left and carry on.

No one is sure about the origins of the common name, even though ancient Egyptians evidently appreciated onions. Walking onion makes slightly more sense: A bulblet cluster can grow heavy and eventually cause its stalk to arch over and bend down to the ground, where it can take root. If the stalk is tall, new plants effectively travel a few feet from the parent plant.

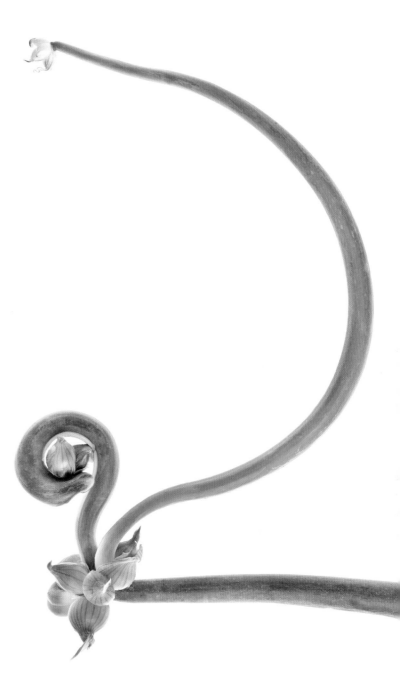

Yes, it looks a bit weird, but nothing truly odd is going on. Like other alliums, this onion produces leafless flower stalks called scapes. The flowers will produce seed, but often we use offsets, bulbils, or bulblets to get more plants—it's faster and more reliable.

These particular onions—like garlic and a few other related plants—can form quite a gathering of reproductive material atop their seedstalks. Little flowers give way to bulblets and, as shown, sometimes crowd one another. You can pluck them off and plant them.

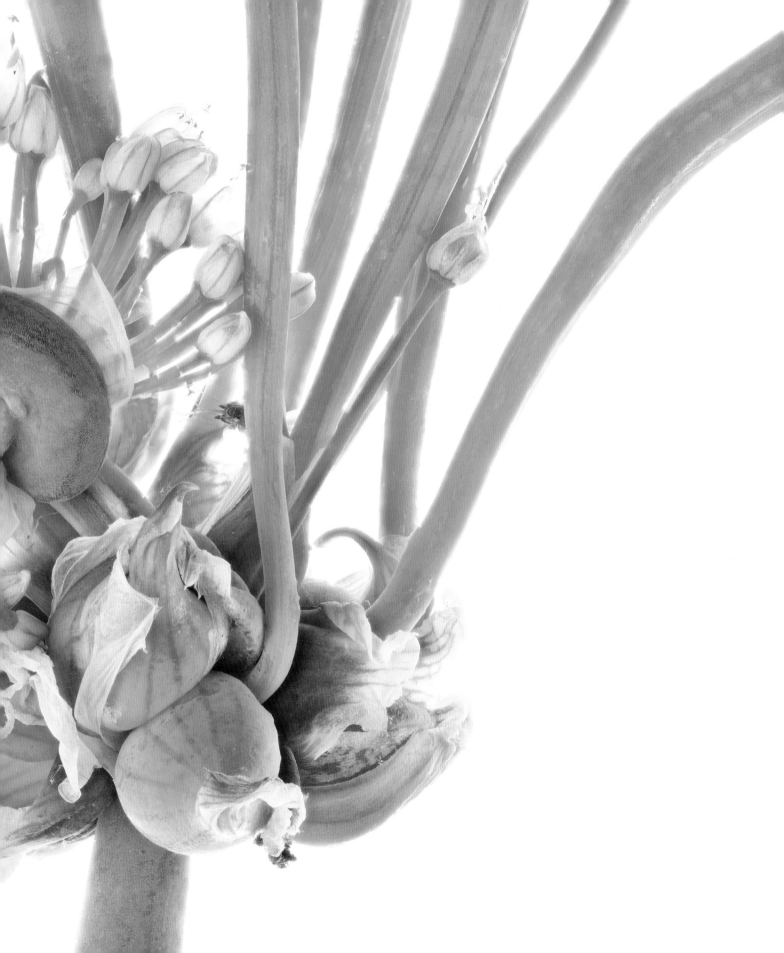

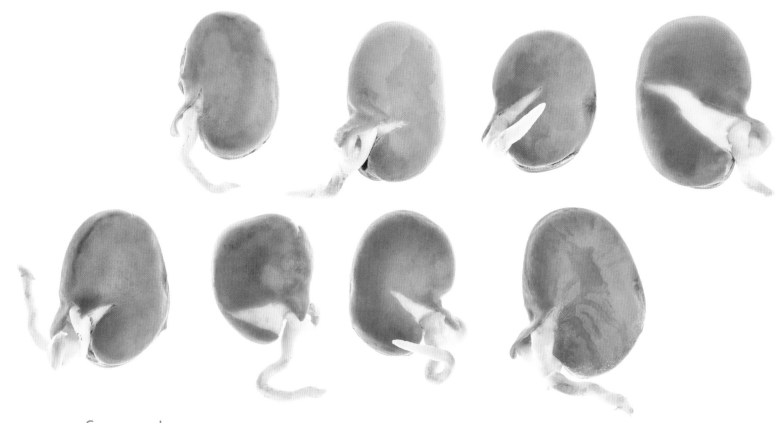

fava bean

Vicia faba

Beans are traditionally held up as an example of a dicot seed. It's easy to identify the protective seed coat, the endosperm within, the little embryo, and—in time—the first pair of leaves. Fava beans are no exception.

But favas, or broad beans, also have unique qualities. First is their long history, tied to their worldwide distribution. Ancient Greeks and Romans grew and ate them. They were known in ancient Egypt. They are a staple of Middle Eastern, Asian, and Mediterranean cooking. Plants are self-pollinating—with help from bumblebees, who adore their fragrant flowers—but also prone to crossing, so there are variations in size and flavor.

Unlike other beans, favas tolerate frost and struggle in hot weather. They are best sown in spring, when peas and potatoes are planted. You can pick young beans early to enjoy like green beans, or let them go longer and use the mature ones like limas (some cooks remove the tough outer skins). Each long pod has four to eight beans nestled in a velvety interior.

Some people suffer from favism, an inherited condition that causes a reaction to eating fava beans or even being exposed to their pollen. Favism triggers the destruction of red blood cells, and victims feel exhausted; in the worst cases, they slip into a coma. The condition affects men more than women, mostly in the Mediterranean and Africa. Among the likely culprits in fava beans are tyramine, vicine, and covicine (the latter two are alkaloids). Unfortunately, their presence is no deterrent to the plant's main garden enemies, slugs and black aphids.

On the other hand, favas can combat the microscopic protozoa that spread malaria. This is interesting, considering that the plants are indigenous to malaria-prone areas. They are also rich in L-dopa, an agent used to treat Parkinson's disease and high blood pressure.

Fava beans look like big lima beans. They germinate like classic dicots, casting off their seed coats and sending up a pair of leaves and sending down a proto-root. They grow up to be a pod-studded vine.

fig

Ficus carica

You may already know that the small deciduous tree with large, distinctively lobed leaves produces green-yellow or brown figs with pinkish flesh. Figs are popular in warm climates practically worldwide. Gardeners in colder areas raise plants in tubs in sheltered spots, devising ways to protect them from winter temperatures.

What you may not realize is that figs are a bit eccentric. An edible fig is a synconium, fleshy stem tissue with internal flowers. This is why you don't see a display of flowers on fig trees before the fruit forms.

Many figs are parthenocarpic, which means they don't make seeds. Popular varieties, such as 'Celeste', 'Mission', and 'Brown Turkey', produce without fertilization ever taking place. Allow the figs to ripen on the plant. Toss on some netting if birds get interested. Some plants bear more than one crop per season.

Smyrna-type figs are another, more complicated story. These are dioecious. When raised from seed, there will be some female (genetically different from the mother plant) and some male plants, caprifigs. The pollinators are specialized little wasps that hatch inside. Males do their duty and stay behind. A gravid female travels to a flowering caprifig, enters via a pore at one end, lays eggs, and delivers pollen. But she might crawl into a male synconia. Or the female flowers could be short- or long-styled, complicating the pollen delivery. With these figs, successful pollination is hardly a slam dunk.

Some people fret that figs are crunchy not because they are laden with seeds but because there are wasp remnants inside. Cautious eaters should not worry. Where present, the wasp bits disintegrate quickly as the fruit ripens. Besides, most domesticated figs are parthenocarpic.

Sometimes a little knowledge is a dangerous thing. Figs are pollinated by specialized wasps that must climb into the fruit, for the flowers are internal. Regardless of whether they succeed, the wasps never leave (in fact, the males spend their entire short life inside). Is the crunch of a fresh fig actually from wasp bits? Some vegans fret about this, but they should rest easy. Wasp parts naturally disintegrate fairly quickly, and most figs we grow and buy are parthenocarpic, or seed-free. The slightly gritty texture is from the tiny flowers. Or, in the case of smyrna figs, the oily seeds.

horned melon

Cucumis metuliferus

This odd-looking native African fruit is a cucurbit and an annual climber. When sliced open, the interior may remind you of a cucumber, with a thin layer of flesh within the tough exterior and many flattened white seeds. These are embedded in slick, jellylike light green flesh.

A popular way to eat this fruit is to scoop out the insides and suck the watery jelly off the seeds before spitting them out. The flavor is rather bland but slightly sweet, reminiscent of a weak pineapple or a banana-lime-kiwi blend. In his book *The Fruit Hunters*, Adam Leith Gollner remarks that horned melon, or kiwano, is "a Day-Glo spiky orange lump that could be mistaken for a radioactive horned toad," and directs readers to tastier options.

Botanically, the jelly encasing the seeds serves the same purpose in similar-looking fruit. Flavor peaks when the seeds are finally ripe, enticing creatures that can act as dispersal agents to eat the fruit. Birds and rodents enjoy horned melons, as do antelopes in their native habitats. Like the fruit of the prickly pear cactus, it is a welcome source of moisture in arid areas.

If you are intrigued and don't find this fruit in a specialty market, it is easy to grow, provided you have a long growing season. Raise it like you would pumpkins or watermelons—that is, sow seed in full sun after danger of frost has passed, and water regularly. One vine can generate up to 100 fruits. Be forewarned: In an appropriate spot, the vine will grow like gangbusters. When the pear-size fruit forms, it ripens from green to yellow to orange. The many spines (not just studding the fruit, but also on the stems) are clearly protective. Wear gloves.

This exotic-looking cucumber relative sometimes turns up in specialty markets. You can't miss it, for a ripe one is bright orange and studded with sharp little horns. A popular way to eat this in its native Africa is to slice it open, slurp off the slightly sweet, watery green flesh, and spit out the seeds.

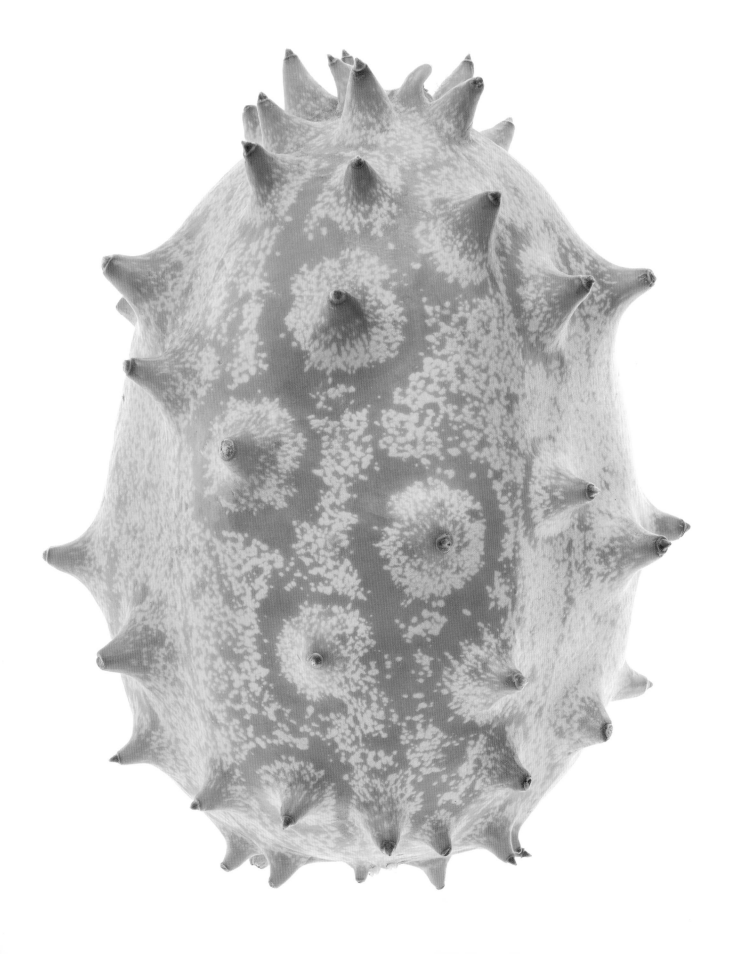

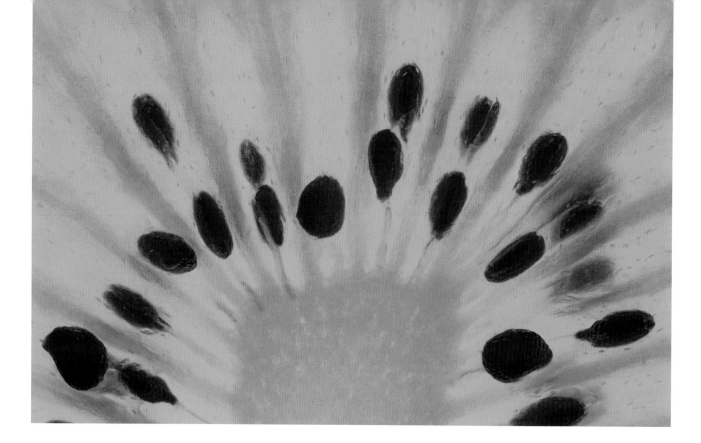

kiwifruit

Actinidia species

We have grown comfortable with kiwifruit in North America, but there was a time when it was an exotic treat from Asia or New Zealand. There are three slightly different versions of this vining plant in wide cultivation around the world. Aptly named *Actinidia deliciosa* was originally exported from China as an ornamental plant, but is today it is valued for its large, hairy brown fruits. Hardy kiwifruit, *A. arguta*, produces little fruits in grapelike clusters and is more cold-hardy. Yet another species, *A. kolomikta*, is hardier still and prized for its handsome pink-and-white-splashed foliage.

Whether egg-size and hairy or grape-size with smooth skins, all kiwifruits start out green and mature to brown. The interior flesh is green, tangy-sweet, and studded with little black seeds. The fruits are rich in vitamin C.

With the exception of a few cultivars, kiwis are dioecious. If you grow them with the plan of raising your own fruits, plant a separate (nonfruiting) male vine nearby. Both male and female flowers are often half-hidden by the lush foliage, and are small, cup-shaped, and white maturing to dull gold. In an odd twist, female flowers have sterile stamens and male flowers have tiny nonfunctional ovaries.

Honeybees mainly perform pollination, although other insects and occasionally wind may assist. Gardeners anxious for a good harvest sometimes intervene, picking a male blossom and rubbing its pollen on up to six female flowers.

You can raise new kiwi plants from seed, but there's no telling whether the seedlings will be male or female until they flower. They are not likely to be copies of their parent plant. You don't have to fuss—you can sow them in flats along with their pulp and thin them later.

Slice open a kiwifruit crosswise and you get to admire its beautiful green flesh speckled near the center with numerous little black seeds. Notice also the lighter-colored rays, which account for the origin of the Latin genus name (*actin* means ray).

okra

Abelmoschus esculentus

Owing to its easygoing, prolific seedpod production, the cuisine of cultures all around the world features the okra plant. Chefs can mitigate the mucilaginous nature of the cut pods or capsules by cooking them in stew, gumbo, or callaloo (where it can act as a thickener). Okra is also served fried, boiled, pickled, and grilled. We eat the tender young fruits; truly mature ones are too fibrous.

The entire okra plant is edible. In some cultures, raw leaves are added to salads. Seeds can be extracted and pressed to make cholesterol-free oil that is high in unsaturated fats. They can also be roasted and sprinkled over foods for a mild-flavored crunch. Ground seeds have been used to make a hot beverage that resembles coffee in color and bitterness but lacks caffeine.

The flower that precedes seeds looks a lot like a popular ornamental cousin, hibiscus. Okras are mostly self-pollinating. Bees, other insects, and even hummingbirds may cause some cross-pollination. Ants could play a role in prying open flowers, but there is no evidence that they transfer pollen. Feeding fire ants have been known to cause buds to abort, however.

Pollinated flowers form fruit rapidly—sometimes it's a matter of four or five days to harvestable pods. To continue production, keep picking. (If the prickliness irritates your skin, wear long sleeves and gloves when handling plants and pods.) At season's end, if you wish to save seed, do so before the aging pods explode and shoot seeds up to several feet away from the mother plant.

RIGHT AND FOLLOWING Who knew okra pods could be so beautiful and exciting? Gardeners and farmers swoop in and harvest the pods while still young, green, and not fibrous—that's the best eating. But if left on the plant, they become striped brown and cream before springing open and flinging out a bounty of brown seeds.

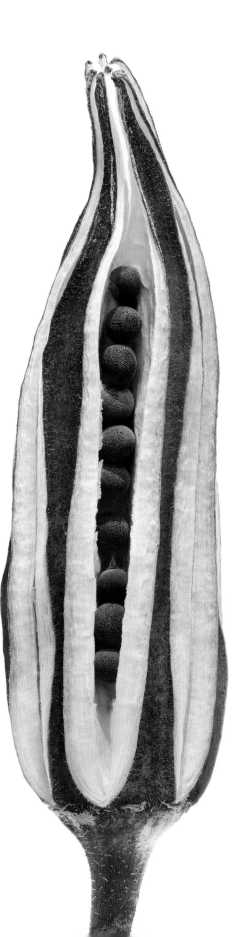

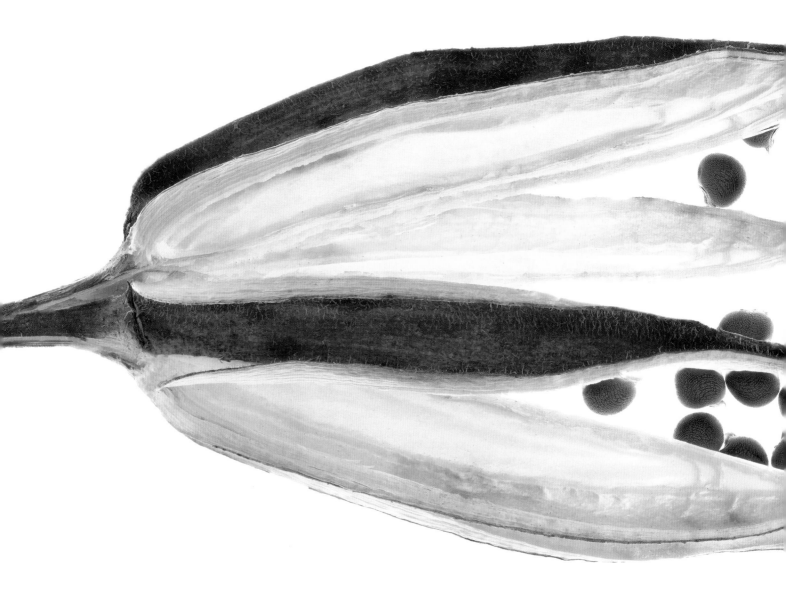

orange

Citrus sinensis species

It was inevitable. Humans eating fruit were bound to consider the seeds a nuisance, especially if they were too large, too hard, or too crunchy. Hence the popularity of the seedless orange.

The seedless navel orange was not deliberately bred that way. It was a chance mutation on a branch of a sour orange tree growing in a monastery garden in Brazil in the mid-1800s. A missionary noticed the navel-like protuberance at the far end of the fruit, which is an aborted or partially formed second fruit. He also noted the lack of seeds and the sweet flavor. He took cuttings and eventually sent some to the U.S. Department of Agriculture. Clones of that fruit made their way to sunny California, where they thrived. It wasn't too long before there were groves of them. Sweet and seedless—what's not to love?

Do not worry about the lack of genetic diversity; there are dozens of variations on the original navel orange. There are also additional seedless options, from clementines to Satsumas to Cara Caras. Such trees do flower, but the blossoms are self-incompatible. They fail to set seed when grown among identical plants. Orchardists propagate instead by grafting.

There is no shortage of oranges with seeds, among them Mandarins, tangerines, blood oranges, and Valencias. Some are easier to peel than others (loose or tight skin is a quality breeders have tinkered with), some have more seeds, and some are very juicy. If you find one you relish, don't consider its seeds to be a deal-breaker. Juicer gadgets and machines can remove them for you.

One last note: If you want a fun horticultural project, orange seeds can be sprouted. However, the resulting tree will not be a copy of its parent.

The essentially seedless, sweet-flavored citrus fruit known as the navel orange is the result of a chance mutation. An alert horticulturist noticed, and the plant took a relatively smooth trip from garden to the USDA to commercial production.

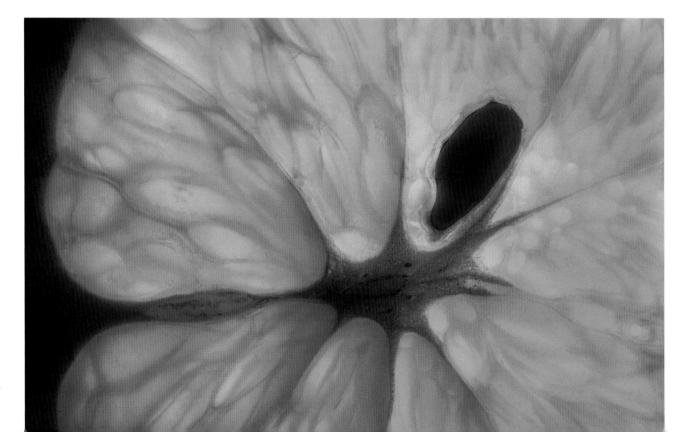

pepper

Capsicum annuum

Every cook, from salad-maker to guacamole-fixer, is well aware of pepper seeds. Cut open any pepper—bell, jalapeño, Anaheim, or Cubanelle—and lodged within the crisp and juicy flesh, mainly at the stem end, are small white seeds.

In hot peppers, the seeds carry a concentration of the fiery compound capsaicin, which is why some people use gloves and fastidiously scrape them out before adding the flesh to a recipe. Capsaicin causes a burning feeling when it comes into contact with skin or mucous membranes. Aficionados pursue the heat, pushing the experience until their mouths burn, their eyes and nose stream, and pain-stimulated endorphins kick in.

A typical pepper, particularly a bell type, is filled with air, not a gel or liquid like some other fruits and vegetables. Evidently this is because capsaicin is not very water soluble. In addition, humans have selected and bred peppers over the years to have more edible flesh, not more or larger seeds. Another theory is that because various peppers are well adapted to dry climates, they have evolved to have little interior flesh, which needs moisture to maintain itself. This is possible, but there are many peppers adapted to many different climates.

All kinds of peppers self-pollinate, although insects such as bees sometimes transfer pollen. Hot peppers are at greater risk of being cross-pollinated because, if you look closely (the bees do), the stigma and style are more prominently displayed above the anthers. If this is a concern, separate them from other peppers by a minimum of 50 feet. Generally speaking, once the fruit turns red, pepper seeds are ready to collect, dry, and put away for next year.

Peer into the interior of a sweet bell pepper and you will notice a lot of open space. Theories abound as to why, but it could simply be that humans have selected for this quality. The other salient feature is that the seeds tend to cluster at the stem end. They correspond with the position of the ovules back when it was in flower.

pomegranate

Punica granatum

Although this delicious fruit traces its origins to ancient Persia and Greece as well as modern-day Afghanistan, it is found in produce markets worldwide. Its common name means seed apple (from ancient Latin *pomum* for apple, and *granatum* for seeded). Its bright red juice, touted for health benefits, is widely available. The original grenadine syrup was derived from the pulp.

Pomegranate is a deciduous tree, and it tends to be on the smaller side (12 to 20 feet high and wide). Often it looks bushy, thanks to a tendency to sucker like crazy. Foliage is glossy, dark green, and leathery. Stems are thorny. The tubular flowers are only 1 to 2 inches across. They're usually bright red, but may be orange, yellow, or white; petal texture is like crepe paper. These come in clusters of up to five, and they are long-lasting, so a tree in bloom is spectacular. The blooms draw bees and hummingbirds. Technically, the flowers self-pollinate (which is typically only about 50 percent effective in leading to fruit), although some crossing can and does occur. Planting a second tree close by will increase your harvest. Note that the dwarf ones meant for growing in pots will flower but produce inedible fruit.

Pomegranate fruit is a many-seeded berry. If you hold one in your hand, it's easy to identify the calyx at one end, where the petals and sepals were. Notice remnants of the stamen cluster. The berry develops from an inferior ovary.

Inside is pithy mesocarp. The chambers are separated by a thin septum, white and spongy in texture. Seeds are lodged within (not always 613, despite legends—generally 150 to 1000). The juicy red covering may be mistaken for an aril, but it is a fleshy seed coat, or sarcotesta.

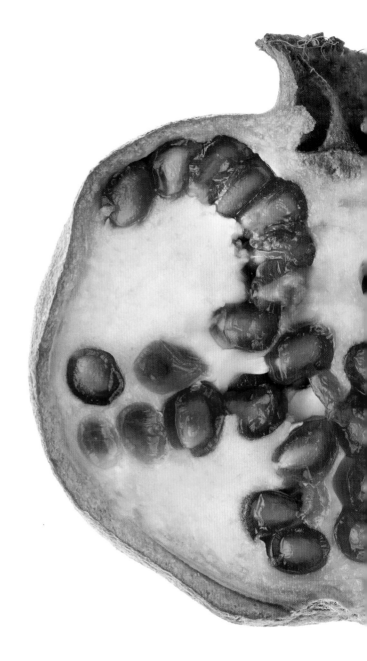

A pomegranate is interesting to eat and fascinating to behold. The top end clearly shows remnants of the flower that came before. The spongy whitish material that fills up most of the interior is pith—edible, but not especially tasty. White seeds are encased in a sarcotesta, the juicy ruby red covering. The fruit's hope, if you will, is that we'll eat the sarcotesta and spare the seed.

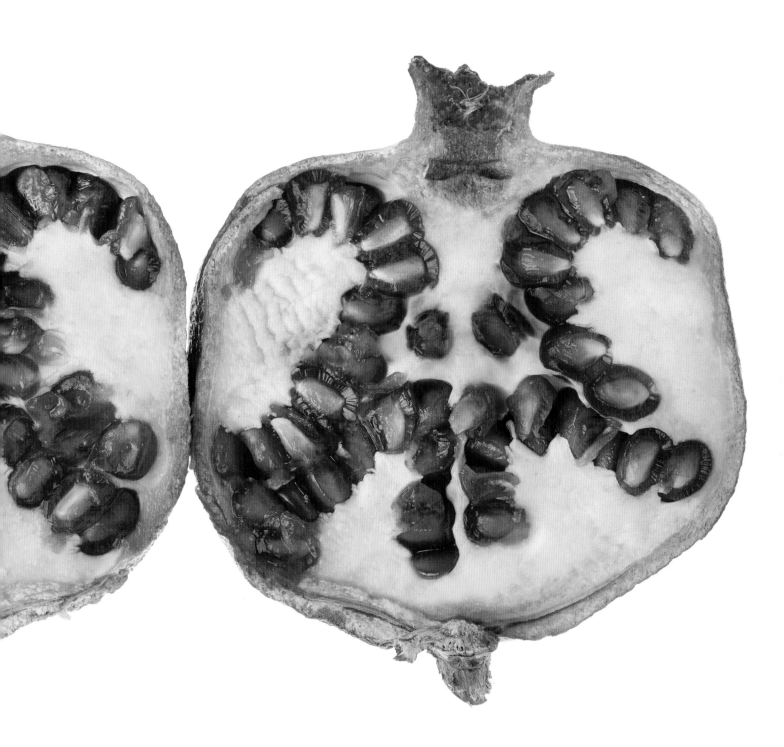

raspberry

Rubus idaeus and hybrids

First things first: A raspberry is not really a berry. The botanical definition of a berry is a simple fruit produced from a single ovary. Grapes and blueberries qualify, but raspberries, blackberries, and their relations do not. A raspberry is a multiple or aggregate fruit. The flower that preceded it had 60 to 160 ovaries. Those individual plump little sections are drupelets, and inside are many tiny light brown seeds.

Here's a tip to help you select the tastiest raspberries. Size and flavor in the cultivated varieties seem have an inverse relationship. The burly 'Titan' has a fairly mild flavor, whereas the smaller fruits of the classic 'Heritage' are bursting with fragrant sweetness. Smaller drupelets also tend to be associated with littler seeds.

If you want to grow your own, do a little homework on cultivar selection, as well as proper siting, culture, and pruning, so you have healthy, high-yielding plants. If you dislike thorns, there are a few thornless varieties. Note that most raspberries, once they get their feet under them, are lusty growers and sucker a lot. They will need space—and controlling.

Which brings us back to reproduction. Birds and other creatures may eat and spread raspberries, depositing the seeds in the garden, on the lawn, or in open areas. Those certainly can germinate, as the trip through the digestive tract breaks down the hard seed coats. Pull out these seedlings or mow them down: a volunteer spot is probably not ideal, and the babies are unlikely to resemble their parents. New shoots coming up from the bases of your plants will fruit.

Although we call raspberries and their kin berries, they are actually aggregate fruits whose many plump little globules or drupelets arose from multiple carpels. Each one contains a seed, which is why these fruits are so very seedy.

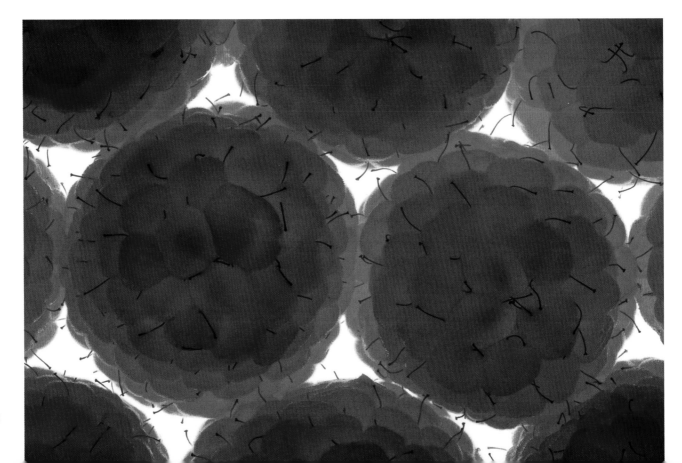

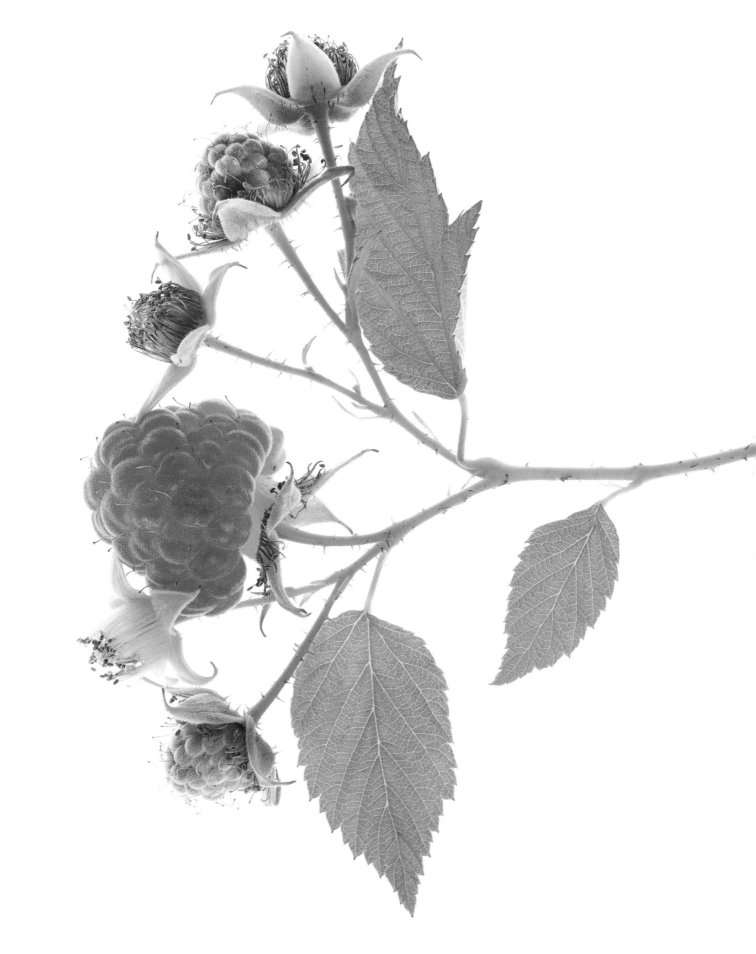

squash

Cucurbita species

Anyone who has cut open a squash or scooped out a Halloween pumpkin recognizes these seeds. Large, flat white or tan squash seeds have a thin, naturally occurring coating that resembles cellophane. If you look closely, they also have a narrow margin all the way around, sometimes of contrasting color. The thin coating is thought to prevent premature sprouting within the squash—that is, it keeps moisture out. It flakes off easily when its work is done or when the seed has dried. The purpose of the narrow margin evidently is to secure the contents, to keep it closed like a sealed envelope as the seed swells and an embryo develops within.

Really flat and lightweight squash seeds are not viable or suitable for planting. Gardeners aiming to save seed for future planting often use the float-in-water test: heavier fertile seeds, which contain an embryo, sink.

The topic of saving squash seeds for next year's garden or beyond has been richly studied over the centuries. The accumulated wisdom of seed savers is widely available in reference books, from seed exchanges, and on the Internet. If this interests you, educate yourself first. Squash sex, leading to true-to-name desirable seeds, is rather complicated.

The short version is that squash are promiscuous. Individual plants have separate male and female flowers, but they do not self-pollinate. Instead, bees and other pollinators (or a gardener who picks a male flower and rubs it into a female flower) facilitate cross-pollination. This makes squash outbreeders rather than inbreeders. Certain squash will mix readily with certain other squash varieties, leading to all sorts of quirky variations and mongrels. They do not, however, consort with related cucurbits like cucumbers and melons.

The flavor of squash flesh varies from type to type, and within in each kind, aficionados detect differences between different named varieties or cultivars. But common to all are these mostly flat, pleasantly crunchy white to tan seeds. You can scoop them out and roast them, perhaps with a sweet or savory coating, or save them for replanting.

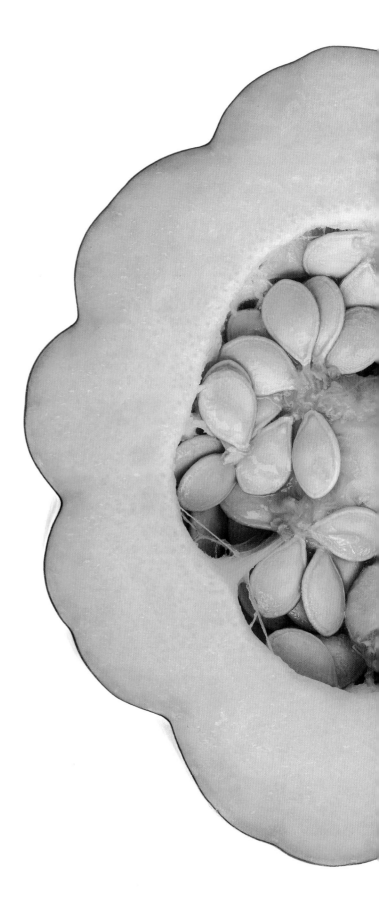

star fruit

Averrhoa carambola

This fruit is an oddity, and not just because of its unique shape. First of all, it's in the oxalis family (Oxalidaceae), which is hardly intuitive. This is a small group, and most of its members are herbaceous and weedy, like sourgrass, yellow wood sorrel, and purple shamrock. The star fruit is produced on a bushy subtropical Asian tree.

Another reason it's peculiar is that the fruit is considered a berry, or a fruit whose ovary wall is fleshy at maturity. Like other berries, star fruit also contains seeds. These are flat, thin, brown, and encased in a gelatinous aril. Typically there are a dozen per fruit. Some cultivated varieties, however, are seedless or nearly so.

Despite its unusual shape, the fruit possesses a certain logic. The fragrant pink-lilac flower that precedes it is five-parted (five petals, five sepals, five styles, five lobes to the ovary), leading to the ridged, five-angled shape of the waxy yellow fruit. This is how its relation to the aforementioned weeds is established, for they too have five-parted flowers and fruit. The presence of oxalic acid produces the sour flavor of the fruit, which has been compared to rhubarb. The plant's foliage reacts to light and folds up in the evening hours; purple shamrock does the same thing.

The plant blooms in clusters and thus produces fruit in clusters. Flowers with long styles are self-fertile; otherwise, mostly bees accomplish pollination. The star fruit's popularity has spread to North America. Look for it in your mainstream grocery store's specialty produce section. It is now cultivated in Florida, Mexico, the Caribbean, Central and South America, and Israel.

A relatively recent arrival in the produce section of conventional grocery stores, star fruit has long been enjoyed in its native Asia for its distinctive sweet-sour flavor. A five-parted flower precedes it, and this configuration is carried over into the formation of the fruit. The plant blooms in clusters, so the fruit is carried in clusters on a tree that grows 20 to 30 feet high.

strawberry

Fragaria ×ananassa

It doesn't take too much reflection to conclude that the fruit of the strawberry is an anomaly. It appears to wear its seeds on the outside of its body. But nothing here is as simple as it appears. A strawberry is not a berry. The seeds are not seeds. Strawberries are an aggregate fruit; that is, many tiny individual fruits embedded in a fleshy receptacle (other examples are raspberries and magnolias). Each of the dark little specks we think of as seeds are actually tiny fruits, each surrounding an even tinier seed. The part we relish most, the red flesh, is technically receptacle tissue.

Strawberries are in the same family as roses. This is fairly obvious when you examine the flowers of each, which have a similar look. While the plant is blooming, the carpels are arranged on a convex receptacle. After the flower fades and the petals fall, the receptacle expands dramatically. The carpels, meanwhile, segue into achenes or nutlets.

You could raise new plants from the achenes if you really wanted to, with the caveat (as is typical of hybrids) that the baby plants will not be just like their parent plant. Wild or alpine strawberry species, *Fragaria vesca*, is commonly and easily raised from seed.

Strawberry size, which can range from ¼ inch to 2 or more inches on some of the robust hybrids, depends not just on the cultivar. It is also the result of the fruit's location on the inflorescence, the density of the crowns on an individual plant, and, of course, on how luxurious growing conditions are in your patch.

While most people understand that strawberries are a bit unusual in the fruit world, carrying their seeds on their exterior, these crunchy little black or brown spots are actually achenes, or single-seeded fruits. The seeds are inside.

tamarind

Tamarindus indica

Although tamarind pods are produced on a big, bushy tree that grows in the tropics, they are obviously bean relatives (Fabaceae). Each one typically holds five seeds. Tree-generated beanpods are not that rare; in North America, for example, we have locusts, catalpas, and mesquite.

Tamarind seeds are rock-hard, including when a pod is fully ripe and brittle. The sticky brown pulp in which they are nestled is eminently edible. In its indigenous tropical Africa, as well as in areas where it has successfully migrated, large birds, mammals, and even bats have traditionally distributed tamarind. Like us, these dispersal agents are attracted to the pulp, whose flavor is a unique blend of sweet and sour. Cultivated trees are available all along the flavor spectrum, so if you live in a warm climate and wish to grow one, clarify your selection at the nursery where you purchase a sapling.

Digestive juices are unlikely to break down tamarind seed coats. Boiling for an hour doesn't even breach them. Directions for eating fresh pods inevitably instruct how to separate the seeds from the pulp, including peeling off the clinging stringy veins, and end with "then, discard the seeds." Pulp is made into preserves and added to chutneys, curries, sauces, and beverages. It is also an ingredient in the iconic Worcestershire sauce.

Seeds are not impossible to break into, however. You can roast them over medium-high heat for about twenty minutes, which allows you to remove the outer coat. The seeds within are still tough. Sprouting requires constant, even moisture and patience, and but germination rates are still low. Hedge your bets by sowing several.

The part of the tamarind tree's pod that most attracts us, and other potential dispersal agents in its native Asian habitat, is the sour-sweet pulp inside. This sticky, pasty substance is used in many recipes and to make juice. The juice is similar to prune juice in both dark color and flavor. Just like prune juice, water is added to pulp, then strained. If you score an actual pod, discard the stringy veins and hard seeds.

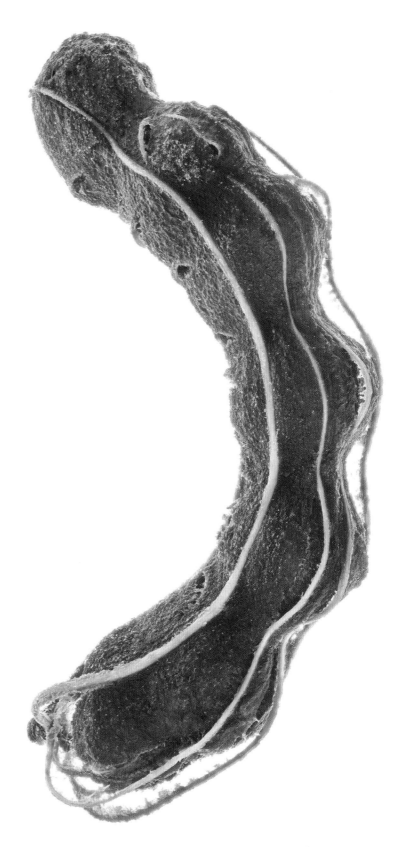

tomato

Solanum lycopersicum

Tomatoes were the first plant from which I ever saved seeds, working with pulp scraped out of 'Moira', a favorite plump, delicious red variety. The experience was instructional.

Among the lessons I learned was that it was a good place to start. Tomato flowers, like their common vegetable-garden comrades beans, peas, and lettuce, are self-pollinating. I didn't have to worry about isolating my plants from other tomato plants.

I knew enough not to try to save seed from a hybrid tomato, but I remained confused about the difference between open-pollinated and heirloom tomatoes. A little research revealed that 'Moira' was not old enough to be considered an heirloom, an old open-pollinated variety passed down for generations. A veteran seed-saver remarked, as I furrowed my brow, "Don't fret. The truth is, heirloom varieties are more like populations—there's always a bit of variation, which is good. Diversity is good." He added, "Anyway, if you like that tomato, for heaven's sake, grow it and save the seeds and replant it and enjoy eating it!"

Surely someone has corrected you when you called tomato a vegetable, pointing to its edible flesh and seeds and asserting that it is a fruit. In the late 1800s, U.S. tariff laws imposed duties on vegetables but exempted fruits. Tomato's status was challenged in the Supreme Court and it was ruled a vegetable based on its popular uses. But even the highest court in the land could not change botanical definitions.

The technique, while easy, is a bit smelly. Scoop out pulp from a ripe tomato, put it in a jar, top it off with water, and let it sit. Over several days, the viable seeds sink. Meanwhile, moldy scum forms on top. This process breaks down the gelatinous membrane surrounding each seed, which contains germination inhibitors and controls some seed-borne tomato diseases.

I was glad when it was time to dump out the scummy water and rinse off, dry, and store my seeds. They did come true the following summer, and yes, I sure did enjoy them.

watermelon

Citrullus lanatus

It doesn't seem that long ago that all watermelons had seeds. When I was a kid, it was great sport to spit the little black seeds at one another and other targets. More and more often, watermelons purchased from a grocery store or at a farmers' market are touted as seedless. They aren't always completely seedless, for some small, thin white things still lurk, which turn out to be seed coats rather than developed black seeds. The flesh is as sweet and tasty as ever. Still, this trend takes the fun out of eating watermelon.

What has happened? Someone—an adult, we can be sure—decided watermelon seeds were an annoyance. The remedy is not some nefarious genetic modification, but rather a hybridization process. Modern watermelons are the mules of the summer fruit world.

One way to create seedless watermelons is to produce triploid seed. A normal (diploid) parent is crossed with a tetraploid parent, which is made by genetically manipulating diploids so their chromosome number is doubled. Triploid watermelon seeds lead to good seedless, functionally sterile fruit; the fruit develops without fertilization (parthenocarpy). For watermelons, this must be redone with each generation.

As for pollination, watermelon plants have separate male and female flowers. At one time, farmers planted a portion of their fields with old-fashioned watermelons so the bees could get some pollen. But recent years have seen the development of nonbearing pollinators, or hybrids that flower but don't generate any fruit.

All this sounds like a lot of trouble and expense. If you want an exercise in nostalgia for yourself or the kids in your life, you'll have to grow your own. But first you'll have to find open-pollinated or heirloom watermelon seeds. They're still around.

Did you know that watermelon seeds are the fruit world's equivalent of an endangered species? Following the will of consumers, farmers increasingly bring seedless ones to market. If you find something that looks like a seed in one of these, it is actually an unfertilized ovule.

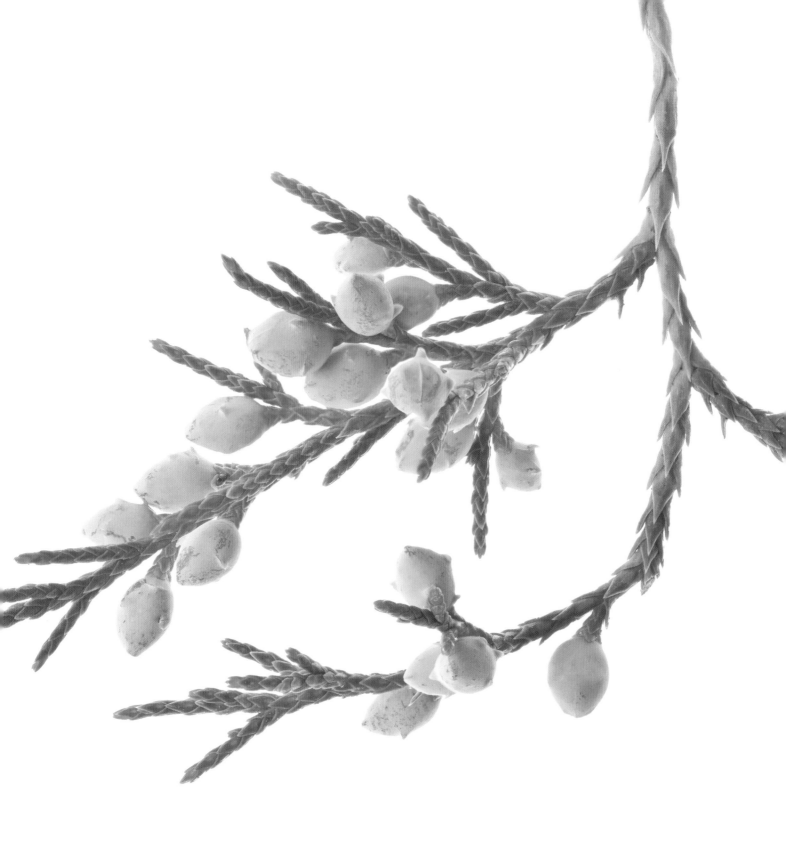

SHRUBS AND TREES

THE FLOWERS of many ornamental trees and shrubs attract our attention—think of the magnolia's spectacular springtime blooms. But plenty of blossoms escape our notice. Do you know what beech or oak flowers look like? Do you know if the blooms are perfect (male and female together) or separate entities on the same or nearby plants? Are they wind-pollinated?

A closer look at trees and shrubs in the context of their fruit or nuts gives us a glimpse into how they cycle through the seasons. Their goal, like other flowering plants, is seed production. However, the odds are often about as lousy as those of sea turtles that lay 100 eggs in a nest only to have two or three babies reach maturity.

Seed production may be involuntary, but there is no guarantee of a next generation. Birds and mammals eat many seeds. Insect damage is another factor. Even when intact seeds are deposited elsewhere, sprouting and reaching maturity remains a difficult journey. Less-than-ideal growing conditions may postpone germination. Seedlings get shaded out, trampled, or eaten. Some species hedge their bets by producing offshoots. Nurseries tend to use asexual reproduction methods, especially cuttings, because faster, easier, predictable saplings result.

The "berries" of the Eastern red cedar are actually fleshy cones. A mere one to three seeds are lodged within. But few get to sprout because many birds and animals eat the harvest.

American beech

Fagus grandifolia

Much praise has been written about the cooling shade cast by this majestic tree at maturity. The tasteless, odorless wood has long been valued for kegs, casks, barrels, and similar containers. The leaves are admired in all seasons.

But the nuts have stories to tell. Within those protective spiny little burrs or husks (the technical term is cupule), in pairs or triplets, are sweet if tannic triangular morsels. Unlike some tree nuts, they are easy to access—no hammer required. Once the nuts are on the ground and autumn is well advanced, they will split open of their own accord. They are high in protein and oil content, and the oil is slow to go rancid.

Lots of creatures relish beechnuts. Early colonists fattened hogs and turkeys on them. They were a favorite of passenger pigeons; in fact, some speculate that the decimation of this nation's original grand beech forests was among the factors in the pigeons' demise. Squirrels sometimes make substantial caches. Other rodents, many birds, and even bears eat them.

Beech-nut chewing gum, however, was never made from beech nuts. It was just a line of popular flavored gums marketed by a company of the same name.

Beech trees are monoecious; they have separate small male and female flowers on the same tree. Wind is the pollination agent. Crops seem to peak every two or three years. Foresters have noted, however, that "sons of beeches" in native stands tend to be root sprouts.

Among tree nuts, the beechnut is on the small side and is not difficult to break into. In fact, ripe ones that fall to the ground usually split open of their own accord. Their nutritious contents are popular with wildlife. Of increasing concern is beech bark disease, wherein a scale insect attacks and an opportunistic fungus moves in and finishes killing off the tree. The genetic diversity of seedlings could provide hope for finding and breeding resistant trees.

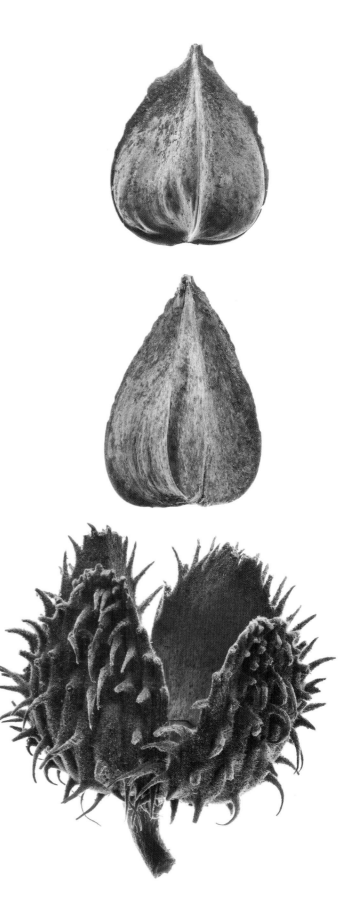

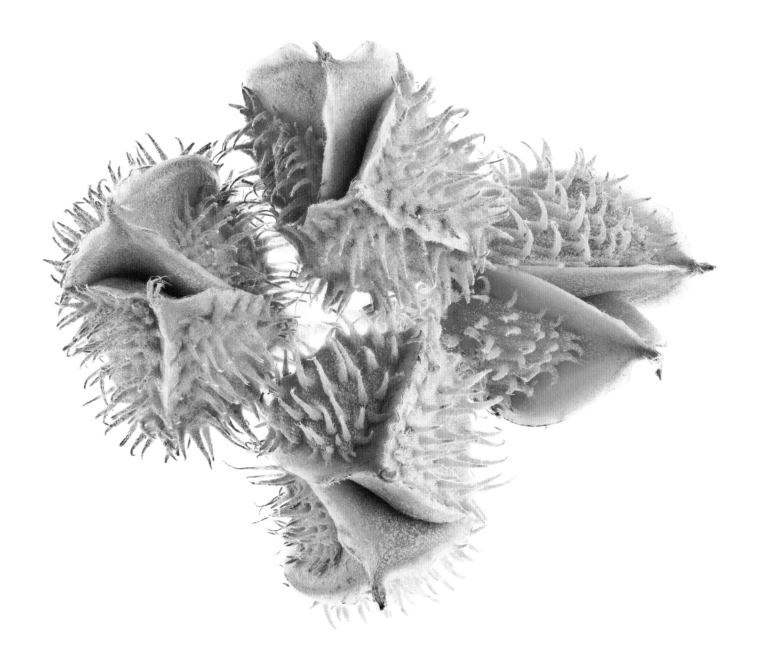

basswood

Tilia americana

Back when North America was sparsely settled, basswood (American linden) trees were widespread along the Eastern seaboard, well into Canada, down to Florida, and out to the Dakotas. Tall, stately trees could reach 100 feet or more. Nowadays those great forests are gone, but the tree, especially its smaller relatives and a few cultivars and hybrids, is commonly seen on golf courses, in public parks, on college campuses, and occasionally as a street tree.

The heart-shaped leaves are a clear clue to the tree's identity, but if there is any remaining doubt, flowers and fruit are distinctive. Small pale yellow blossoms appear in early summer—later than most flowering trees—in cymes, pendulous clusters that are attached to leafy bracts. The flowers are sweetly scented and full of nectar and pollen. They are irresistible to flies, moths, and especially bees; the honey is prized. The bract is thought to flag the inflorescences and make them easier to find. We can certainly spot them from a distance. Scientists have also discovered that the flowers can self-pollinate.

So we look for a bounty of fruit developing and ripening toward the end of summer. As would be expected, they appear in small clusters. The bracts also persist.

Individual fruits are petite drupes, round or egg-shaped, about ½ inch long. They have thick shells and lack ribs. If you can breach the tough pericarp, you will find at least one seed inside (sometimes two, rarely three). Fresh fruit is easier to break into; if left on the tree to turn gray or brown, germination becomes more challenging. Birds and small mammals eat and disperse them. If they sprout, rabbits and deer nibble seedlings. Root sprouts remain an important alternative reproduction strategy for these trees.

Basswood trees are easily recognizable by their ribbony, papery bracts, and they produce rather small fruit. If we can identify them from a distance, so can the creatures that eat the fruit and disperse the seeds—mainly birds and squirrels.

beautyberry
Callicarpa americana

No gardener who adores forsythias can look askance at any-one who grows beautyberry. Like that springtime standby, this multistemmed shrub has only one season of interest—autumn. At that time, the unremarkable leaves fade and fall off, exposing gray stems covered with a startling berry display. These are not the dusky purple of grapes, but rather a unique and thrilling shade best described as orchid purple.

The aptly named beautyberries appear on current sea-son's growth. This allows a gardener to chop back the bush to within, say, 6 inches of the ground in late winter or early spring and await resurgence. If you reside in an area of harsh winters (both the American species and its Japanese cousin, *Callicarpa japonica*, are rated hardy in USDA zones 5 to 8) that harm the top growth or cause stem dieback, you'll still get a show.

The flowers, visited by bees, butterflies, and more, are not very splashy. They are merely 1 inch across and pale purple, pink, or white. However, they are carried in cymes, so fruits are grouped as well. This is a good thing, because individ-ual berries, or drupes, are small, at best ¼ inch in diameter. They cling to the shrub's stems at nodes, in dense clusters that may be 1½ inches around. You will get a better fruit set if you grow several bushes to allow for cross-pollination.

The timing of their appearance works well for dispersal. Hungry birds (including catbirds, brown thrashers, mocking-birds, Carolina wrens, and robins) relish the fruits. However, they generally do not strip the plants bare. To highlight their beauty in fall, try planting one of these in front of a wall, a fence, or an evergreen backdrop.

There are other bushy plants around with a good autumn berry display—viburnums, pyracantha, and aronia come to mind. But the aptly named beautyberry stands out thanks to its amazing and unusual color. Left to its own devices, a bush will attain about 5 feet high and wide, but because it fruits on current-season wood, you may chop it back almost to the ground in late winter. Beautyberry seems to fruit more heavily with this drastic treatment.

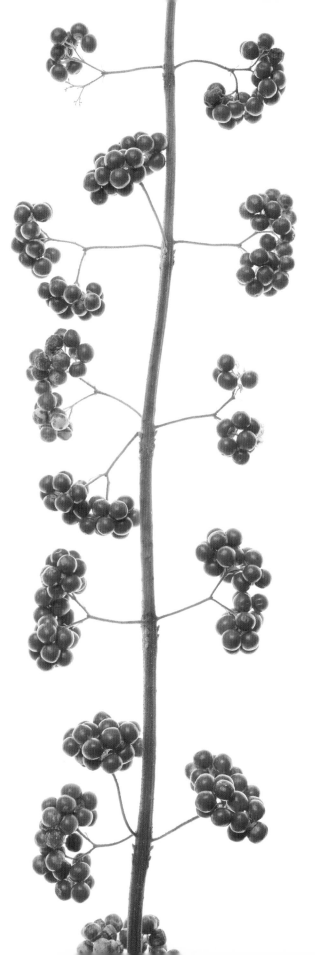

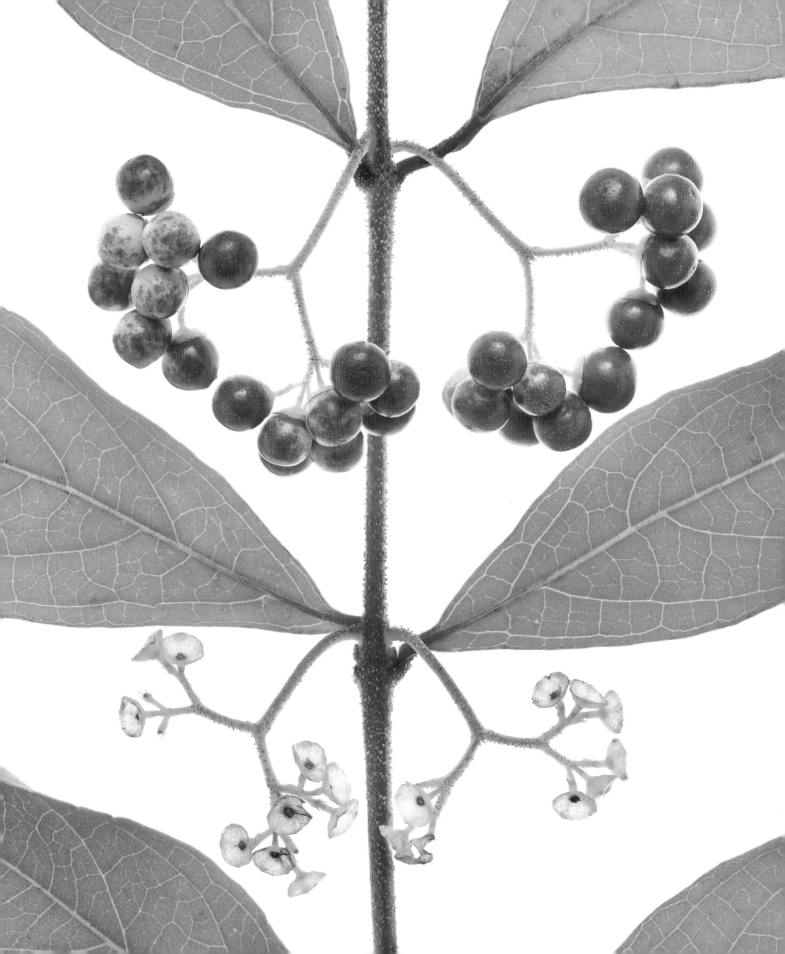

black walnut

Juglans nigra

The black walnut is not very friendly. It deploys its protection as ferociously as a medieval castle and repels approach in a variety of ways. It has a pungent scent that some find off-putting. The notoriously allelopathic tree secretes juglone, a compound that is toxic to many other plants. Particularly vulnerable are rhododendrons, peonies, honeysuckle, roses, and lawn grass.

The fruit is also is a tough nut to crack, tougher than the related English or Persian walnut (*Juglans regia*). When a crop has ripened on a mature specimen, it rains down almost continuously over a period of weeks in late summer to autumn. These are round and green, and can be up to 2 inches in diameter. Wear a hard hat.

Nuts ripen inside their husks and remain intact while still on the tree. Even the impact of falling may not break them open. Bash them with a hammer, stomp on them with heavy boots, or run a car or truck over them. Lay them out to dry. Later, extract the nutmeat with a nut pick. But beware: walnut oil will stain everything.

After all that drama, you may wonder how on earth a new tree ever gets started. Nurseries tend to graft gentler, easier-to-crack English walnut branches onto hearty American walnut rootstock. Production will be better if you grow several so cross-pollination occurs. Left to their own devices, sometimes the nuts will sprout in their own good time.

These are not true nuts, but drupe stones, like the stones of peaches and plums. The part we harvest and eat is a pair of enlarged fleshy cotyledons. Their tasty nutritional content is meant to provide protein to the developing embryo.

You may be well aware that black walnut meat—so rich, earthy, and nutritious—is hard to get to because of the notorious toughness of the outer layers. But did you know it's not even a nut? Botanists classify it as a drupe, or a fruit with a pit.

cardboard plant

Zamia furfuracea

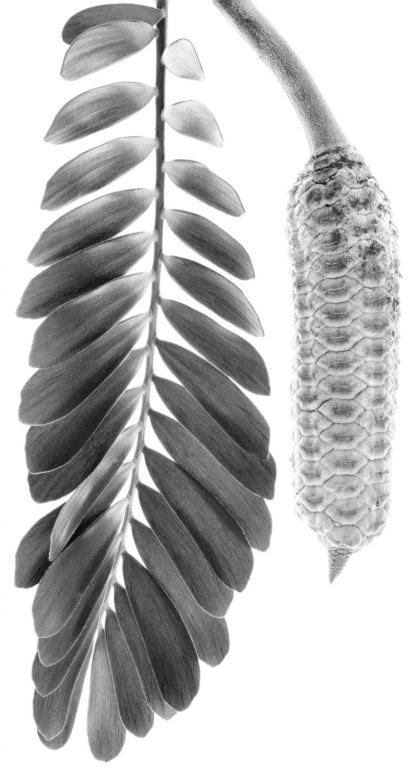

You might mistake this plant for a palm, but it is actually a cycad, a group of durable and unique plants that have been around since the time of dinosaurs. Cycads are not flowering plants, but gymnosperms, like pine trees.

This particular plant got its common name from the stiff, slightly fuzzy texture of its fronds, which are reminiscent of cardboard. In Florida and other warm-climate areas where it thrives, it will look good year-round and is often employed as a handsome backdrop for colorful flowers. It is both drought- and salt-tolerant, and thus is useful in coastal areas. It is also slow growing and requires almost no maintenance.

Cycads are dioecious; there are male and female plants. There is no way to know until cones appear, arising upward from the trunk. Smaller male cones bear pollen. In nature, beetles transfer it to the larger brown female cones. When pollination succeeds, females respond by dramatically expanding in size. In this species, the female cones eventually break open to reveal a bounty of tightly packed scarlet seeds.

Raising new plants from seed is rare. They can take up to four months to germinate—time enough for a patient gardener to despair. Seedlings are also susceptible to fungal diseases. The seeds contain a dangerous neurotoxin.

Cycads also form baby plants, or pups, at their bases. You can carefully separate off and replant these pups. They will be clones of their parent, which is fine, but the genetic diversity inherent in seed-raised cycads is worth encouraging—some cycads, not just this one, are endangered species. While many went extinct a long time ago, those that remain in modern times are threatened by habitat destruction and overcollection.

Cycads, popular in Florida and Gulf Coast landscaping, are actually gymnosperms. Flowering and consequently seeds are not a common sight (no doubt because the cone-bearing plants are dioecious and also depend on beetle pollination). All plant parts contain alkaloids, steroids, neurotoxins, or tannins. The levels are especially concentrated and dangerous in the seeds—ingestion can kill a child or a pet.

Caucasian wingnut

Pterocarya fraxinifolia

Analysis of the nomenclature of this impressive tree is a bit perplexing. The compound genus name *Pterocarya* refers to wings or birds, and hickories or nuts in general. An alias is suggested, *Juglans fraxinifolia*, plus it is placed in Juglandaceae; this affinity would make it kin to walnuts. The long, pinnately compound leaflets, shiny green in season and yellow in autumn, do resemble walnut foliage. Yet *fraxinifolia* suggests a resemblance to ash trees, which isn't quite right.

Further up the genetic ladder, this tree is grouped in the same subclass as magnolias. Abundant springtime male flowers are dangling 5-inch yellow-green catkins, which bring to mind completely unrelated poplar or birch. Meanwhile, female flowers are up to 20 inches long and develop winged fruits that look a bit like large elm fruits, except they are carried in long chains.

When a common name refers to a plant's fruit, it's a safe bet that the fruit is its most prominent feature. The wingnut doesn't disappoint—a mature tree bears plenty of winged nuts. These do not resemble walnuts or hickory nuts, nor do they look like magnolia fruits. Each is about ¾ inch across, with papery wings. These hang in chains up to 20 inches long, starting off green and maturing to brown. They are hard to miss.

Metal nuts with two wings to allow for one-handed tightening have been called *wingnuts* ever since they were invented. In more recent times, the term has become synonymous with fool. The plant edition may be eccentric, but few would malign its imposing, handsome features.

There are plenty of winged nuts in the plant world, like the samaras of maples and elms. The tree that acquired this common name has an unusual version of the trusty samara. When the green color fades to brown, individually each one is reminiscent of a wafer-thin, dry wild mushroom, perhaps, or a little umbrella. Each one holds and transports a single seed. Because they hang on the tree in long chains, you have to come in close to appreciate their details.

crabapple

Malus species

To say that crabapples are a diverse bunch would be an understatement. A walk through a well-stocked nursery or an armchair search on the Internet turns up dozens upon dozens. They are enduringly popular, cold-hardy street and park trees. Foliage varies in color and form. The flowers, so glorious in spring, are in the white-pink-red range. Those that are not sterile produce ornamental fruit.

All this diversity results from crabapples crossing freely with other crabapples, aided by bees. Any attractive tree could be named, propagated by cuttings, and disseminated. But if you raise one from seed, you could get just about anything. Leaves could be incised or lobed, with serrated or nearly smooth edges. Habit could be the sought-after vase shape, or something else. Fruits could be tiny or the size of marbles, and yellow, green, or red. Two superb specimens that have stood the test of time are 'Donald Wyman' and Japanese crabapple, *Malus floribunda*. Both are reasonably resistant to the diseases that plague these trees, which is yet another factor to consider when choosing one.

Because the trees bloom in umbels (or corymblike racemes), the fruits are carried in clusters. Pomes develop from an ovary below the flower that is typical of such fruits. The calyx is often still evident. The dark seeds within are pips.

Apples and crabapples are in the same genus and look similar. The difference, according to tree expert Michael Dirr: "If the fruit is 2 inches in diameter or less, it is a crabapple. If the fruit is larger than 2 inches, then it is classified as an apple."

Clusters of tart little fruits on ornamental crabapple trees are not significantly different from the large apple fruits we enjoy eating. These fruits are true pomes. The only difference is their size.

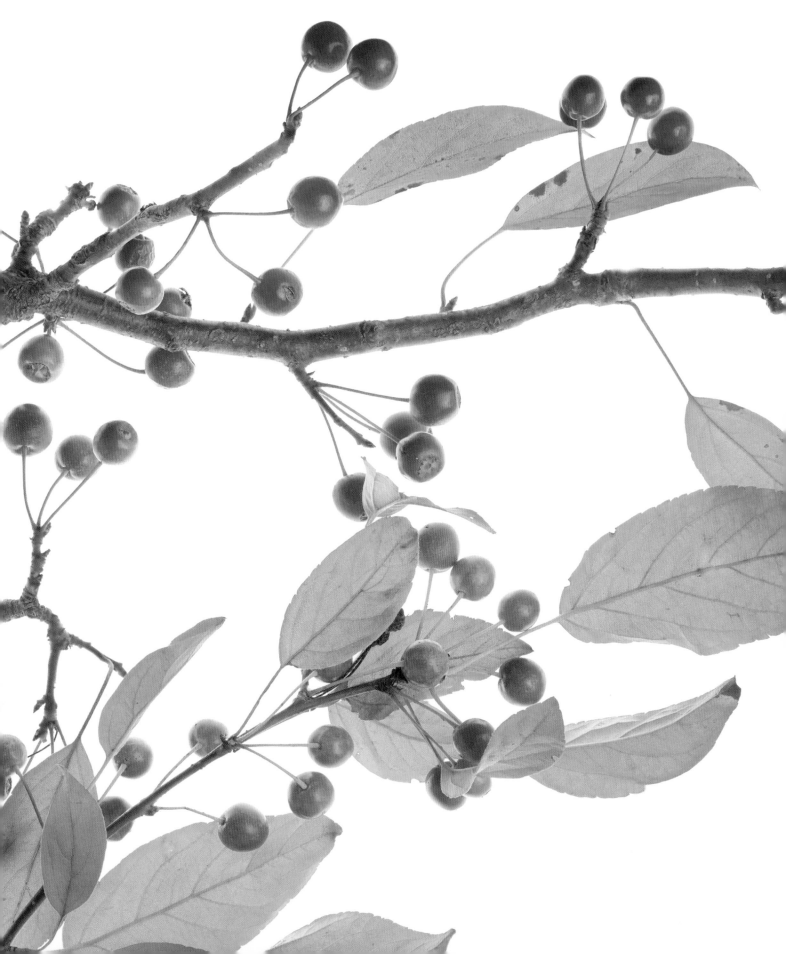

deodar cedar

Cedrus deodara

This elegant tree is often found a long way from home, and not by its own accord. Native to the Himalayas, it grows quickly when young and adapts well to full sun and dry ground. Branches droop gracefully, sweeping to the ground. Older trees have a pyramidal profile. Small (2- to 3-inch), dense male cones shed clouds of yellow pollen. Females, initially purplish, are larger (up to 4 inches), barrel-shaped, and held erect on the branches. Seeds ripen and then drift down.

Prolific seed production does not account for its worldwide distribution in warmer climates. The tree, much admired in its native haunts, was brought into cultivation centuries ago. Seedlings are variable. Especially attractive plants can be raised from cuttings or grafted onto a sturdy rootstock. There are numerous cultivated varieties, so a gardener or landscaper can pick from a range of forms, mature sizes, and foliage hues. Shorter ones make fine hedges. Deodar cedar graces forests, parks, and gardens from India to Italy and Scotland to Seattle. Some horticulturists long for a genuinely cold-hardy variety.

Cedar cones are resinous, which has two practical purposes: clasping the oily seeds and discouraging foraging wildlife. It takes at least an entire year—autumn to autumn—for the seeds of this species to ripen. At that time, the resin loosens its grip, the scales of the cone dry and spring open, and the seeds scatter. (Cones of the related Atlas cedar, *Cedrus atlantica*, are much more tight-fisted.) Deodar cedar cones bear two to a scale. They are triangular, with rounded corners, and measure ½ inch or less, including their papery wings. Bountiful crops are usually borne every three years, with light crops in the intervening years.

The prominent, stout cones of cedar trees actually follow fertilization of a female cone. Male cones are small, more like catkins, and fade away after shedding their dustlike pollen. Unlike those of, say, pines or spruces, these are more papery than woody and are laden with sticky resin. As such, these trees are more closely related to arborvitae, cypress, and juniper.

ear tree

Enterolobium cyclocarpum

Ear tree, one of the great novelties of the tree world, is native to tropical regions from Mexico into South America. It is also the national tree of Costa Rica. Wherever it thrives, it becomes immense—100 feet tall and nearly as wide—so it is highly valued as a shade tree.

The tree is a legume (a member of Fabaceae), related to peas and beans, as are mimosa, acacia, mesquite, and locusts. Like those, it has pinnate leaves. But while long beanlike pods are typical of such plants, ear tree has odd-shaped ones. Initially green, its hard brown pod looks more like a large curled-up bug—or an ear.

Development of these pods is pretty boilerplate. First come the springtime blooms, white spikeballs containing up to fifty individual flowers with a bounty of filamentous stamens. Sweetly scented, they attract lots of pollinators, especially bees. Green pods form, but slowly—it is not uncommon for an entire year to elapse between the decline of the bloom and the pods' maturity. Lodged inside are hard, round red-brown seeds. Evidently the trees delay ripening to coincide with the arrival of the rainy season.

In addition to the pods' unique shape, there is another oddity. No bird or mammal eats them. Botanists have theorized that long ago, giant sloths and prehistoric bison consumed them. A trip past the teeth and through the digestive juices of such beasts would have sufficiently weakened the hard seed coat so new plants could germinate in new locations. Lacking that avenue, only soggy seeds under existing trees or ones collected by enterprising humans tend to generate seedlings. In Florida, where it has made incursions, the tree is considered weedy.

The curious fruit of this tropical leguminous tree is not a traditional pod, but curled like an ear. Seeds take up to one year to develop and ripen because the tree has evolved to time their release to coincide with the start of the rainy season.

Eastern red cedar
Juniperus virginiana

Not all coniferous plants have woody cones. Those of the Eastern red cedar look like little berries, but are actually small cones with fleshy merged scales. Despite its cedarlike fragrance, this plant is not a true cedar, but an upright juniper. There are many cultivars for landscaping use, but they are trees or substantial shrubs. Some branches have closely pressed, scaly, blunt-tipped foliage; others, even on the same tree, have sharp, prickly little needles.

The orange-colored cedar apples occasionally seen attached to the twigs are not the true fruit. These are galls that develop in damp spells and dry up in dry weather. They are caused by a rust fungus that has an alternate host on apple and crabapple trees, where it manifests as leaf spot.

Yet another oddity of this evergreen is the fact that it is generally dioecious. Males have little yellow-brown cones, noticeable on the branches in all seasons. Female cones vary from soft green-blue to gray-blue. After clouds of yellowish pollen are released to the winds of spring, female trees begin to ripen the roundish, resinous fruit. One to three shiny brown seeds are inside. The berries darken in color the longer they remain on the plant.

Birds will eat the fruit, but often as a last resort in late autumn or winter. Cedar waxwings like them—hence their name. The seeds are thus spread far and wide. Bird dispersal causes this tree to overtake empty fields and grassy meadows.

Humans sometimes use the fruit. Simmered in venison stew, they impart a desirable sweet-pungent flavor. Gin is made from the fruits of this tree's near relatives *Juniperus communis* and *J. occidentalis*.

Eastern red cedar, actually a tree juniper, is dioecious; there are separate male and female trees. When fertilization succeeds, the females develop these signature blue berries. Despite their small size and their coloration, they are considered cones and they hold little brown seeds.

eucalyptus

Eucalyptus globulus

The acrid, medicinal scent of eucalyptus trees is a Proustian trigger for anyone who has lived in or visited California. Of all the introduced species, the Tasmanian blue gum is the most extensively planted and seeded. Originally brought to the state on the heels of the Gold Rush days, this fast-growing, oily tree was deployed as a windbreak (particularly for citrus groves), tried for railroad ties (with disappointing results), and grown for fence posts and poles. In modern times, it has earned a bad rap as an invasive species that displaces native plant communities, and for being a fire hazard because of its high oil content.

This is a tall, straight-trunked, solemn tree with shreddy bark at maturity and sickle-shaped dark green leaves. The early spring flowers, which appear singly in leaf axils, are about 2 inches across and creamy white. They have very long stamens and no petals, so they look like a round bottlebrush. Their abundant, powerfully scented nectar draws many insects, especially bees. The result is an excellent, aromatic honey.

Another result, of course, is the practically woody seedpods.

These are small (1 inch across or less) ribbed capsules with a warty texture. They are blue-gray when fresh and age to dark brown. A given fruit will have three to six valves on the top part. When mature, it splits open along those lines and sheds many dark brown tiny seeds along with some brownish-red chaff. Germination is difficult where there is lots of leaf litter—it gets in the way, and mature leaves contain germination-inhibiting chemicals. Light is not required, but soil is. But every year, some manage to sprout. From tiny seeds mighty eucalyptus trees may grow.

Whimsical buttons, warty creatures, musical bells: The seedpods of eucalyptus inspire imaginative comparisons. Children have used them as props in dollhouses and they are even recommended in the current trend of fairy gardening. They contain tiny dark seeds, which you can shake out.

goldenrain tree

Koelreuteria paniculata

If you encounter this deciduous tree in a park or a garden, you don't soon forget it. It is striking in every way, even luxurious. A mature specimen may be 30 to 40 feet high and wide, with a rounded profile. The lush foliage is composed of long, fernlike bipinnate compound leaflets, each of which can reach 15 inches. The yellow flowers really stand out, partly because yellow flowers on trees are a rather unusual sight, but also because they appear later in the summer, when few other ornamental trees are blooming. They cover the tree, too—one in full bloom seems to radiate.

At close range, you can see that the flowers are carried in foot-long (more or less) clusters. Individually blooms are a mere ½ inch wide, with four petals and prominent stamens. Coming in close also gives you a waft of their sweet, intoxicating scent. Bees and other pollinators can't resist. When the petals fall, they form a carpet under the tree—hence the common name.

But the show is not over. As expected, given the flower panicles, seedpods are carried in long tresses as well. They are inflated, papery, three-valved capsules of lime green maturing to rose. They measure 1 or 2 inches across and look gorgeous against the darker green leaves. By autumn, they fade to beige, then turn brown, while the foliage pales to yellow before dropping off. They often remain on the tree well into winter.

Little round seeds are nestled inside the papery lanterns. These are dark and round, three to a pod. The trees are widely adaptable, and if healthy, they reseed easily and prolifically. In fact, some complain that the goldenrain tree is invasive. Pick pods you can reach while they're still colorful, and mow underneath and nearby to thwart unwanted seedlings.

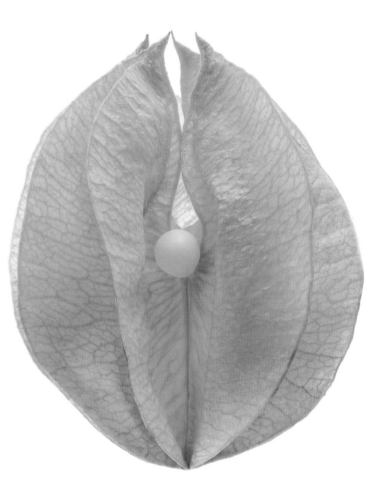

RIGHT When newly formed, the pods on these trees are undeniably beautiful. Because the valves are thin and pliable, it's easy to peel them away and get a look at the seeds within. Typically there are three valves with three seeds per pod.

OPPOSITE Goldenrain tree pods gain a more menacing aspect as they mature and get ready to disseminate across the landscape. The green and rose hues give way to tan and brown and the seeds darken. In cross-section like this, they resemble a hooded pod monster in a low-budget science fiction film.

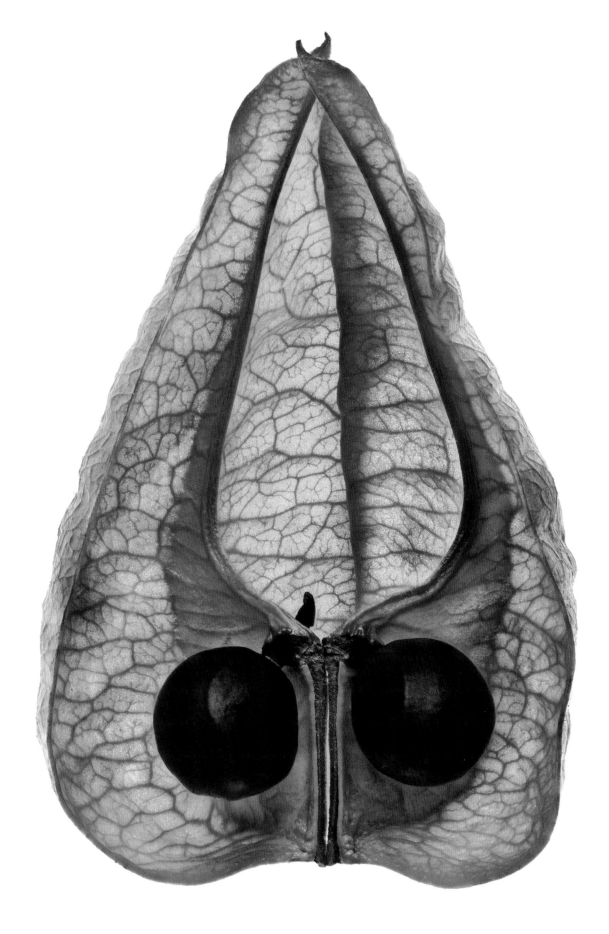

This exuberant tree generates a bounty of puffy, papery, lanternlike pods every autumn. They are three-valved and harbor hard, pealike black seeds. These germinate readily; too readily for some people's taste. Expert gardener Steve Bender calls it "the worst tree I ever planted," and adds, "I fear the pod people!" It is beautiful, though. Caveat emptor.

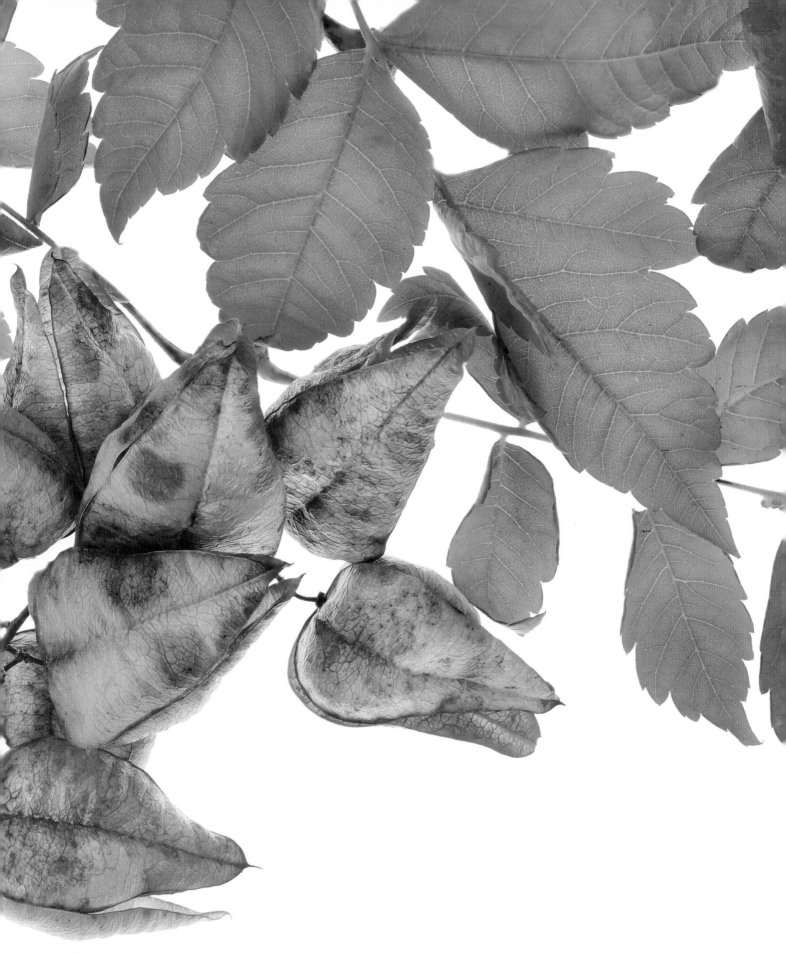

jacaranda

Jacaranda mimosifolia

The jacaranda tree is a beauty. It is the iconic street tree in my hometown of Santa Barbara, California, and widely grown in other Mediterranean climates, from South Africa to Portugal to South America. As the *mimosifolia* species name indicates, its abundant leaves are reminiscent of mimosa leaves or very finely cut ferns.

The tubular 2-inch lavender-blue flowers appear in great hazy panicles in spring and summer. There are also white-flowered varieties available from nurseries. After pollination by insects, some unique-looking flat seed capsules develop. Typically about 3 inches across, these have been likened to a small coin clutch or wooden castanets.

The resemblance to mimosa trees might lead you to think that jacaranda is a member of the legume family. The seed capsules should disabuse you of that idea, for they are certainly not the expected beanlike pods. Instead, this tree is in Bignoniaceae, a broad family that includes the big, somewhat messy *Catalpa* tree and the lusty, woody climber known as cross-vine, *Bignonia capreolata*. Its detractors point out that jacaranda, too, sheds a lot of debris, from sticky spent flowers to faded leaflets to the seed capsules. It is, after all, deciduous. The cycle repeats every year.

Prying open the capsules is impossible while they are still green (I know; I've tried). Clearly this is meant to dissuade any predators, insect or mammal, and to give the seeds within a chance to ripen. When they dry to brown, on the tree or on the ground, the capsules finally hinge open. Inside is a surprise—a papery layer studded with small winged brown seeds, like coins in a botanical purse. They depend on the wind for dissemination, a featherweight ending for a story that began with such a stubborn, substantial capsule.

Bountiful lavender-blue blossoms yield to very stubborn and distinctive seedpods. These fit in the palm of your hand, and children enjoy painting them to look like turtles or ladybugs. Split apart and painted or lacquered, they've also been turned into novel necklaces and earrings. If you gather an older dried pod, you'll be surprised at how light and frail the little seeds are.

kousa dogwood

Cornus kousa

This is not the iconic flowering dogwood; there are a number of key differences. Where *Cornus florida*, the similar version from the West Coast of North America, *C. nuttallii*, and various hybrids and crosses are midspring bloomers, the Asian dogwood bursts into bloom later, after it has leafed out. The fruits of the native trees are nothing to write home about, but those of the kousa are distinctive: pink or red, up to 1 inch in diameter. They hang on the tree like Christmas ornaments out of season.

But we are getting ahead of ourselves. What most people think of as dogwood flowers are actually colored bracts, usually creamy white, pink, or red, occasionally yellow or green. There are four, and they open fairly flat. Kousa petals are pointy and gratifyingly long-lasting. Actual flowers are tiny, green or yellow, and clustered in the middle. Various insects aid pollination.

This fruit is technically considered a drupe. It will not split open when ripe. The interior is pulpy; the few seeds deep inside have hard shells. Its odd-looking bumpy surface originates from the flower carpels.

When the fruit is ripe in midsummer, indicated by a bright coral red color, you could certainly eat it or use it to make smoothies, wine, or even jelly. The flavor can be as sweet as a papaya, mango, or melon. The bumpy skin is gritty and rather bitter, so discard it. In the fruit's native haunts, monkeys relish it and help spread the seeds about. In North America, the occasional bird, squirrel, or inquisitive human will try it. Flavor varies depending on the cultivar, the tree's age, growing conditions, and timing. Remember that these trees are selected and sold based on their flowers, so if you're up for culinary adventures, you have to take your chances.

The otherworldly fruit of the later-blooming Asian dogwood tree is a sight to behold. The compound berry produces an odd-looking surface, but the fruit is edible. Aficionados claim the flesh has a sweet, almost tropical flavor, but impressions vary.

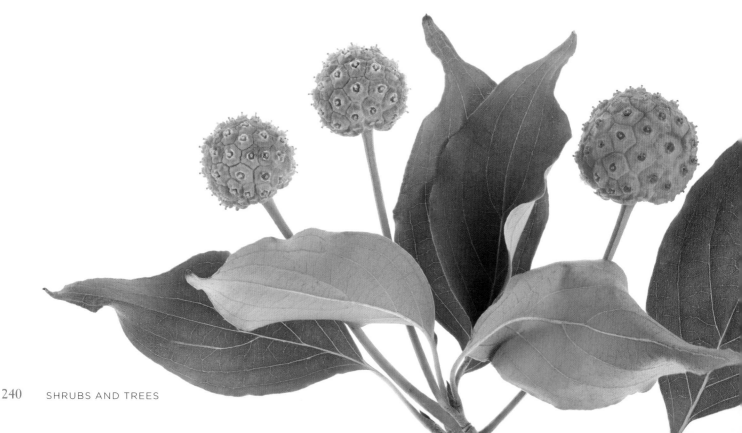

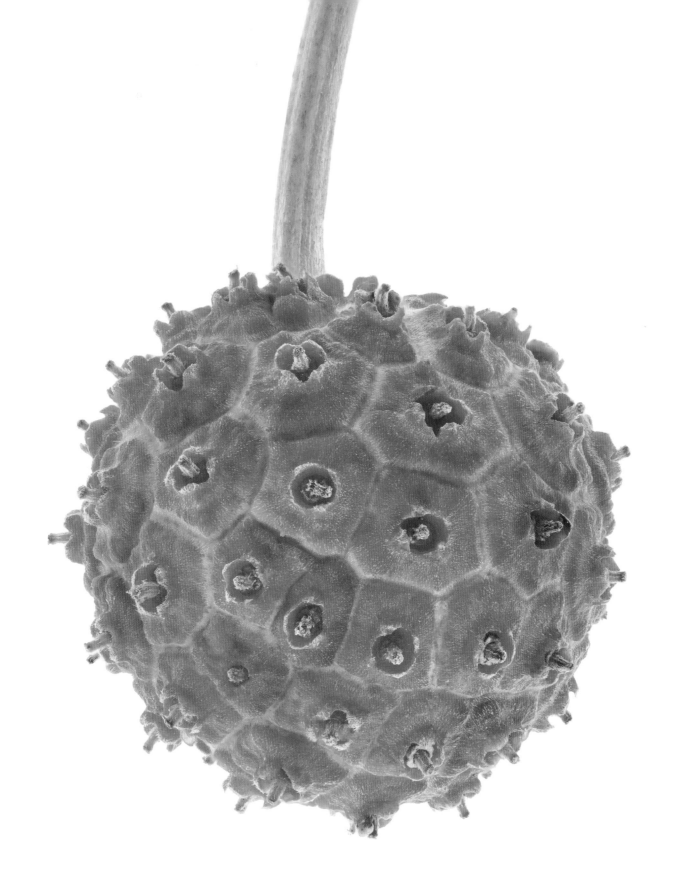

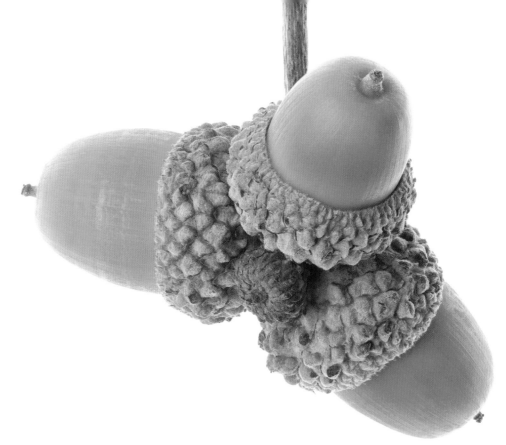

oak

Quercus species

Ah, acorns. The joy of squirrels. In productive years, the bane of anyone trying to cross a yard or deck laden with them. And a challenge for an aspiring botanist. Dendrology exams and competitions sometimes call upon participants to identify oaks by their acorns. It seems fair because every species has a slightly different look, but there are easier ways to tell oaks apart. Firm acorn identification should just complete the process.

Botanically, an acorn is a nut containing a solitary seed (rarely, two or three). The bulk of an acorn is not filler, but cotyledons. The hard, dry shell is meant to keep out moisture and, with less success, hungry insects. The cupule around the twig end of the acorn varies in size, shape, and texture of its scales, but serves to protect at least one end of the nut. Squirrels may nibble the end with the embryo so their caches don't germinate, but some oaks have responded over evolutionary time by shifting their embryos deeper inside.

Oaks are hardly the only big trees to emerge from such a small seed. The immense California redwoods, *Sequoia sempervirens*, grow from 3 to 4 mm seeds. In contrast, acorns are too heavy to wind-disperse. Gravity brings them to the ground, where mammals and larger or ambitious birds gobble them up. Pigs love them, too. Foresters estimate that of those that sprout in the wild, less than 5 percent mature into new trees.

Acorns are high in both carbohydrates and tannins. Native Americans leached them to make edible meal and flour, but I'm with food historian Waverley Lewis Root, who remarked that they are "best eaten indirectly by man, in the form of pork."

Acorns vary from species to species, but all have the same features. The cupule, which is composed of scales, clasps and protects the stem end from moisture as well as predation. There is a hard seed coat and an interior fruit wall. The meat is made up of two cotyledons (oaks are dicots). The embryo is tiny and usually begins near the tip. The exterior nipple is simply a remnant of the flower style.

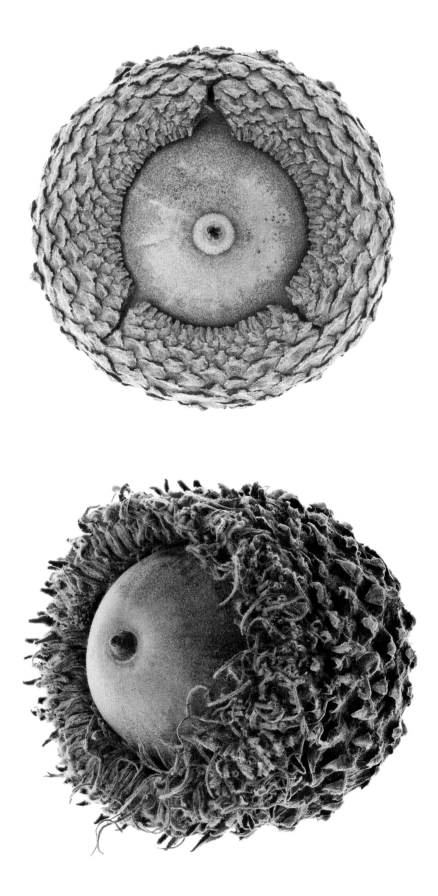

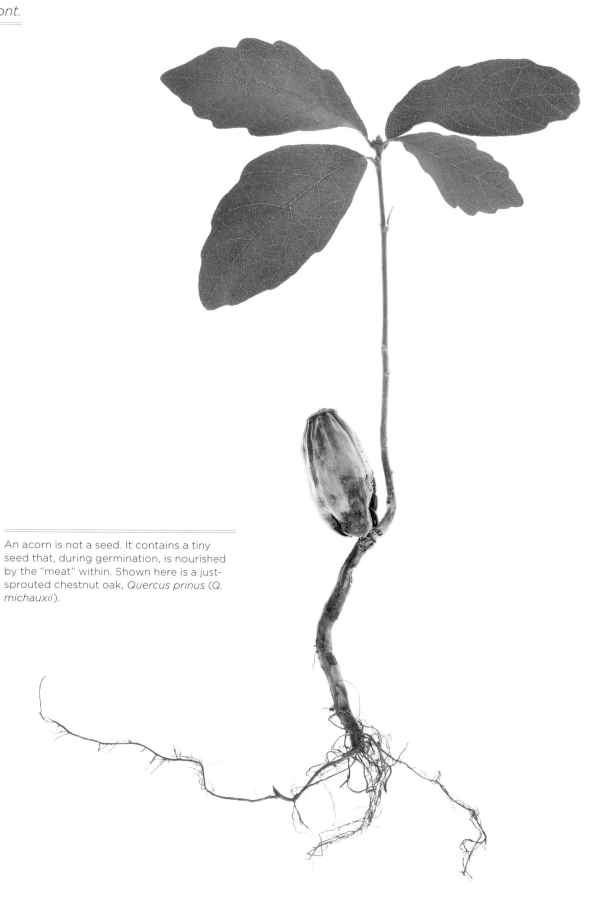

An acorn is not a seed. It contains a tiny seed that, during germination, is nourished by the "meat" within. Shown here is a just-sprouted chestnut oak, *Quercus prinus* (*Q. michauxii*).

Osage orange

Maclura pomifera

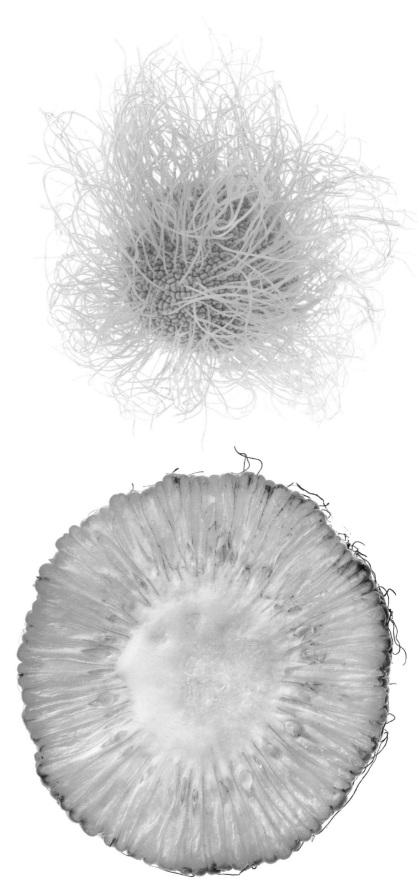

"A real mess" is how some people describe what happens after this tree ripens its strange-looking, inedible fruit. It's not really a popular landscape tree for other reasons, despite its ability to adapt to lousy soil and urban growing conditions. When young, the twigs are armed with stout spines (although spineless varieties are available). It grows quickly, which may or may not be an asset. Fall leaf color varies from so-so to sensational. When punctured, the fruit leaks a bitter milky sap that turns black on exposure. It's not poisonous, but it's not attractive either.

Osage orange is dioecious, so the mess from falling fruit can be laid at the foot of the females. The greenish male and female flowers are nothing special, although both are round in shape, or nearly so. (Sometimes the male flowers are borne in small racemes.) Female flowers are 1-inch round balls carried on short stalks. The dark hairs are stigmas, remnants from the ovary as the compound fruit forms.

If fertilized, the female develops this surprisingly sizable and unmistakable yellow-green fruit, which ranges from 3 to 6 inches in diameter. Its wrinkly, bumpy texture is the result of densely packed drupes. It's not a stretch to liken these to oranges, although they never turn that color. They do have a slight citrusy scent, but they are in the mulberry family.

These so-called oranges are not lightweights, and you don't want anyone or anything—even your car—to be under a tree when they begin to fall. Squirrels, other small mammals, and some birds may feed on the seeds within, but none seem to be avid dispersal agents. It is thought that perhaps the mammal that co-evolved with this tree is now extinct.

This compound fruit is nearly obscured by stringy stigmas when young (TOP). As it grows, they dry and some fall off. If you cut open a mature fruit (BOTTOM), it exudes sticky sap.

FOLLOWING It's not orange in color and not really an orange or even a citrus fruit. Nor, to be honest, is it tasty. Osage orange allegedly got its moniker from its size and shape. The netting of little brown strings is made of stigma remnants. This tree's strong, durable wood is orange—perhaps that's the true origin of the name.

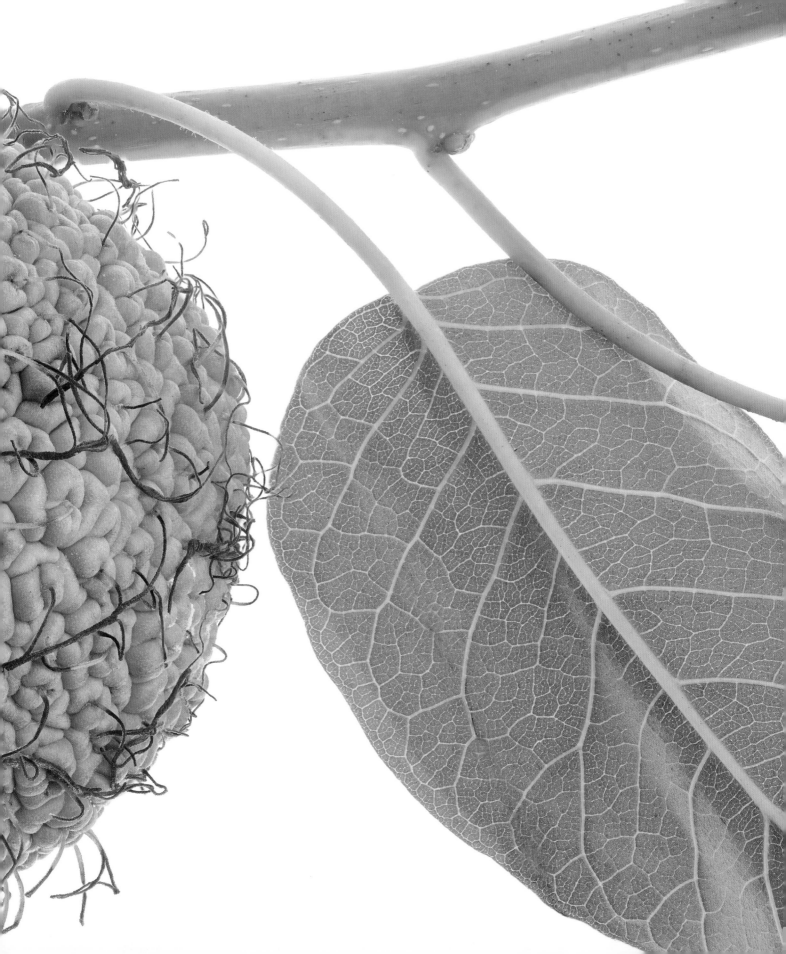

red maple

Acer rubrum

Perhaps no other tree genus is so commonplace as the maple throughout the United States and up into Canada. There are many natives. Red maple, *Acer rubrum*, and sugar maple, *A. saccharum*, dominate in eastern North America, while bigleaf maple, *A. macrophyllum*, is widespread out west. There are many introduced ones, notably the many beautiful, smaller-statured Japanese maples, varieties of *A. japonicum*, and the maligned Norway maple, *A. platanoides*. Most are easygoing in a home landscape or park setting, rarely decimated by pests or diseases, and handsome in every season.

We don't grow or appreciate maples for their seeds. And yet they follow the spring flowers, often in profusion, and they are hard to ignore. The botanical term is samaras, or winged nuts. They spiral to the ground like tiny whirling helicopters, a form that has provided entertainment for children and inspiration for inventions like World War II parachute drops. Eventually the papery wings rot away, and the seeds sprout easily.

Maple fecundity can be astonishing. This phenomenon was evocatively described by Verlyn Klinkenborg, writing from his upstate New York farm in spring:

> A week after the snow left, I started seeing tiny seedlings everywhere—in the garden, across the lawn, throughout the pasture. They looked as if they had been thickly broadcast by someone with a sure hand . . . every samara that fell last year seems to have taken root. We now live in the middle of a forest that's 3 inches tall. When the sun sets, it catches the tint of the seedling maples and the pasture turns bronze.

Just as some people can identify an oak by its acorn, a maple may be identified by its samara. The angle of the wings is often telltale. For example, those of the ash-leaved maple diverge at a 60-degree angle, while those of the Norway are nearly horizontal.

You have undoubtedly seen maple keys or samaras in their spinning, whirling flight. But pause and watch more closely next time. The design slows their descent so they land gently, but it also allows a blowing breeze to push them back upward. Thus, hopefully, their journey lasts longer and they travel further.

rose

Rosa species

Folks who have roses in their yards or who observe nature in autumn know that hips, the fruits that follow, vary widely. Some resemble cherry tomatoes in size and color, like those of beach roses (*Rosa rugosa*). Others, mainly vintage and wild species, sport hips that look like little elfin urns. The persistent remnants of the flower's calyx at the far end add a touch of whimsy as these dangle on the plants, sometimes well into the colder months.

Rose hips are rich in vitamin C, even more so than oranges. They also contain significant amounts of A, B, E, and K, some organic acids, and pectin. The latter make them mildly laxative and diuretic. Consequently, rose hips in dried and powdered form are on the shelves of health-food stores, especially in herbal teas. Hips are tart and can be used as a substitute for cranberries. Cooks also add them or their extracts to jam and jelly, syrup, baked goods, and even soups.

Most rose hips are crunchy with seeds, which may be separated from the pulpy flesh. A rose hip is a nutlet-filled berry. The flower's carpels convert to nutlets (individual, thick-walled—for their tiny size—seeds). It's almost a pome, like an apple, except the interior is not divided into cavities.

If you like the look of hips, there are two schools of thought about leaving them on. Letting them develop is presumed to hasten the natural season-end process of going dormant. Plucking off flowers before fruit can form, or dead-heading, tends to inspire a plant to redirect its energy into generating more blooms.

Roses may be raised from seed. But rose genetics are complex, so there is no telling what you might get.

Hips are the fruit of roses, and they are valued for late-season garden color and vitamin C content. Evidently the common-usage term traces back to old England, where the fruits of wild and briar roses were called *hep, heope,* and *hiopo*.

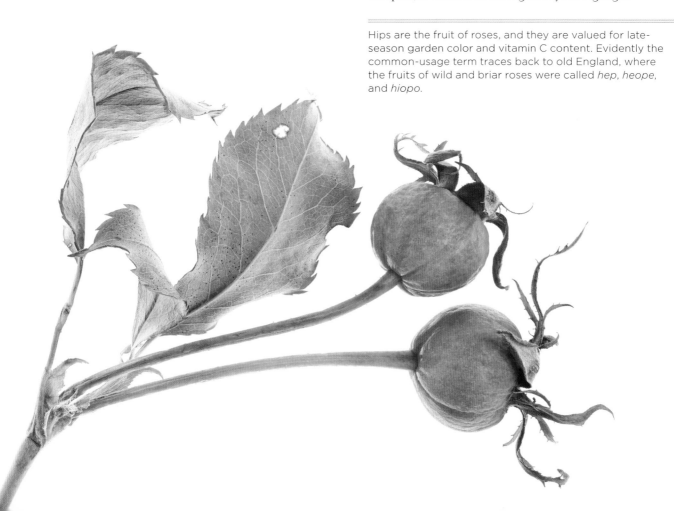

screwbean mesquite

Prosopis pubescens

Native to deserts of southwestern North America, Baja California and Mexico, and South America, mesquites are tough plants. Where soil is dry and rocky, they tend to grow slowly to form large multistemmed shrubs, whereas in cultivation or in areas of deeper soil, they can send down a taproot, grow more quickly, and gain a more treelike profile. A picturesque canopy of light shade forms, thanks to the airy leaflets. If the leaflets aren't enough of a clue that mesquite is in the bean family (Fabaceae), the dangling seedpods that follow a springtime flurry of small yellowish flowers give it away.

Of all the mesquites, the screwbean, or tornillo, has the most distinctive seedpod. Tightly coiled and up to 2 inches long, the pods begin green and dry and harden to golden brown. Just looking at one reveals that it is indehiscent, or not going to split open on its own. It takes a trip through the digestive tract of a foraging mammal—often rodents, but also coyotes, some birds, and even deer—to soften that protective coat and release the bounty of tiny seeds. Cattle may also eat them, despite an aversion to the plant's spiny stems. Presumably, an enterprising gardener could accomplish scarification by filing, nicking, or soaking. Occasionally time and perhaps wet conditions will also break down these hard cases.

The spiraled shape of this one is a curiosity. It may offer better protection from insects because there is less exposed surface. Other mesquites with traditional beanlike pods suffer significant insect damage—less pods, less seeds per pod, and less viable seeds. On the other hand, this one's smaller size and surface area meant it was not the first choice for Native Americans making mesquite flour by grinding up dry pods.

All mesquites, woody members of the bean family, have pods. Those of the aptly named screwbean mesquite are so unique that the tree cannot be mistaken for anything else. These pods take self-defense to a whole new level. They're not just hard, they're particularly difficult to open. Instead of clear seams that might be pried apart, the spiral shape discourages almost any attempts to get at the seeds.

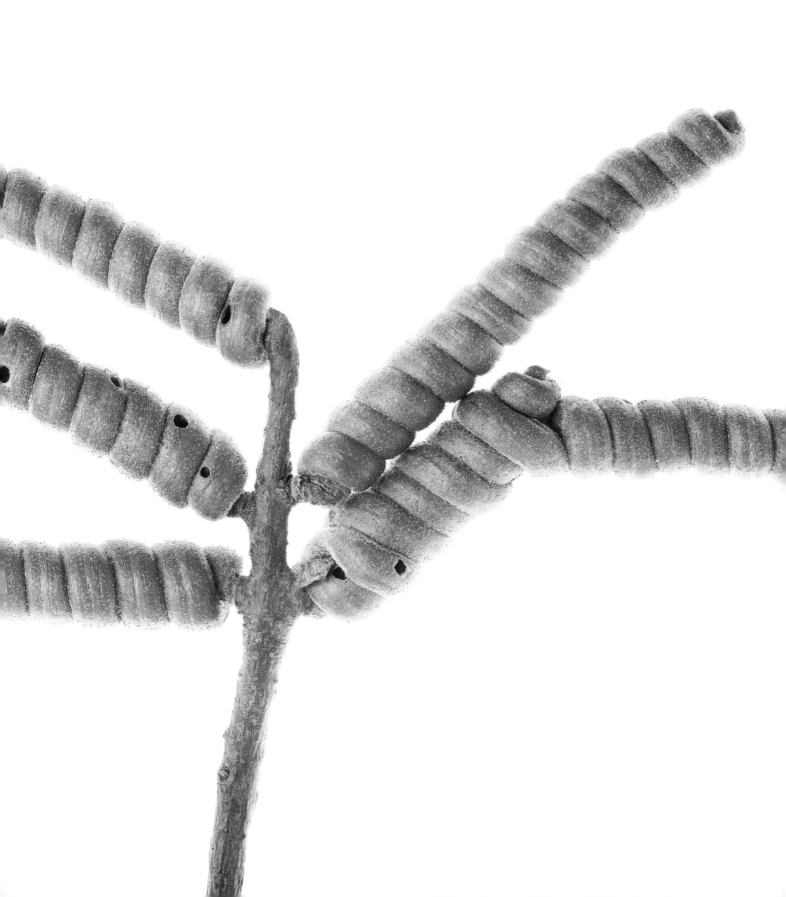

screwpine

Pandanus utilis

If you have visited or live in Florida, or have traveled to tropical coastal locales in the Pacific or Southeast Asia, you may have seen a screwpine. In nature, the trees can attain 50 or 60 feet with multiple stems and impressive aerial prop roots. In cultivation, they are more circumspect, and usually treated like a specimen plant or displayed in a large planter pot.

Although screwpines superficially resemble a palm, thanks to plentiful, slender, strappy leaves, they are in their own family. The common name refers to the way individual leaves are twisted near their base. Some species are also prickly. In native haunts, the foliage is valued for weaving baskets, mats, and so forth. The leaves are also used to wrap rice, meat, or fish prior to steaming or to flavor soups and stews. Juicy pandan paste, extracted from the leaves, is often featured in Thai and Filipino recipes. Its flavor is herbal and floral.

Plants are either male or female. Pollination is aided by wind and perhaps also by insects and animals, depending on the setting. While not large—generally between 6 and 12 inches long, depending on the species—the heavy green fruit bear a superficial resemblance to pineapples. The fruit is composed of keys, many tightly packed, wedge-shaped drupes. Layers of fibrous pericarp and mesocarp cover the true seeds, which are further protected by a hard endocarp. When it ripens, the entire fruit turns yellow to red. The sweet-flavored edible portion of the keys, after removal and on closer inspection, is the lower juicy, colored part.

Viable keys float, which is a clue to dispersal in native habitats. It's not hard to grow a new plant from one, should you wish to try.

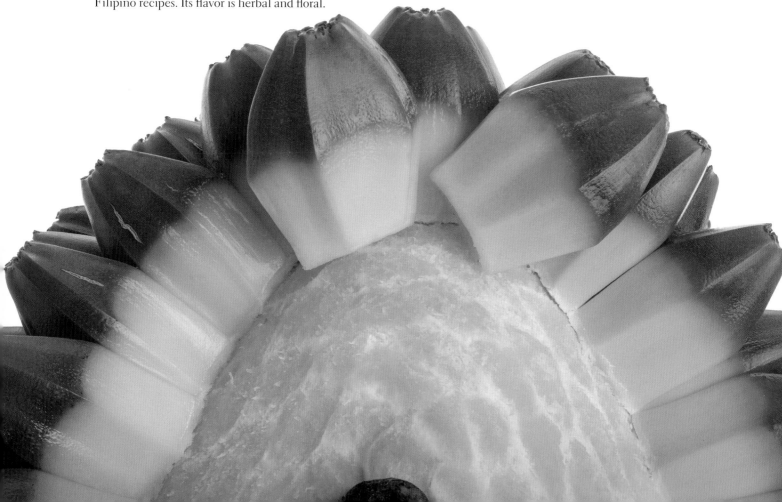

The tropical tree known as screwpine is not a pine, although its fruit bears a superficial resemblance to a large, chubby pinecone. It is made up of densely packed keys that are actually wedge-shaped drupes. Harvested at the right time, the lower, colorful part is sweetly delicious.

253

southern magnolia

Magnolia grandiflora

The magnificent blossoms of the southern magnolia may steal the stage, but the woody conelike fruits that follow merit some appreciation. They are rather unique in the world of tree fruits.

Magnolia flowers produce no nectar. Despite the seductive call of rich fragrance, bees and butterflies give them a pass; beetles do the necessary work. The protein-rich pollen is an important food source for them. Magnolias are an old-fashioned, actually ancient, genus.

The 3- to 5-inch-long fruit is an aggregate or multiple fruit. Out of context, you might mistake it for an exotic tropical fruit. However, it has something in common with raspberries and strawberries. These also develop when several ovaries present in a single flower merge together. Raspberries are an aggregate of drupes and strawberries are an aggregate of achenes; magnolia fruits are an aggregate of follicles.

When ripe, the follicles split open along the front side to expose the fleshy-coated red sarcotestal seeds. Their bright color, especially contrasted against a brown background, lures hungry birds as well as mammals like squirrels and possums.

Ripe seeds will fall out of their holding places yet remain on the fruit, held by what is essentially a short umbilical cord. This threadlike silken material is unrolled spiral wall thickenings composed of vascular bundles, which make them fairly strong. The little red seeds dangle, even moving enticingly in a breeze to attract notice.

Only fresh seed germinates well; a dried out one cannot be revived. Seedlings may pop up or an enterprising gardener can try sprouting a few. But seeds from one of the many lovely cultivars will not come true.

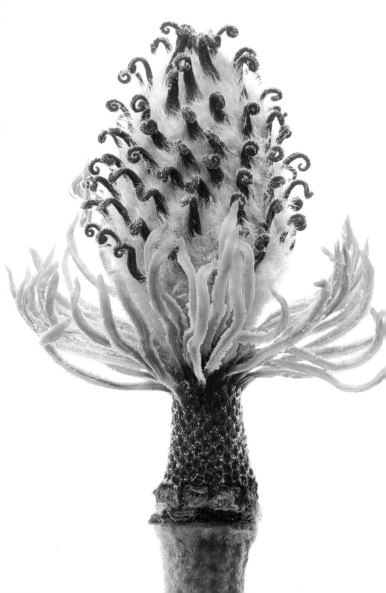

RIGHT This is what a magnolia blossom looks like once its beautiful petals (well, technically tepals) fall off, prior to going to seed. Those weird curlicue things are the stigmas and arrayed below them are the golden-brown stamens. Who knew such a simple, elegant flower hid such bizarre-looking elements in its center?

OPPOSITE A magnolia fruit looks odd because it *is* odd. It is an aggregate-type fruit, a complex of follicles. The seeds eventually loosen but don't fall right away; instead they dangle, still attached by a bit of vascular tissue. At that point, they might remind you of one of those West African percussion instruments with the beads dangling off a dry gourd—a lilolo or an axatse.

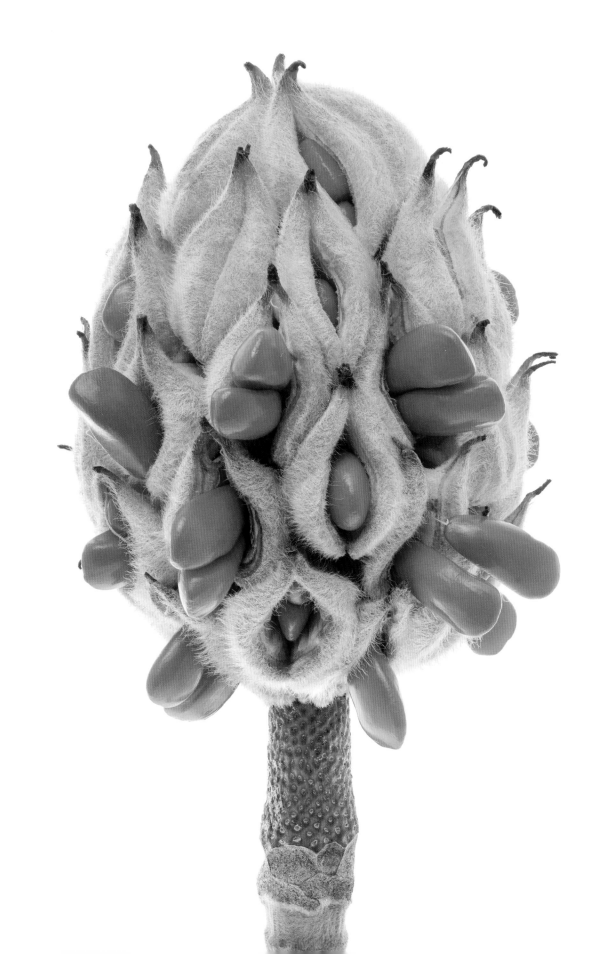

staghorn sumac

Rhus typhina

Throughout the North American Eastern seaboard into southern Canada and inland to Michigan, this sumac is a familiar sight. It forms towering clumps and colonies, especially in exposed or disturbed areas of poor soil. Its velvety stems lead to the common name of staghorn sumac. But it is most easily recognized by its bright red fruits, which rise above dense compound leaflets. (It is related to the rarer poison sumac, *Rhus vernix*, a plant that favors swamps and has yellow-green flowers followed by clusters of whitish berries.)

The downy red fruits are carried aloft on stem tops. These plants are dioecious; that is, male and female flowers are carried on separate plants, although both types are green-yellow. Males are big, loose, wide panicles, while females are smaller and more condensed. Various insects, especially bees, do the pollinating. Females ripen the signature fuzzy red berry spikes.

Technically sumac fruits are drupes. Like other drupes—cherries and olives, for example—they hold stonelike pits. These are small. Drying and mashing (even in a food processor) can separate them out.

Sumac's red fruit hangs on through season's end and sometimes through the winter months. Wildlife dine on it, especially birds. Grouse and pheasant favor it, as do crows, gray catbirds, robins, and more, which enables seeds to move to new areas.

Humans are also interested in the fruit. You can brew a tart beverage by soaking the red berries in cool water, then straining. You'll need about a dozen to flavor a gallon of cold water. (Hot water leaches off the acid, ruining the flavor.) The result is a pink-orange drink that resembles pink lemonade. In fact, pink lemonade was likely invented to mimic this beverage, which Native Americans and early European settlers enjoyed.

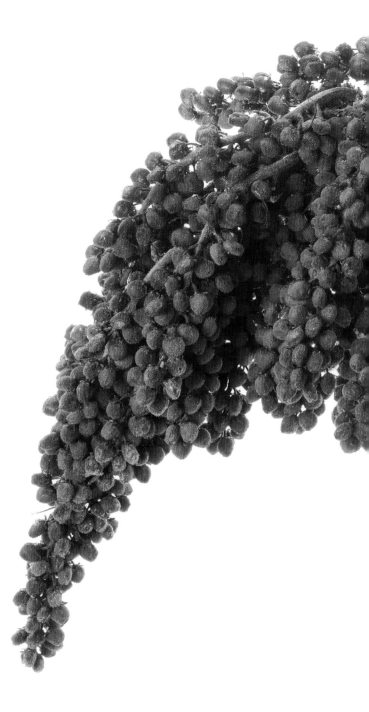

The ripe brick red fruit of the North American staghorn sumac is perfectly safe to consume, and you can use it to make a tart, vitamin C-rich beverage. The name, however, comes from the Arabic word for red, in reference to a related species native to the Middle East. Over there, that sumac is ground into a reddish powder and adds a sour kick to recipes from tabbouleh to fattoush salad to spice rubs.

sweetgum

Liquidambar styraciflua

For those of us who grew up where sweetgum trees lined the streets, flinging the fruit at one another was great fun. The spikeballs are only about 1½ inches in diameter, so no one got seriously hurt. Then a few of us grew up to be gardeners or botanists, and we wondered why the spikeballs are balls and why they are spiky.

For answers, we need to trace back to the flowers. The male ones are 3- to 4-inch racemes held upright on branch ends. Color is bright to rusty red. Female ones are solitary, dangling ½-inch cream-colored heads; these develop into spikeballs. Both types of flowers are on any given tree, and wind does a passable job of pollination.

Bearing in mind that the female flowers are actually clusters, you can extrapolate how the fruit becomes a cluster of capsules. It is easy to view tiny individual flowers with long, elaborate stigmas all over the surface. Each female flower then develops into a fairly woody, two-beaked fruit capsule, so spikeballs are really multiple fruits. Any given one will be studded with forty to sixty fruits.

As spikeballs dry out on the tree, the capsules will split open along a seam. When pollination was successful, one or two small brown seeds, equipped with little wings to aid dispersal, developed inside. These measure about ¼ inch across. Unpollinated balls, on the other hand, contain sawdust-size ovules.

In any event, when the capsules open, the contents fall out, get blown away, or are eaten by birds, squirrels, and chipmunks—all legitimate ways to distribute. Empty balls can hang on a tree all winter and even into the following spring.

The spikeball of the sweetgum tree is really an aggregate of up to sixty individual fruits. Pollinated ones mature one or two winged seeds, which disperse when a beaked fruit splits open. Dried-out empty balls, as any kid knows, are sharp, easy, and fun to toss, and generally cause more annoyance than harm.

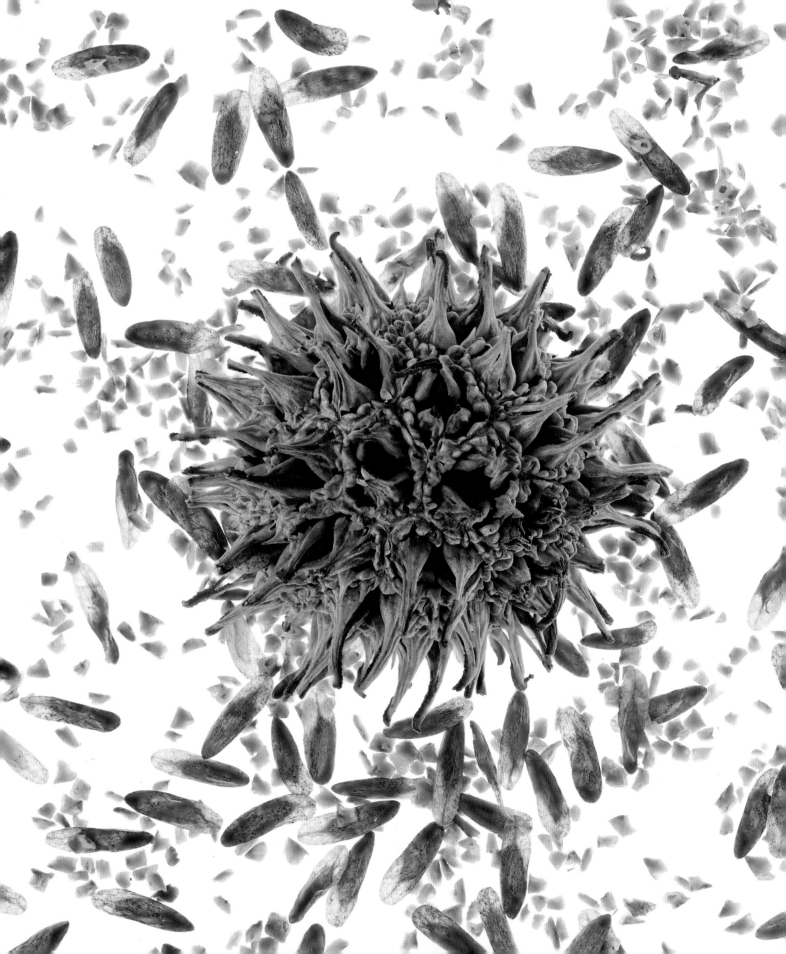

sycamore

Platanus occidentalis

Seeking relief from blazing sun in arid places is a matter of scanning the topography for an arroyo, a riverbed, or a bottomland area where there might be water or at least shade. Even from afar, such places are flagged by the presence of what naturalists call indicator plants, including willows, alders, and sycamore trees. Seeking refuge under a large sycamore tree often also affords an opportunity to observe its ball-like fruits.

Sycamores are easily identified and appreciated at a distance because of their mottled upper bark, which is reminiscent of a camouflage pattern. At closer range, the big leaves, which are shaped like blunted maple foliage, are certainly telltale, thanks to their green tops and downy undersides. But coming in close to examine the fruits is rewarding.

About 1 inch in diameter, the balls are usually borne singly at the ends of slender drooping stalks. This is a distinguishing characteristic of the American tree. Those of the related London plane tree, *Platanus acerifolia*, are usually carried in pairs, while the Asian one, *P. orientalis*, brings them in bundles of three or more. The Western sycamore or aliso, *P. racemosa*, has impressive clusters of three to seven.

These distinctive fruits have inspired the common names of buttonwood and buttonball tree. They are considered multiple fruits, and it's not hard to poke at and extract the fuzzy (winged), elongated achenes. Like the achenes of the much smaller dandelion plant, they can drift away on a breeze. Birds, squirrels, and muskrats—and water, when present—also aid dispersal.

When fresh and green, the balls hold together well. As they ripen, often clinging to the tree well into winter, they turn brown and break apart.

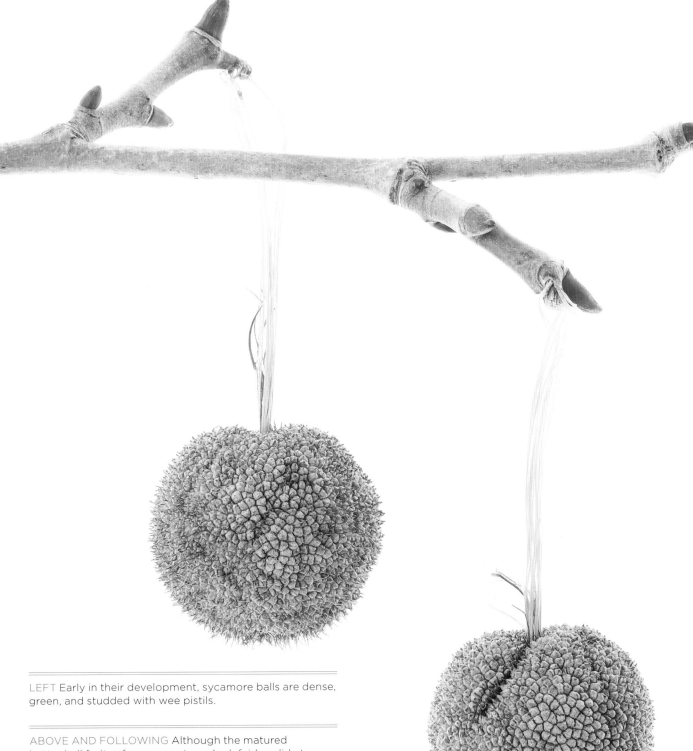

LEFT Early in their development, sycamore balls are dense, green, and studded with wee pistils.

ABOVE AND FOLLOWING Although the matured buttonball fruits of sycamore trees look fairly solid at a distance, they are soft because they are composed of achenes with the fluff to the outside. That's a lot of single-seeded nutlets to disperse. Birds eat some, while squirrels, beavers, and muskrats consume others. Many just drift away and dry out. But every now and then one sprouts and, with luck and time, becomes a huge tree.

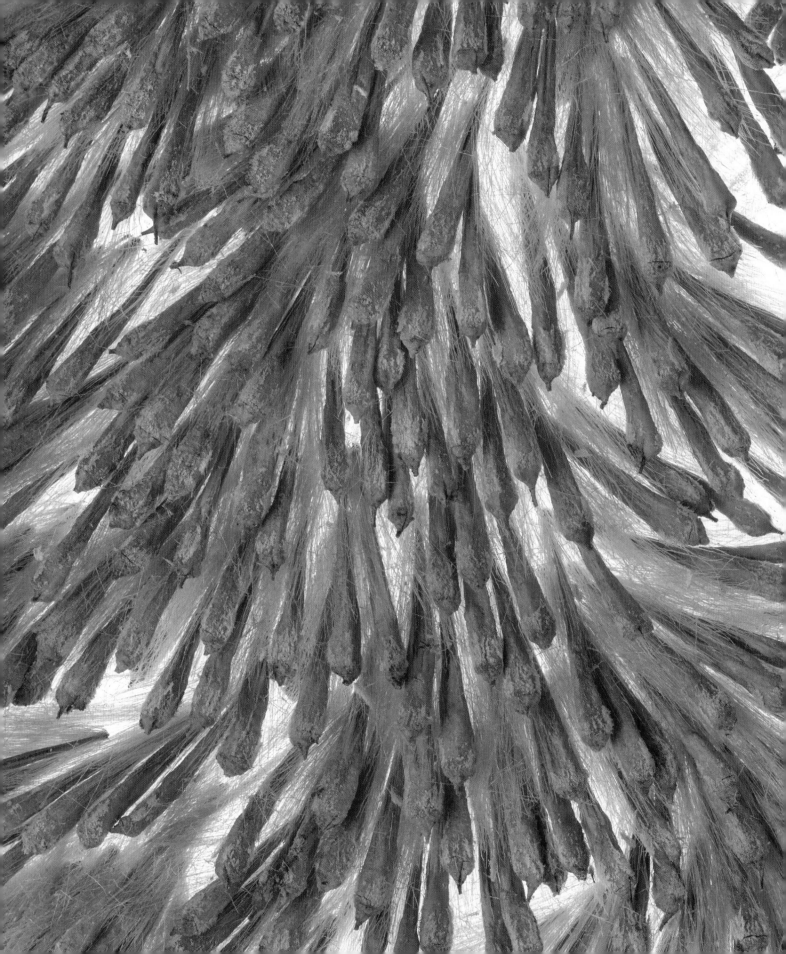

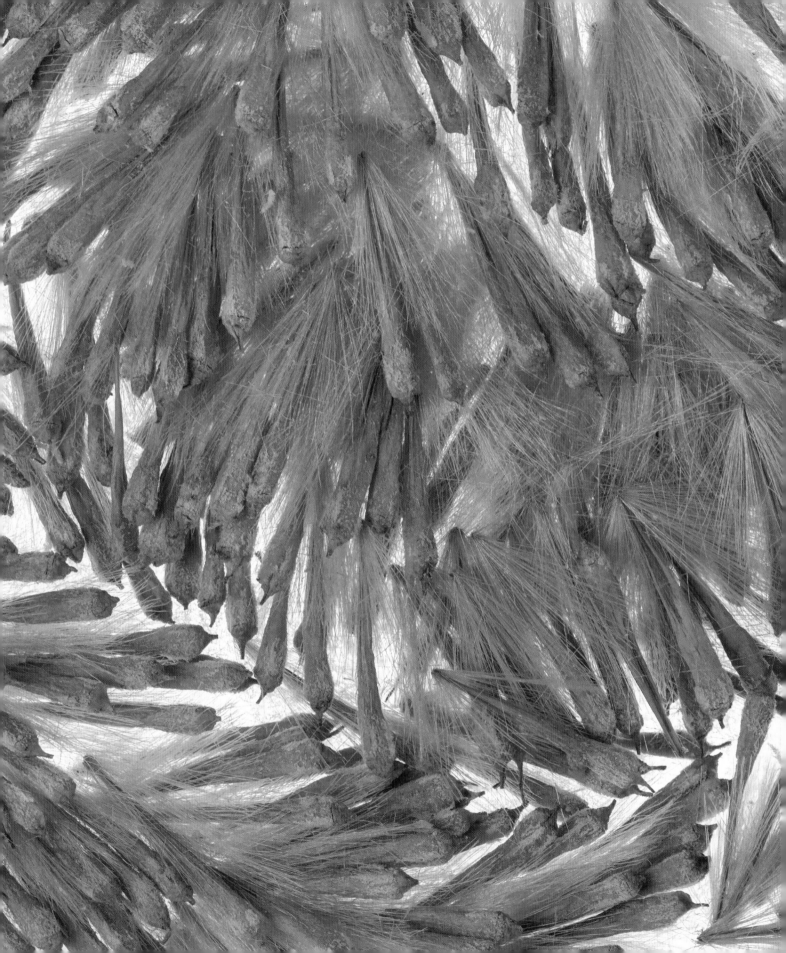

tree of heaven

Ailanthus altissima

I once participated in an effort to clean up an overgrown urban lot. After the garbage was hauled out, we began clearing the weedy vegetation. Our fearless leader, a slight-framed older woman, brandished a machete at the many ailanthus saplings. "I. Hate. This. Trashy. Tree," she grunted with every blow. They fell before her assault. But when I revisited the area not long afterward, they had returned sevenfold.

Ailanthus trees are dioecious, and there always seem to be plenty of both sexes. The yellow-green flower panicles skulk among the profuse pinnately compound leaves. The staminate ones are stinky as well as more prolific; the female ones are odorless. All sorts of insects pollinate—bees, flies, beetles, and more. The result, on the female plants, is lots of orange to red inch-long samaras.

Inspection of these samaras reveals that the seeds are quite small, a mere 5 mm across. Proportionally, the rest of the samara is quite large and lightweight, with twisted tips. These spin and sail easily on the wind, and float on water. A single plant can produce thousands.

But hordes of viable seeds dispersing far and wide from late summer into the following spring are only part of the problem with this invasive Chinese import. Any roots left in the ground will sprout—even fragments and those that have lost their top growth to hacking attackers.

Eradicating an unwanted clump or even just one larger specimen requires a battle plan and persistence. Clipping out samaras before they disperse, where practical, only limits spread. Repeated cutting back and mowing low might be an option. Spray with toxic herbicides (triclopyr or glyphosate) only if desperate, determined, and educated on proper application timing, methods, and risks.

Ailanthus is incredibly prolific in its seed production. Each twisty reddish or yellow-green winged fruit sports a single centrally placed seed. These are carried in clusters, like the flowers that came before them. They are generated in prodigious amounts, even on saplings. When they release, it's a botanical tsunami.

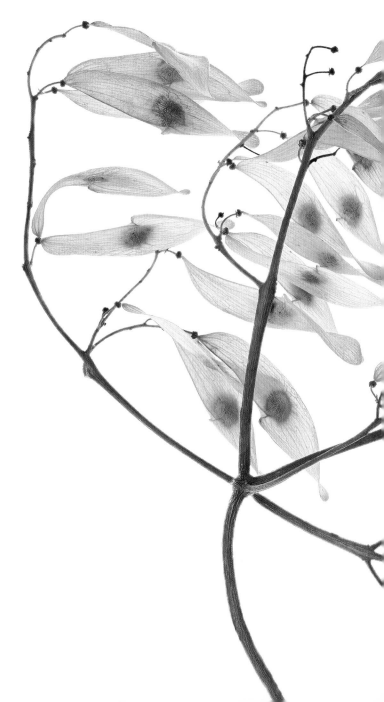

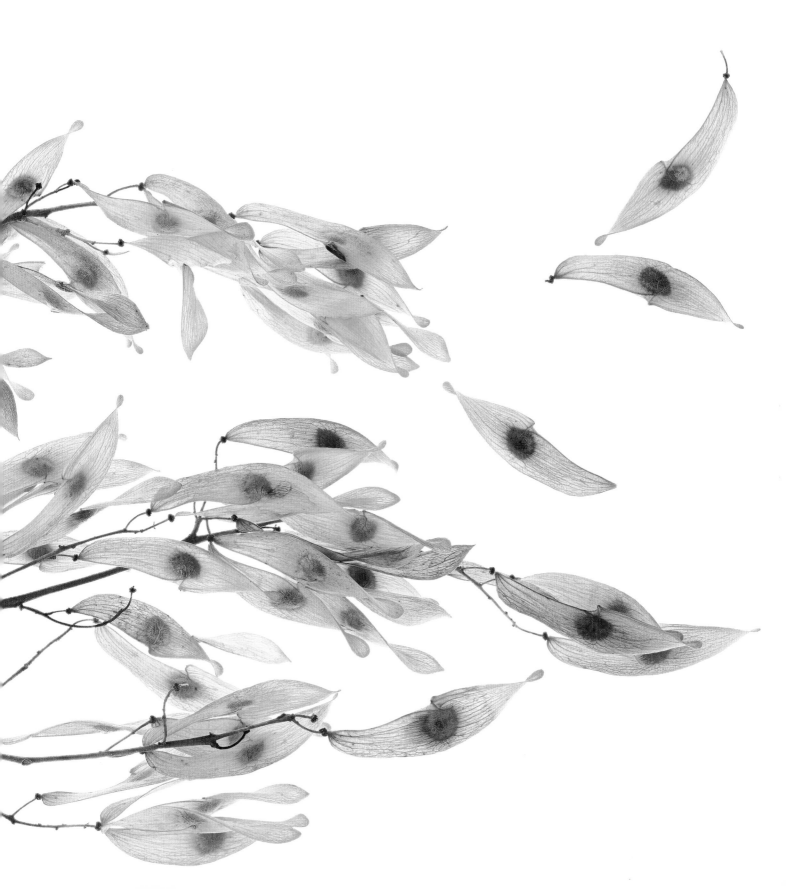

tulip poplar
Liriodendron tulipifera

Tree lovers lavish praise on the tulip poplar. Michael Dirr, author of authoritative volumes on woody plants, calls it magnificent. *Hortus III*, the classic botanical reference not given to hyperbole, describes it as "one of the noblest of American trees." It reaches 60 to 90 feet tall and half as wide. Owing to its great size, however, it is mainly encountered in parks, estates, botanical gardens, and occasionally towering over other hardwoods in a forest setting. Even novices recognize it by the distinctive shape of its lobed leaf, which looks like a keystone or a child's rendering of a tulip blossom.

It is not the leaf that gives the tree its common name, but the cuplike flowers. These appear in late spring, caried aloft on twig ends. About 2 or 3 inches across, they have six rounded green-yellow petals with orange center flares, backed by three sepals. A center conelike spike develops, reminiscent of a magnolia blossom's center—not surprising, given that they are in the same family. This is the female part of the flower, and it develops into a unique aggregate fruit.

Unlike magnolia fruit, however, tulip tree fruit is not woody, and its pollination is neither odd nor old-fashioned— bees, other insects, and high-flying hummingbirds do the work. A compact cluster of long, narrow carpels segues into a compact cluster of winged seeds. Later, most of these papery samaras disperse on the wind or are eaten by squirrels. What is left behind browns and hardens and rather resembles a tulip blossom again.

Unfortunately, this tree lacks lower branches, which often places both flowers and fruit out of view of humans. You might be able to detect the remains of the fruit when the tree is bare for the winter and the branches take on the aspect of misshapen candelabra.

Tulip tree flowers, and consequently fruit, tend to be borne on the upper branches of these stately trees, so it is difficult to see them. The one shown here is actually a clutch of winged seeds. It is well into the process of drying out, splaying open, and releasing seeds to go where they will on the wind.

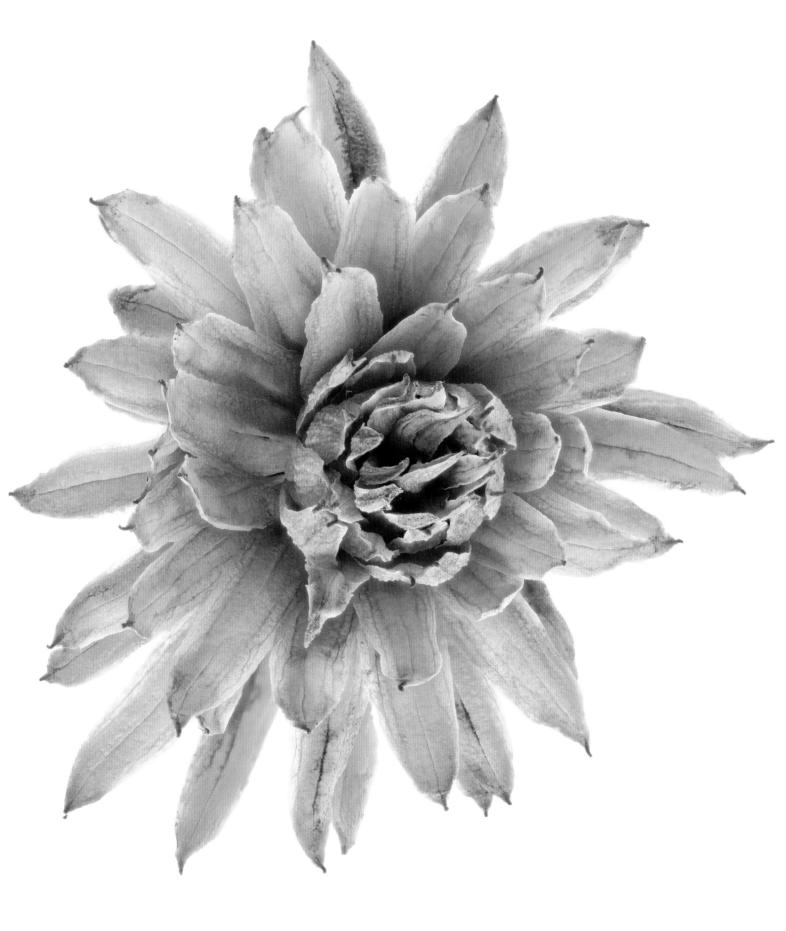

wisteria

Wisteria species

Wisteria flowers are much admired, especially when fragrant tresses adorn mature, healthy plants. Japanese wisteria, *Wisteria floribunda*, has violet-blue pealike blossoms in racemes of 8 to 20 inches long. Opening begins at the base of a cluster and proceeds upward, prolonging the show. Chinese wisteria, *W. sinensis*, has shorter clusters, between 6 and 12 inches. Its flowers all open more or less concurrently.

Sometimes, but not always, these beauties are followed by dangling, velvety brown pods that encase fat brown seeds. If the flowers hadn't convinced you, the pods definitively indicate that the plant is in the bean family (Fabaceae).

Even without prying one open, you can count how many seeds are inside a pod ripens, which constricts as it ripens. Some have as many as eight; some have as few as one. Left on the plant, they dry, until one fine day they explode and fling their seeds away.

You might be curious to collect the seeds and try raising more plants. Certainly you could, but be patient. Seed-raised ones can take as many as ten to fifteen years to generate any blooms. And if your source plant is a cultivated variety, the babies won't look like the parent plant.

Seed production may be unimpressive because of pollination. Bees and other insects visit, but hummingbirds are especially successful. They are drawn to the tubular shape as well as the high concentration of blooms; it's possible to dine well without expending a lot of energy flying around. Other pollinators are at a disadvantage because the tresses lack a good spot to perch and rest. Some suggest cross-pollination; that is, another blooming wisteria plant in the vicinity could be helpful.

When growth is rampant, don't blame the seeds. Where wisterias are concerned, expansion is mainly vegetative.

A wisteria-pod explosion tends to leave the original in fragments. Twisted, sprung pod segments and small dark seeds scatter. If you happen to be around at the moment of expulsion, you're more likely to hear the commotion than to witness where the seeds land.

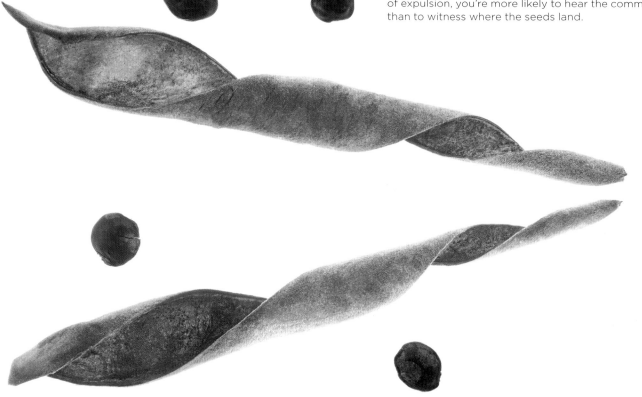

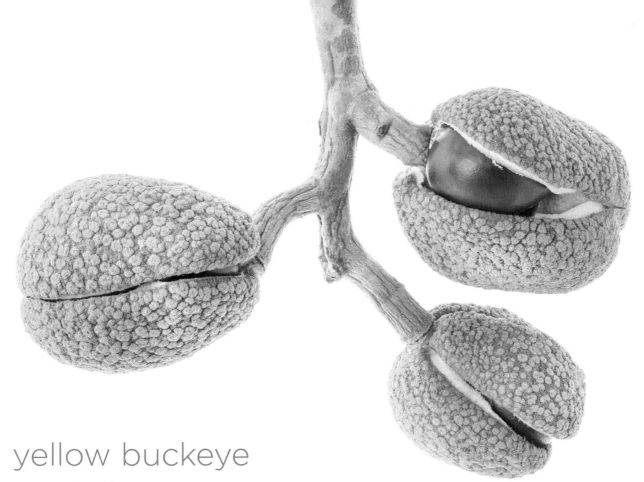

yellow buckeye

Aesculus flava

If you're from the Buckeye State, Ohio, you may be sentimental about these plants. If you have childhood memories of stuffing your pockets with lucky buckeyes—the smooth chocolate brown seeds—you may also be nostalgic for them.

The name of the plant derives from the seeds and traces back to Native Americans. They called it *hetuck*, which means eye of the buck. This fits, given the buckeye's size and brown shine, and presence of a lighter spot (the basal scar) on it.

There are a number of native species, all of which look fairly similar. The Ohio buckeye, *Aesculus glabra*, is the most widely distributed one. From California comes one more tolerant of dry soils and hot summers, A. *californica*. The Texas buckeye, A. *arguta*, has smaller leaves, flowers, and capsules. The yellow buckeye, A. *flava*, is so named because of its yellow-green flowers. All have signature compound palmate leaves and a tendency to be a bit messy (defoliating, dropping twigs). They bear rough-textured dehiscent capsules that split apart at maturity. Within you will find one to three seeds.

If you'd like to try your hand at raising a plant from a buckeye, don't wait. They dry and shrivel in storage. Sow them after collecting, ideally in a deep container or bed, as they develop long taproots. No special treatment is necessary for germination, although a cold winter helps some species. Protecting the seeds from hungry squirrels may be more of a concern. A temporary screen or piece of landscape fabric may do the trick.

Buckeye seeds can be poisonous to humans. Ingestion can also kill horses, cattle, sheep, and pigs. They have high tannin content and contain glycosides.

Buckeye seeds, of all species, have a high tannin content and other bitter or toxic components that make ingesting them inadvisable. Native Americans evidently employed extracts to stupefy fish, and bookbinders once used aesculin-rich paste because book-nibbling insects shun it.

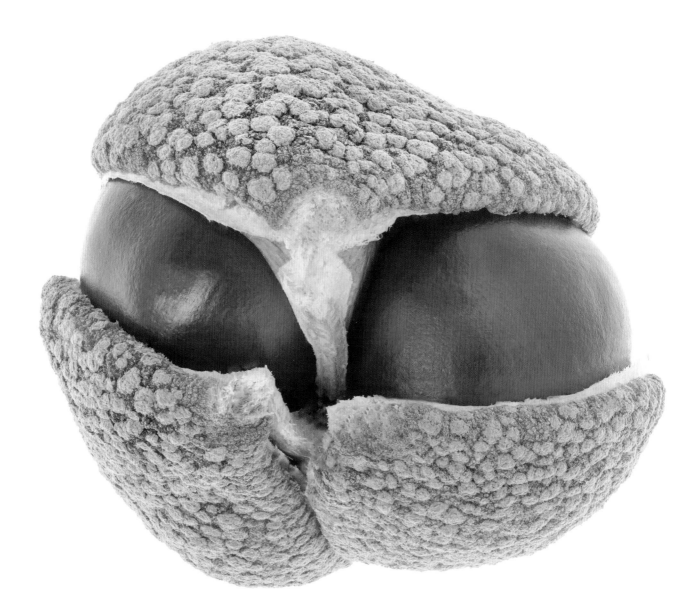

Buckeye capsules contain the prize: up to three rounded, shiny seeds, each with a large basal scar—hence the "eye of the buck."

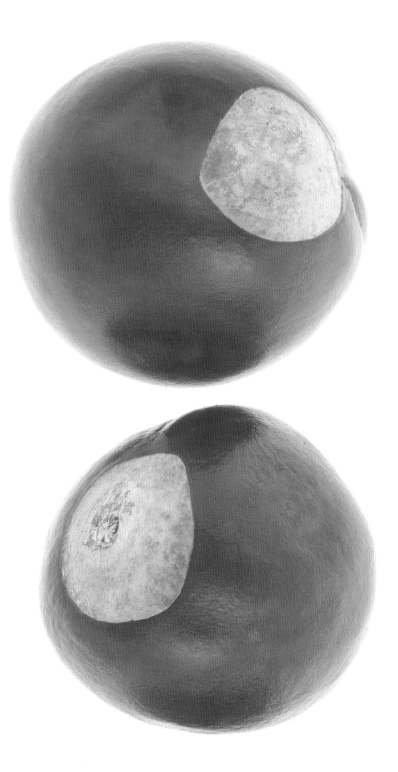

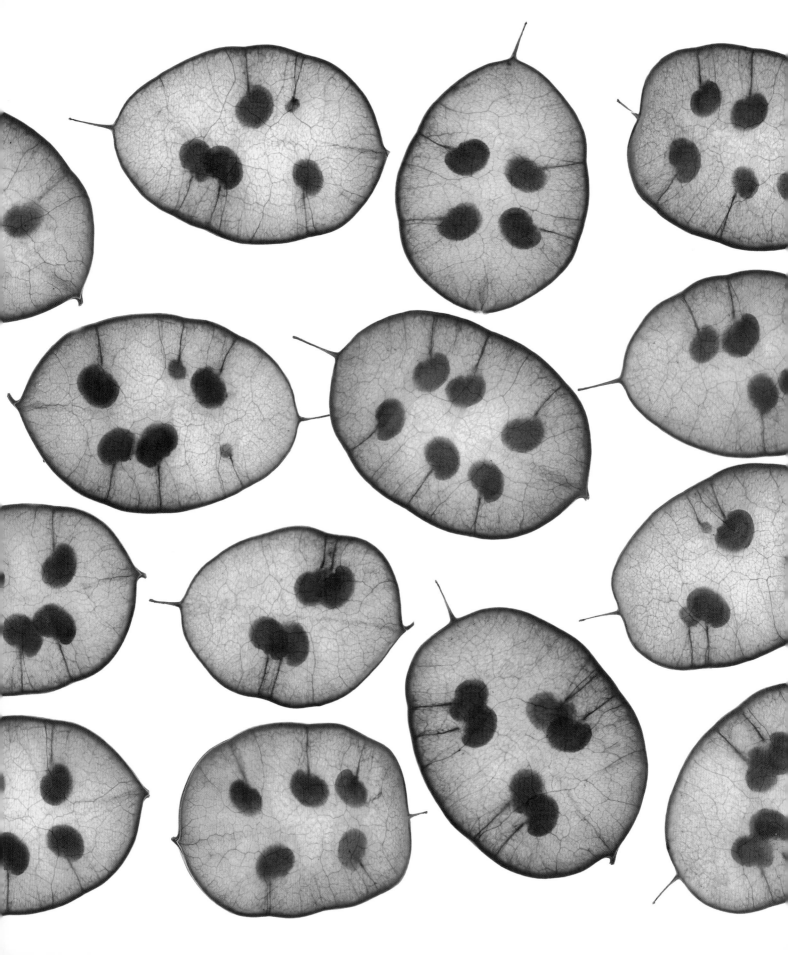

METRIC CONVERSIONS

INCHES	CM
¼	0.6
½	1.3
¾	1.9
1	2.5
2	5.1
3	7.6
4	10
5	13
10	25
20	51
30	76
40	100
50	130
60	150
70	180
80	200
90	230
100	250

FEET	M
1	0.3
2	0.6
3	0.9
4	1.2
5	1.5
6	1.8
7	2.1
8	2.4
9	2.7
10	3
20	6
30	9
40	12
50	15
100	30
1,000	300

The flat capsules of *Lunaria annua* shelter small, flattened seeds. For more, please refer to page 81.

RECOMMENDED READING

Abelman, Michael. 2005. *Fields of Plenty: A Farmer's Journey in Search of Real Food and the People Who Grow It.* New York: Chronicle Books.

Abelman, Michael. 1993. *From the Good Earth: A Celebration of Growing Food Around the World.* New York: Harry N. Abrams, Inc.

Ashworth, Suzanne. 2002. *Seed to Seed: Seed Saving and Growing Techniques for Vegetable Gardeners,* 2nd edition. Decorah, Iowa: Seed Savers Exchange.

Brown, Lauren. 2012. *Weeds and Wildflowers in Winter.* Woodstock, Vermont: The Countryman Press.

Bubel, Nancy. 1988. *The New Seed-Starters Handbook.* Emmaus, Pennsylvania: Rodale Press.

Chace, Teri Dunn. 2013. *How to Eradicate Invasive Plants.* Portland, Oregon: Timber Press.

Chace, Teri Dunn and Robert Llewellyn. 2013. *Seeing Flowers: Discover the Hidden Life of Flowers.* Portland, Oregon: Timber Press.

Chaskey, Scott. 2014. *Seedtime: On the History, Husbandry, Politics, and Promise of Seeds.* New York: Rodale Inc.

Clausen, Ruth Rogers and Nicolas H. Ekstrom. 1989. *Perennials for American Gardens.* New York: Random House.

Cohen, Russ. 2001. *Wild Plants I Have Known…and Eaten.* Essex, Massachusetts: Essex County Greenbelt Association.

Deppe, Carol, 2000. *Breed Your Own Vegetable Varieties: The Gardener's and Farmer's Guide to Plant Breeding and Seed Saving.* White River Junction, Vermont: Chelsea Green Publishing.

Dirr, Michael A. 2011. *Dirr's Encyclopedia of Trees & Shrubs.* Portland, Oregon: Timber Press.

Dirr, Michael A. 2009. *Manual of Woody Landscape Plants,* 6th edition. Champaign, Illinois: Stipes Publishing Company.

Eiseley, Loren, 1959. *The Immense Journey: An Imaginative Naturalist Explores the Mysteries of Man and Nature.* New York: Vintage Books.

Fenyvesi, Charles. 1992. *Trees: For Shelter and Shade, for Memory and Magic.* New York: St. Martin's Press.

Fussell, Betty, 2004. *The Story of Corn,* reprint edition. Albuquerque, New Mexico: University of New Mexico Press.

Gollner, Adam Leith. 2013. *The Fruit Hunters: A Story of Nature, Adventure, Commerce, and Obsession.* New York: Scribner, A Division of Simon & Schuster, Inc.

Halberstadt, Alex. April 7, 2013. "The Spice is Right: With a Sprinkling of Lior Lev Sercarz's Pixie Dust, Almost Anything Might be Edible," *New York Times' Sunday Magazine,* pp. 64–94.

Halpin, Anne Moyer. 1996. *Horticulture Gardener's Desk Reference.* New York: Macmillan.

Heistinger, Andrea, in association with Arche Noah and Pro Specie Rara. 2013. *The Manual of Seed Saving: Harvesting, Storing, and Sowing Techniques for Vegetables, Herbs, and Fruits.* Translated by Ian Miller. Portland, Oregon: Timber Press.

Hill, Lewis. 1985. *Secrets of Plant Propagation: Starting Your Own Flowers, Vegetables, Fruits, Berries, Shrubs, Trees, and Houseplants.* North Adams, Massachusetts: Storey Publishing, LLC.

Jaffrey, Madhur. 2007. *Madhur Jaffrey's Quick & Easy Indian Cooking.* New York: Chronicle Books.

Kesseler, Rob, and Wolfgang Stuppy. 2008. *Fruit: Edible, Inedible, Incredible.* San Rafael, California: EarthAware Editions.

Kesseler, Rob, and Wolfgang Stuppy. 2012. *Seeds: Time Capsules of Life.* San Rafael, California: EarthAware Editions.

Klinkenborg, Verlyn. 2003. *The Rural Life.* Boston: Little, Brown and Company.

Kowalchik, Claire, and William H. Hylton, eds. 1987. *Rodale's Illustrated Encyclopedia of Herbs.* Emmaus, Pennsylvania: Rodale Press. Reprinted 1998.

Lacy, Allen. 1990. *The Garden in Autumn.* New York: Henry Holt and Company, Inc.

Lyons, Stephen J. September 15, 2013. "Sowing the Seeds of Preservation," *American Way Magazine* (in-flight magazine of American Airlines), pp. 48–52.

McDorman, Bill. 1994. *Basic Seed Saving.* Tucson, Arizona: Pahsimeroi Press.

Morley, Margaret Warner. 2010 reprint. *Little Wanderers.* Whitefish, Montana: Kessinger Publishing, LLC.

Rupp, Rebecca. 1990. *Red Oaks & Black Birches: The Science and Lore of Trees.* North Adams, Massachusetts: Storey Publishing.

Shiva, Dr. Vandana. 2013. *Making Peace with the Earth.* London: Pluto Press.

Shiva, Dr. Vandana. 2000. *Stolen Harvest: The Hijacking of the Global Food Supply.* Boston: South End Press.

Silvertown, Jonathan. 2009. *An Orchard Invisible: A Natural History of Seeds.* Chicago: The University of Chicago Press.

Stokes, Donald and Lillian. 1986. *A Guide to Enjoying Wildflowers (Stokes Nature Guides).* Boston: Little, Brown and Company.

Stokes, Donald and Lillian. 1976. *A Guide to Nature in Winter (Stokes Nature Guides).* Boston: Little, Brown and Company.

Thomas, Lewis. 1978. *Lives of a Cell: Notes of a Biology Watcher.* New York: Penguin Books.

Turner, Carole B. 1988. *Seed Sowing and Saving (Storey's Gardening Skills series).* Pownal, Vermont: Storey Communications, Inc.

Viard, Michel. 1995. *Fruits and Vegetables of the World.* Ann Arbor, Michigan: Longmeadow Press.

Viola, Herman J. and Carolyn Margolis. 1991. *Seeds of Change: Five Hundred Years Since Columbus.* Washington, DC: Smithsonian Institution Press.

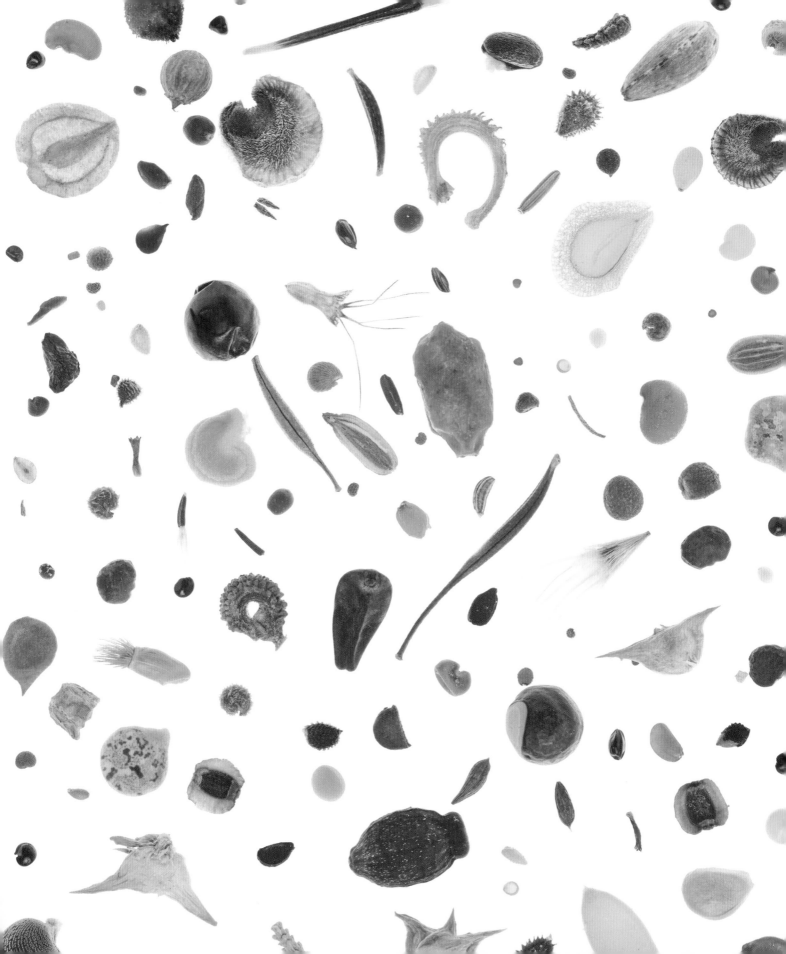

ACKNOWLEDGMENTS

Robert thanks the many dedicated gardeners who took up the challenge to search for and provide seeds and seed-pods as he worked on this project.

Garden writer Nancy Ross Hugo gave advice and seeds from her garden, and she even grew a few plants and their seeds specifically for these pages. John Hugo and Phil Marx watched their Osage orange tree until the early fruit emerged, then climbed into the branches to collect specimens. Carolyn Achenbach saved many seedpods for the book and shared her amazement at the beauty of what usually ends up in her compost pile.

Additional gardeners—Kathy Thomas, Fran Boninti, Candy Crosby, Anne Vanderwaker, Ann Coles, Eleanor Gould, McCrea Kudravetz, Trizia Lee, Kelly Riley, P. Will Neumann, and Virginia Carpenter—provided specimens. The Lewis Ginter Botanical Garden in Richmond, Virginia, and the Sara P. Duke Gardens at Duke University generously saved seeds. Many thanks are due to Mike, Karen, and Evan O'Brien for making a family project of hiking their fields to collect winter seedpods. Paula Biles searched the tropical wilds of Florida for the most exotic specimens, and Teri Dunn Chace journeyed to California in search of unique West Coast seeds.

Timber Press editor Tom Fischer produced a never-ending list of seeds for which to search. (Okay, it wasn't quite never-ending. Kew Gardens researchers in London estimate there are more than 400,000 flowering plants in the world, all of which produce seeds.)

Technical thanks goes to Jon Golden for his computer assistance and his "when things go wrong" skills. Also special appreciation goes out to Rik Littlefield, the inventor of the stacking software Zerene Stacker, for many optical conversations and his great insights into the nuances of macro photography.

Extreme thanks to Google, where he went after getting euphorbia sap in one eye. With the functioning eye he was able to read that he needed to wash the afflicted one with milk to prevent permanent blindness.

Finally, he would like to acknowledge his wife, Bobbi, for her support in this project and her willingness to let poisonous seedpods explode and propel seeds 30 feet across the room.

Teri would especially like to thank: Paula Biles, for being our Florida stringer and for her unflagging curiosity about and enthusiasm for the natural world; Bill McDorman, co-founder of the Rocky Mountain Seed Alliance (rockymountainseeds.org) and former executive director of Native Seeds/SEARCH, for reviewing the manuscript in its early stages and for the important work he does with seed preservation, research, and education; Tim Creamer, a superb science teacher and naturalist; herbalist Lisa Ferguson Crow of Hawthorne Hill Herbs (hawthornehillherbs.com); and the excellent staff of the Polly Hill Arboretum on Martha's Vineyard.

She also would like to thank the following for help, encouragement, and inspiration: the staff of Timber Press, Sarah Rutledge Gorman, Alan Chace, Tristan and Wes Dunn, MaryJane Blau, Daniel Stone, Deborah Olson, Steve Frowine, Betty Mackey, Kent McMillan, Everett Holt King, David Chinery, Lee Reich, Jan Blüm and Karla Rae Prabucki, Barb and Steve Damin, Jeff the UPS guy, Jules Verne, Maya Angelou, James Gurney, Diana Gabaldon, and Garnet Rogers.

Seeds, in all their marvelous diversity, share a common goal: shelter the embryo of a new plant until it's time to sprout.

INDEX

Abelmoschus esculentus, 201–203
acanthus, 14
Acer, 44
Acer japonicum, 248
Acer macrophyllum, 248
Acer platanoides, 248
Acer rubrum, 248
Acer saccharum, 248
achene, 38, 46
Achillea species, 180–181
acorns, 10, 34, 242
Actinidia deliciosa, 200
Actinidia species, 200
Aesculus arguta, 269
Aesculus californica, 269
Aesculus flava, 269–270
Aesculus glabra, 269
Ailanthus altissima, 264–265
Alcea rosea, 80
Allium 'Globemaster', 98
Allium caeruleum, 98
Allium christophii, 98
Allium macleanii, 98
Allium ×proliferum, 193–195
Allium 'Purple Sensation', 98
Allium schoenoprasum, 164
Allium species, 98
Allium unifolium, 98
amaranth, 92
Amaranthus caudatus, 92
American beech, 218–219
Anasazi beans, 24
Anemonella thalictroides, 150
Anemone quinquefolia, 150
Anemone virginiana, 150
Anethum graveolens, 172–173
angiosperms, 17
apoximis, 22, 134
apple, 14, 15, 32, 50, 184–185
Aquilegia species, 132–133
aril, 25, 178

Arisaema species, 118–121
arugula, 186–187
arum, 118–121
Arum maculatum, 118
Arum species, 118–121
Asclepias syriaca, 142–144
Asclepias tuberosa, 126–127
ash, 44
Asian long bean, 188–189
asparagus, 22
Asteraceae, 32, 124, 134, 158, 180, 191
Atlas cedar, 230
Averrhoa carambola, 211

bananas, 32
Baptisia australis, 140
Baptisia tinctoria, 140
basswood, 220–221
beans, 15, 17, 18, 20, 30, 47
beautyberry, 222–223
beebalm, 122–123
bees, 122, 155, 166, 176, 200, 234, 254
bigleaf maple, 248
Bignonia capreolata, 238
Bignoniaceae, 238
birds, 15, 34, 46, 48, 50, 112, 122, 128, 165, 176, 179, 208, 232, 256
bitter melon, 190
blackberries, 32
blackberry lily, 60–61
black-eyed Susan, 124–125
black salsify, 191
black walnut, 54, 224
blueberries, 32, 50
Brassicaceae, 81, 108, 186
bulbs, 36
burdocks, 48
Burroughs, Edgar Rice, 84
butterflies, 126, 128, 176, 222, 254
butterfly vine, 62–63
butterfly weed, 126–127

calendula, 158–159
Calendula officinalis, 158–159
California buckeye, 269
Callicarpa americana, 222–223
Callicarpa japonica, 222
calyx, 41
Canada thistle, 128–129
Capparidaceae, 108
Capsicum annuum, 205
capsules, 30, 41
Cara Caras, 204
cardboard plant, 34, 225
Carex species, 148–149
carpel, 38
carrots, 15
Castaneda, Carlos, 168
castor bean, 160–163
castor oil, 160
catalpa, 15
cattail, 130–131
Caucasian wingnut, 226–227
cedar cones, 10
cedar waxwings, 232
Cedrus atlantica, 230
Cedrus deodara, 230
celandine poppy, 104
Chapman, John (Johnny Appleseed), 184
Chasmanthium latifolium, 106–107
chiltepins, 50
Chinese lantern, 64–67
chives, 164
Cirsium arvense, 128–129
Citrullus lanatus, 215
Citrus sinensis, 204
Clausen, Ruth Rogers, 64
clematis, 38, 59, 68–73
Clematis lasiandra, 68
Clematis species, 68–73
Clematis tangutica, 68
Clematis texensis, 68

clementines, 204
Cleomaceae, 108
Cleome houtteana, 108–111
coconut milk, 24
columbine, 132–133
compound fruits, 32
coneflower, 165
cones, 10, 34–36
conifers, 34
Consolida species, 86–87
corms, 36
corn, 17–20, 23
corn poppy, 101, 104
Cornus florida, 240–241
Cornus kousa, 240–241
Cornus nuttallii, 240–241
cotton, 166–167
crabapple, 228–229
creeping stems, 36
cucumbers, 32
Cucumis metuliferus, 198–199
Cucurbita species, 210
currant, 32
cuttings, 38
cycads, 25, 34

dandelions, 22, 44, 46, 134–137
datura, 10, 168–171
Datura innoxia, 168
Datura metel, 168
Datura species, 168–171
Datura stramonium, 168
Datura wrightii, 168
Daucus carota, 146–147
deodar cedar, 230
Deppe, Carol, 15, 28
devil's claw, 138–139
devil's trumpet, 168
The Dharma Bums (Kerouac), 48
Dicentra eximia, 155
Dicentra spectabilis, 155

dicots (dicotyledon), 17–20
dill, 15, 28, 172–173
dioecious plants, 22, 34
Dirr, Michael, 266
dispersal, 45–52
division, 36
d-lysergic acid amide (LSA), 94
dormancy, 25, 52–54
drupes, 32
drying, 54–56
dry seeds, 51–52

ear tree, 231
Eastern red cedar, 217, 232
Echinacea species, 165
eggplant, 192
Egyptian onion, 193–195
Eiseley, Loren, 47
Ekstrom, Nicolas H., 64
elm, 44, 46
embryo, 22–23
endosperm, 23–24
Enterolobium cyclocarpum, 231
Equisetum species, 141
Eruca vesicaria, 186–187
eucalyptus, 233
Eucalyptus globulus, 233
Euphorbiaceae, 160
European arolla pine, 50
expulsion, 47–48

Fabaceae, 30, 47, 140, 213, 231, 250, 268
Fagus grandifolia, 218–219
false indigo, 140
fava bean, 196
favism, 196
female seed parts, 15–17, 38–41
fennel, 15
ferns, 36, 141
fertilization, 15–17
fibers, 157–215
Ficus carica, 197
Ficus carica 'Brown Turkey', 197
Ficus carica 'Celeste', 197

Ficus carica 'Mission', 197
fig, 10, 32, 197
fireweed, 10
firs, 34
Flanders poppy, 101, 104
flower clusters, 32
flowers, 17–20, 22, 38–41
follicles, 30
Fragaria ×*ananassa*, 212
Fraxinus, 44
fruit, 14, 15, 32–33, 41, 48, 49, 52
fruit flesh, 14, 32–33, 184
The Fruit Hunters (Gollner), 198

garden flowers, 59–116
garlic, 17
germination, 25, 53–56
Gibbons, Euell, 130
gin, 232
ginkgo trees, 22, 34
goldenrain tree, 46, 234–237
goldenrod, 10
goldfinches, 128, 165
Gollner, Adam Leith, 198
Gossypium hirsutum, 166–167
grapes, 10, 32, 50
grasses, 106
gymnosperms, 17, 34–36

harvest, 50–52
Helianthus annuus, 112–113
hellebore, 74–79
Helleborus ×*hybridus*, 74
Helleborus niger, 74
Helleborus species, 74–79
herbs, 157–215
Hesperis matronalis, 81
hitchhikers, 48–49
holly, 22
hollyhock, 80
honesty, 81–83
hops, 22
hoptrees, 44
horned melon, 198–199

horsetail, 141
horsetail spores, 10
humidity, 54
hummingbirds, 122, 176
hybrid plants, 25, 51
hybridus, 74
Hypericum, 84

ingestion, 49–50
insects, 34, 176, 188
Ipomoea 'Heavenly Blue', 94
Ipomoea nil 'Scarlet O'Hara', 94
Ipomoea purpurea 'Grandpa Ott', 94
Ipomoea species, 94–97
Iridaceae, 60
Iris domestica, 60–61

jacaranda, 238–239
Jacaranda mimosifolia, 238–239
jackfruit, 32
Jack-in-the-pulpit, 118
Jaffrey, Madhur, 178
Japanese maple, 248
Jefferson, Thomas, 168
jewels of Opar, 84–85
jewelweed, 47
jimsonweed, 168
Juglandaceae, 226
Juglans fraxinifolia, 226
Juglans nigra, 224
Juniperus communis, 232
Juniperus occidentalis, 232
Juniperus virginiana, 232

Kerouac, Jack, 48
kichiwa, 92
kiwi, 22, 200
Klinkenborg, Verlyn, 248
Koelreuteria paniculata, 234–237
kousa dogwood, 240–241

Lamiaceae, 122
larches, 34
larkspur, 86–87

layering, 36–38
leaves, 17, 20
Lilium lancifolium, 151–153
Lilium superbum, 151
lily, 17, 151–153
Liquidambar styraciflua, 258–259
Liriodendron tulipifera, 266–267
London plane tree, 260
lords and ladies, 118
lotus, 88–91
love-in-a-mist, 174–175
love-lies-bleeding, 92–93
Lunaria annua, 81–83
lyre-leaved sage, 176–177

mace, 25, 178
Maclura pomifera, 245–247
Magnolia grandiflora, 254–255
male seed parts, 15–17, 38
Malus domestica, 184
Malus domestica 'Gala', 184
Malus domestica 'McIntosh', 184
Malus domestica 'Red Delicious', 184
Malus 'Donald Wyman', 228
Malus floribunda, 228
Malus species, 228–229
maple, 34, 44, 46, 248
marijuana, 22
Mascagnia macroptera, 62–63
Matthiola incana, 81
meadow rue, 150
medicine, 157–215
melon, 51
milkweed, 10, 30, 142–144
Momordica balsamina, 190
Momordica charantia, 190
Monarda didyma, 122–123
money plant, 81
monocots (monocotyledon), 17–20
monoecious plants, 22, 34
morning glory, 94–97
moths, 122
mulberries, 32
mullein, 145

multiple-seeded fruits, 32
Myristica fragrans, 178

Native Americans, 140, 179, 242, 250, 256,
 269
Nelumbo nucifera, 88–91
Nigella, 157
Nigella damascena, 174–175
Nigella sativa, 174
Norway maple, 248
nutmeg, 25, 178
nuts, 33–34, 41

oak, 242–244
Ohio buckeye, 269
okra, 10, 183, 201–203
onions, 17, 98, 164, 193–195
orange, 204
orchids, 24
oriental plane, 260
oriental poppies, 101
ornamental onion, 98
Osage orange, 245–247
Oxalidaceae, 211

Paeonia 'Coral Charm', 99
Paeonia species, 99–100
Pandanus utilis, 252–253
Papaver orientale, 101
Papaver rhoeas, 101, 104
Papaver somniferum, 101
Papaver species, 101–105
parthenocarpy, 36
paternity, 15–17
pears, 50
peas, 15
peony, 99–100
pepper, 205
perennial plants, 51
Perennials for American Gardens (Clausen
 and Ekstrom), 64
petals, 41
Phytolacca americana, 179
pineapple, 32

pine nuts, 34
pines, 34
Pinus edulis, 34
Pinus pinea, 34
pistils, 20, 38
Platanus acerifolia, 260
Platanus occidentalis, 260–263
Platanus orientalis, 260
Platanus racemosa, 260
pods, 15, 30, 41
pokeweed, 179
pollen, 20
pollination, 15–17, 34
pomegranate, 25, 32, 206–207
pomegranates, 25
poppy, 101–105
Portulaca, 84
Proboscidea species, 138–139
Prosopis pubescens, 250–251
Ptelea, 44
Pterocarya fraxinifolia, 226–227
Punica granatum, 206–207
pyracantha, 50

Queen Anne's lace, 15, 117, 146–147
Quercus species, 242–244

Ranunculaceae, 174
raspberries, 32, 208–209
red maple, 248
rhizomes, 36, 130, 141
Rhus typhina, 256–257
Ricinus communis, 160–163
ripeness, 50–52
rocket, 81, 186
Root, Waverley Lewis, 242
Rosa species, 249
rose, 10, 249
rose hips, 10, 249
Rubus idaeus and hybrids, 208–209
Rudbeckia fulgida var. *sullivantii*
 'Goldsturm', 124
Rudbeckia species, 124–125
rue anemone, 150

sago palm, 34
Salvia coerulea, 176
Salvia farinacea, 176
Salvia leucantha, 176
Salvia lyrata, 176–177
Salvia splendens, 176
samaras, 34, 44, 46, 248
sarcotesta, 25
Satsumas, 204
Scorzonera hispanica, 191
screwbean mesquite, 250–251
screwpine, 252–253
sea oats, 106–107
sedge, 148–149
seed coats, 24–25, 41, 49, 54
seed development, 15–17
seed forms, 15, 28–41
seed groups, 17–20
seedheads, 29–30
seed interiors, 20–25
sepals, 41
Sequoia sempervirens, 242
Shirley poppies, 101
shrubs, 217–270
Silvertown, Jonathan, 20
simple fruits, 32
single-seeded fruits, 32
skunk cabbage, 118
Smyrna-type figs, 197
soil, 53
Solanum lycopersicum, 214
Solanum melongena, 192
Solanum melongena 'Black Beauty', 192
southern magnolia, 254–255
spices, 157–215
spider flower, 108–111
spores, 36, 141
spruces, 34
squash, 210
staghorn sumac, 256–257
stamens, 20, 38
star fruit, 211
stigma, 38
stock, 81

storage, 54–56
stratification, 53
strawberries, 212
Stylophorum diphyllum, 104
sugar maple, 248
sunflower, 34, 112–113
sweetgum, 258–259
sycamore, 260–263
Symplocarpus foetidus, 118

Talinum paniculatum, 84–85
tamarind, 15, 213
Tamarindus indica, 213
Taraxacum officinale, 134–137
Tarzan and the Jewels of Opar
 (Burroughs), 84
Tetraberlinia moreliana, 47
Texas buckeye, 269
Thalictrum, 150
thimbleweed, 150
Thomas, Lewis, 56
tiger lily, 151–153
Tilia americana, 220–221
tissue culture, 38
tomatoes, 32, 51, 52, 214
touch-me-nots, 10
Tragopogon porrifolius, 191
tree of heaven, 264–265
trees, 217–270
tulip poplar, 266–267
turk's cap lily, 151
Typha latifolia, 130–131

Ulmus, 44
umbelliferous plants, 28

vegetable plants, 51
Verbascum blattaria, 145
Verbascum species, 145
Verbascum thapsus, 145
viburnum, 50
Vicia faba, 196
Vigna unguiculata subsp. *sesquipedalis*,
 188–189

Viola species, 154
violet, 154

water-aided pollination, 34, 46
watermelon, 215
weeds, 117–155
Western sycamore, 260
wet seeds, 52
wheat, 23, 24
white salsify, 191
wild bleeding heart, 155
wildflowers, 117–155
wild oats, 106

wild plants, 25
wind pollination, 34, 45–46
wisteria, 10, 268
Wisteria species, 268
wood anemone, 150

yarrow, 180–181
yellow buckeye, 269–270
yucca, 114–115
Yucca filamentosa, 114–115

Zamia furfuracea, 34, 225

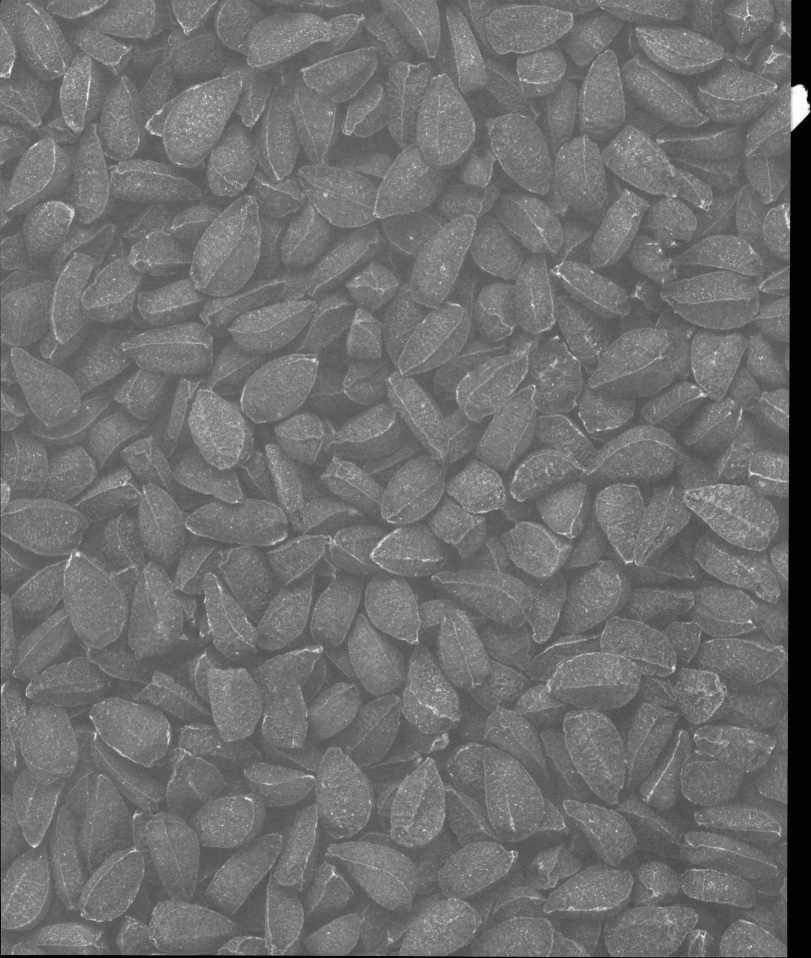